I<small>MAGE</small> A<small>CTS</small>

WITHDRAWN
UTSA Libraries

2

IMAGE

WORD

ACTION

IMAGO

SERMO

ACTIO

BILD

WORT

AKTION

Editors
Horst Bredekamp, David Freedberg,
Marion Lauschke, Sabine Marienberg,
and Jürgen Trabant

HORST BREDEKAMP

IMAGE ACTS

A SYSTEMATIC APPROACH TO VISUAL AGENCY

Translated, edited, and adapted by
Elizabeth Clegg

DE GRUYTER

Interdisciplinary Laboratory in the Hermann von Helmholtz Center for Cultural Techniques

Sponsored by

This publication was made possible by the *Image Knowledge Gestaltung.
An Interdisciplinary Laboratory* Cluster of Excellence at the Humboldt
University Berlin with financial support from the German Research
Foundation (DFG).

First published as *Theorie des Bildakts.*
Frankfurter Adorno-Vorlesungen 2007, Berlin 2010.

The English translation is based on the second edition *Der Bildakt.*
Frankfurter Adorno-Vorlesungen 2007, Berlin 2015.

ISBN 978-3-11-053630-0
e-ISBN (PDF) 978-3-11-054857-6
e-ISBN (EPUB) 978-3-11-054758-6
ISSN 2566-5138

Library of Congress Cataloging-in-Publication Data
A CIP catalog record for this book has been applied for at the Library of Congress.

Bibliografische Information der Deutschen Nationalbibliothek
The Deutsche Nationalbibliothek lists this publication in the Deutsche Nationalbibliografie; detailed
bibliographic data are available on the Internet at http://dnb.dnb.de.

© 2018 Walter de Gruyter GmbH, Berlin/Boston

Image on cover: *Madonna of Essen* (detail), c. 990, Treasury, Cathedral, Essen

Series Managing Editor: Marion Lauschke
Series design: Petra Florath
Printing and binding: Hubert & Co. GmbH & Co. KG Göttingen

This paper is resistant to aging (DIN / ISO 9706)
Printed in Germany

www.degruyter.com

Library
University of Texas
at San Antonio

In Memory of
John Michael Krois
24 November 1943 – 30 October 2010

Philosopher and Friend

TABLE OF CONTENTS

Preface to the English Edition

The core of this book derives from the first pages of my doctoral dissertation on iconoclasm, as published in 1975. This opened with a photograph from the Cambodian Civil War that I had recently found in the *Frankfurter Rundschau*. It showed a soldier of the Khmer Republic cleaning his rifle while seated alongside – and thus under the assumed protection of – a painting and a figurine of the Buddha.[1] Such a juxtaposition of weaponry and imagery was startling, for it at once called into question both the categorical distinction between the two and its implicit demotion of the latter.

Cambodian soldier on the battlefield, with a painting and a figurine of the Buddha, *Frankfurter Rundschau* 27 July 1973.

1 Bredekamp 1975, pp. 10–14.

My sensitivity to evocative instances of this sort was to be enhanced through a rediscovery of the germanophone historiography of art that had been lost as a result of the emigration of scholars from Europe in and after 1933. My attention was drawn, above all, to adherents of the intellectual tradition initiated, in Hamburg around 1900, by Aby Warburg and his closest colleagues, Ernst Cassirer and Edgar Wind. In this context Wind seemed to be of particular importance on account of his later endeavour, in the 1960 volume *Kunst und Anarchie* (known in England as that year's Reith Lectures "Art and Anarchy"), to fathom the active function of images. For me this was a source of inspiration.[2] Also deeply compelling was the quintessentially Warburgian conviction that images were possessed of a genuine "right to life",[3] and that this entailed both an obligation to uphold this right and, conversely, a duty to oppose the abuse that images may suffer

Especially remarkable was the discovery of what the Warburg tradition deemed appropriate for the attention of those with a keen interest in the "image": a Mediaeval tapestry was as likely to be the starting point for an enquiry as was an entity then still at the cutting-edge of visual technology, such as a page from the illustrated press. The distinctive visual qualities of each chosen subject were, moreover, acknowledged and respected, even while all restrictions on the scope for enlightening comparison were removed. Such an approach was later to be defined as *Bildwissenschaft* (literally, "image science").[4]

Underpinning this expansion of conventional "art history" into a true "image history", open to every possible sort of consciously created figurative form, was the conviction that the images devised by humanity do not merely represent, but veritably *construct*, do not simply illustrate, but actively *bring forth*, that which they show. As my own deeper understanding of "image history" gradually evolved, I sought – from the mid-1970s at the University of Hamburg, and from the early 1990s at Humboldt University, Berlin – to apply this conviction in my own work, some of which I came to regard as the retrospective launching of a message-in-a-bottle destined for the key players in the original Warburg circle.

These efforts assumed a new dimension during the 1990s, when John Michael Krois – himself initially trained in the United States as a philosopher, but since 1993 based at Humboldt University and editing the collected works of Ernst Cassirer – was seeking a scholarly collaborator in his project to overcome the limitations of a philosophy restricted to words alone. Together, we founded a study group, *Bildakt und Philosophie der Verkörperung* [Image Act and the Philosophy of Embodiment], in which philosophers and art historians would meet on an equal footing. In response

2 On the Hamburg circle: Krois 1998, p. 184; Krois 2009 *Introduction*. On Wind, see Schneider 2009.
3 Reciprocally, on the "human rights" of the eye: Hofmann, Syamken and Warnke 1980.
4 Bredekamp 2003 *Neglected*.

to our shared belief that this venture should have a strong linguistic element, a further Berlin scholar, the historian of language Jürgen Trabant, also joined the group.

As reflected in the essays gathered in the series *Actus et Imago*, published from 2011 (twenty volumes had appeared by 2016),[5] our research group attended to every aspect of the de-centred, enactive, and embodied mind. In doing so we came to the conclusion that what had so far been lacking in the scholarly approach to such issues was a sufficient appreciation of the image not as a passive entity awaiting human scrutiny, but as an activating force in its own right. Gradually, there emerged the notion of the "image act" as the essential, facilitating counterpart to the Philosophy of Embodiment.

The evolution of the present volume – from its origins in a course taught in Berlin in 2006, by way of its adaptation into the text of the Adorno Lectures delivered in Frankfurt in 2007, and its extension into the first, 2010 German edition, to its 2015 revision – is outlined in my Acknowledgements.[6] So I should like, in conclusion, to comment on the original, German term for "image act" – "der Bildakt" – and on some of the problems raised by its translation into English. "Bild" is not the exact equivalent of either "image" (more abstract in its connotations, but also more widely applicable) or "picture" (more material in its associations, but also more restricted in its application). In as far as this book considers visually perceptible material forms, however diverse their mediums, the term "picture act" might well have seemed the more appropriate; and it has, in other contexts, occasionally been employed.[7] But in as far as my concern is with the immaterial *energeia* inherent to the form and with the responses that this may call forth in the beholder, the term "image act" was evidently the more fitting. Further encouragement for my decision in favour of "image act" came from several re-readings of David Freedberg's seminal publication *The Power of Images*,[8] where this term is used in a sense that is very close to my own. Reference to the "image" has, in the interim, been further reinforced through the titling of a number of my book's earlier translations.[9]

In its English version (a translation, but also an adaptation) my initial exposition has been much enhanced through the generous intellectual engagement, the scholarly range, and the well-honed art-historical eye of Elizabeth Clegg.

5 See also Fingerhut / Hufendiek 2013.
6 See pp. 289–91.
7 See, for example, Bredekamp 2014 *Picture*.
8 Freedberg 1989.
9 Notably into French (2015, translated from the 2010 German edition) which used "l'acte d'image." As of 2017 the volume also exists in Italian, Spanish, Portuguese, Japanese, and Mandarin editions.

INTRODUCTION:
THE PROBLEMATIC CENTRALITY
OF THE IMAGE

I. INCREASING REFLECTION OF THE IMAGE

It is only since the 1960s that thought and debate about the status of images has again reached that pitch of intensity it had attained during the Byzantine Iconoclastic Controversy of the eighth and ninth centuries or the iconoclasm that marked the radical Protestant movements of fifteenth- and sixteenth-century Europe. For this reason it now seems both appropriate and timely to seek to ascertain precisely why images and the claims regularly advanced for their conception, their formation, their elaboration, and their power have become such persistent issues.

First among the five chief reasons that spring to mind is the ubiquity of the pictorial in the new technologies of communications, information and entertainment (the "new media"): the smart phone screen, the online press site, the internet, the proliferating televisual and cinematic formats. With a myriad images daily whizzing around the globe, it is as if contemporary civilisation were seeking to pupate itself within a cocoon spun from their shimmering trails. It is above all the entertainment industry, a factor of formidable economic clout, which has generated the most familiar model of this phenomenon, unprecedented in its dimensions as in its depth: "the flood of images". And, as with all methaphors of deluge, this powerfully evokes both the fear of impotence and an urge to self-defence.[1]

Secondly, there is the use of images in politics. Here, one of their roles has always been the representation of dominion. And, even within the "flood of images", both still and moving depictions of particular groups and individuals retain the power to leave their mark on the collective memory of a city, a nation, a continent and, on occasion, the entire world, and thereby to exert a variety of influences shap-

1 Giuliani 2003, pp. 9–19; Schulz 2005, p. 9. On metaphor: Kolnai 2007 [1929], pp. 30–31 and Theweleit 1977. On criticism of the concept: Schwemmer 2005, pp. 197–98.

ing political life and much more.[2] It is above all for this reason that the twentieth century was called "the century of images",[3] although there are earlier eras to which the phrase might well have been applied. Today an unpredictable blending and cross-fertilisation of older and newer images has significantly enhanced this characterisation. Images can serve both as allies and as traitors to an established political order.

Thirdly, one can look to the military sphere. Images have always been an effective weapon – as symbols of victory, as propaganda, as indoctrination – even in the arsenals of well-matched belligerents, be it in parallel with, or subsequent to, the more literal waging of war. But in the context of an asymmetrical war they may even become primary weapons. Harnessing the "launch systems" of the mass media and the internet, they serve to extend the battlefield from the local to the global by transmitting, far more directly than was ever previously possible, all that is most deeply disturbing – inflammatory rhetoric, scenes of combat or torture, distressing hostage scenarios – to the eyes of those geographically remote from the conflict zone. In some circumstances this latest manifestation of the "war for hearts and minds" may achieve far more than can conventional weaponry.[4]

The fourth reason is supplied by the sciences. These have always played a significant role in the creation of iconographies beyond the religious sphere; but the degree to which technological innovation and high aesthetic standards have been applied, since the 1960s, in the visualisation of the invisible is an entirely new phenomenon. It is now quite some time since the standards of publications in the natural sciences have caught up with those of publications devoted to the fine arts. The visual brilliance being achieved today by accounts of recent progress in aspects of medicine, molecular biology, nanotechnology, research into climate change and space exploration, goes far beyond the concept of mere illustration. When such images are readily employed not as forms of representation, but as autonomous, analytical tools, one is undeniably confronted with a highly significant instance of the "iconic turn". Whether in the form of sequential simulations or of diagrammatic models, such images now dominate any engagement with scientific evidence, as

2 Among examples still internationally recognisable are the (reconstructed) planting of the American flag on the Japanese island of Iwo Jima on 23rd February 1945; Willy Brandt falling to his knees at the site of the former Warsaw Ghetto on 7th December 1970; or some of the photographs testifying to the regime of torture implemented in 2003 at the prison at Abu Ghraib.
3 See also the equally, if diversely, comprehensive publications: *Mythen der Nationen* 2004, and *Das Jahrhundert der Bilder* 2009.
4 Bredekamp and Raulff 2005.

well as the prevailing approach to both meteorological and socio-economic fore-casting.[5]

Finally, one must take into account the increasingly prominent legal status of images. Half a century ago these were relatively freely available, restricted only through copyright provisions and a respect for the dignity of depicted individuals. Today they are often "protected" by a great many other barriers, financial as well as legal, often to the ultimate advantage of the "image industry", which has itself become a significant branch of the economy. All too often, this is a hindrance to scholarly research.[6]

In every one of these five spheres images that had once been secondary phe-nomena – treasured and fostered, though also subject to criticism and sometimes even forbidden – have now advanced to primary status. Simultaneously, however, a long-running conflict regarding the particular nature of their value has come to a head. This is the result of a contradiction between two assumptions. Some argue that knowledge is only securely established when sensorial, in particular visual, impressions have ceded to abstract notions. Others maintain that, on the contrary, it is through sensorial impressions, and above all through the visual input of strik-ing images, that thought is stimulated, feeling is aroused and ideas are engendered.[7]

Between the resulting extremes of exculpation (as effectively impotent) and demonisation (sometimes in the most extreme forms), images have steadily con-tinued to attract serious attention from disciplines other than those – Archaeology and Art History – that have a securely founded association with their study. It is now indisputable that one is no longer in a position to address the contemporary world without first attending to the question of images. What follows is intended to serve as a commentary upon this situation.

2. Leonardo's Invitation to Captivity

A remark of Leonardo da Vinci's supplies a motto for this undertaking. It is among the most profound statements ever made on the power inherent in an image. The words, inscribed on a slip of paper, are supposedly addressed, by the subject of

5 On the "iconic turn", see Boehm 1994. On the problem of the image and the sciences, see *Das Technische Bild* 2008 (translated into English as *The Technical Image* 2015).

6 Bruhn 2003; Bruhn 2009, pp. 115–30. The scope for research on the part of the disciplines traditionally devoted to the image has been strongly impacted by this (Bredekamp and Haff-ner 2008; Steinhauer 2009).

7 Jay 1993, Pape 1997 and Zittel 2009 have comprehensively defined and deplored the tradi-tion, among philosophers, of paying little attention to images.

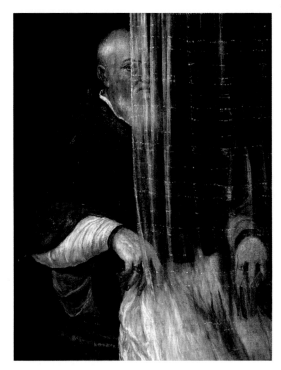

Fig. 1 Titian, *Portrait of Filippo Archinto*, Oil on canvas, 1551/62, Philadelphia Museum of Art.

an as yet unveiled portrait, to a potential spectator: "Do not unveil me if freedom is dear to you, for my face is the prison of love".[8]

This utterance plays on the practice of shrouding pictures in order to uncover them only on the most important days in the Church calendar. According to Leonardo, such a work informs the person approaching it that its uncovering will almost certainly entail the sacrifice of that individual's freedom. The image speaks and, in doing so, it demands a reaction. To leave the portrait covered will preserve freedom, but at the cost of a potentially extraordinary experience; yet risking all for the sake of that experience may destroy everything that defines and distinguishes an autonomous self.

[8] "Non is coprire se llibertà / t'è cara ché 'l volto mio / è charciere d'amore" (Leonardo da Vinci, 1930–36, Vol. 3, 1934, fol. 10v, p. 16). Marinoni discusses the divergent view that "ché" is here to be read as "che", meaning "that" (Leonardo da Vinci 1992, p. 8: fol. 10v, note 8). Yet this would barely seem to make sense. The individual addressed can hardly be envisaged as relinquishing freedom through uncovering something that is already known. For an argument along these lines, see also Fehrenbach 1997, p. 325. On a similar formulation in the work of Ludwig Wittgenstein, see Schürmann 2008, pp. 173–74.

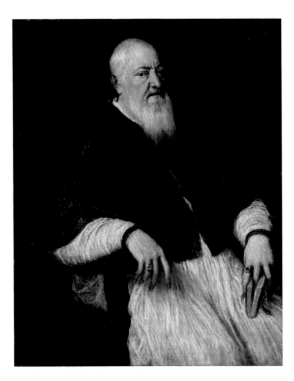

Fig. 2 Titian, *Portrait of Filippo Archinto*, Oil on canvas, c. 1554–56, Metropolitan Museum of Art, New York.

Titian's portrait of Filippo Archinto (Fig. 1) may offer a means of understanding more about Leonardo's maxim. The painting, completed in all likelihood in 1558, shows the Archbishop of Milan, who had been appointed to this post by Pope Paul III (Alessandro Farnese), but whose accreditation had been withheld by the civil authorities. While the Archbishop's ring is clearly visible, the book that signals his proclamation can be only vaguely discerned through the veil that covers half his body. This discrepancy has been interpreted as an allusion to the fact that Archinto had been appointed to the office of Archbishop but had not been given the right to exercise that office. As a document of failure, it would then be seen to convey an air of resignation.[9]

Yet an alternative interpretation appears to be no less plausible: this takes as its starting point the fact that the left extremity of the veil runs through the sitter's own right eye. This was traditionally viewed as the eye of justice, from which nothing remained hidden.[10] If Leonardo's maxim were imaginatively applied to this instance,

9 Betts 1967, p. 61.
10 Lomazzo, Vol. 6, LIII (1844, pp. 393–96).

the spectator would be advised that if the veil were pulled further to the right then this person would confront the sitter's full gaze, and thereby be taken prisoner by it.[11] Fully uncovered, however, the image would effectively take on another role: not so much a revealed portrait as the re-emergence of one completed somewhat earlier (Fig. 2).[12] For a spectator aware of the earlier work, the visible right forefinger in the later version might well seem to play with the notion of the portrayal of "liveliness".

Such an interpretation is supported by an aspect of the theory of the two-sided body, championed by the polymath Girolamo Cardano. As Cardano's patron, Archinto would surely have been familiar with the philosophy of his chief work, *De vita propria*, which held that the left side of the body was to be seen as that of spiritual achievement, while the right side was associated with damnation. If Titian's later record of Archinto were indeed an allusion to this theory, the leonardesque threat of what might follow the uncovering of a partially veiled portrait would carry greater weight.[13] Regardless, however, of the interpretation of Titian's picture from this point of view, it seems more than likely that Titian shared Leonardo's fascination with the notion of the power exerted by the painted gaze itself.

No less than any of his enlightened contemporaries, Leonardo would have started with the assumption that artfully contrived objects had the capacity to speak and to command. Leonardo's maxim alludes, moreover, to the commonly observable phenomenon of images exerting a decisive influence on the freedom of those who look at them; and the veiled portrait that he invokes stands in a tradition that persists to this day. This was taken up by Man Ray, whose wrapped and tied objects were intended to underline the potentiality within a work through its concealment, and later by Christo and Jeanne-Claude in their own "wrapping" projects.[14]

Leonardo's maxim also acknowledges the problem of the autonomy of the image. While humanity has the distinctive capacity for spoken language, it encounters images as a distanced form of corporeality. Neither through the expenditure of emotion, nor through any amount of linguistic manipulation, can images be drawn back fully into that human order to which they owe their creation. Therein lies the essence of the fascination of the image. Once created, it is independent. It may then become the object of admiring astonishment, but also of that most powerful of all emotions: fear.

11 The model derives from the iconography of Moses, upon whose face the reflected glory of the Divinity was so strong that he had to wear a veil so as not to blind all those around him: Verspohl 2004, pp. 54–55. Comprehensive on the motif of the veil: Krüger 2001; Wolf 2002 *Schleier*.
12 Francis Bacon's veil paintings have effectively resumed this sort of transformation (Steffen 2003, p. 133).
13 This argument is to be found in Hall 2008, pp. 117–18.
14 *L'énigme d'Isidore Ducasse*, 1920/71, in: *Alias Man Ray* 2009, pp. 50–51; Christo 1993; Christo and Jeanne-Claude 2001.

3. THE *ENERGEIA* OF THE IMAGE

Until the Enlightenment, the notion of a power inherent in the image, encapsulated by Leonardo in an inimitably concise form, was a firmly established component in image theory, and was identified, as a naturally occurring force, in Latin terms such as *vis, virtus, facultas* and *dynamis*.[15] As material entities, and also as features in a theatre of memory, images occurred as *imagines agentes*.[16] Thereafter, however, the notion of a power inherent to the image fell out of favour, coming to be associated with magical thinking and religious occultism. If images breathed, sweated, bled, excreted oils, cried tears or were able to stand on their heads – in short, if they became obtrusively active within the sphere of the human spectator – then faith in miracles was seen to be conspiring with visual theology.[17]

A particularly striking instance in of the history of "living images" relates to the so-called Slacker Crucifix in the Mariacki Church (Saint Mary the Virgin) in Kraków, dating from the late fifteenth century, which features in numerous reports as capable of speaking and singing. It was also said to have resisted all attempts at the application of new paint. As the painter charged with this task laid his hands upon the work, the surface seemed to him as if it had become soft, as if it were part of a living body.[18] In the contemporary understanding of images, such events and concepts are no less present, even though these remain in the realm of fiction, as in the case of David Cronenberg's film of 1982, *Videodrome*, in which a television screen acquires the same liveliness as skin in order to seduce and then subdue the observer, so luring him to his death.[19]

After the Enlightenment, the notion of living and active images was effectively banned from art-historical discourse, to become, in time, an object of study in the realm of Anthropology and Ethnology.[20] An image, in as far as it consists of anorganic matter, can of course have no life of its own. Accepting this is of particular

15 Germanophone variants were "Kraft," "Tugend" and "Wirkung". With regard to Paracelsus, Karl Möseneder has compiled a history of the emergence of this concept (Möseneder 2009, pp. 73–162).

16 The formula was established by the unknown author of the *Rhetorica ad Herennium*. See also the striking enquiry undertaken in Berns 2005.

17 Dobschütz 1899, pp. 102–96; Kris and Kurz 1934, pp. 77–87; Freedberg 1989, p. 301 and passim.; Elkins 2001, pp. 156–57; *Animationen / Transgressionen* 2005, passim. On reports that the relic in Rome thought to be the Veil of Veronica had stood upside down, see Wolf 2002 *Schleier*, p. 48.

18 Jurkowlaniec 2006, pp. 351–55.

19 See also Mitchell 2005, pp. 217–221, and Fürst 2009. On the cancellation of distance in general, see Mondzain 2002.

20 Brückner 1966. Fundamental from the point of view of Ethnology: Gell 1998. See also Mitchell 2005, pp. 7–8.

importance for an art historian, whose duty it may be to detect even the deepest layer of under-drawing in a painting and to explain this in strictly material terms. But a nominal "certainty" that images consist of dead matter in fact only aggravates the problem. For it is "only human" to demand more of them. They are expected to be more than a mere reflection of whatever is projected into them. (This is no less true of images than it is of works of literature or of music; but in the case of images materiality presents a particular problem.)

The observer manifestly does receive a "return" on those ideas and emotions that have, in the very act of looking, been "invested" in the work of art.[21] For, in focusing intently upon that work, the observer becomes attuned to that which is latent within it. In a manner barely susceptible to control, this latent quality may then emerge from the merely potential to confront such a person with a counterpart. And not only may this prove to be beyond that individual's control; it may even lead inexorably to a leonardesque form of captivity.

Aby Warburg was second to none in engaging with this duality in the work of art as simultaneously inorganic and yet infused with a "life" of its own. In a fragment of his unfinished psychology of art one finds the dictum: "Du lebst und tust mir nichts" [You live and do me no harm].[22] Behind this assertion, however, there lies concealed more of an invocation than a certainty. Warburg was well aware that the self, ever re-forming and sheltering, might encounter, through images, sources not only of support but also of injury. The fact that the animated image possesses, alongside its capacity to move, also a capacity to harm, is among the essential characteristics of the phenomenology of the image act that is at the heart of what follows.

Of supreme concern here is the notion of *energeia* deriving from the linguistic theory of Antiquity, which Aristotle in his *Poetics* saw as arising when writers succeeded in the exercise of *pro ommatoun poiein* [setting before the eyes]. A verbal representation was said to be persuasive when it gave the impression that it might have been alive.[23] In the *Rhetoric* Aristotle associated this *pro ommatoun poiein* with the *energeia* that gives "expression to actuality".[24] This sort of rhetorical skill, fired by the animation of metaphor, has an affinity with the image taking on material substance. The reason for this lies in the fact that metaphors, in order to achieve

21 Mitchell 2005; Stjernfelt 2007, pp. 90–91.

22 Aby Warburg, *Grundlegende Bruchstücke zu einer monistischen Kunstpsychologie*, Nachlass, Warburg Institute, London; cited after Gombrich 1970, p. 71. See also Kany 1989, p. 13. On this point, see also Mainberger 2010, pp. 251–52.

23 Aristotle, *Poetics* XVII, 1 (1995, pp. 86/87–90/91, here 86/87). See also Rosen 2000, p. 178. In general: Plett 1975.

24 Aristotle, *Rhetoric* III, xi, 2, 1412a (1926, pp. 404/401–406/407, here 406/407). See also Gödde 2001, p. 246. The corresponding Latin term would be *evidentia*: Pichler 2006, pp. 140–41.

their ends, must be so strongly set off against their background, and in themselves so tightly woven, that they attain an almost "sculptural" quality. The model for Aristotle is the deliberately planned city, which offers a theatrical density, within which there arise images just as compelling as they are surprising.[25] This transfer of images from language to the physical presence of artefacts was adopted during the Renaissance as a fundamental motif of art theory.[26] When Leonardo writes of a painter "setting [something] before our eyes" then he, too, accomplishes the transfer of *energeia* from the realm of rhetoric into that of the visual arts.[27]

It is from this tradition that there derives the power that, according to Leonardo, confronts the prospective observer with a choice: either to dispense with looking upon the work of art or to relinquish any claim to freedom. It is of course understood that the observer will, in either case, be seized by a sense of the immensity of the decision. Yet, within the sheer bravado of the notion of the loss of freedom, there is more than a hint at something irredeemably dark. Both aspects will here come under consideration.

25 Campe 2008, pp. 42–52.
26 Rosen 2000, pp. 173–78.
27 Rosen 2000, p. 177; Rosen 2009, p. 58.

I

ORIGINS AND CONCEPTS

I. DEFINING THE IMAGE

A. *HOMO FABER* AND "AESTHETIC DIFFERENTIATION"

Over two million years ago, *homo habilis* was able to invest small lumps of basalt with a new dimension by chipping them with other stones, and thereby gradually shaping them into bellied forms with a pointed tip. These basalt objects then found many uses.[1] Over one and a half million years ago, his descendants had attained the ability to shape stones in such a way that their sharp edges made them into versatile tools – often archaeologically characterised as "hand axes" – even while the perfect symmetry of their form was remarkable in its own right.[2] A great many hand axes were, however, apparently never used, or were simply too small to be used. These examples would be further refined into the delicately faceted entities now termed "leaf points", in which implicit function (primarily as projectiles) and exquisite form blend seamlessly (Fig. 3). Objects of this sort are even more closely associated with the prehistory and early period of *homo sapiens*. The spears made 600,000 to 400,000 years ago, found in what is now Lower Saxony, are of such formal perfection that it would seem that the use to which they were put was itself imbued with an aesthetic element.[3]

Collections of fossils that are around 200,000 years old, assembled in small heaps so as to draw attention to that which is common to their particular range of

1 Le Tensorer 2001, pp. 58–60; *Evolutionary Aesthetics* 2003, pp. 260–62; Facchini 2006, pp. 98–111.

2 Le Tensorer 2001, pp. 62–64 discusses the discovery that older hand axes often appear more aesthetically pleasing than those made more recently, which would seem to point to an initial symbolic surplus, followed by a phase during which more attention was paid to function. See also Wynn 2002.

3 *Die Schöninger Speere* 2007.

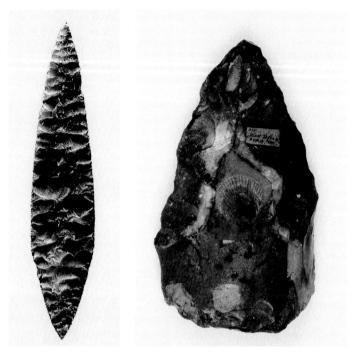

Fig. 3 Planar "leaf point" projectile worked on both sides Stone, c. 22,000 to 16,000 years old, Found at Solutré-Pouilly, Saône-et-Loire, France.

Fig. 4 Hand axe of the acheulean type, incorporating fossil scallop shell (*Spondylus spinosus*), Flint, c. 200,000 years old, Found at West Tofts, Norfolk Cambridge Museum of Archaeology and Anthropology.

shapes, are an early sign of the capacity for what scholars have termed "aesthetic differentiation".[4] In the form of a particular hand axe (Fig. 4) this capacity evidently fostered the creation of one of the most astonishing shaped objects to have survived from the dawn of humanity. So skilfully has its final shape been created through chipping away around the fossil scallop shell it contains that this last is preserved almost as if it were inserted as an ornament at the very centre of the resulting object.[5] The transformation of the surrounding stone into a frame for the distinct entity within it testifies not only to an effective awareness of "aesthetic differentiation", but also to a will to enhance this quality by means of deliberate design. Here one encounters that capacity for discrimination that belongs to the fundamental

4 Lorblanchet 1999, pp. 82, 89–91.
5 Oakley 1981, pp. 208–09.

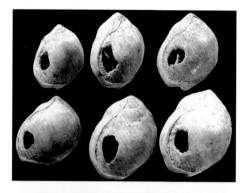

Fig. 5 Perforated freshwater snail shells, c. 75,000 years old, Found at Blombos Cave, Western Cape, South Africa, Iziko South African Museum, Cape Town.

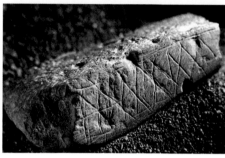

Fig. 6 Incised ochre stone, c. 75,000 years old, Found at Blombos Cave, Western Cape, South Africa, Iziko South African Museum, Cape Town.

definition of the "image".[6] Achievements of this sort have become the distinctive sign of human evolution: to be human was to have attained the cognitive and technical capacity for refashioning naturally occurring shapes and the desire to absorb these, intellectually and emotionally, into a distinct human sphere.[7]

The probability that an elementary connection exists between *homo erectus* and the creation of "images" has recently been further strengthened through the instance of perforated freshwater snail shells, found in a layer of sediment around 75,000 years old at Blombos Cave, Western Cape, South Africa (Fig. 5). Each shell exhibits a hole at more or less the same spot on its surface, in each case evidently created through external force, be it pressure or percussion. Two or three such objects perforated in this fashion might have come about by chance; but a total of 41 similarly perforated shells would lead one to assume that these are the elements of some form of ornamental necklace. This example would seem to meet the condition that "images" can be recognised as such only through the possibility of comparing

6 On "iconic differentiation": Boehm 1994, p. 30; on the aesthetics of the hand axe: Boehm 2007, pp. 34–38.
7 Klotz 1997, pp. 12–13.

several examples so as to exclude occurrences of merely coincidental formation and similarity.[8]

No less astonishing is the fact that, within the same layer of sediment, examples of ochre stones were also found, their surfaces carefully smoothed, apparently so as to provide suitable planes into which geometrical patterns might then be incised (Fig. 6). These scratched lines, also around 75,000 years old, likewise exhibit so seemingly intentional a homogeneity that they prompt one to conclude that they are already evidence of both a shared, rather than an individual, skill and a communal understanding of the significance of its application.[9]

B. IMAGES FROM THE IVORY AGE

Even the most recent discoveries in the realm of sculpture have issued in recognition of the need to backdate assumptions regarding the emergence of the "differentiated image". It has been above all items discovered during the last decade that have so decidedly called into question the prevailing evolutionary theories that they allow one to perceive, in their eminently sculptural three-dimensionality, the remarkable interplay of imitation and abstraction.

For a long time the so-called *Venus of Willendorf*, a roughly 30,000-year-old hand-sized stone figure, notable for its emphatic sexual characteristics, its corporeal ostentation and its mysterious head-covering, was viewed as the unchallenged "star" among sculptural works from the Palaeolithic period.[10] A decade ago, however, items now considered the oldest figural images to be found so far were discovered in the Swabian Jura, in what is now south-western Germany. Carved from mammoth ivory, they are estimated to be around 30,000 to 40,000 years old. One of these, a female figure, 6 centimetres in height, and found in the cave at Hohle Fels, has protruberant breasts, beneath which the hands appear as if laid upon the torso. Between the stubby legs the pubic triangle is as clearly marked as is the deeply grooved vulva (Fig. 7). The tiny head is no more than a small loop, so that the head of the wearer, be this male or female, would effectively replace it, suggesting the substitutive function of this piece may have outweighed the mimetic.[11]

Most of the recently discovered mammoth ivory figures are, however, of animals. Among these are the *Waterfowl*, in shape resembling a spear-head (Fig. 8), also

8 Errico et al. 2005.
9 Errico et al. 2005, pp. 257–58.
10 Mellink and Filip 1985, p. 276, no. 257a and 257b.
11 Conard 2009 *Venus*. The emphatic sexual character of this figure and of other such statuettes is underlined through what one might take for a male counterpart that is around 28,000 years old (Conard and Kieselbach 2009). On the entire complex, see also *Les chemins de l'Art Aurignacien en Europe* 2007.

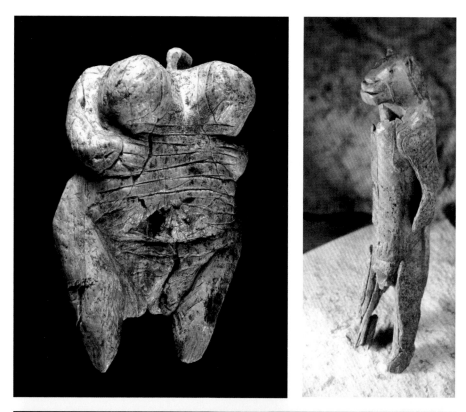

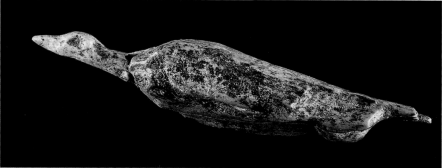

Fig. 7 *Venus*, Mammoth ivory, c. 40,000 to 35,000 years old, Found in the Hohle Fels Cave, Swabian Jura, Institut für Ur- und Frühgeschichte, Universität Tübingen.

Fig. 8 *Water fowl*, Mammoth ivory, c. 35,000 years old, Found in the Hohle Fels Cave, Swabian Jura, Institut für Ur- und Frühgeschichte, Universität Tübingen.

Fig. 9 *The Lion Man*, Mammoth ivory, c. 50,000 years old, Found in the Hohenstein Stadel Cave, Swabian Jura, Museum für Kunst und Achäologie, Ulm.

excavated in the Hohle Fels cave,[12] and the so-called *Lion Man* (Fig. 9): the most notable figure to be discovered so far, not least on account of its height, of 30 centimetres, and found in the cave at Hohlenstein Stadel.[13] While its lower limbs appear to be those of a beast of prey standing on its hind quarters, the upper limbs seem to be the arms of a human being. The head, however, has mutated into that of a lion. The marked corporeal tension of this figure complements the hybridity of its bodily elements.

The wealth of small-scale sculptural figures found in recent years is so overpowering that it would seem appropriate here, by analogy with the conventional invocation of a Stone Age and a Bronze Age, to speak of an Ivory Age. Taking into account other finds in the same area – invariably decorated pieces of clothing, purposefully devised musical instruments, and meticulously shaped tools – it is apparent that an overtly "aesthetic" element was, in this context, by no means merely an addition, but the outcome of the "fermentation" of the achievement of earlier cultures. And so the conclusion drawn from the evidence of the hand axe is reinforced: the "image" is to be recognised as the essential determinant of humanity as a species.

This in turn establishes the basis for a comprehensive concept of the "image". As the non-figurative hand axe already itself possesses a semantic form, "images" cannot be said to emerge only where artefacts exhibit figural characteristics. Because it is now fundamentally impossible to establish whether a given artefact would have been regarded as primarily useful or otherwise, so is it also impossible to distinguish between "image" and "art". In its fundamental, initial definition, the concept of the "image" encompasses every form of conscious shaping.

C. ALBERTI'S *SIMULACRA*

With this broad definition of the "image" one approaches another such, in this case as simple as it is compelling, which was proposed in the fifteenth century by the Italian artist, architect and mathematician Leon Battista Alberti. According to Alberti, one might speak of "images" (he uses the Latin term *simulacra*) from that moment when naturally occurring entities, such as tree roots, evince a minimum of human elaboration. As soon as such an entity bears a trace of human intervention, it is seen to meet the requisite conceptual criterion. In this definition non-physical

12 Conard 2009 *Tiere*, p. 259. A further animal figure (found in the Vogelherd Cave), around 3 centimetres in height and also carved from mammoth ivory, exhibits the sculptural modelling of a bulky body in which the swelling of the surface is as clear below the shoulder blades as it is in the area of the hips. Rows of x-shaped crosses, which here again allude to the systematic application of an element of "graphic" art, cover both the back and the stomach (Floss 2009, p. 249).

13 *Der Löwenmensch* 2005; see also Wehrberger 2007.

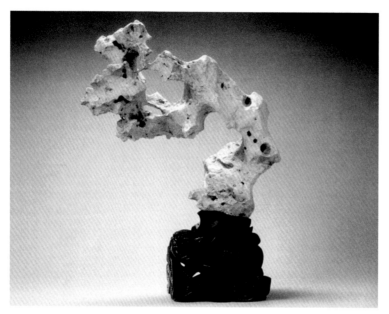

Fig. 10 White sandstone from Taihu region of northern China, with marked overhang and perforations, reworked and supplied with a pedestal, Ming to Qing dynasties, 17th / 18th centuries, Richard Rosenblum Collection, New York.

entities are left out of account because, in Alberti's view, it is only the material capacity for resistance that allows for the wilful aspect of latency that establishes the basis for the question to be posed as it is here.[14]

Alberti's condition would have already been met when pictorially shaped natural forms were recognisably processed and elaborated through the provision of pedestals and framing. This was a prominent characteristic of the tradition – both European and Chinese – of "chance images". At least since the publication, in 1667, of Athanasius Kircher's *China illustrata*, it was known that Alberti's definition of the origin of "images" in the inspiration that might be derived from the example of tree roots and similar natural entities had been formulated centuries earlier in Chinese art theory.[15] An impression of work in the Chinese tradition might, for example, be derived from a half-metre-tall white sandstone object, which was probably acquired by a collector in the seventeenth century (Fig. 10). This had been extracted from its original natural context because it was thought that, with its markedly projecting

14 Alberti, *De Statua*, §1 (1999, p. 22). This wide-ranging concept is followed in Freedberg 1989, which supplies a model for the present study.
15 Chang 2003, pp. 55–56.

"arm" and its numerous perforations, it would invoke the memory of storm-driven clouds. But it is not only the semantically stabilising addition of a pedestal that makes the stone into an "image". For its naturally occurring perforations were also smoothed and strengthened through having their edges filed down, in order to enrich the impression of the intermittent wafting of wind. In this aspect the object approaches works of twentieth-century sculpture of the sort associated with Alberto Giacometti.[16]

Transgressive manifestations of this sort, mediating between naturally occurring entities and consciously created "images", present the conceptual problem as to whether the former might not also be appreciated as examples of the latter. In accordance, however, with Alberti's original proposal, one should here adopt, as a primary definition, the notion that one may speak of "images" as soon as naturally occurring entities evince a trace of human intervention and elaboration.

2. Plato, Heidegger, Lacan

A. Plato's (Dis)regard for Images

In contrast to the situation in Theology, images have never assumed a central role in Philosophy. An important reason for this deficiency lies in the assumption that Plato conceded to images an only minor, if not altogether negative, status. In order to gain space for a new beginning, one must therefore start by ascertaining how far this assumption is correct.

In the construction of an assumed opposition between Philosophy and the image, a key role was played by Plato's Parable of the Cave, recounted in Book VII of his *Republic*. Here, Plato imagines a natural subterranean chamber, occupied by a community unaware of the (real) world beyond, but nonetheless perfectly content with this restriction for they mistake their immediate surroundings for the entirety of that world, not least as these are perpetually enlivened by the multifarious cast of a shadow-play. Jan Saenredam, in his engraving of 1604, sought to envisage this spatial arrangement with a fire situated on the left throwing shadows of idols placed along the top of a wall on to the inner surface of the Cave (Fig. 11).[17] The Cave-dwellers have become used to these shadows, which, as images effectively generated by the firelight, are the symbol of a merely secondary world that is far from the truth. They believe in them and, as a willing audience, are beholden to them.[18] In the area

16 Monahan 1998, pp. 44–45.
17 *Die Masken* 2002, pp. 166–67.
18 Plato, *Republic*, VII, 514a–517b (1935, pp. 118/119–130/131).

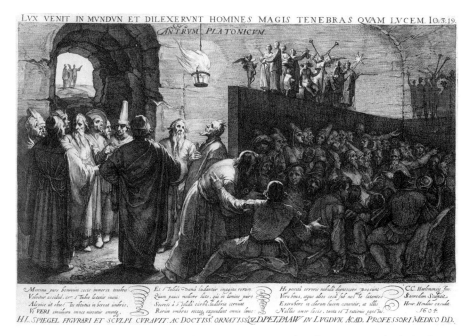

LVX VENIT IN MVNDVM ET DILEXERVNT HOMINE*S* MAGIS TENEBRA*S* QVAM LVCEM. Io.3.19.

Fig. 11 Jan Saenredam, *Plato's Parable of the Cave*, 1604, Engraving after an untraced painting by Cornelis Cornelisz. van Haarlem.

leading to the entrance to the Cave the wise men, here seen gathered in earnest discussion, are fully aware of the deception that is taking place. The Cave-dwellers, however, remain fully in the grip of their shadow-induced emotions.

Through his manifest disdain for such delusions, Plato would seem to disqualify the entire sensorially perceptible world as a cosmos of epiphenomena, which hindered access to the light of truth. In resembling the idols atop the wall in the Cave that determine the shadows cast by the firelight, images of every sort would also seem to meet with his disapproval. This grouping of shadows and images would have readily met with understanding in Antiquity in so far as portraiture was then widely associated with outlines drawn around cast shadows.[19]

At the same time the nature of Plato's more specific criticism of images reveals that this was also an implicit recognition of their power. When he claims that the Cave-dwellers – in effect, the great mass of humanity – would rather attend to the sequences of shadows derived from idols than the light of the sun and the world of ideas and of truth that it illuminates, this signifies, *ex negativo*, an effective acknowledgement of the all but irresistible power of images. A stronger recognition

19 Pliny, *Natural History*, XXXV, v, 15 (1968, pp. 270/271): "De picturae initii [...]".

of the capacity of images to influence human emotions, ideas and actions was hardly ever better formulated than it is in Plato's account of the shadow-play theatre.

No surviving text of Plato's is primarily focused on questions raised by the visual arts; and, whenever these are discussed, they serve, rather, for the resolution of other problems. This has ensured that, in view of Plato's occasional and frequently contradictory statements on art, it is all but pointless to attempt to extract from these a concise aesthetic.[20] It is, however, notable and highly significant that all such statements are marked by the conviction that images are infused by an active power. The certitude implicit in the Parable of the Cave regarding the power of the cast shadows may be assumed to embrace images of every sort. In Plato's view, as is evident elsewhere in the *Republic*, this power is so strong, and thus by implication so dangerous, that its "desire to rule us" must be countered through a series of prohibitions. On the other hand the capacity of images to serve as models is so indispensable for the education of the young that it is to be positively encouraged. It is between these two poles that Plato's concept of the "image", and by extension of "visual art", may be seen to oscillate.

In essence, as is soon apparent, Plato's rejection is chiefly aimed at those images that duplicate the sensorially perceptible world through imitation, in order – or so he assumes – to take its place.[21] The reasons for this rejection, as developed above all in Book X of the *Republic*, strike twenty-first-century readers as unconvincing and somewhat disturbing, not least because this section of the text has little of the imaginative verve and the linguistic sparkle of the Parable of the Cave.[22] In his sketch of what might constitute an ideal state, the iconophobic arguments seem harsh and humourless. To the objection that artists were able to reproduce anything that had ever existed on the earth or in the heavens, comes the dismissive rejoinder that anyone capable of holding a mirror in his hand could equally count himself among such fabricators of imitations.[23] Having made his position clear, Plato (now harking back to the Parable of the Cave) goes on to denounce any artist or poet who succeeds in the rendition of a natural or man-made motif: "For it is phantoms, not realities, that they produce".[24] The rule that there is no place in an ideal state for the mimetic poets[25] goes also for the mimetic artists.

20 Catoni 2005, p. 279.
21 Schmitt 2001, pp. 36–37.
22 This is in accordance with the anomaly that Plato, while a critic of vividly evoked myths, was himself one of the greatest mythopoeists. But here there is in fact no contradiction, in that, for Plato, the mythological and the intellectual represented two "complementary" approaches to truth (Most 2002, p. 18).
23 Plato, *Republic*, X, 598b (1935, pp. 430/431).
24 Plato, *Republic*, X, 599a (1935, pp. 434/435).
25 Plato, *Republic*, X, 605b–c (1935, pp. 456/457–458/459).

Here, too, however, as with the Parable of the Cave, the reason for this ban lies in Plato's fondness for the back-handed compliment. Poets whose work is merely imitative encourage their readers to become absorbed in, even ruled by, those excessive emotions and injurious impulses, when it is precisely such emotions and impulses that "ought to be ruled".[26] The recommended ban on such poetry is inevitable because it is capable of wounding its readers and because there is also the ever-present danger of their "slipping back into the childish loves of the multitude".[27] Mimetic painting, for its part, is far too preoccupied with the theme of illicit love, and it "associates with the part in us that is remote from intelligence".[28] These linguistic formulae of aversion and fear reveal, as do the corresponding passages of the Parable of the Cave, that Plato by no means underestimates what mimetic painting can achieve. Rather, it is in recognition of its power, which he holds to be excessive, that he demands that its practitioners be banned or, at the very least, that they remain under surveillance.[29]

The fact is – and it is all the more worthy of emphasis in that it has repeatedly been overlooked – that Plato acknowledged not only a reprehensible, but also a highly valuable, effect in mimetic images. When Socrates, in the *Cratylus*, insists that painters do not necessarily have to proceed by repeating, detail by detail, all that they find in nature, but have the capacity, through omission, to draw attention to what is most important, this reads almost like a retraction of the accusation that artists are nothing but mere forgers. Plato has Socrates explain that the same goes for poets as for painters: words do not, for example, have to attend to every detail of the matter in hand. They may, indeed, characterise it far more effectively through selection and omission. According to Socrates, there would be neither paintings nor poems if these did nothing but duplicate things through meticulously reproducing them.[30] Like paintings, poems, on account of their capacity for concise presentation, possess the ability to give a clear account, such as Plato, in the *Timaeus*, ascribes to astronomical models: "To describe all this [the dynamism of the cosmos] without an inspection of the models of these movements would be labour in vain".[31]

It is suggestive, moreover, of a degree of appreciation when Plato compares his own considerations regarding an ideal state with a painting – both entities approximating a "master plan". The fact that a painter might depict a human being as so perfect that this depiction could never fully correspond to reality is here

26 Plato, *Republic*, X, 606d (1935, pp. 462/463).
27 Plato, *Republic*, X, 688a (1935, pp. 468/469).
28 Plato, *Republic*, X, 603b (1935, pp. 450/451).
29 Plato, *Republic*, III, 401b–d (1930, pp. 256/257–258/259).
30 Plato, *Cratylus*, 432d (1926, pp. 164/165). See also Catoni 2005, p. 76.
31 Plato, *Timaeus*, 40d (1929, pp. 86/87).

equated by Plato with the notion of his own *Republic*. For that, too, cannot depict the ideal state in all its aspects, and yet it is not on that account without value.[32]

It is significant that, in the *Republic*, Plato invokes a portrait in order to make a comparison with the design for a state. Plato's starting point lies in the idea that a portrait must be harmonised in all its components. If the eyes, as the organ associated with the most valuable of the senses, were represented by precious gems, the overall impression would be thrown out of balance; and, in the same way, in devising a state, one must always bear in mind the whole: "If someone says one particular aspect [of the portrait] is not of the finest material – we should think it a reasonable justification to reply: 'Don't expect us, quaint friend, to paint the eyes so fine that they will not be like eyes at all, nor the other parts. But observe whether by assigning what is proper to each we render the whole beautiful'".[33] In this comparison of his ideal state with an accomplished portrait, Plato affirms an aesthetic of what is fitting. Here, too, he speaks not of the meaninglessness of images, but rather of their role as exemplars.

Ultimately, one finds that Plato adopts a notion of the "image" that is remarkable in being so comprehensive – ranging from gesture, by way of dance, to mural paintings and sculpture – and in turn assumes that all these will serve, in the ideal state, to encourage an awareness of form. This notion is developed above all in his theory of *schemata*. These are models for the stereotypical sequence of movements, through which bodies become images.[34] In the *Cratylus* Socrates observes how the body transforms into an image, with for example the lifting of a hand in order to allude to something elevated or weightless. The same goes for the imitation of the movement of horses or other animals. For "the expression of anything […] would be accomplished by bodily imitation of that which was to be expressed".[35] The appropriate gestures and movements enable the *schemata* to emerge and become established as a point of reference for others.[36]

In so far as Plato stresses the specific significance of *schemata* as dynamically shaped mediums of imitation, this is especially the case for dance. By means of ges-

32 Plato, *Republic*, V, 472d–e (1935, pp. 504/505). See also Schmitt 2001, p. 32 and Boehm 1996, p. 97.

33 Plato, *Republic*, IV, 420d (1930, pp. 318/319).

34 During recent years a fundamental reassessment of this aspect of Plato's notion of images has come about as a result of Maria Luisa Catoni's reconstruction of non-verbal communication in Greek Antiquity (Catoni 2005, and Catoni 2008).

35 Plato, *Cratylus*, 423a–b (1926, pp. 132/133).

36 Catoni 2005, p. 72. In the context of these considerations, one might wonder if Plato's theory of *schemata* could in some respects be compared with Aby Warburg's theory of "pathos formulae" ("Pathosformeln"), which he saw as able to channel the psychic energy of the repeatedly reanimated motifs derived from Antiquity (Catoni 2005, pp. 324, 243–44). See also Settis 2008, p. ix. On Warburg, see also pp. 253–64.

ture and structured movement the element of *mimesis* is here absorbed into a greater whole, with the further addition of music and some of the fine arts.[37]

This notion finds its clearest exposition in a passage in the *Laws* in which an Athenian Stranger tells of the pictorial art of the Egyptians: "[...] it appears that long ago they determined on the rule of which we are now speaking, that the youth of a State should practise in their rehearsals postures and tunes that are good: they were prescribed in detail and posted up in the temples [...]".[38] The models of the approved "good" forms might then impress the young Egyptians, and in due course their younger siblings, as guides for their development, both as individuals and as members of society. In this context the speaker recognises why the style of Egyptian painting was never permitted to change. Even after ten thousand years every element would be "wrought with the same art".[39] In as far as images depict human beings, Plato readily acknowledges their potential value in both establishing and preserving desirable social norms. Looking to Egypt, he finds confirmation for this view.

In a systematic sense, images also function as a basis for thought. Plato, in his Simile of the Divided Line (which, within the *Republic*, shortly precedes his Parable of the Cave), had understood that the capacity for graphic visualisation had two contradictory aspects. On one hand it was a subordinate skill in as far as it was, of necessity, dependent upon sensorial impressions. On the other hand it was indispensable because the superior forms of reasoning – guided always by *axiomata* – were unable in their own right to function adequately in the lower realms. Plato accordingly provides an account of how the "higher" and the "lower" capacities may fruitfully collaborate: for the soul "uses as images or likenesses, the very objects that are themselves copied and adumbrated by the class below them, and that in comparison with these latter are esteemed as clear and held in honour".[40]

This statement signifies more than merely an acknowledgment that it may, after all, be possible to attain to the higher realms by way of capacities derived through the senses. Plato is here, rather, intent upon a deeper examination of the scope of precisely those images that, in the Parable of the Cave, he seems to despise as mere shadow-play. One might imaginatively compare his approach here with the principle of the catapult: a long process of contemplative tension and restraint issuing in a sudden productive release.

37 Catoni 2005, pp. 213, 279–81. On alternative interpretations of the *schemata* as geometrical figures and formally self-contained bodies, see Catoni 2005, chap. I. For Plato, dance is the most important vehicle of *schemata*: Catoni 2005, p. 314. On the *schemata*, see also: Gödde 2001, pp. 242–43.

38 Plato, *Laws*, I, ii, 656d (1926, pp. 100/101). See also Assmann 1986, pp. 520–22, and Catoni 2005, pp. 294–95.

39 Plato, *Laws*, I, ii, 656e–657a (1926, pp. 102/103).

40 Plato, *Republic*, VI, 511a–b (1935, pp. 112/113).

According to Plato, the role of images is contradictory. It is true that they serve as a foundation for thought and for successful action; but it has to be admitted that they conceal the truth. On the whole Plato contrives to take account of both sides. He was an enemy only of those images that he viewed as a threat to the community. And he defended and welcomed those images that he recognised as a civilising factor. Behind both extremes there stands a deep-seated fear of encountering in the image a sphere in which the philosopher may be unable to assert control.

Plato's readiness to countenance the censoring of certain types of poems or paintings, and indeed even to expel from his ideal state those poets and painters of whom he most disapproved, is anathema to modernity. At the same time contemporary suspicions are at once aroused by the ethical role he ascribed to those poems and paintings of which he did approve. Plato's enthusiasm for surveillance would have made his ideal state into an aesthetically and politically rigid society that would have excluded all that is dear to the modern sensibility: disruptive provocation, the rejection of perceived norms, the element of shock, the fictive and the surreal. In this respect, Plato remains an antipode to contemporary civilisation; but it is precisely in his role as an enemy that he points, better than does hardly any friend, to what it is now pertinent to ask. It is a matter here of evolving a philosophy that finds new possibilities within the zones of its own blindness.[41]

B. HEIDEGGER'S *VOLTE-FACE*

The mid-twentieth-century German and French philosophers Martin Heidegger and Jacques Lacan independently devoted themselves to the same issues as had Plato long before them, in each case in a manner as inimitable in its vigour as it was paradigmatic in its weaknesses. Both sought to take images seriously, in a philosophical sense, without delegating them to the conceptual context of aesthetics. Yet they were both, nonetheless, overcome by the very anxiety that stands behind Plato's reflections on the effects that images may have.

In Heidegger's essay "Der Ursprung des Kunstwerkes" [The Origin of the Work of Art], first published in 1950 but deriving from lectures given in Freiburg, Zürich and Frankfurt in 1935–36, he accomplished a *volte-face* not only in thinking about "Time" as the condition of "Being", but also in incorporating entities of supra-historical value (such as works of art, notwithstanding their emergence in specific historical circumstances) within his own notion of "Being".[42] His idea that works of art were to be considered, and indeed respected, as "things" and that those looking at

41 Wind 1979, pp. 9–17. See also Krois 2006, pp. 176–77, 187.
42 Gadamer 1960, "Zur Einführung", pp. 106–07. Fundamental from an art-historical point of view: Boehm 1989; on textually immanent understanding: Kern 2003.

works of art were not in possession of the fundamental knowledge that they required for this task, led Heidegger to his conviction that the work of art would inevitably reveal, on its own terms, that which was of greatest importance within it. In this context he repeatedly made use of concepts (implicit or explicit) such as that of the "active thing" and the "active image". This can be found, for example, in the perception that "Things, in the quite literal sense, steal up on us bodily";[43] that, even a serviceable "tool" has an identity and a life of its own and that it "looks at us, i.e. glares at us;"[44] that a particular painting (of a peasant's clogs) by Vincent van Gogh had "spoken";[45] and that history is "collaboratively shaped" by the work of art.[46] These observations led Heidegger to a particular view of how the work of art exerted its effects: deeply withdrawn into itself, it is only from this remoteness that it sends forth hints at unfathomable values: "The lonelier the work is, complete in its form, the more purely it appears to shed all relations to humanity, and the more simply there emerges the impact of what it tells us: that this work *exists*".[47]

But Heidegger abandoned the thrust of this line of argument at that point where consequences might have been drawn from such a characterisation of the work of art. Where this step should have been taken, Heidegger's text loses its precision, and he turns to the conventional theme of the rivalry between the arts, which is then resolved in favour of poetry: "If all art is, in essence, poetry, then architecture, painting and music must be derived from poetry".[48] One is of course at liberty to believe such a thing. But when a text that emphatically gives pride of place to Van Gogh's painting of a peasant's clogs then proposes that the visual arts are derived from poetry, the anger of disappointed expectation sets in.

In his own regular Freiburg University seminars, however, Heidegger took greater risks. In one of the sessions held in the winter semester of 1936/37, Werner Körte, then serving as the University's Lecturer in Art History, gave a remarkable talk on Albrecht Dürer's watercolour drawing *The Hare* (Fig. 12), in which he underlined the alien quality inherent in the depicted animal. Its gaze, he claimed, suggested that it places no trust in humanity, remaining the more truly self-contained

43 Heidegger 1950, p. 15: "[...] rücken uns die Dinge ganz wörtlich genommen, auf den Leib".

44 Heidegger, 1950, p. 18: "[...] uns anblickt, d.h. anblitzt".

45 Heidegger, 1950, p. 24: "[Dieses] hat gesprochen".

46 Heidegger, 1950, p. 56: "[... Geschichte] mitgestaltet".

47 Heidegger, 1950, p. 54: "Je einsamer das Werk, festgestellt in die Gestalt, in sich steht, je reiner es alle Bezüge zu den Menschen zu lösen scheint, umso einfacher tritt der Stoss, dass solches Werk ist, ins Offene, [...]".

48 Heidegger, 1950, p. 60: "Wenn alle Kunst im Wesen Dichtung ist, dann müssen Baukunst, Bildkunst, Tonkunst auf die Poesie zurückgeführt werden".

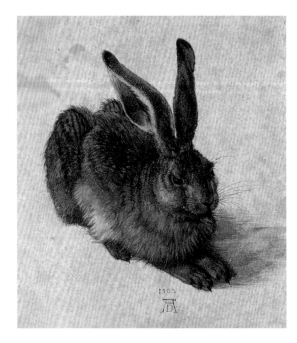

Fig. 12 Albrecht Dürer,
The Hare, 1502, Watercolour
and gouache with white
heightening on paper,
Albertina, Vienna.

the more alive it seemed: "a warm, breathing creature, in which we might well believe that we can see the breath moving its flanks".[49]

According to the account of this seminar provided by one participant, Wilhelm Hallwachs, Heidegger had emphatically accepted both of Körte's observations. This situation offered him an occasion to associate his own definition of the work of art – as withdrawn into itself to the point of inexplicability and, as a result of this autonomy, preserving a capacity for unforeseeable revelations – with the here mooted category of "animation". It was in particular the hare's eyes that evinced, in his view, an inhuman element of restraint, but thereby also a heightened apprehension of its surroundings. It was his recognition of this instance of a creature perceived as "beside itself" that led Heidegger in due course to state his belief that (in the fullest sense) "The hare lives".[50]

Confronted with the "animation" in the watercolour, Heidegger went on to rehearse the entire conceptual content of his exposition on the work of art, in order to conclude with the question as to what has to happen in order for a work of art to become a work of art without its owing this status to some form of commission and /

49 "[…] ein warmes, atmendes Wesen, von dem man förmlich meint, man konne sehen, wie der Atem seine Flanken bewegt": Körte 2005, p. 157. On Dürer's watercolour: *Der Hase* 2002.
50 Heidegger 2005, p. 100: "Der Hase lebt".

or to public recognition.[51] Had Heidegger pursued the question he himself had posed, he would at this point have been able to embark on a discussion of the paradoxical "animation" of the work of art that would be purged of all conventional art-historical assumptions.

The problem here lies not in the arbitrary character of Heidegger's concept, nor in the obscurity of his language, nor even in his definition of both object and context in diametrical opposition to the meaning of the work of art in question.[52] What makes his great text such a disappointment is, rather, its inconsequential ending, which seems less well fitted to "save the phenomena" than simply to rescue philosophy.[53]

C. LACAN'S PACIFICATION OF THE GAZE

In confronting the participants in his 1964 Paris seminar with the problematic notion that not only art but also simple objects might arouse in the observer the impression that they exuded an active force, Lacan ventured into a domain much like that already explored by Heidegger. Lacan understood this problem in terms of the capacity of the work itself to look at the individual who is engaged in observing it. The example he cites is indeed a "sparkling" artefact: a sardine can reflecting the sunlight as it bobs up and down upon the waves, as viewed from a fishing boat off the coast of Brittany. A fisherman, Petit-Jean, points out to Lacan that he, the philosopher, could see the can, but that it could not see him.[54] This jokingly made remark then moved Lacan to evolve a contrary theory out of the ambiguity of the term "regarde" (which means both to observe something / someone, as in "elle regarde cet homme", and to be of concern to someone, as in "cela ne me regarde pas").[55] By this

51 Heidegger 2005, p. 108.
52 Schapiro 1968; on this and on the subsequent debate between Schapiro and Jacques Derrida: Boehm 1989, p. 256–57, 271–72.
53 Heidegger's *volte-face* has been persuasively interpreted as a reflection of his own political retreat. See "Das Kunstwerk als um die Tat gebrachte Autonomie" (Thomä 1990, pp. 693–724). Babette Babich has embarked upon a fascinating attempt to think this through, as it were with Heidegger, in which she has pursued the question of the impact associated with the bronze figures of Antiquity, which outnumbered the inhabitants of many a city, thereby allowing the latter to "forget" that these were sculpted entities (Babich 2009).
54 "Et Petit-Jean me dit – Tu vois, cette boîte? Tu la vois? Eh bien, elle te voit pas!" (Lacan 1973, p. 89). See also the essays in Blickzähmung und Augentäuschung 2005, and, with particular relevance, Meyer-Kalkus 2007.
55 Lacan 1973, p. 89. According to Lacan, Petit-Jean had himself in fact employed the verb "voir", not the verb "regarder".

means he perseveres in insisting that the observer is indeed the object of the object's own gaze.[56]

As a critic of the illusion that objects might ever be comprehended in an entirely valid way through the window of central perspective, Lacan emphasises the intellectual difficulty of truly absorbing the notion of the vanishing point: "I am not simply that dot-like creature that one might discern at that geometrical point from which perspective is supposed to run. It's true that the picture [le tableau] is delineated in the depth of my eye. The picture is certainly in my eye. But I am in the picture."[57]

Because the reflecting sardine can that floats upon the waves cannot be explained in terms of central perspective, it resists the effort to draw a clear distinction between subject and object. It is "not simply that constructed relationship: the object to which the philosopher clings".[58] Rather, Lacan himself becomes the can's own picture: "Something that appears to be a light looks at me, and it is by dint of this light that I become conscious of something at the back of my eye [...] the impression of the rippling of a plane, which does not, at the outset, seem to be at any distance from me. By this means something comes into play that would be elided in a purely geometrical relationship – the depth of field in all its ambiguity, its variability, its resistance to my control".[59]

The can floating upon the waves in the sunshine in all its glittering ambiguity makes its counterpart (the human observer) into a diffuse object that defines itself, in this role, as merely an errant speck, a *tache*.[60] It is striking that this meta-

56 This is related to Maurice Merleau-Ponty's "chiasmus of gazes", as also to Jean-Paul Sartre's earlier observations, in his chapter on "Le regard" in *L'Être et le Néant*, on the impact on an individual's sense of self on becoming the object of another's gaze (Sartre 1943, pp. 310–68). See also Belting 2005, and the more critical view in Schürmann 2008, pp. 190–92. On Merleau-Ponty, see pp. 202.

57 "Je ne suis pas simplement cet être punctiforme qui se repère au point géométral d'où est saisie la perspective. Sans doute, au fond de mon oeil, se peint le tableau. Le tableau, certes est dans mon oeil, Mais moi, je suis dans le tableau" (Lacan 1973, p. 89. On the critique of central perspective: Linfert 1931, p. 152; see below, p. 239.

58 "[...] qui n'est point simplement le rapport construit, l'objet sur quoi s'attarde le philosophe" (Lacan 1973, p. 89).

59 "Ce qui est lumière me regarde, et grâce à cette lumière au fond de mon oeil quelque chose se peint [...] qui est ruisellement d'une surface qui n'est pas, d'avance, située pour moi dans sa distance. C'est là quelque chose qui fait intervenir ce qui est élidé dans la relation géométrale – la profondeur de champ, avec tout ce qu'elle présente d'ambigu, de variable, de nullement maîtrisé par moi" (Lacan 1973, p. 89).

60 "Pour tout dire, je faisais tant soit peu tache dans le tableau" (Lacan 1973, p. 89). Lacan's "tache" corresponds to the found, for example, in Hans Sedlmayr's analysis, in the paintings of Jan Brueghel, of a schematic indeterminacy of colour marks diffusely loosening themselves from objects (Sedlmayr 1934; on this point: Schwartz 2005, pp. 167–72). On the macchia, see also Suthor 2010, pp. 89–90.

phor already seems to anticipate the notion of the power that an image may assume: the notion of the image act. The floating can in the sunlight is the symbol of every image that attracts the gaze because its role as an object is inextricable from its resistance to control. "In reality it is, rather, this that seizes hold of me, that swirls about me at every moment, and that makes out of the landscape something quite other than a perspective, something other than what I called the picture".[61] Persuasively, Lacan then develops the notion that, "in the spectacle of the world, we are creatures who are observed".[62]

In a manner comparable to Heidegger's own *volte-face*, Lacan's theory of the gaze at length reverses into a form of self-defence that hints at panic. The primal, Platonic anxiety at the confrontation with the uncontrollable image redirects his phenomenology into a focus on the world of the "inartistic" artefact, in which he identifies the source of a tireless aggression, and which he may then set in contrast with painting, which offers a form of relief. In the light of the onrush of an "observing" world (of "mere" objects), art is the filter through which the weapons of the gaze are deactivated. It is in this sort of calming process that there lies "the pacifying, Apollonian effect of painting".[63]

By this means, however, Lacan altogether deprives the work of art of its simultaneously aggravating and stimulating exigence. In as far as his theory sees in the work of art a soothing capacity, and thus a defence against the gaze of the object, he accomplishes a de-fusing of art that in effect yields to the philosophical tradition of its degradation. The problem innocently brought up by Petit-Jean was evoked by Lacan only, at last, in order to silence it.

3. Speech Act and Image Act

a. Towards an image act

Lacan's retreat is all the more surprising in that the French sociologist Henri Lefebvre, in the second, 1961 volume of his highly regarded *Critique de la vie quotidienne*, had spoken of the image as an "act".[64] By analogy with the notion of the magic of objects, this might be understood as its capacity to be autonomously effec-

61 "C'est bien plutôt elle qui me saisit, qui me solicite à chaque instant, et fait du paysage autre chose qu'une perspective, autre chose que ce que j'ai appelé le tableau" (Lacan 1973, p. 89).
62 "[...] que nous sommes des êtres regardés, dans le spectacle du monde" (Lacan 1973, p. 71).
63 "C'est là l'effet pacifiant, apollinien, de la peinture" (Lacan 1973, p. 93). See also, in agreement with this view, Cremonini 2008, p. 114.
64 "L'image est acte" (Lefebvre 1961, p. 290).

tive. Evidently inspired by the Marxist notion of autonomously efficient commodities as fetishes, Lefebvre addressed the problem of the autonomous activity of images and artefacts that Lacan adopted only in order to suppress it.[65]

Lefebvre's formula *l'image est acte* was, in 1990, taken up by the French photographer and photographic theorist Philippe Dubois, as *l'acte iconique*, and for the first time further developed with reference to photography.[66] In the same year a German equivalent – *der ikonische Akt* – was used, more or less in the same general sense, by the Egyptologist Jan Assmann.[67] Returning to the term proposed by Philppe Dubois, in 2006 the Swiss-German art historian Beat Wyss employed the bi-partite form *Bild-Akt*, that is to say "image-act", intending through this means to signal a mood of reflection, immanent in the work itself, upon the process of its own creation. Wyss recommended that *Bild-Akt* be employed with specific reference to the period following the Second World War, when work of this sort was especially prominent.[68] It was the image in its most comprehensive sense that the German art historian Gottfried Boehm had in mind in defining it, in 2001, as both "fact and act" ["als Faktum und als Akt"];"[69] and in 2007 Hans Belting embraced an equally comprehensive concept.[70] Art history has always enquired not only into the active observer (whom it has recognised as constituting part of the image), but also into the related issue of the functioning of the image itself. And in the most recent art-historical research there has indeed been a manifest concern with the "effects" of images, Even without the invocation of the concept itself, this concern would, nonetheless, appear intriguingly close to an interest in the image act.[71] Much the same development has of late been seen both in Archaeology[72] and in the study of Religion.[73]

65 Lefebvre 1961, pp. 85–98. Fundamental on this point: Böhme 2006, pp. 319–27, esp. 325–26.

66 Dubois 1990, p. 15. On this point, see also Wolf 1998 and Sykora 1999, pp. 63–65.

67 Jan Assmann developed a theory for Ancient Egypt, which defines the impact of images in relation to their context (Assmann 1990; Assmann 2004, pp. 99–104).

68 Wyss 2006, text vol., pp. 36–39. Many of his examples are cited again in the present volume (see Chap. V, 2.b. and 2.c.) in the context of earlier periods.

69 Boehm 2001, p. 13. Regarding the matter of action, see also *Movens Bild* 2008.

70 Belting 2007.

71 Fundamental on the formally constitutive aesthetics of reception: *Der Betrachter* 1992. For the most comprehensive representation of the functions, see Kunst 1987. For the fruits of more recent research into specific areas, see Wenderholm 2006, pp. 95–114 and passim; Boerner 2008, pp. 55–58, 126–93.

72 In the wake of Assmann's undertaking, the archaeologist Adrian Stähli researched the interconnection between the activity of speaking images in Greek Antiquity and that of those using and interrelating with these images (Stähli 2002).

73 Peter J. Bräunlein has attempted to define the territory of the *image act* (in which he holds a modern scientific theory of religion to be preserved), with a view to developing a complex meta-theory (Bräunlein 2004, p. 201).

The invention and dissemination of the term *image act* was and is evidently also a reaction to the increasing presence of the pictorial in the primary zones of communal life. This has, nonetheless, for some time been seen rather as a symptom than as a surmounting of the pressure of a ubiquitous problem, because the crucial question – whether autonomous activity can indeed be ascribed to images in themselves, or if this is only permissible in relation to the emotional, intellectual and physical responses of those engaging with them – has barely been discussed, let alone resolved.[74]

B. A COMPLEMENTARY ALTERNATIVE

A further strand in the gradual emergence of a more securely defined notion of the *image act* is provided by some of those engaged in drawing on the fruits of pragmatic research into language. These have sought to understand interest in the "act" as a visual phenomenon as a variant of interest in the "act" as a verbal phenomenon: the *speech act*. One of the starting points for this undertaking was to be found in the late eighteenth-century scholar Friedrich Daniel Schleiermacher's incidental remark that within the "act of speaking" were implicit also the "acts" of hearing and of understanding.[75] If speaking was perceived as an instantaneous expression that anticipated and thereby accommodated the possible forms of an answer, then this process of give and take was seen to open up a new Front into a space of action and of exchange. This approach was also represented by the early twentieth-century philosopher Charles Sanders Peirce.[76] Many a false conclusion might have been avoided if this further context for the definition of the *speech act* had been employed.

The concept has, however, so far been chiefly associated with the work of John L. Austin, which came to prominence in the early 1960s. His own fundamental instances of "active speaking" – the placing of a bet, the solemnisation of a marriage, the launching of a ship or the challenge to a duel – demonstrate that spoken

74 The distinct positions are represented, for example, by Lefebvre, who favours the notion of the "magical" effect of images (Lefebvre 1961, p. 290), and Stähli, who emphasises the actions of the users (Stähli 2002). Among earlier reflections on the impact of images, one should bear in mind Dagobert Frey's emphasis on the "reality character" ["Realitätscharakter"] of the work of art, in which he applied a broad concept of the image, albeit without employing the term "Akt" (Frey 1935). See also Hans Ulrich Reck's volume *Eigensinn der Bilder* (2007). My own earlier contributions to this subject range from observations in the published version of my doctoral dissertation (Bredekamp 1975, p. 12) to the article "Bild – Akt – Geschichte" (2007). Marie-José Mondzain's reflections on the violence exerted by images come, in many respects, close to mine (Mondzain 2002).

75 Schleiermacher 1959, p. 80. See also Cloeren 1988 and Strube 1995, column 1536.

76 Peirce 1931–1958, Vol. 5, 1934, p. 386.

statements create facts.[77] The performative aspect is especially clear in the example of the launching of a ship, where the formula "I hereby name this ship ... " cannot but be immediately followed by the smashing of a bottle of champagne, swung on a rope, against the ship's hull. In such "speech-act-events" one observes the greatest possible effect exerted upon the world, not only as a form of appeal, but also in a legal sense.

By comparison with Austin's tentative openness, John Searle introduced a conceptual certainty, stating in his volume of 1969 that "speaking a language is a matter of performing speech acts according to systems of constitutive rules".[78] And therein lay the essence of his later bitter feud with Jacques Derrida.[79] In the tradition of the battle waged by Philosophy and Linguistic Analysis against the apparent diffuseness of everyday language, there in due course unfortunately disappeared any sense of that openness maintained by every form of living speech.[80]

Attempts to establish a theory of the *image act* out of the theory of the "speech act" got underway with two advances on the part of Søren Kjørup. It was he who supplied the impetus for the replacement of the "words" in Austin's theory of the *speech act* with "images", in order by this means to be able to develop the notion of a "pictorial speech act" or even a "pictorial act". On this basis he was effectively able to transform Austin's *How to do Things with Words* (the title of his volume of 1962) into "Doing Things with Pictures" (the subtitle of his own article of 1974).[81] Since Kjørup's initial venture, it has become the norm for strategies to be pursued in which words as instruments of the "speech act" are exchanged for images, or in which words and images are considered in terms of their combined effects. Here, however, there arose the problem that the conceptual logic of the two starting points did not correlate. The *speech act* relates to an unfurling linguistic continuum, but not to any individual word within it, to which the image (on account of its own internal consistency) would necessarily correspond. In seeking a more correct analogy for the *image act* one would have in this context to invoke the notion not of a *speech act*, but of a *word act*. Images, moreover, in accordance with this construction, are placed in the same functional interconnection as words, and thus equally understood as instrumental. But this contradicts that which is most essentially characteristic of the image. A number of attempts to further develop Searle's transformation of Austin's theory have come up against the same problem. They have profited from the clarity of defi-

77 Austin 1962.
78 Searle 1969, p. 38.
79 Searle 1977; Derrida 1988, p. 8–23. See also Rolf 2009, pp. 151–85.
80 Trabant 2003, pp. 298–300, also Stettter 1999; Jàger 2001, Kràmer 2005; Cancik-Kirschbaum and Mahr 2005.
81 Austin 1962; Kjørup 1974, pp. 219, 221; Kjørup 1978. A further move was undertaken by Novitz 1977, pp. 75–80.

nition developed by Searle but, in the realm of images at least, they have paid the same high price in terms of a conceptual rigidity.[82]

After the passage of well over fifty years, it is now possible to conclude that the continuing attempt to apply the theory of the *speech act* to the world of images has proved itself, at best, a very promising essay in the reformulation of aesthetics in what has, in the later part of that period, become the age of the *iconic turn*. But there can as yet be no talk of the clarification of a theory of the *image act* in which images truly take centre stage, nor the founding of a true *image science* [*Bildwissenschaft*] that might then be derived from this.[83]

C. THE IMAGE AS PROTAGONIST

A new approach, proposed here, locates the image not in the place formerly occupied by the spoken word, but in that formerly occupied by the speaker. The image is, in short, no longer the instrument, but the actor – indeed, the "prime mover", the protagonist. The *image act*, as understood in what follows, adopts the dynamism inherent in the relationship between the *speech act* and its own social, political and cultural environment, but it finds its starting point in the latent capacity of the image to move the viewer.[84]

As demonstrated by the case of Leonardo's maxim, a particular concern for images by no means signifies investment in a territorial struggle between image and word. That particular case is indeed exemplary in turning on a text through

82 Unmatched in its conceptual precision is the essay, drawing on linguistic analysis, by Oliver Scholz, which correctly regards as problematic in this context the replacement of the term "words" by the term "images" (Scholz 1991, p. 129; new edn. 2009, p. 161). At the interface between Visual Studies and Ethnology, the anthropologist Liza Bakewell defined, with reference to the perlocutionary aspect of the act of speech, an "act of images" (Bakewell 1998, p. 30); and in 2003 Volkmar Taube, in direct response to Kjørup's theory, elected to use the paradoxical formulation of the "visual act of speech" ["der bildliche Sprechakt"], in order to emphasise the enduring necessity of a linguistic element (Taube 2001, p. 250). Over the following years Klaus Sachs-Hombach made several ambitious attempts to employ Searle's theory of the *speech act* towards a conceptualisation of the image in as far as its communicative function is seen to lie in an illocutionary process of observation (see also, in particular, Sachs-Hombach 2003, pp. 157–90, and Sachs-Hombach 2006). Drawing on both components, Ulrich Schmitz, in a 2007 debate with Sachs-Hombach, proposed his own approach to making use of Searle's conceptualisation, enlivened with a pictorial example (Schmitz 2007), Silvia Seja has published a concise summary of the entire discussion (Seja 2009).

83 On this in more detail: Bredekamp 2006 *Erfahrungen*. There is, however, promise the linguistically informed approaches of Elize Bisanz and Dorothee von Hantelmann, which are centred, respectively, on the procedural aspect of signs (Bisanz 2002), and the forms of works of art (Hantelmann 2007).

84 On the concept of latency; Koch 2004 *Latenz*; Gumbrecht 2009.

which the reader is immediately confronted with an instance of the *image act*. In its almost surreal extremity, it conveys the speechless struggle of the image against the poetic surplus of language.[85]

In the conviction that language may attain its highest development in interaction with the image, or indeed through a stimulating rivalry with the sphere of the visual, recognition of the *image act* also necessarily entails a strengthening of language: its finesse, its anarchy, its inscrutability.[86] If images possess an unassailable rank among the cultural instruments of a technologically advanced civilisation, they do not challenge language in order to weaken it, but in order to invoke that sort of testing through which true strength can emerge.[87] A capacity for the appraisal, analysis and contextualisation of images derives from that same pool of abilities as do a host of linguistic and literary skills. It is through the demands it continues to make upon language that reflection upon images is its ally.[88]

With its abundant production of images, the present time places any student of these under heightened pressure; but it also affords unprecedented opportunities for considering every aspect of the subject and for addressing each in the most informative and enriching contexts. The ultimate objective of the present work might be defined as a concern to revisit, in imagination, the circumstances of Plato's own reflection on images (and, by implication, on *image acts*), taking up again the consistently profound questions that were posed there, but coaxing from him and his interlocutors answers – both critical and constructive – that might prove beneficial now. Throughout, the motivating conviction has been that one may speak of true enlightenment only if this embraces the visual, the haptic and the auditory as the primary sites in which this achievement may be tested, appraised and affirmed.

*

85 On the philosophical critique of language, see Trabant 2003.

86 Bredekamp 2009 *Bildangst*. Acknowledgement of the capacity of language to evolve would logically incur a repudiation of the notion of an over-extension of its possibilities. Fundamental on this: Bierwisch 1999, pp. 176–78. See also Jäger 2001, and Majetschalk 2002, pp. 61–62.

87 Plato, *Cratylus*, 439b (1926, pp. 186–87). On this matter, see Trabant 2003, passim.

88 The goal of the *linguistic turn* – to engage with the analysis of language so as to ensure that it serve as the dominant medium of knowledge – has forced all life out of the thin air of such conceptual purification. As a result of its own lack of vitality, this "turn" was constrained to fall back on non-linguistic elements, thus issuing, in due course, in the *iconic turn* (Boehm 2007, p. 44). Plato's Simile of the Divided Line in fact presents a version of this sort of intellectual development. See also Hogrebe 2006, p. 176: "The last century opened with consciousness, exhausted itself in language, and closed with the image".

Three of the most significant ways in which the latent capacity of the image may be stirred into impacting upon the feelings, thoughts and motivation of engaged observers are each treated in the chapters that form the core of this book: 3, 4 and 5. These consider the *image act* as, respectively, *schematic* (where an ostensibly inanimate entity is, by diverse means, "animated" – as in the case of the *tableau vivant* [56], the automaton [73], or the biofact [99] – in order to serve, in some sense, as exemplary); *substitutive* (where the "impress" of a living form is understood to stand in for the original, be it in the case of photography and its antecedents, the *vera icon* [102] and the nature print [105], in the excesses of iconoclasm [119, 124], or in the contemporary global "war of images" [135, 136]); or *intrinsic* (where latent capacity is most directly manifest in formal energy: that of line or colour [143, 150], as evinced in sculptural "transmigration" [170, 171, 176], or as proven in the resilience of the Warburgian "pathos formula" [185, 191].

Serving as a prelude to this core of the book and mediating between word and image, chapter 2 considers the diverse ways in which speech has been explicitly attributed to every sort of "artefact" and "work of art", and the diverse relationships with humanity – both individuals and communities – that are affirmed by this means: the vessel from Classical Antiquity acknowledging its rightful owner [14]; the richly figured Mediaeval Cathedral door taking pride in the achievement of its maker [28]; the mid-twentieth-century sculpture-as-target avenging a personal history of incestuous abuse [45].

In conclusion, chapter 6 extends the notion of the *image act* in three directions: to the revelatory insights into the mechanism of "natural selection" that, as Charles Darwin argued in the mid-nineteenth century, powers animal and human evolution; to the tradition of approaches to the phenomenon of vision itself that originates, in Rome around 60 BC, in the poetic and philosophical writings of Lucretius; and to both pre-existing and newly emerging intellectual traditions – above all, the Philosophy of Embodiment – with which the ideas here embraced share the most encouraging common ground.

II

INHERENT THEORY

I. EARLY STATEMENTS IN THE FIRST PERSON SINGULAR

A. THE EVIDENCE OF ANTIQUITY

The image act has been a feature of numerous cultures; yet this persistence has not so far brought forth a suitably concise theory. The omission has, however, been more than compensated through the repeated efficacy of inscriptions and captions of a particular sort. These function through allowing the work itself to speak in the first person singular. By this means it is possible for artefacts to describe the connection between themselves and those who commissioned or created them, or who in due course may come to own them or use them, in terms of a series of interactions in which they themselves assume a by no means subordinate role. In thus speaking of themselves, they evince diverse manifestations of the image act.

Rudiments of this way of thinking about man-made entities are even to be found in the Old Testament. In the Book of Isaiah those who have lived unwisely are confronted with the notion of an object made of clay renouncing its own creator with the words: "He made me not".[1] While the likelihood of such a denial being uttered is here explicitly discounted, the capacity of the work to speak is implicitly assumed, in line with a widely shared view that artefacts might have something self-willed about them.

This is in fact by no means an isolated case. A similar conflict between a work and its maker occurs in a story preserved in Hurritic, one of several long extinct languages of the Ancient Near East. A beaker, artfully contrived in copper, abuses the smith that made it on account of its own imperfections, urging that it be destroyed in its entirety. The smith, in response, hopes that his work will fall into a

1 *The Holy Bible (King James Version*, 1611), Old Testament, Isaiah 29:16.

canal.[2] In another version of this tale the faithless artefact hopes that the copper-smith's hands will be crushed and the sinews of those hands torn out; whereupon the smith utters a curse and demands that the beaker be not only destroyed but also drowned in the water of a canal. The accompanying commentary is in this case no less instructive than is the tale itself, for it compares the artefact with an ungrateful son.[3] It is as adversaries that creator and work here encounter each other.

It would appear that there was no shortage of artefacts enabled, by their makers, to express themselves in the first person singular. Those deriving from the cultures of Classical Antiquity carry, moreover, a striking diversity of messages. The

Fig. 13 Roman brooch known as the *fibula praenestina,* Gold, 750 BC, Museo Preistorico Etnografico Luigi Pigorio, Rome.

earliest evidence from Ancient Rome is a brooch now known as the *fibula praenestina* (Fig. 13), made in the mid-eighth century BC and discovered in a tomb in the former Roman settlement of Praeneste (now Palestrina), around 35 kilometres east of the capital. This bears, scratched along the surface of the casing of its pin, the following inscription (to be read from right to left): *MANIOS: MED: FHE: FHAKED: NVMASIOI* [Manios made me for Numerius].[4] Through referring to both a creator and an owner, this inscription allows the object to acknowledge the nature of the relationship between itself and both of these.

In the case of Ancient Greece artefacts inscribed so as to suggest utterances in the first person singular are among the earliest surviving evidence of script.[5] The

2 Neu 1988, pp. 28–31.

3 Ünal 1994, p. 863.

4 *Inscriptiones Latinae* 1965, Vol. 1, no. 1, p. 3. In classical Latin the inscription would have read: Manius me fecit Numerio. On variants of the translation: Lehmann 1989, p. 9. The suspicion that this item was a forgery has been refuted in terms of all the principles of archaeology, philology and even forensics (Wieacker 1984; Lehmann 1989; Fuhrmann 1999, pp. 21–22).

5 For comprehensive coverage of the phenomenon in general, see: Häusle 1979, and Severi 2009, who, most illuminatingly, endeavours to tackle it with the help of the linguistic theory of Karl Bühler.

Fig. 14
Drinking bowl of
the skyphos type
from Attica,
Ceramic,
c. 650 BC
Agora Museum,
Athens.

Fig. 15
Black-figure
drinking bowl
from Attica,
attributed to the
Phrynos Painter,
found in Vulci,
Lazio, Ceramic,
c. 550 BC, British
Museum,
London.

fragment of a krater (a large vessel used for mixing oil and water) from the last quarter of the eighth century BC, discovered in a grave on the island of Ischia, is inscribed so as to refer to the potter (his name only partially preserved): "[...]inos made me".[6] From the same period there are Greek examples that, like the *fibula prae-nestina*, supply information on ownership: "I am Ame's".[7] A Greek bowl made in around 650 BC (Fig. 14) bears an inscription of this sort on its belly: "I am the drinking vessel of Tharios".[8] In using its own tongue to name not its maker, but its owner, the bowl, it is implied, is able to distinguish between itself, its own function, that owner and the broader social context within which it belongs. In addition to refer-

6 *Magna Graecia* 2005, p. 375, no. III.94. On this and the following examples, see also: Catoni 2010.
7 *Magna Graecia* 2005, p. 375, no. III.93.
8 Walter-Karydi 1999, p. 292.

ring to a work's maker and / or to its owner, an inscription in the first person singular might also refer to further potential users. In the case, for example, of a particular wide-bodied drinking cup we read: "I am the kylix of Panchares, used at drinking parties by him and his friends".[9] From here it would be the obvious next step for a vessel to identify itself as a gift: "Epaineto gave me to Charopo".[10]

Often added to such forms of self-description was information on a vessel's intended use. In addition to the painted scene of the birth of Athena from the head of Zeus on a bowl made in Attica in the mid-sixth century BC (Fig. 15) is the jovial command: "Greetings: now drink [from] me!"[11] Such salutations could, on occasion, be intensified into admonitions: a vessel made in 675/650 BC, of a type serving as a container for oil or perfume, informs and, simultaneously, threatens:' "I am the lekythos of Tatiae; he who steals me will go blind".[12]

How seriously such statements were to be understood is attested by a work in bronze dating from the shift in the art of Greek Antiquity from the Geometric to the Archaic style (Fig. 16).[13] This has lost its lower legs and its feet, its right arm, its helmet and its originally inset eyes; but, inscribed along its swelling thighs is the following inscription: "Mantiklos offered me, at the cost of a tenth of his income, to him who, with his silver bow, strikes from afar". The small, bronze figure, that is to say, is an offering to Apollo, made by an individual by the name of Mantiklos and costing him the equivalent of a tenth of his income. The declaration ends, however, in a bewildering fashion: "But you, Phoibos,

Fig. 16 *Mantiklos Apollo*, votive figure from Thebes, Boetia, Bronze, 7th century BC, Museum of Fine Arts, Boston.

9 Arena 1986.
10 Steinhart and Wirbelauer 2000, pp. 268, 283, no. 20.
11 Immerwahr 1990, p. 48, no. 228.
12 Bartonek and Buchner 1995, pp. 199–200.
13 *Die Geschichte der antiken Bildhauerkunst*, Vol. 1, 1, 2002, pp. 76–77.

will give for it the sum desired".[14] This earnest statuette serves, then, not only as an offering to the god; it also makes a request that is so freighted with a hint of demonstrable necessity as to approach a veritable command.

As has been shown even in the course of this brief preliminary survey, numerous forms of address might be employed in the clearly customary practice of allowing artefacts to speak in the first person singular. Those from Ancient Greece and Rome personified in this way might be very variously distinguished – be it in terms of ownership, in relation to a particular social context or a conflict of interests, or as the means of extorting a donation. The abrupt transition from the first to the second person is by no means incidental. It reflects, rather, a systematically observed custom.

B. Reflexive animation

The potential inherent in this procedure was enhanced in cases where an inscription was read aloud.[15] Inscriptions in the first person singular would have assumed an activating role when they served as triggers for the movement of an observer's lips. An especially striking instance of this is provided by a kore (the figure of a young woman) made by the sculptor Aristion of Paros and presumed to date from around 550–540 BC (Fig. 17).[16] This rigidly erect individual is dressed in a tightly belted chiton, which has a narrow, meander-patterned panel running from its neck to its hem. In her left hand she holds a lotus blossom in front of her upper torso, while with her right she pulls taut a section of the

Fig. 17 Aristion of Paros, *Phrasiklea,* figure marking her own grave, Parian marble, c. 550–540 BC, National Archaeological Museum, Athens.

14 Walter-Karydi 1999, p. 298, trans. from German version in: *Die Geschichte der antiken Bildhauerkunst*, Vol. 1, 1, 2002, p. 76.

15 It is on this premise that the analysis of Svenbro 1988 / 1993 is based. See also: Stähli 2002, pp. 67–84, and Severi 2009, pp. 30–32.

16 *Die Geschichte der antiken Bildhauerkunst*, Vol. 1, 1, 2002, p. 189; Brinkmann, Koch-Brinkmann, Piening 2010.

skirt: a gesture that hints, albeit modestly, at a stylised game of alternately conceal-
ing and revealing the body beneath. Through the first line of the inscription on the
pedestal, the figure defines itself, in the first person singular, as serving to mark a
grave: "I shall forever be called the funerary monument of the maiden Phrasikleia".[17]
Nor was this animation of the sculpted figure of a deceased person an especially
rare instance. Numerous examples from the Palaeo-Venetian Era found in the region
around Padua attest to grave stelae assuming the voices of the deceased.[18]

In employing the first person singular, the sculpted figure of Phrasiklea pre-
serves the dead woman in an animated form. By way of the inscription, an alliance
is established between the image and the onlooker as soon as the latter begins to
read these words aloud. In thereby enhancing the animation of the marble figure,
which in its own way purports to be the deceased, the reading observer becomes a
medium through which Phrasiklea, although herself dead, may nonetheless live.
And, through this interplay of image, script and speech, there comes about a two-
fold transgression. Just as the stone figure absorbs into itself the living Phrasiklea,
so too does the speaking reader literally embody the monument's own claim to be
alive.

The transition from living individual to the sculpted figure of that person,
such as is maintained in the funerary monument to Phrasiklea, is captured in the
play of question and answer in the inscription accompanying the figure of a youth
from Smyrna: "You ask, Wanderer, who it once was that is now re-made in the form
of a stela, a funerary monument, and in the image on the stela. As the son of Try-
phon, I bear the same name. I completed fourteen circuits of life; and that is what I
once was. Yet now I am become a stela, a funerary monument, a stone and an image".
It is here striking that the image is described as an only recently created sculpture
and yet also as the form in which the deceased now "truly" exists. Its artificiality is
not seen to contradict a capacity to "exist" and to speak.[19]

All such usages of the first person singular have aroused the suspicion that
magical or occult practises were here at play.[20] It has, on the other hand, been sug-
gested that one should understand the use of the first person singular not as the
utterance of the monument itself, but as an indirect representation of the deceased.[21]

17 Trans. from German version in: Karanastassis 2002, p. 195. On the double use of the first
 person singular: Häusle 1979, pp. 53–54.
18 Striking examples from Padua are assembled in: Zampieri 1994, pp. 107–11.
19 Häusle 1979, p. 128.
20 Burzachechi 1962.
21 Raubitschek 1968, pp. 11–12. Suppositions of this sort have been all the more encouraged
 because so much significance has of late been attached to the cruel, dionysiac and magical
 side of Greek culture. Walter Burkert's notion of its "wilder Ursprung" [savage origins] (1991)
 is a case in point.

Yet rationalisation of this sort deprives the speaking works of their reflexive subtlety. In common with the cited examples from the Old Testament or found in fragments of Hurritic or in the history of Ancient Rome, the works from Ancient Greece are distinguished precisely through the fact that their makers imbued magical powers not to natural entities but to man-made artefacts. They define a limit within which their performative function is not credulously assumed but is consciously reflected.

This becomes especially clear in the case of works that refer, through their complex inscriptions, to two distinct personae. One of the earliest surviving bowls bearing Greek script, the vessel of Nestor, found on Ischia, offers the following prospect: "[I am] Nestor's, a bowl most suitable for drinking. But he who drinks from this bowl will immediately be seized by a desire for the beautiful crown of Aphrodite".[22] One is here initially struck by the fact that this bowl, evidently in use at drinking parties, promises to anyone drinking from it that he will thereby partake of an aphrodisiac. This promise is in itself less surprising, however, than is the switch from the first person singular to an objective description of the vessel: "this bowl". While the bowl itself speaks in order to identify its owner, it is the voice of this owner, or possibly of the vessel's maker, that takes over in order to tell us about those drinking from it. In this effective schizophrenia one encounters the express deployment of the first person singular as a conscious means of emphasising the animation of the work.

As shown here, variants upon such formulae may refer to an owner, to the structure of relationships between artefact, maker, owner and user, or to conflict between a work and its creator; they may serve as a warning to prospective thieves, as a means of addressing a divinity, or as a starting point for the interplay between an inscription and the voice of its reader.[23] The figures from Classical Antiquity bearing inscriptions in the first person singular encapsulate the conviction that artefacts so inscribed will engage with humanity as entities that are not only autonomous, possessed of a body and capable of speech, but that are also able both to motivate the individuals encountering them to act in certain ways, and to exert further influence upon them.[24] This is, indeed, a precursor of the insight informing Leonardo's maxim on the ability of a work of art to deprive its admirers of their freedom.

22 Häusle 1979, pp. 57–58; Pavese 1996. See also: Catoni 2010.
23 Numerous further objects might be mentioned (see also: Ploss 1958, pp. 27–32; Burzachechi 1962; Raubitschek 1968; Walter-Karydi 1999; Stähli 2002).
24 Mitchell 2005, pp. 39–40.

Fig. 18 Arabic writing box, Brass with silver and copper inlay, 1230–1250, British Museum, London.

C. EXAMPLES FROM THE ISLAMIC WORLD

In the art of Islam there is no less remarkable a range of variation among works speaking in the first person singular. As in the case of the examples from Classical Antiquity and those yet to be considered from the European Middle Ages, Islamic inscriptions encompass everything from an object's own account of itself to complex expressions of self-appraisal.

A basin made in Damascus in 1340/1350, the so-called Baptistière de Saint Louis (its designation derived from its later use, by the French nobility, as a baptismal font), observes, without pretension: "I am a vessel for carrying food".[25] But a thirteenth-century smoking apparatus from what is now northern Syria supplements its own functional self-definition with a note of self-appraisal: "Inside me is hellfire, but without dissemination of odours".[26] A water container of the fourteenth century, and similarly made in what is now northern Syria, likewise plays with the metaphor of fire; but here it is, rather, the heat involved in the process of creation, in combination with the harm it may inflict, that prompts the object to describe itself as bringing relief and healing to humanity: "I am a *haab* of water, wherein there is healing. I quench the thirst of mankind".[27]

A writing box of the thirteenth century, and again made in what is now northern Syria (Fig. 18), interprets its own aspiration and purpose with reference to

25 English text (with slight adaptation) as cited in: Müller-Wiener 2011, no. 38.
26 English text as cited in: Baer 1983, p. 214.
27 English text as cited in: Reitlinger 1951, p. 21.

the Koran: "I wish to do nothing but to the best of my ability. / Yet my success depends upon God, and upon Him alone".[28] In contrast, however, with this avowal of humility, a second inscription maintains that the beauty of an implement is worthless if its duration is but a day, whereas: "I am the single gem of my / your time, so there is no gem like me".[29] In as far as the hardness of a precious stone was a symbol of temporal endurance, the work here speaking in the first person singular defines itself as an instance of supra-historical significance. Here, then, a first inscription, poised ambiguously between presumption and meekness, is set against a second that is positively bursting with pride at its owner's form.

The evidence of even just these few examples – each nonetheless striking in its way – reveals that the autonomy of the artefact was barely less skilfully and eloquently conveyed in the Islamic world than it was in the cultures of Classical Antiquity.

2. THE SIGNATURE AS WITNESS TO THE SELF

A. FROM THE WORK TO THE PERSON

Within the compass of Christendom an abbreviated form of the artist's signature might ensure that the object bearing it functioned in the manner of an image act. The customary, latin form of inscription comprised the name of the individual commissioning the work or that of the artist, in addition to a designation of the object itself and a verb. As evinced by the inscription incorporated within the Last Judgement carved above the West Door of the church of Saint-Lazare in Autun, consecrated in 1130 (Fig. 19), these elements would be combined in a formulaic sequence. This invariably opened with the artist's name, and it went on to designate the object, with *HOC*, and to include a verb, *FECIT*. The artist's signature appears here, in this standardised form, directly above the frieze depicting the Elect and the Damned that extends across the entire portal (Fig. 20): "GISLEBERTUS HOC FECIT" [Gislebertus made this].

Both the terseness and the positioning of this statement convey a sense of the presumptions that might be associated with signatures of this sort. The name "GISLEBERTUS" is positioned between the procession of the Elect and the very edge of Christ's mandorla, so that the artist's name gives the impression of serving as a membrane through which the Elect are about to pass as they enter the Kingdom of

28 English text (with slight adaptation) as cited in: Baer 1983, p. 216. *Koran*, 2:28.
29 English text as cited in: Baer 1983, p. 216; variant proposed by Louisa Macmillan, written communication to the author, 2nd September 2010.

Fig. 19 Gislebertus, *Last Judgement* relief above West Door of Saint-Lazare, Autun, Consecrated 1130, *in situ.*

Fig. 20 Detail of Fig. 19, with inscription incorporating artist's name.

Heaven. To pride in his own work the artist has added a sense of certainty that his name will attain a heavenly immortality.[30] This case affords an exemplary demonstration that during the Middle Ages – which scholars have traditionally assumed to

30 Bredekamp 2000 *Mittelalter*, p. 222. On the refutation of the doubts voiced by Linda Seidel regarding the identification of the signature with the artist (Seidel 1999, pp. 63–72), see: Burg 2007, pp. 220–221, note 51, and Dietl 2009, Part 4, p. 1830.

Fig. 21 Bernardus Gelduinus, Table altar made for Saint-Sernin, Toulouse, Marble, before 1096, *in situ.*

Fig. 22 Detail of table altar seen in Fig. 21, with inscription.

be an era in which culture was informed by supra-individual values –[31] artefacts were, in reality, designated through inscriptions identifying both artists and patrons by name, and this to a degree probably unequalled in any other historical period.

Within this context it is not surprising that, in continuation of the practice of Antiquity, the designation of the object as *HOC* [this] is to be found, in a great many cases, replaced by *ME* [me].[32] Contemporaries of Gislebertus would have been confronted with just such an example in an especially prominent location within the Cathedral of Saint-Sernin in Toulouse (Fig. 21). The slender and elegant marble slab of a table altar made shortly before 1096, which rests upon a centrally positioned block, is one of the earliest examples of a figurally worked piece of carved marble to date from the period after Antiquity. Along the border of the upper surface there appears a row of letters that, while partially abraded, are nonetheless relatively easy

31 Among art historians, at least, this view no longer prevails. The several stages in this shift can be traced in Claussen 1981, 1992 and 1993–94, and Dietl 1987 and 1994, in addition to Burg 2007. See also: Bredekamp 2000 *Mittelalter,* and Reudenbach 2008, pp. 45–51.

32 The only research as yet devoted to this subject is that published in Ploss 1958.

to read as the statement: "BERNARDVS GELDVINUS ME FEC[IT]" [Bernhard Gelduin made me] (Fig. 22).[33] The spectacular metamorphosis of the designation of an object into an inscription employing the first person singular here occurs at precisely that sacred place where, in liturgical tradition, the transubstantiation of wine into the blood of Christ and of bread into the body of Christ was seen to occur.

A work that named its own maker using the first person singular might also designate the individual who had commissioned its making. Even early examples of the customary formula *ME FIERI IUSSIT* [ordered that I be made] are found to greatly extend the narrative, indeed spiritual, scope of such works.[34] A small bronze cross of the early twelfth century (Fig. 23) engages so succinctly, and yet so profoundly, with the formula that it may be said to bear the imprint of an entire epoch.[35] Through its arms outstretched against the horizontal beam and through its vertically positioned body, the sculpturally modelled figure of Christ assumes the shape of the cross itself. The crucified Christ wears a regal crown, a token of His Heavenly Dominion; and the very moment of His death on the cross is thus already signalled as a prelude to His life eternal as King of Heaven. The star fixed above His head alludes to His ultimate return as Redeeming Judge.[36]

A further chronological dimension emerges through the presence of the outlines of Christ's body, most notably the broad sweep of the arms, marked on the simulated wood of both the upright and the horizontal bronze beams. Revealed when the figure of Christ was removed from the cross, these present a disturbingly strange, ghost-like image (Fig. 24). Unlike the *vera icon*, the cloth upon which the face of Christ was imprinted through the traces left by sweat, blood and dirt,[37] and equally unlike the Turin Shroud (widely familiar somewhat later), which appeared

33 Gerke 1958, p. 8; Hearn 1981, p. 69.

34 Among these there belong, for example, the monumental candelabrum made in around 990 for the Cathedral in Essen with its inscription: "MATHILD·ABBATISSIMA ME FIERI IVSSIT ET ΘXP CO[N]S[ECRAVIT]" [The Abbess Mathilde ordered that I be made, and dedicated me to Christ] (Bloch 1962, Text Vol. I, pp. 534–36; Henkelmann 2007, p. 151); the Herimann Cross at the Diocesan Museum in Cologne, made in around 1050, its own inscription, on the upper end of the cross, reading: "HERIMANN ARCHIEP[ISCOPV]S ME FIERI IVSSIT" [Archbishop Herimann ordered that I be made] (Bloch 1962, Text Vol. I, p.33 [see *Ornamenta Ecclesiae* 1985, Vol. I, p. 134]); or the inscription on the thorn of the so-called Hesselbach Cross in Darmstadt: "ME FIERI IVSSIT VIII" (Bloch 1992, p. 33). Each of these first-person-singular statements relates to the person commissioning the work, not to the person casting it, who would usually be indicated with *ME FECIT* (Bloch 1992, p. 33).

35 The work can here be touched on only briefly. See also the more detailed discussion in: Bredekamp 2008 *König*. Fundamental on this subject: Bloch 1992, pp. 126, 129.

36 "[...] there shall come a Star out of Jacob". *The Holy Bible* (*King James Version*, 1611), Old Testament, Numbers 24:17.

37 Wolf 1998.

Fig. 23 Anonymous, *Christ on the Cross*,
Bronze, early 12th century, Bode Museum,
Staatliche Museen SPK, Berlin.

Fig. 24 Part of cross seen in Fig. 23, with figure
of Christ removed.

Fig. 25 Detail of cross seen in Fig. 23, with
inscription above Christ's head.

to preserve the imprint of Christ's head, body and feet,[38] what is found in the lines
incised upon the bronze cross is an image of Christ comprising traces of only those
parts of His body and loincloth that were in direct contact with it. These traces cor-
respond to the hours during which Christ, pierced by the nails of martyrdom, hung
upon the cross.

Above the head of the figure of Christ an inscription appears at the far end of
the upright beam (Fig. 25): "WOLFRA / MUS P[RESBYT]ER IVS[S]IT ME / FACERE"
[Wolfram the priest ordered that I be made]. Used here in combination with the star
of the Last Judgement, the traces of the body of the dead Christ, the Resurrection
implicit within the Crucifixion, and the insignia of Christ's Heavenly Dominion, the
first person singular becomes a generator of simultaneous temporal epochs. With

38 Molteni 2000; Geimer 2001 *Menschenhand*.

Fig. 26 (above left) Ring-form door handle with lion's head, Treasury of St. Bonifatius, Freckenhorst (formerly used at original church building), Bronze, c. 1100.

Fig. 27 (above right) Figural capital, probably from Trier, Marble, c. 1140, Rheinisches Landesmuseum, Trier.

the animation of matter the crucified Christ is endowed with the capacity to invoke the dynamism of diverging temporal spheres in the active stasis of the cast bronze.

The use of *ME FECIT* and *ME FIERI IUSSIT* was not limited to explicitly religious contexts. Objects such as door knobs, candelabra, capitals, architectural features, and elaborately contrived entities of every sort might, through the use of these formulae, be designated in relation to those who had commissioned them, cast them in metal, painted them or sculpted them.[39] Among the most important of speaking artistic creations of this sort were bells, their chimes serving as acoustic enhancement of the animation signalled through their inscribed surfaces.[40] The tolling of the Great Bell of Lüneberg, which since 1385 had not only marked the hour but had served to rally the populace to a general assembly or to raise the alarm on the occasion of fire or on the advent of war, also made its voice heard through the inscription it bore: "m[a]g[iste]r iohan[ne]s me fecit" [Master Johannes made me].[41]

39 Ploss 1958; Grimme 1985, pp. 86–87. The extensive research undertaken by Albert Dietl (Dietl 2009) discovered 147 signatures of this sort from Mediaeval Italy alone, in addition to occasional instances in northern Europe.

40 Ploss 1958, pp. 33–35.

41 http://www.lueneinfo.de/fuerstmu/objekte/2004/glocke.html (2007). The number of bells with first person singular inscriptions is remarkable. Wolfgang Wolters was able to point to four examples from Venice alone: above the Porta di S. Alipio at the Cathedral of San Marco; at Pietro di Castello; at S. Vial; and at S. Catharina in Mazzorbo (written communication). In addition, the principal bell at Gloucester Cathedral bears a *ME FECIT* inscription.

In addition to bells, other utensils were enabled to speak through the medium of their inscriptions: the handle of the principal door of the church of St. Bonifatius in Freckenhorst was inscribed; "BERNHARDVS ME FECIT" [Bernhardus made me] (Fig. 26).[42] Alongside its practical purpose, this object was seen to embody the threshold between the profane and the sacred realms; and, in this connection, its lion's head, with its exceptionally large eyes, was believed to possess apotropaic powers, enabling it to ward off evil.[43]

By the same token, architectural elements might also be provided with inscriptions in the first person singular. A twelfth-century capital from Trier bears an inscription alluding to the sculptor who carved it: "ADAM FECIT ME" [Adam made me] (Fig. 27). As this capital is carved so as to depict figural allegories of two of the four rivers traditionally associated with Paradise – the Phison and the Geon – the sculptor's name may here have assumed a further dimension.[44] Architectural elements in numerous churches were effectively characterised as living bodies through the addition of *ME FECIT* inscriptions. An especially impressive example is supplied by the ribbed vault in the late-twelfth-century octagonal church of San Sepolcro at Torres del Rio in northern Spain.[45] Such instances vividly convey the dual character of much ecclesiastical architecture: this signified the body of the church, but it was also animated, indeed performative, stone.[46]

B. A DOUBLING OF THE SELF

An abundance of works speaking in the first person singular relates to aspects of the activity of the artist or artisan, thereby affording further communicative and expressive possibilities. The creator, for example, of the twelfth-century bronze door made in Magdeburg and later incorporated into the fabric of the Cathedral of Novgorod immortalised himself within it through positioning the inscription: "RIQVIN[VS] ME FE [CIT]" [Riquinus made me], in the form of a nimbus, around

42 Mende 1981, no. 12, pp. 208–09, Fig. 28. For a refutation of the assumption that "Bernhardus" relates to the donor (Bley 1990, pp. 192–94), see: Dietl 2009, Part 4, p. 1867, no. B 128.

43 Bley 1990, pp. 189–90.

44 Dietl 2009, Part 4, pp. 1959–60, no. B 376. See also: Eichler 1935, pp. 80–81. One of the capitals of the porch of the Benedictine Abbey of Saint-Benoît-sur-Loire, erected in around 1030, bears the inscription: "UNBERTUS ME FECIT" (Bredekamp 2000 *Mittelalter*, pp. 193, 196). An angel carved on a capital at Sainte-Foy in Conques is shown as if uttering the inscribed words: "BERNARDUS ME FECIT " (Dietl 1994, p. 184, Fig. 6).

45 Sutter 1997, p. 64.

46 Kendall 1993, pp. 113, 116.

Fig. 28 Riquinus, Self-portrait among Biblical scenes illustrated on door of Cathedral of Saint Sophia, Novgorod, Bronze, mid-12th century, *in situ*.

his own head (Fig. 28).[47] As the pincers he holds are shown pointing towards the last letter to have been added to the as yet incomplete verb "FECIT" [made], it is clear that the depicted figure is at this very moment, and through the agency of his own bronze relief portrait, engaged in generating the inscription that acclaims him by name. Through the veritably dizzying logic of what is here shown and what is here implicit, one is prompted to understand that this door, made in bronze, has itself brought forth an image of its creator in order, through him, to generate also the inscription that now enables it to speak in the first person singular.[48] Here, then, the

47 Sauerländer 1963, Fig. 38, p. 55; Bloch 1992, p. 33; Mende 1994, pp, 74–76, 157, plate 100. On the pouring technique, see also: *Bild und Bestie* 2008, p. 53.

48 There is in fact something systematic in these spiralling layers. See also: Mende 1994, p. 169, plate 163, on the connection established in 1180 / 1190 at the cathedral at Monreale between the signature "BARISANUS TRAN[ENSIS] ME FECIT" [Barisanus of Trani made me] and the self-portrait of the artist on the right-hand door jamb of the northern nave. See also: Burg 2007, p. 194, Fig. 87.

Fig. 29 Baptismal font made for the
Cathedral of St. Peter, Osnabrück,
Bronze, c. 1226, *in situ.*

capacity to speak and the capacity to create are reciprocally imbued to the artefact
itself.

Numerous other formulations illustrate with what profundity the first per-
son singular signature might be employed with reference to the act of creation, be it
in the case of further works cast in metal,[49] or of paintings.[50] The rigour with which
the formally compressed precision of the first person singular may develop the ana-
lytical arc of the problem – the fact that images consist of anorganic material and yet
function as if they were alive – is revealed lastly in the case of inscriptions that refer,
in the tradition of Antiquity (noted in the case of the Nestor vase from Ischia), to

49 The two door handles made in the second half of the thirteenth century in Trier employ the
 first person plural in order to emphasise the involvement of two individuals: "MAGISTER
 NICOLAVS [ET] MAGISTER• IO / ANES• DE• BINCIO• NOS• FECERONT " [Master Nicolaus and
 Master Johannes of Bingen have made us], and to differentiate between the wax of the
 model, the fire employed to achieve the liquefaction and the shaping of the material: "QUOD
 FORE CERA DEDIT TVLIT IG / NIS [ET] AES TIBI REDDIT" [What the wax has modelled the fire
 took away and the bronze has restored to you]. See also: Mende 1981, no. 128, pp. 162–63,
 figs. 210–11, Bloch 1992, p. 33, and Dietl 2009, Part 4, p. 1960. In a similar fashion the tomb in
 Augsburg Cathedral of Bishop Wolfhart von Roth, who died in 1302, declares: "OTTO ME
 CERA / FECIT CVNRATQVE PER ERA" [Otto made me through the use of wax, and Konrad
 made me through the use of bronze]. See also: Bauch 1976, p. 98, figs. 148, 149, Bloch 1992,
 p. 33, and Dietl 2009, Part 4, p. 1829.
50 For example, in the case of Simone Martini's panel of 1317 of St. Louis of Toulouse for Naples,
 where an inscription running across the architectural setting of the predella expressly
 eschews a *ME FECIT* for the words "ME PINXIT" [painted me]. On this case, see: Castris 2003,
 p. 139.

several distinct individuals. Such inscriptions make the first-person-singular form employed by a speaking work into an intellectual game with the scope for conflict that, as has been observed, may emerge between an animated work and its maker.

An especially notable example is to be found engraved on the baptismal font of the Cathedral of Osnabrück, made in around 1226 (Fig. 29): "WILBERNVS•PE[TR]E• CONFERT•ISTVT•TIBI•DONVM•VT•P[ER]TE•SVMMVM•POSSIT•HABERE•BON[VM]• GERARD[VS]•ME•FEC[IT]."[51] The first part of the text follows in the tradition of the numerous inscriptions through which gifts and dedications are so defined: "Wilbernus dedicates to you, Peter, this gift, so as to partake, through you, of the highest bounty". The author of the inscription, that is to say, links his donation with the reciprocal gift of grace in the form of the "highest bounty", a quality associated with Saint Peter, who was traditionally believed to be empowered to rule upon admission to the Kingdom of Heaven.

In view of this tightly interlinked relationship between gift and reciprocal gift, through which donor and saviour meet, it is all the more astonishing to encounter the leap from "DONUM" to "ME" in what follows: "Gerardus made me". The donor here addresses the work in a distanced form of the accusative case, while the work, for its part, in the very same breath, affirms itself in the first person singular. The perspectival shift, from *opus* to *persona*, is here then accomplished within a markedly small space.

Employing this sort of reflexivity, in addition to the further possibilities open to works speaking in the first person singular, Jan van Eyck succeeded in bestowing upon these an all but unsurpassable form. His painting of a man in an elaborately upfolded red chaperon (not, as often assumed, a "turban" – an altogether tighter and firmer form of headgear) has since the seventeenth century been regarded as a self-portrait (Fig. 30).[52] The figure encountered here regards the observer with that intensity from which, according to Nicholas of Cusa, there is no escape. And it is hard to avoid a sense that both Leonardo's maxim and Titian's musings upon the power of the gaze are here foreshadowed. In its autonomy this gaze fastens upon the observer, regardless of where the latter is to be found, and be it at rest or in motion.[53] This effect is reinforced through the first-person-singular inscription found on the painted frame, its own *trompe-l'oeil* simulation of a stony material testifying to a capacity specific to the art of painting:[54] "JOH[ANN]ES•DE•EYCK•ME•FECIT•A[N]NO MCCCC•33•21•OCTOBRIS" [Jan van Eyck made me on 21st October in the year 1433].

51 *Die Zeit der Stauffer* 1977, vol. 1, no. 646, p. 496, Fig. 452. See also: Bloch 1992, p. 33; *Bild und Bestie* 2008, p. 179, Fig. on p. 181; Dietl 2009, Part 4, p. 1913.

52 Gludovatz 2005, p. 136; *Renaissance Faces* 2008, p. 178.

53 See below, pp. 199–203.

54 Gludovatz 2005, pp. 123–24.

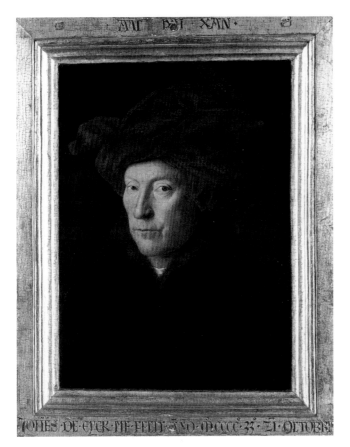

Fig. 30 Jan van Eyck, *Portrait of a Man*, Oil on wood, 1433, National
Gallery, London.

The ostensible emphasis upon the date of completion and the spectator's own dawn-
ing realisation of how ephemeral must be the precarious arrangement of folded,
wrapped and tucked fabric make the picture seem nothing short of a divine act of
creation accomplished within a split second.[55]

The inscription on the upper picture frame, in a mixture of Greek and Flem-
ish, effectively adds a further form of the first person: "ALC•IXH•XAN" [in as far as I
am able to achieve it]. Strictly speaking, the two inscriptions must be understood as
interconnected: "In as far as I am able to achieve it, Jan van Eyck made me". This is

55 On the inscription: Gludovatz 2005, pp. 126–33, where there is also discussion of the coinci-
 dence of spouse and image in the 1439 portrait of Margareta van Eyck. On this problem in
 particular, see: Gludovatz 2004, pp. 24–28. On the inscription, see also: Liess 2000, Vol. 2,
 pp. 772–75, and Burg 2007, pp. 406–07.

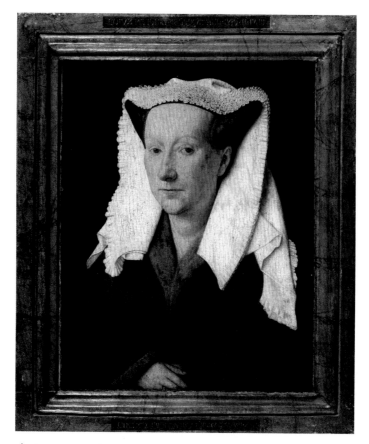

Fig. 31 Jan van Eyck, *Portrait of Margareta van Eyck,* Oil on wood, 1439,
Groenigemuseum, Bruges.

to say that the painting, in its role as a pre-existing possibility, and to the best of its
ability, has endowed the painter with the capacity to give it a real existence. While
possessed of its own logic, this reading is, however, also improbable in as far as
ALC•IXH•XAN (in the sense of "As only I can") was a motto that Jan van Eyck rather
frequently employed.[56]

As yet other paintings attest, this sort of contradiction was to be neither
resolved nor relieved. When the portrait of Jan van Eyck's wife, Margareta (Fig. 31)
speaks in the first person singular, the painted wife appears to designate her own
husband as her creator: "CO[N]IV[N]X M[EUS] JOH[ANNES] ME COMPLEVIT A[N]NO.
1439.17º IVNIJ / ETAS MEA TRIGINTA TRIV[M] A[N]NORVUM.ALC•IXH•XAN." [My

56 On this point see, most recently: Burg 2007, p. 409.

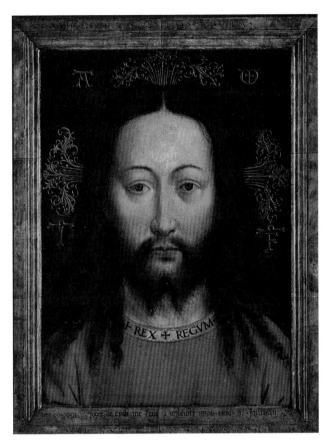

Fig. 32 Copy after Jan van Eyck, *Portrait of Christ,* Oil on wood,
after 1635, Gemäldegalerie, SPK, Berlin.

husband Johannes completed me on 17th June 1439. I am thirty-three years of age].[57]
The painter's role in creating the image of his wife here signing in the first person
singular is, however, already implicit through the addition of his own motto: "In as
far as I am able" / "As only I am able". This dual role recalls that traditionally associ-
ated with Mary, as both mother and bride of Christ. In a reciprocal fashion, Jan van
Eyck's painting speaks of the artist as both the husband and the creator of the living
image of his wife.

Were one to seek an intensification of the outlandish logic to be associated
with such a claim, one can find it in Jan van Eyck's lost depiction of Christ, of which

[57] *Jan van Eyck* 2002, cat. no. 25, p. 235. Fundamental on this matter: Gludovatz 2005, pp. 126–29;
Renaissance Faces 2008, pp. 180–81.

the copy now in the Gemäldegalerie in Berlin (Fig. 32) is thought to preserve the most authentic impression.[58] In this case the artist's motto, *ALC·IXH·XAN*, as usual in capital letters, precedes the inscription, which has the portrait of Christ speak in the first person singular: "Joh[ann]es de eyck me fecit et amplevit anno 1458 31 Januarij" [Jan van Eyck made me, completing (the work) on 31st January 1458]. The first person singular here belongs to a portrait "of" Christ that evidently cannot show Christ himself, but which is nonetheless able to speak in this manner. The first person singular used by this stand-in for Christ corresponds to the "I" ["IXH"] in the painter's own signature.[59]

Jan van Eyck's earliest surviving signed work (Fig. 33) bears, in addition to the name of the subject, a certain Timothy, and the phrase "LEAL SOUVENIR" [faithful remembrance], the inscription: "Actu[m] a[n] no d[omi]ni 1432 10. die octobris a ioh[anne] de Eyck" [Executed in the Year of Our Lord 1432 on 10th October, by Johannes van Eyck]. If, as has been assumed, the term *Actum* derives from a juridical context, it is possible that it may here be employed in connection with the portrait as a form of painted authentication and thus as a case of the image act in its legal dimension.[60]

In the contradiction between the artist's "I" and the "me" of the artefact, Jan van Eyck's portraits bring to the point the fundamental problem as to how it is that the work of art, although created by the artist, nonetheless appears to be a living soul. It is here significant that both manifestations of an "I" – that of the artist and that of the work – appear side by side.[61] Through its dual nature the artist's inscription becomes a conduit for the power that confronts humanity in an idiosyncratic fashion that is no less disturbing than it is alluring.[62] Jan van Eyck's inscriptions affirm the simultaneous existence of each of his paintings as both created object

58 As an "unlicensed" portrait, this will have seemed like a second emanation of the *vera icon*, thereby encouraging the production of numerous replicas (Frommel and Wolff 2006, p. 8).

59 On the motif of the status of an artist (in Alberti's definition) as an individual *quasi divinus*, see also: Gludovatz 2005, p. 132; and Frommel and Wolf 2006, pp. 7–9.

60 Dhanens 1980, pp. 178, 182; Burg 2007, pp. 410–11; *Renaissance Faces* 2008, p. 98. Belting 2001, pp. 127–28, by contrast, believes the image to have had a commemorative role.

61 The more precise the reading becomes, the more its object becomes unclear, as if in a process of conscious encipherment. On this motif, see also: Belting and Eichenberger 1983, pp. 106–07.

62 This embodies, in a complex fashion, that which George Herbert Mead has analysed as the transition from the acting "I" to the reflected "me". In the objectified "me" the "I" recognises its "own designation" in the context of the outcome of its actions. According to Mead's criteria, the "I" of the image becomes the medium for the artist himself becoming "me" as a paradigm of the self-objectifying "I". This at length allows for that transition from the active "I" to the "me" to take place, a development that can occur only through reflection on the context of the completed action (Mead 1964, p. 141).

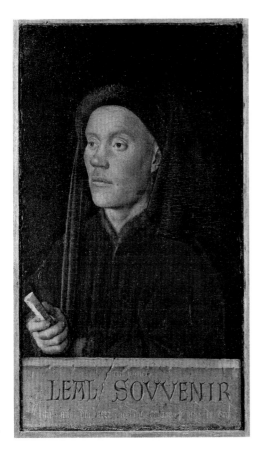

Fig. 33 Jan van Eyck, *Timothy (Leal Souvenir)*, Oil on wood, 1432, National Gallery, London.

and autonomous subject. Through the inscribed "me" the animation of the work appears not as an outwardly directed realisation, but as an inherent *energeia* that cannot but strike the observer.[63]

C. THE ANIMATION OF WEAPONS

The history of works of art speaking in the first person singular was to continue well beyond the period of the Renaissance, be it in northern or in southern Europe.[64] Outside the realm of the fine arts, moreover, the *ME FECIT* formula evolved

63 In this respect these inscriptions may be said to have supplied a motto for the portrait right up until the period when photographic technology was sufficiently developed as to make "portraiture" of a sort accessible to all; for more on this aspect, see: Burda 2007.

64 The continuation of the motif is attested through the inscription "L[orenzo] Lotto me fec[it]" on the cartouche held in the left hand of the sitter in this artist's *Man in a Black Hat* in the

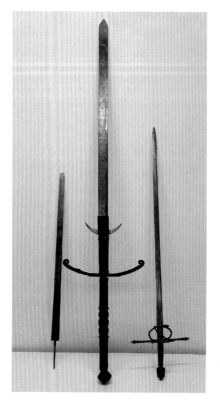

Fig. 34 (from left to right) Blade of a sword made in Solingen, first half of 17th century; South German two-hander, late 16th century; Sword made in Solingen, c. 1600, Deutsches Historisches Museum, Berlin (Depot Berlin-Spandau).

a semantics of its own; and this was above all the case in the manufacture of every sort of weaponry. Just as town- and city-dwellers would come to recognise that life and death might well hang upon the tolling of a particular local bell, so too have soldiers on every battlefield learnt to value their own weapons as a form of living

Gemäldegalerie, Berlin. The inscription appears to relate to the content of this roll of paper (understood to be a drawing), and thus to refer, together with the life-encompassing letters A and O (for Alpha and Omega), to the artist's oeuvre in its entirety (Winner 2005, pp. 96–98. See also: Gilbert 2000, p. 86). As evinced by the martyred figure of St Bartholomew made by Marco d'Agrate in 1562 for Milan Cathedral, inscriptions of the *ME FECIT* sort also endured in the realm of sculpture (Mariacher 1987, p. 210). On the front of the pedestal for this figure, who has placed his own flayed skin, like voluminous drapery, over his shoulders and around his hips, we find the inscription: "NON ME PRAXITELES SED MAR[CUS] FINXIT AGRATES" [Not Praxiteles but Marco d'Agrate shaped me]. The "ME" of a sculpted figure of a martyred saint makes liveliness itself into a criterion in the stimulating rivalry with the sculpture of Antiquity. The sixteenth-century here trumps Antiquity through the work's own manifest ability to "speak" of itself.

Fig. 35 Detail of south German two-hander seen at centre of Fig. 34, with maker's signature.

Fig. 36 Detail of south German two-hander seen at centre of Fig. 34, with continuation of maker's signature.

Fig. 37 Milanese dagger, 1475, detail, with inscription Arsenal, Staatliche Kunstsammlungen Dresden.

Fig. 38 Detail of blade of a sword made in Solingen seen at left of Fig. 34, with maker's signature.

alter ego. This was especially so in the case of guns, their status as explosive auto-
mata fitting them especially well to assume an even further autonomy.[65] A light field
cannon of the sort known as a falconet, made in 1531 in the city of Regensburg,
declares itself to be the wife of the carnivalesque inversion of a piper whose image it
bears: "I am the piper's other half".[66]

Among the equally numerous slashing and stabbing weapons bearing *ME
FECIT* inscriptions are a southern German two-hander from the late sixteenth cen-
tury and swords made in Solingen around 1600 and in the first half of the seven-
teenth century, all now to be found in the collection of the Deutsches Historisches
Museum in Berlin (Fig. 34). The blade of one of these terrifying weapons, at the point
where it emerges beyord the parrying hooks, bears along the centre of one side the
name of the maker: "STANTLER" (Fig. 35). Specifying no Christian name, this inscrip-
tion refers to a member of the Munich and Passau family of swordsmiths. The other
side of the same blade effectively continues the inscription through the words "ME
FECIT" (Fig. 36), so that this as a whole reads: "Stantler made me".[67] As the blade
bears no figural attribute it may itself be perceived as speaking in the first person
singular.[68] Here there is an effectively bi-polar tension between the producer and his
product in as far as the signature of the swordsmith is positioned back-to-back with
the first-person-singular assertion of the weapon made by him.

One side of the blade of a further sword is divided by two longitudinal sets of
grooves, between which are diverse figural motifs and an inscription in Latin
(Fig. 38). Reading from left to right, one discovers that the swordsmith has inscribed
his own mark in the form of the heads of three bishops, an imperial orb, then a
further bishop's head.[69] Into the space between these markings and a further group
of the same, there leaps the highly stylised outline of a wolf, shown as if running
towards the point of the sword. This blade is inscribed to indicate that the maker
was a swordsmith in Solingen, by the name of Peter Munich: "PETER MVNICH / ME
FECIT / SOLINGEN". Once again, it is here not the maker who speaks of his product,
but the object itself that speaks of its maker.

Weapons of this sort are very well represented in historical collections: the
Dresden Arsenal, for example, can boast a number of particularly valuable examples.

65 Ploss 1958, pp. 41–42.
66 Müller 1968, image on p. 89, text on p. 91.
67 Müller and Kölling 1984, Fig. 119 (p. 198), p. 374.
68 In the case of another sword, made in around 1600, the following has been beaten down the
 centre: "CLEMENS KEVLLER SOLINGEN". On the reverse side the object again speaks in the
 first person singular: "CLEMENS KEVLLER ME FECIT" [Clemens Keuller made me]. Again, it
 is not the maker speaking here, but rather the sword he has produced (Müller and Kölling
 1984, p. 378).
69 Müller and Kölling 1984, Fig. 141, pp. 212, 378.

Among these is a dagger made in Milan in 1475 (Fig. 37), in the central groove of which is the inscription: "DANIELO ME FECIT / IN CASTELLO MEILANO 1475" [Daniel made me in 1475 at the castle in Milan].[70]

In all these examples the signature is found to be the personal statement of a tool of battle, which – be it as life-saver or as death deliverer – was understood as an extension of its user's own body. The more closely the reader is able to observe the inscription, the further he is drawn into a sphere in which the difference between observation and action, between the living and the anorganic, is ever more sharply marked. This is the zone of the image act.

3. Works of Art that Speak

A. Pasquino in Rome

Constituting a distinct category are works of art that were found to "speak" in such a way that they posed a challenge to authority, thereby setting up a form of iconic opposition. Their own animation was not attested through the presence of a ME FECIT; it evolved, rather, in a narrative fashion.

The most celebrated example is to be found in Rome: in the fragment of an ancient sculpted figural group (Fig. 39).[71] Its original subject has been variously interpreted: as a gladiator shown cradling the body of the opponent he has defeated, as a soldier overcome by despair as he supports the corpse of Alexander the Great, or as the Greek king Menelaus grieving over the slain Patroclus. Cardinal Oliviero Carafa initially had the sculpture put on display near the church of San Pantaleo.[72] It was accompanied by a notice informing observers that: "I am here thanks to Oliviero Caraffa [*sic.*] in this Year of Grace 1501".[73]

Only shortly after its re-positioning, outside the former Palazzo Carafa near Piazza Navona, the group had already become an important link within a series of sculptures from Classical Antiquity that, on account of their own stony invulnerability, were able to give voice to truths that could not have been stated with impunity through any other medium. To begin with, the Pasquino was esteemed as an authority on education in the Humanist tradition. Each 25th April it would be cos-

70 Inv. no. VI/36. There is also a sword (perhaps from Milan) (1556; VI/383), a dagger from Munich (1558; VI/95), a sword from Valencia (c. 1590; VII/39), two daggers from Solingen (c. 1600; VI/243 and VII/32), in addition to a riding sword also from Solingen (c. 1620; VI/420).

71 Fundamental on this from the effective point of view of the image act: Barkan 1999, pp. 209–31.

72 Haskell and Penny 1982, pp. 291–96. See also the comprehensive research recorded in: *Ex marmore* 2006.

73 Cited after Erben 2005, p. 20.

Fig. 39 The so-called *Pasquino*, Marble, Roman copy of Hellenistic original of
3rd century BC, Piazza di Pasquino, Rome.

tumed as a figure from Classical mythology. Carefully selected, freshly composed
verses in Latin would be affixed to it, and these would then be read and discussed by
scholars and students. After only a few years, the practice of attaching slips of paper
to the sculpture or of displaying these in its immediate vicinity had made of it a
veritable advertising pillar for political polemic (Fig. 40). The figure came to be
known as *Pasquino* in allusion to an artisan of that name who had become infamous
for his plain-speaking and whose statements and satires took aim in particular at
cardinals and popes.[74]

74 Haskell and Penny 1982, p. 291.

Fig. 40 Antonio Lafreri, *Pasquino,* Engraving on paper, 1550,
Staatliche Graphische Sammlung, Munich.

It was, moreover, at precisely the point when the Pasquino settled into its role
as a critic of society that it began to speak in the first person singular. In order to
protect the satires attached to it, the figure came to be regarded as a *statua parlante*
[speaking statue], for whose statements no-one could be held responsible.[75] It was
often the case that a fictional conversation between statues would take place: a
question might, for example, be put to Marforio, the statue of a reclining river god
that occupied a courtyard on the Roman Capitol, and in due course this would be
answered by Pasquino. In this fashion there arose, among the various Roman *statue*

75 Erben 2005, p. 19.

parlanti, and above all at night, a continuous, critical dialogue both on the general mood of the times and on the minutiae of day-to-day politics in the city.

One of the thousands of poems that were, in effect, thus attributed to Pasquino attacked the then Pope, Clement VII (Giulio di Giuliano de' Medici), on account of the Sack of Rome that had occurred in 1527: "Clement, I have told you, and I'll tell you again now: / And if I did so [in the same way] I would not be Pasquino. / And I will say it in Italian because if it were in Latin, / it's quite possible that you wouldn't understand what I'm saying".[76] Clement VII, for all his Humanist education, appears to Pasquino as little better than a barely educable schoolboy, incapable of mastering Latin, and he is finally addressed as follows: "and as such ill luck has overcome you, / please have the good grace to stay in San Giovanni [in Laterano] / and occupy [just] one room and a kitchen".[77]

The endeavours of Pope Leo X (Giovanni di Lorenzo de' Medici) to place limits upon this example of free speech and to forbid the adulation of Pasquino had been of no avail; equally unsuccessful had been the plan of the Dutch Pope, Hadrian VI (Adriaan Florenszoon Dedal), to have the figure thrown in the Tiber.[78] It retained its status as a protecting power for satires and criticism. And, if the first-person-singular texts affixed to it were read aloud by those who had come to see them, the result was not unlike the aforementioned instances in Greek Antiquity of animation by means of spoken sound. Through thereby newly realising the combined effect of image, text and speech, Pasquino created the space for the airing of critical public opinion.

B. MEMLING'S *LAST JUDGEMENT*

The capacity of a work of art, speaking in the first person singular, to lay claim to a life of its own, to assert a desire to associate with its own kind, and so to formulate criticism and thereby bring influence to bear was also a feature of later centuries.

An example of particular historical significance is to be found in an early nineteenth-century occurence relating to Hans Memling's *Last Judgement* (Fig. 41), completed between 1455 and 1471. In the painting's left panel one finds the Ascent of the Elect, who may be observed moving calmly and steadily in the direction of a diffuse realm of brightness that is visible through an open double door. The Damned,

76 "Clemente, io tel dissi, or tel ridico, / che s'io 'l facessi non sarei Pasquino e dicol per volgar / perché latino forse non saperesti quell che io dico" (Marucci 1988, p. 104).

77 "e chi ti venga adosso tal ruina / ch'abbi di grazia star a San Giovanni / ed aver una sala e una cucina" (Marucci 1988, p. 104).

78 Haskell and Penny 1982, p. 292.

Fig. 41 Hans Memling, *The Last Judgement*, triptych, Tempera on oak wood, 1455–1471, Muzeum Narodowe, Gdańsk.

meanwhile, shown in a scene from Hell in the right panel, are sucked diagonally down into what resembles the gaping mouth of a volcano.[79] In the central panel the souls of the recently deceased are being weighed by the Archangel Michael. While the fate of each soul is contested by angels and devils on the left, in a scene that effectively continues into the panel of the Elect, on the right Satan's henchmen are already expelling the Damned. Through the figure of a man shown crawling along the earth in the foreground while looking out at those looking on, these feel, as indeed intended, as if drawn into this depiction.

In the wake of Napoleon's initially victorious military campaigns across much of Europe at the start of the nineteenth century, Memling's triptych was among the works of art slated for seizure, as spoils of war, on the advice of Dominique Vivant Denon ("Napoleon's eye"). On 6th July 1807 it was, therefore, removed from Danzig [Gdańsk], previously under Prussian rule.[80] In the winter of 1807/08, how-

79 The painting was first identified in Gustav Hotho, 1843, pp. 128, 131–33. See also: Vos 1994, p. 85. On the picture's history: Belting and Kruse 1994, pp. 244–45; most recently, Blumenröder 2008, p. 205.

80 On this campaign: Savoy 2003 *Patrimoine*, Vol, 1, pp. 117–46. See also: Savoy 1999, pp. 171, 179.

ever, alongside other important works confiscated from German collections, it was put on display in Paris, in two halls at the Musée du Louvre.[81] After the Battle of Waterloo, in June 1815, the painting formed part of the "triumphal procession" in which a portion of the seized works of art was returned to the former owners.[82] These works were also brought together in a splendid exhibition in Berlin, in which Memling's triptych from Danzig was the central attraction.[83]

At the end of October 1815 an article appeared in the *Berlinische Nachrichten* that purported to be written by the triptych itself: "The words of the Danzig picture showing the Last Judgement addressed to its friends".[84] The triptych argued that the humiliation of defeat and plunder had been dispelled through the satisfaction felt at being put on exhibition in the Louvre. The company of other works of art and the discussion, admiration and research that this had set in motion had issued in the painting's resurrection.[85] From this experience of appreciation there had emerged a belief that it was now in order to issue certain demands: "I, the picture from Danzig, who am a living example of an existence that had heretofore been most unfruitful, do beg and beseech you to ask your king to display, in his Prussian museum of German art, these trophies of war in order, through art, to enliven the peace".[86] While it proved impossible to secure Memling's triptych of the Last Judgement for Berlin (it returned to Danzig, where it then remained), the encouragement voiced by the painting was reciprocated through the erection, in 1825–28, of Karl Friedrich Schinkel's Königliches (later Altes) Museum, the first purpose-built museum for art in Berlin.[87]

81 The catalogue alludes, proudly, to 14th October 1807, the date on which the exhibition opened, as the first anniversary of the Battle of Jena (Savoy 2003 *Patrimoine*, Vol . 2, p. 2; *König Lustik!?* 2008, no, 70, p., 231). See also: Chézy 1858, p. 351 and, on this point, Savoy 2003 *Kulturtransfer*, pp. 139–40.

82 Savoy 2003 *Patrimoine*, Vol .2, p. 143. On the overall course of events: Wescher 1976, pp. 131–45, and Savoy 2003 *Patrimoine*, Vol. 1, pp. 147–95.

83 *Verzeichnis von Gemälden 1815*, no, 1, pp. 1–3; Vogtherr 1997, p. 79. On what follows, see also the account given in: Savoy 2003 *Patrimoine*, Vol. 1, pp. 398–99.

84 "Worte des Danziger Bildes", 1815. This discovery is owed to: Savoy 2003 *Patrimoine*, Vol. 1, p. 143. The first part of the 1815 article appeared as: "Nothwendige Empfindungen". The author of the article in the *Berlinische Nachrichten* is unknown. He must, however, have belonged to the circle of Gottfried Schadow; or the text might even have been written by Schadow himself. Also in favour of this possibility is the fact that he accepts the attribution of the work to Michael Wolgemut, Albrecht Dürer's teacher (*Verzeichnis von Gemälden 1815*, p. 26. See also: Schadow Vol. 1, 1987, p. 108).

85 "Worte des Danziger Bildes", 1815 [p. 6].

86 *Beutekunst unter Napoleon* 2003, p. 143.

87 Vogtherr 1997, pp. 74–148; Van Wezel 2004.

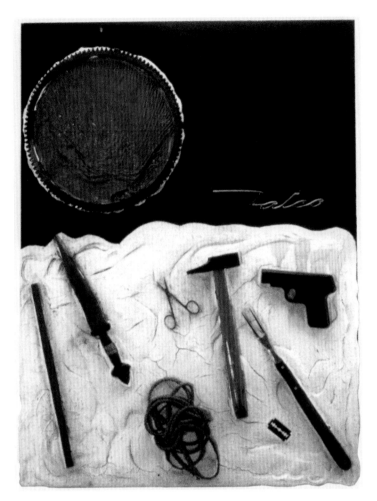

Fig. 42 Niki de Saint Phalle, *Tu est moi (Paysage de la mort)*, Plaster and diverse objects on wood, 1960, Princeton Art Museum, Princeton University.

C. SAINT PHALLE'S SHOOTING PICTURES

The phenomenon of works of art speaking in the first person singular endures to this day. The most striking instance to occur in more recent decades is to be found in the "destruction pictures" made by Niki de Saint Phalle in the early 1960s. The bright colour and cheerfulness characterising those sculptural works that chiefly account for this artist's international popularity may also be recognised as the inverse of a burden of trauma that compelled Saint Phalle to make of the work of art an *alter ego* of her own physical self.

Saint Phalle's personal motivation related to experiences that were far removed from "destruction" in a purely aesthetic sense. It was only later that she admitted that her destruction pictures had been strongly motivated by the memory of being repeatedly sexually abused, as a child, by her father. *Tu est moi*, an assemblage from 1960 (Fig. 42), was one of the first works in which Saint Phalle sought to assuage this trauma through engaging both formally and thematically with violence.[88] The simultaneously nonsensical and troubling lexical play in the titular statement "you is I", in which the second and first personal pronouns are linked through a verb in the third person singular, translates the problem posed through the portrait images of Jan van Eyck into a paradoxical sequence of three words. The work and the artist, although separate entities, here share a single identity, where it is not clear as to which is "I" and which is "you". All that is clear is that the work and its creator here achieve a curiously detached form of union.

An element of menace enters the equation through the nature of the motifs that feature here. Beneath a lunar disc, made out of plaster but the colour of blood, which appears as if it had just muscled in to mask the sun, several objects are laid out upon a plaster support, among them a knife and a length of rope – every one of them a potential accessory in a resort to violence, as if they were waiting to be used to such an end by the observer. This interpretation is further urged through the potential for a mis- or parallel understanding of the title *Tu est moi* [you is I] as its homophone: "Tuez-moi" [kill me].[89] One might initially identify the "I" with the artist, here issuing the order for her own murder so as to put an end also, by this means, to her trauma. But it is soon evident that the "I" might, alternatively, be identified with the work itself. What one might well call "the Jan van Eyck problem", articulated through the use of two sorts of "I" in the inscriptions on the frames of his paintings (see above regarding Fig. 30), is again posed in Saint Phalle's work. And now it is a matter of life and death. For only that which is living can be killed.

Saint Phalle pursued this theme in her "image destruction actions" (or performance pieces) of 1961. At the Musée d'Art Moderne de la Ville de Paris and at the Stedelijk Museum in Amsterdam she created an assemblage of paint-filled figures with targets for heads, at which both she and a number of spectators then hurled darts (Fig. 43). The three variants of the title of the first of these throwing pictures – *Saint Sébastian*, *Portrait of my Lover* and *Martyr Nécessaire* – reflect the compulsive duality in the role-swapping (victim / perpetrator; sufferer / actor) through which

88 *Niki de Saint Phalle* 2001, no. 82, p. 54. See also: Wimmer 2006 *Vergewaltigung*, p. 251.

89 Ortel 1992, pp. 146–47; Wimmer 2006 *Vergewaltigung*, p. 251; Wimmer 2006 *Verschwinden*, p. 80.

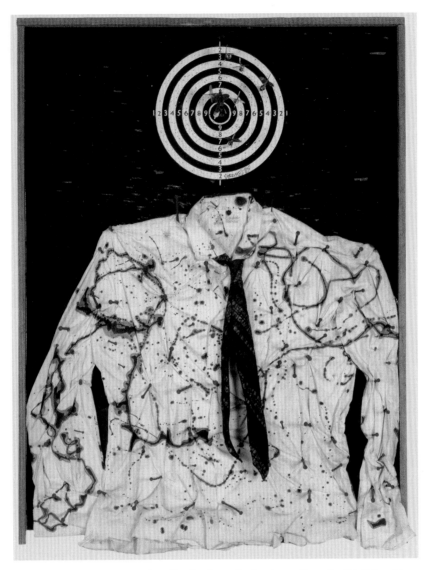

Fig. 43 Niki de Saint Phalle, *Saint Sébastian (Portrait of my Lover / Portrait of My Beloved / Martyr Nécessaire)*, Paint, wood, and diverse objects, 1961, Sprengel Museum, Hanover.

the ambiguous power of this work is revealed.[90] These actions issued in a euphorically experienced compulsion to make the spectator more actively aware of the image as itself a body through witnessing the injuries inflicted upon it: "How about

90 *Niki de Saint Phalle* 2001, no. 158, p. 80. See also: Wimmer 2006 *Vergewaltigung*, p. 251–53; Wimmer 2006 *Verschwinden*, pp. 82–84.

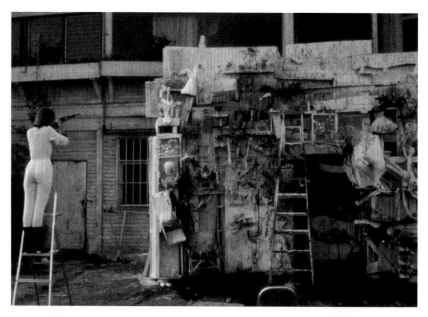

Fig. 44 Niki de Saint Phalle, *Drôle de mort (Gambrinus)*, Shooting action piece,
9 February 1963, Neue Galerie im Künstlerhaus, Munich.

if the image were to bleed – were to be wounded, just as people can be injured. For
me, the image would then become a person with feelings and sensations".[91] With
Saint Phalle's subsequent work, the "shooting pictures" that were to cause quite a
stir, those present fired with rifles at similarly humanoid plaster shapes, so that
some of the paint with which these were filled spurted out, while some flowed
down the outer surface (Fig. 44).[92] As the product of "executions", these spurting and
flowing images were manifestations of the punished perpetrator with whom the
artist was herself inescapably associated, so that the killing of such an image might
also be understood as a form of suicide: "The image was the victim. WHO was the
image? All men? Small men? Tall men? Fat men? Men? My brother JOHN? Or was I the
image? Was I firing at myself in a RITUAL, that allowed me to die by my own hand
and to be re-born?"[93]

91 Saint Phalle to Pontus Hultén in: *Niki de Saint Phalle* 1992, p. 160.
92 *Niki de Saint Phalle* 2001, nos. 159–70, pp. 81–86; nos. 226–433 (with some exceptions),
 pp. 106–202. See also: Wimmer 2006 *Verschwinden*, pp. 86–102.
93 "La peinture était la victime. Qui était la peinture? Tous les hommes? Petits hommes? Grands
 hommes? Gros hommes? Les hommes ? Mon frère JOHN? Ou bien la peinture était-elle MOI?
 Me tirais-je dessus selon un RITUEL qui me permettait de mourir de ma propre main et de
 me faire renaître?" (Saint Phalle to Pontus Hultén, in: *Niki de Saint Phalle* 1992, pp. 161–62;
 see also: Wimmer 2006 *Vergewaltigung*, p. 254, Wimmer 2006 *Verschwinden*, p. 99).

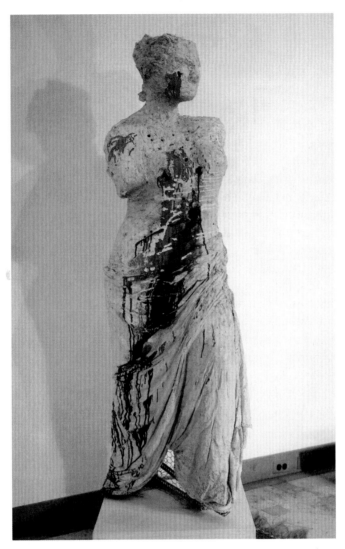

Fig. 45 Niki de Saint Phalle, *Vénus de Milo,* Painted plaster over metal armature, action piece, 4 May 1962, Maidman Playhouse, New York.

With her "shooting pictures", which were to climax in May 1962 in her *Vénus de Milo* (Fig. 45),[94] Saint Phalle took an entire art-theoretical tradition to a level where it would also foreshadow the later "war of images". As the image here appeared to function autonomously, Saint Phalle can be seen – not unlike John Cage, Jasper

94 *Niki de Saint Phalle* 2001, no. 300, p. 143.

Johns, Robert Rauschenberg and Jean Tinguely – to have taken aim, through her actions, at the concept of representation. If the murder of the image, as enacted through the rifles fired at Saint Phalle's paint-filled plaster entities, did indeed encourage a sense that images had begun "to live",[95] then this effectively pulled the rug from under all of those theories that saw the image as merely "standing" in" for something else. What was here conceived as a "crisis of images" and a "death of painting"[96] was in truth the advent of an engagement with the reflection of their essential validity.

The harm sustained by Saint Phalle during her own childhood thus issued at length in an exemplary formulation of the fundamental problem: that images were their own products, if not their own selves, and that they nonetheless signified something deeply alien. In this one finds a further, more general aspect, which the "shooting pictures" served to expose. With the formula *Tu est moi* the artist overcame the structural fear of being confronted, within the work, by a product of her own creativity that was itself an autonomous being, through attacking that which triggered this fear. In as far as the work of art becomes the object of an act of destruction, in the very moment of that destruction its separate existence ceases.

Witnesses to the artefact or work of art speaking in the first person singular – which have here been traced back to the earliest forms of documentation from the Ancient Near East – may be said to attain an extreme form in Saint Phalle's *Tu est moi*. These testify to the sense, apparently occurring in all periods and in every culture, that man-made objects, even though they are artificial creations, are possessed of a life of their own. In its paradoxical structure, this circumstance is so uncanny as to be veritably unsettling,

That which theorists have avoided articulating has nonetheless been all the better asserted by the artefacts and works of art through their own self-referential statements. The use of the first person singular, in an inscription, harnessing an *energeia* inherent in the work, emerges from the depth of the phenomenon itself, as if to relieve the theorists of their compulsion to devise formulae for that which can be described only in the form of a paradox. In their compensatory aspect, such inscriptions, in being inextricable from an object, permit a higher form of theoretical reflection.

In earlier ages the force that images seemed mysteriously to exude would be explained as in some sense god-given;[97] but this was a merely external solution, unable to solve the problem on its own terms. With the Enlightenment this conflict might have attracted serious intellectual enquiry, but this did not occur. Reluctance

95 Wimmer 2006 *Verschwinden*, p. 90.
96 Wimmer 2006 *Verschwinden*, note 106, note 169.
97 Möseneder 2009, pp. 73–162.

to come up with formulae and theories relating to phenomena that might well be associated with magic and occultism ensured that the problem was henceforth consigned to the realm of literature. Countless authors – among them E.T.A. Hoffmann, Theodore Fontane, Honoré de Balzac, Oscar Wilde, Antoine de Saint-Exupéry and Stanisław Lem – have since found inspiration in the subject of autonomously active works of art.[98]

In common with such literary reflections upon the fundamental problem of images, works of art speaking in the first person singular are of considerable consequence for epistemology. In their capacity to make manifest a repressed aspect of human relationships with the formed world, they operate in a region beyond that attainable through theories associated with imitation, representation or Constructivism. From the perspective of works of art speaking in the first person singular, such forms of philosophy and art theory will necessarily appear as mere variations on a misguided attempt at conceptually de-fusing what remains a very real problem.

With her assemblage *Tu est moi* Saint Phalle embarked on adopting the opposite view and pursuing it right up to the border of self-annihilation. Her "shooting pictures" are incunabula in the history of the autonomous activity of the image manifest in the work itself. They may be said to constitute an extreme sum total of the variants of the image act, in each of which the image "speaks" through formal qualities in the work. Of these variants, the *schematic image act* – distinguished above all by the unmediated effectiveness of the "life" inherent in the image – comes into play by dint of the use of the first person singular, and is encountered in its most intense form when (as in the case of the Mantiklos figure, Fig. 16) the first person singular is employed to state a command. One is concerned with the *substitutive image act* – defined by the exchange of image and body – above all in the case of works of art bearing inscriptions that relate (as in the copy of Jan van Eyck's portrait of Christ, Fig. 32) to two personae. Lastly, the *intrinsic image act* – epitomised by a work's positive appraisal of its own formal qualities – has been present throughout the entire history of humanity's conscious shaping of objects. Already a factor in the production of the first consciously shaped hand axes (Fig. 4), it may be found to recur in instances as contextually diverse as a writing box from the Near East (Fig. 18), the bronze door devised by Riquinus (Fig. 28), or the words retrospectively attributed to Memling's *Last Judgement* triptych (Fig. 41). The entirety of artefacts and works of art that may be seen, in whatever way, to speak in the first person singular, constitutes the evidence out of which a theoretical concept of the image act may be derived.

98 Osterman Borowitz 1985, pp. 29–30; Macho 1999. On Futurism, see: Ingold 1980. For the most comprehensive exposition of the literary topos of the living statue, see: Gross 1992. For more recent examples from the literature, see: Kronauer 2008 and Mettler 2009.

III

Schematic Image Acts: Animation of the Image

i. Living Images

A. *Schemata* and *Tableaux Vivants*

An inscription on a particular statue from Greek Antiquity, dating from between the end of the fifth and the start of the fourth centuries BC, imparted in a singular fashion not only the figure's memorialising purpose but also the significance of its subject. This sculpted figure represented Arbinas, a dynast of the city of Xanthos in western Lycia, whose intellectual and military virtues were much prized, as evinced in the inscribed acknowledgement, which had been devised by Symmachus of Pellana. As in the case of the figure of Phrasikleia (Fig. 17), that of Arbinas distanced itself from the person it was representing through the use of the first person singular: "He had me, the image of himself, dedicated to Leto".[1] Through this form of self-description, it emerges that the statue here speaking was dedicated to Leto, mother of Apollo and Artemis. The use of the first person singular in itself signals the figure's living presence.

The next element in the inscription introduces, however, an additional form of self-interpretation, relating to the sculpted figure in its formal guise: "The schema illustrates the status of his heroic deeds".[2] A *schema* was a formal criterion, which defined the man to whom it was applied in terms of his perceived worth, in order that this then serve as an example to be followed by those to whom it was presented. *Schemata* established a standard for appraisal, and thereby also for orientation and imitation, in terms of the particular form of a living figure.

It is proposed that this notion of the *schema* serve as the basis of the concept of a schematic image act to be explored and elucidated in this chapter. It should be

1 Cited from Catoni 2005, p. 221; Catoni 2008, p. 200; with reference to Hansen 1989, no. 188.

2 Cited from Catoni 2005, p. 221; Catoni 2008, p. 200; with reference to Hansen 1989, no. 188.

noted that the modern understanding of the term *schema* differs from that implicit in the example cited above because it relates more strongly to patterns of perception, expression and action deriving from widely accepted norms.[3] In Classical Antiquity, as observed by Roland Barthes, the concept of the *schema* was applied to bodies that were shaped and used as images.[4] To begin with, this had been a concept employed in mathematics, where entities, whether defined in terms of geometrical line or of stereometrical surface, were seen to be possessed of a certain pictorial consistency. Taking his starting point in the laws of mathematics, Plato transferred this meaning, in its literal sense, to human bodies, which it was possible to arrange in evocation of certain formally stylised poses or movements, these in turn serving as examples to be imitated.[5] Going one step further, this definition was in turn transferred to living works of art, as represented by the sculpted figure of Arbinas.[6]

It has largely gone unrecognised that Plato's definition of the *schema* has been adopted and applied in the contemporary practice of corporeal aesthetics. In the Philosophy of Embodiment the Platonic *schema* is understood as the summation of all those controlling procedures that facilitate the poses and movements of which the body is capable.[7] It is to this recurrence of the meaning of *schema*, as the corporeal basis of knowledge and conduct, that the definition of the schematic image act relates. This embraces images – either living or simulating the state of being alive – that aim at exemplary effects.

The most obvious instances of the schematic image act, on account of the very term traditionally used for them, are *tableaux vivants*, literally "living pictures", or more comprehensively "living images". These use painstakingly arranged groups of men, women and children so as to achieve an imitation of a particular, often celebrated, painting, mural, or work of relief or three-dimensional sculpture. In order to fulfil their function as living images, those participating must, throughout, remain absolutely still. In combination with the appearance of being alive and the maintenance of an artful form, fixity enables such participants to leave a lasting impression that may be understood as a *schema* in Plato's sense.

There are accounts of the presentation of living images in the Hellenistic era.[8] It would be reasonable to assume that the tradition endured beyond Antiquity; but it is only from the fifteenth century that one encounters an increasing number

3 Steudel-Günther 2007, column 472.
4 Barthes 1977, pp. 7–8, distinguishes the term *schema* in the modern sense from its meaning in Greek Antiquity. See also Gödde 2001, pp. 241–42.
5 Catoni 2005, pp. 278–91. See above, pp. 22–23.
6 Catoni 2005, p. 221; Catoni 2008, pp. 200–01.
7 Krois 2002; Krois 2006.
8 Hesberg 1989; Köhler 1996, pp. 123–25.

of reports on the practice of creating exemplary images through an artful arrangement of immobilised human bodies. The earliest surviving dated record comes from the year 1437, when a *tableau vivant* of the Passion of Christ was staged on the occasion of the triumphal entry into Paris of the French king Charles VII: "There was no speaking or gesturing; it was as if pictures had appeared upon a wall".[9] The interpretation of the living image here as an embodied mural was to be the first of many comparisons with diverse categories of the visual arts.

A *tableau vivant* of Christ Carrying the Cross during a papal Corpus Domini procession in Viterbo in 1462 was reported to have remained "as immobile as a statue";[10] and a chronicler of *tableaux vivants* in Liège in 1549 emphasises that the actors

> appeared like woven images, without moving their eyes; they neither carried anything, nor did they have about them anything except that pertaining to what they represented: both men and women resembling a tapestry of living figures.[11]

The capacity – doubtless achieved only through long practice – to appear all but indistinguishable from a figured tapestry made it possible

> for one, through merely looking at the stance of each person, to comprehend what each of them was and what each of them signified, be it through their gestures or through their appearance, be it in the pose of the body or the positioning of the hands or the placing of the feet.[12]

The fact that living figures are here compared with a tapestry reveals, as do the aforementioned comparisons with a mural or a work of sculpture, that in the *tableau vivant* one can detect a connection between life and art that itself projected, in the

9 "et fu fait sans parler ne sans signer, comme ce feussent ymaiges enlevez contre ung mur" (cited after Helas 1999, p. 4, note 29).

10 "homo Christum exprimens, [...] immobilis, et quasi statua perseveravit" (cited after Helas 1999, p. 243 Q CXXXV; see also p. 49).

11 "que dando como en pannos pitados sin mouer los ojos, ni pestannas ni hazer cosa fuera delo que representava, assi hombres, como mugeres, que quien quisiera ver un tapiz de figuras vivas" (cited after Helas 1999, p. 245 Q CXL. Trans. Helas 1999, p. 5, note 23).

12 "Representando tan al proprio la hystoria, que alli fe hazia, q solo de verla postura de cada persona se podia facilmente entender, quien era cada uno lo que representava, assi enel gesto y semblante, como enla postura d'el cuerpo y de las manos, piernas y pies" (Helas 1999, p. 245, Q CXL. Trans. Helas, p. 5, note 23).

sense of Plato's *schema*, the sort of assimilation of the former into the latter that an observer would then recognise as a model for imitation.[13]

This principle was to have momentous consequences for art history, as demonstrated in the case of the *tableaux vivants* that formed part of the Neapolitan triumphal procession prepared for Alfonso of Aragon in 1443, which offered a veritable re-animation of the iconographies of Antiquity. Here, the Renaissance was effectively incorporated as a *schema* before it had evolved into an artistic norm.[14] The grandeur one may associate with that occasion is in marked contrast to an occurrence around a decade later, during the procession in honour of the patron saint of Florence, John the Baptist, which revealed the capacity of *tableaux vivants* to deceive. Inspired, it would seem, by the aforementioned festivities in honour of the King of Aragon, the Florentine event was likewise stylistically oriented towards Antiquity; and it included one processional float that bore a temple, within which a cult statue had been erected. This construction served as the stage for the living picture of the Emperor Augustus (Octavian): this seems indeed to have been the first such *tableau vivant* to feature a ruler from Antiquity. When the ornately dressed cast had taken their places on the float for the *rappresentazione*, it appears that a certain German was able to climb up and join them there because spectators would at first have taken him for simply another participant. Mistaking the representation of Augustus for one of the king of Aragon, whom he detested, the German first knocked the temple's cult statue, and then the living image of the Emperor, down on to the piazza. He was only overpowered as he was attempting to climb up one of the pillars of the temple, in order to get his hands on a row of children, who were there posed in imitation of a frieze of cherubim.[15] In the opinion of Matteo Palmieri, who recorded the event, this interloper was simply "pazzo" [mad]; but the man's confusion would in itself have revealed that he had correctly understood that the living image was here functioning as a work of sculpture. It was the figures' sheer presence, alternating as it did between artifice and animation, that would have induced him to commit two forms of iconoclasm: an attack upon a work of sculpture and an attack upon a living image.[16]

A far fuller appreciation of the potential impact of constructions of this sort is evinced by a chronicler reporting on the triumphal entry of Joanna of Castile into Brussels in 1496:

13 Folie and Glasmeier 2002, p. 19.

14 Helas 1999, pp. 61–88, 290, Fig. 26.

15 "E rivolto a Ottaviano, ch'era vestito d'un velluton paonazzo broccato d'oro, richissimo vestire, el prese et fello capolevare sopra'l popolo in piazza" (Helas 1999, p. 198 Q XXIV. On this occurrence: Helas 1999, pp. 86–87, 171).

16 In this he denied the distance that is indispensable for the emotional "proximity" of the living image: Kablitz 2008.

Fig. 46 *The King of Granada pays homage to Queen Isabella of Castile, Tableau vivant* marking the entry of Joanna of Castille (Isabella's daughter) into Brussels in 1496, Colour woodcut on paper, c. 1496, Kupferstichkabinett, Staatliche Museen SPK, Berlin.

As will become clear, they were able, not only through a fitting representation of the deeds and through marvellously sumptuous costumes and effects, but also through a well-judged moralising figural interpretation of the Scriptures, to cheer the spirits of all (and in particular of those who are educated).[17]

The visual documentation of these *tableaux vivants* depicts curtained stages (Fig. 46), upon which a series of living pictures would come into view by way of an increasingly exciting alternation of concealment and revelation:

Then there were the images or posed figures (which we shall call *personagias*) on raised stages or enclosed scaffolds, which were set up at the corners of the streets and which would, according to the signal given, be concealed behind

17 "Que nedum gestorum congrua fictione ac mirabili pomposoque apparatu quam optime condecentis tropologie (vt patebit) applicatione cunctorum (literatorumque precipue) animus oblectavere" (Helas 1999, p. 245 Q CXXIX. Trans. Helas 1999, p. 4).

curtains provided for this purpose or displayed to the eyes of those who were just then passing by.[18]

The *tableaux vivants* devised for the triumphal entry of Philip II into Brussels in 1549 also make clear that the alternation of display and concealment was itself intended to enhance the sensational aspect of such presentations:

> The self-portraits [*autos*] are represented by living persons, and when the curtains were parted it was astonishing to see with what majesty, poise and art these persons stood before us.[19]

In their very presence – seeming to be frozen and yet at the same time intensely alive – *tableaux vivants* may be said to stand in the first rank of those images that testify, through their use of living bodies, to the formal and operational principles of the schematic image act, as derived from the Platonic understanding of the *schema*: living individuals, immobilised so as to resemble works of art and thereby imprinting themselves, as exemplary entities, upon the minds of spectators.

B. Living images modelled after paintings

In around 1480 Hugo van der Goes framed his *Adoration of the Shepherds* (Fig. 47) between two externally positioned persons, each shown drawing a curtain to one side. This reveals that the staging of *tableaux vivants* had rapidly had an impact upon the practice of painters.[20] One of the forms of the schematic image act that was to serve as an external resource for painting had soon become one of its intrinsic devices.

Living images, meanwhile, repeatedly took pre-existing paintings as their models, thereby creating *tableaux vivants* of a second order. The *Ghent Altarpiece* by Jan and Hubert van Eyck (Fig. 48) thus served in 1458 as the starting point for a living image comprising three storeys, the whole displayed to view upon the drawing of a curtain:

18 "Sequuntur effigies seu scemata figurarum (quas personagias vocamus) in scenis seu elevatis et clausis esschaufaudis in conis vicorum locatarum que pretereuntium cum opportunitate tum requesta cortinis ad hoc aptatis nunc velebantur nunc patebant obtutibus" (Helas 1999, p. 245 Q CXXXIX. Trans. Helas 1999, p. 4).

19 "que eran respresentados los autos de personas vivas, era maravillosa cosa ver en abriendo las cortinas, con quanta magestad, postura y arte estaban hechos personajes" (Helas 1999, p. 245. Q CXL. Trans. Helas 1999, p. 5, note 23).

20 Sander 1992, plate 14. See also Kemp 1986, pp. 55–57; and, on the motif of real and depicted curtains in general, pp. 21–45.

Fig. 47 Hugo van der Goes, *Adoration of the Shepherds*, Oil on canvas, c. 1480, Gemäldegalerie, Staatliche Museen SPK, Berlin.

Fig. 48 Hubert and Jan van Eyck, *Ghent Altarpiece*, Oil on wood, 1432, St. Bavo, Ghent.

The stage consisted of three superimposed sections. When, at the approach of the Duke, the curtain was pulled aside, one saw, at the centre of the upper-most section, God the Father, beneath a golden canopy, between the Virgin and Saint John, and surrounding them a choir of angels. God was seated upon a throne of ivory, the imperial crown upon His head and the sceptre in His hand.[21]

We next learn of the central panel with the altar and the sacrificial Lamb, the dove taking flight and the lateral groups of Martyrs, Saints, Patriarchs and Apostles.[22] In addition, now departing from the painted model, there was a fountain occupying its own section: "In front of the scaffold there was a beautiful spring, representing the Fountain of Life, and from out of it there gushed three streams of wine".[23]

The question as to how far paintings of the Renaissance and of subsequent eras derive, in a direct sense, from living pictures has frequently been addressed with reference to Michelangelo Merisi da Caravaggio.[24] The reciprocal question as to whether those arranging *tableaux vivants* systematically looked for guidance to works of art leads us to the aforementioned category of living pictures of a second order. Following the start of systematic excavations at Pompeii, in the 1740s, this subject assumed a new dimension. Now and again excavators would come upon hollow spaces, which had been formed through the incinerated corpses of those killed in the after-effects of the eruption, in AD 79, of Vesuvius. These thus appeared as if enacting what might be achieved through the performances of living actors.[25]

Together with the simultaneously discovered Pompeii murals, overwhelming in their immediacy, these humanoid spaces inspired the series of "attitudes" that made up the one-woman performances staged from the mid-1780s in Naples by Emma Hamilton, the young English mistress, and from 1791 the wife, of the British Envoy to the Kingdom of the Two Sicilies, Sir William Hamilton, who was himself a

21 "in drie stagien verdeeld en met witte gordynen gosloten. Als de hertog naderde werden de gordynen ter zyden geschoven, en de vertooning van 't mysterie begon: men zag in 't midden van de hoogste slagie God den Vader onder een' gouden troon zitten, tusschen de maegd Maria en Sint Jan Baptiste; langs weêrkanten waren zy door een koor engelen omringd, die genoegelyk zongen en speelden. God de Vader zat op een ivoren zetel, met de keizerlyke kroone op 't hoofd, eenen scepter in de hand" (Blommaert 1847, p. 21; trans. Kindermann 1959, p. 218. See also Helas 1999, p. 5).

22 Blommaert 1847, pp. 21–22. See also Kindermann 1959, p. 218.

23 "Voor het theater was eene schoone fonteine gesticht, die de bronne des levens verbeeldde en uit wier hoogsten appel drie gorgelen liepen met wyn" (Blommaert 1847, p. 22; trans. after Kindermann 1959, p. 218).

24 Frommel 1971; Rosen 2009.

25 Papet 2002, pp. 29, 33; Trempler 2013.

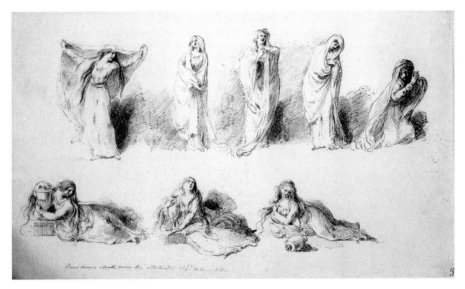

Fig. 49 Pietro Antonio Novelli, Lady Emma Hamilton's "attitudes", Pen and ink over pencil on paper, 1791, National Gallery of Art, Washington, D.C.

keen antiquarian and collector. In these she sought to imbue with life a continuous sequence of briefly held poses derived from the sculpture of Antiquity or the wall paintings of Pompeii (Fig. 49).[26] Here, art seemed so directly to assume life, and life to be so fully elevated into art, that Johann Wolfgang von Goethe was moved to report in rapturous tones on his encounter, in the spring of 1787, with this form of *tableau vivant*.[27] In the evening twilight, which Lord Hamilton knew how to use to best advantage,[28] Emma's poses achieved, in Goethe's opinion, an incomparably stronger visualisation of the sculpture of Antiquity and of the painted motifs found at Pompeii than works of art might have done: "Here one observes what so many thousands of artists would love to have accomplished. Here perfected in movement and astonishing in its variety".[29] For Goethe, this particular manifestation of the living image was so enthralling because it evinced the animation of that image in an ideal form, the impact of which, in the most direct sense of an embodied visual *schema*, was to prove far-reaching.

26 Rehberg and Piroli 1794, plate II, from Jooss 1999, Fig. 14. See also Miller 2002, pp. 201–20.

27 Goethe 1992, pp. 157–58. Fundamental on the vogue for such performances around 1800: Holmström 1967, and Jooss 1999.

28 "Der alte Ritter hält das Licht dazu" (Goethe 1992, p. 258).

29 "Man schaut, was so viele tausend Künstler gerne geleistet hätten, hier ganz fertig in Bewegung und überraschender Abwechslung" (Goethe 1992, p. 258).

The capacities of *tableaux vivants* of the second order ensured that, during the last quarter of the nineteenth century, living pictures were to evolve into one of the most popular forms of visual art. Highly successful publications such as Edmund Wallner's 1876 volume *Eintausend Sujets zu lebenden Bildern* [A Thousand Subjects for *Tableaux Vivants*], selected their models for potential enactment from popular works of art and from public monuments, and showed how these might be realised in living form.[30] *Tableaux vivants* were frequently staged, as an entertainment both popular and gently indoctrinating, at the May Day (1st May) celebrations encouraged by the Workers' Movement, at which they functioned as temporary monuments to goals yet to be realised. Here, too, well-known works of art would serve as models.[31]

Living images were to feature especially prominently in the art of the twentieth century, in the context of its positive mania for overcoming the dividing line between image and body. Man Ray, for example, had the idea of devising arrangements – for the purposes of photography – in which some of the missing body parts of torsos from Classical Antiquity were replaced by the corresponding parts of the bodies of real women (Fig. 50).[32] Here the process of embodiment was subsumed within the medium of the image: Man Ray's photographs, in themselves already possessed of a "skin" as silver gelatin prints, restored these composites of sculpture and living body to the sphere of images.

Between the end of the 1970s and the start of the 1990s the American artist Cindy Sherman pioneered living images of this sort – and one might well classify these as belonging to a third order – through herself re-enacting motifs from the history of art and the history of cinema, then recording the results in photographic form.[33] Sherman's intention to realise the image as a manifestly breathing body goes beyond bodily travesty to the animation of the work itself. Sherman's posed works recall the aforementioned practice of Man Ray: she uses her own body in order to relocate the principle of the living picture within the sphere of the image.

The video and performance artist Eleanor Antin has posed this question of status in a yet more exaggerated form. In taking Pompeii as the setting for the scenes she imagines, she has in mind a site that was of immense significance for the history of living images in the art of the nineteenth and twentieth centuries. Antin had typical situations from the eve of the catastrophic eruption of Vesuvius posed by actors; the scenes were then recorded as large-format colour photographs, which were in turn assembled into her series *The Last Days of Pompeii*. In *The Artist's Studio*,

30 Wagner 1993, pp. 94–95.

31 Wagner 1993, pp. 109–10. See also, on the nineteenth century: Reissberger 2002; Mungen 2006; on the twentieth century: Folie and Glasmeier 2002.

32 *Tableaux Vivants* 2002, p. 77.

33 For example, Untitled *224, 1990, colour photograph in *Tableaux Vivants* 2002, p. 162.

Fig. 50 Man Ray,
Untitled, Silver gelatin
print on paper, 1933.

for example (Fig. 51),[34] a sculptor is at work on a marble figure of a woman, who poses for him seated on a large wooden platform. The doubling of the living woman in the sculpted figure is here so perfectly staged that one can detect only slight differences: in the former the hair is very slightly more piled up at the back, and the cloth concealing the pubis has greater volume where it meets the floor.

Closer inspection, however, prompts one to ask whether the living model really is as alive as it at first seems to be, or is in fact a work of art that has been placed on the platform in order to be copied in marble by the sculptor. The gleam of light on the knees is suggestive of an artificial material such as acrylic. Uniting elements both surreal and exact, Antin uses the artwork of her photography to transfigure the principle of the living image into a perpetual puzzle for the viewer.

34 *Tableaux Vivants* 2002, p. 120.

Much the same might be said of certain attempts to reproduce works of art as *tableaux vivants* in the medium of moving pictures. In all probability, the most striking approach to this problem was that adopted by Pier Paolo Pasolini in his film *La Ricotta*, in which he sought to recreate Italian Mannerist paintings such as Rosso Fiorentino's 1521 *Deposition* altarpiece in Volterra (Fig. 52). A photograph of the film being shot shows Giuliano Briganti's book on Mannerism, in which this painting was reproduced (Fig. 53).[35] The project had to be abandoned, however, because an extra by the name of Stracca compromised the requisite immobility through his own inability to keep still. Only when he eventually took on the role of the crucified

Fig. 51 Eleanor Antin, *The Artist's Studio* from the series *The Last Days of Pompeii*, Colour photograph on cardboard support, 2001, Ronald Feldman Fine Arts, New York.

Fig. 52 Still from Pier Paolo Pasolini's 1963 film *La Ricotta*.

and dying thief did he meet the requirements of the living image.[36] Through this simulated death on the cross the living image shook off its illusory character. In the attempt to recreate a Mannerist painting, the imitational scope of the *tableau vivant* attains in film its most extreme form.[37]

Around three decades later, but effectively working in the same tradition, Bill Viola had Pontormo's *Visitation* of 1528–29 recreated by several figures in a variant of the living image. While a *tableau vivant* usually requires that the human body be immobilised into a sculpture of itself, in Viola's video-sound installation of 1995,

35 The book in question is Briganti 1961. It has not been possible to trace the source of this photograph.

36 Barck 2008, pp. 259–60.

37 See also the interpretations proposed in Horstmann 2007, p. 65, and in *Tableaux Vivants* 2002, pp. 104–05.

Fig. 53 Pier Paolo Pasolini in 1963 at work on his film *La Ricotta*, with two images in Giuliano Briganti's book of 1961, *La Maniera Italiana*.

Fig. 54 Still from Bill Viola's 1995 video-sound installation *The Greeting*.

Fig. 55 Still from Peter Greenaway's 1982 film *The Draughtsman's Contract*.

The Greeting (Fig. 54), female figures approach each other in extreme, oneiric deceleration. The transgression of life into art through the freezing of movement (as in Pasolini's project) here occurs in the form of movements that come close to the stillness of a *tableau vivant* through a reduction in their natural speed.[38]

Both Jean-Luc Godard's *Passion* of 1982 and Derek Jarman's *Caravaggio* of 1986 (this last implicitly accepting the assumption that the artist based his painted compositions on living images)[39] are further variants on the attempt to activate the principle of the *tableau vivant* in the medium of cinema.[40] The same is true of Peter Greenaway's 1982 film *The Draughtsman's Contract*, in which immobile, naked figures repeatedly appear. Mistaken as works of art by the opulently dressed principal characters, they are able to function as secret witnesses (Fig. 55).[41]

This principle has also been implemented in the staging of opera. Sasha Waltz's choreographic contribution to the 2007 Berlin production (at the Staatsoper Unter den Linden) of Pascal Dusapin's 1991 opera *Medeamaterial*, with libretto by Heiner Müller, opens with the appearance of a gigantic frieze, its seemingly life-size figures being projected on to the back wall of the set.[42] As if made out of a dull,

38 *Bill Viola* 1997, pp. 62–63.
39 Frommel 1971.
40 Krüger 1990.
41 Schuster 1998.
42 *Medea* 2007. See also Sasha Waltz 2008, p. 81.

Fig. 56 Sasha Waltz, *Tableau vivant* at the opening of Pascal Dusapin's 1991 opera *Medea-material*, in the 2007 production at the Staatsoper Unter den Linden, Berlin.

leaden metal or an unpolished marble, these mud-smeared creatures posed or moved so as to evoke fundamental modes of human behaviour and feeling: a brawl, a gathering, a small family group, yet another quarrel (Fig. 56).

This opening sequence was inspired by the myth of origin to be found in Ovid's *Metamorphoses*, according to which humankind had evolved out of stones thrown by the single surviving man and woman into the mud left behind by a universal deluge:

> Then, when they had grown in size and become milder in their nature, a certain likeness to the human form, indeed, could be seen, still not very clear, but such as statues just begun out of marble have, not sharply defined, and very like roughly blocked-out images [...] And in a short time, through the operation of the divine will, the stones thrown by the man's hand took on the form of men, and women were made from the stones the woman threw.[43]

43 "mox ubi ereverunt naturaque mitior illis / contingit, ut quaedam, si non manifesta videri / forma potest hominis, sed uti de marmore coepta / non exacta satis rudibusque simillima signis / [...] inque brevu spatio superorem numine saxu / missa viri minibus faciem traxere viroram / et de femineo reparata est femine iactu" (Ovid 1977, I, 403–06, 411–13; I, 393–413 for the episode in its entirety).

In Florence, Ovid's account of the universal deluge was associated with the notion that, after the flood waters had subsided, Tuscany had been the first region on earth to become civilised. This city on the Arno could count not only as the cradle of post-diluvial humanity, but also as the region in which the capacity to imbue stones with life was first understood as the primordial form of art. Florence was thereby identified as the city of living art.[44] In the grottoes of its Boboli Gardens, created by Bernardo Buontalenti between 1583 and 1593, this vision took on real form. Their walls were covered in a dense mud, within which there crystallised the schematic figures of men, women and goats. Michelangelo's two herculean *Prisoners*, incorporated into the walls in 1585, are to be observed as if struggling to squirm out of this subterranean mire: a motto for Florentine self-regard (Fig. 57).[45]

In the endeavour to imagine exemplary situations of human interplay and antagonism, Sasha Waltz adopted, through her frieze, the notion that, out of the immobility of an enveloping layer of mud, new life can arise that is, in itself, the very symbol of the image act. The mere sight of the initially immobile frieze aroused a palpable sense of anticipation in the audience. Almost as soon as one of the figures in what still appeared to be a cast relief made a first, all but imperceptible shift or gesture, and then increasingly, as more and more of them engaged in slow, repeated movements, those watching were apparently seized by an urge to reciprocate, as if all were part of a single, spasmodically writhing body. On stage, as a gigantic living image transgressing the boundaries between sculpture, *tableau vivant* and slow-motion ballet, the figural group, passing by imperceptible degrees from immobility to movement, thus enacted theemergence into life of a seemingly sculpted frieze as the inner principle of creation out of the image act.

An extended variant lies in the superimposition of the space of the image and that of the spectator. The technique, dating back to the era of the wall paintings of Pompeii, not of inserting the painted body into a composition, but of merging the space of the active image with that of the spectator in such a way that the latter, as a living element, is effectively immersed in the work, was to create, on a much larger scale, a real experience of space. Visiting panoramas in the nineteenth century, viewers would feel themselves projected into the landscape settings they encountered.[46] However, the immersive techniques associated with the illusory digital three-dimensionality of contemporary cyberspace, with its simulated bodies in perpetual motion in the most extreme form of spatial dissolution, have finally led the way out of the realm of the living image.[47]

44 Heikamp 1965.
45 Bredekamp 1988.
46 Fundamental on this matter: Burda-Stengel 2001; Grau 2001.
47 Burda-Stengel 2001; Grau 2001.

Fig. 57 Bernardo Buontalenti, First chamber of the Boboli Grottoes,
1583–93, with Michelangelo's *Prisoners,* Boboli Gardens, Florence.

Diametrically opposed to this principle is the phenomenon of self-stylisation,
through which artists become living images of themselves. Outstanding among the
protagonists in this development are Gilbert and George, who since the late 1960s,
as a London-based artist duo, have revolutionised the genre (Fig. 58).[48] Defining
themselves as "living sculptures", they have rendered obsolete the question as to the
animation of the work in granting it a permanent affirmation. Through their per-
petually shifting positions, they attest to the fact that persons may represent sculp-
tures and, as a consequence, that images do indeed live. Gilbert and George *are* the

48 Jahn 1989, p. 89.

Fig. 58 Gilbert and George, *The Singing Sculpture,* Bodies,
clothing, accessories, metallic paint, 1970, Nigel
Greenwood Gallery, London.

work as a living image, and they thereby imitate themselves in real time, and in
such a way that all differentiation between image, imitation and life disappears.
And in this they are real symbols of the schematic image act. In their case the
exemplary value lies in the fact that the removal of the border between life and art
itself becomes the content of the message. Through these forms of self-display, the
schematic image act is folded back upon itself so as to make possible an exemplary
merging of art and life.

All of these forms of the *tableau vivant* are variants on the attempt to over-
come the distance between artefact and human body by means of deploying human
beings as bearers of an image. The power of living images lies in the fact that they
enable each spectator to encounter in them a pictorial counterpart to the self. This,
however, touches upon a deeper problem: that, within the work, there is an auton-
omous *energeia* that comes near to the life force with which humanity is itself
endowed. The union of image and body is intended to trigger the schematic acti-
vation of the observer. A process of intuitive identification permits a privileged
intellectual and emotional engagement with both the form and the implications of

the presented poses. This was indeed the intended purpose of the Platonic *schema*, within the tradition of which living images persist to this day.

C. EMPATHY: ITS MEANINGS AND ITS OPPONENTS

It may reasonably be assumed that no philosophical development has allowed itself to be more strongly inspired by living images than that Theory of Empathy evolved in Germany in the late nineteenth century by Friedrich Theodor Vischer, his son Robert Vischer, and the latter's contemporary Theodor Lipps, with the aim of insisting that the same intensity of emotional response be brought to lifeless material as to living persons. In either case the stance recommended was the outcome of the aesthetic tendency to see the artefact not as lifeless matter, but as an entity capable of both receiving and responding to the feelings of a living individual.[49]

This concept has experienced a boom in popularity thanks to Cognitive Theory and the discovery of so-called mirror neurons.[50] On account of this success, it has risked being reduced to little more than a mechanistically applied model for satisfactory social relations; and it has, for this reason, been countered by the notion of "narrative empathy". This defines empathy as a product of the harmony that can emerge, in a procedural fashion, out of an initial conflict. With its emphasis on an individual's empathy for a counterpart, it ensures the exclusion of a third party. Understood in this fashion, empathy is a complex process for the resolution of conflict.[51]

This more recent critique of the aesthetic concept of empathy had a predecessor that was no less intellectually astute in the form of the art-historical doctoral dissertation that Wilhelm Worringer submitted in Bern in 1907, and first published, as *Abstraktion und Einfühlung* [Abstraction and Empathy], in Munich in 1908.[52] In empathy Worringer does not, for example, see an individual's regard for and acceptance of a counterpart, but rather the latter's replacement by that individual's imperiously projecting self. Empathy, according to Worringer, shifts the focus of attention from the form of the work to the "stance of the observing subject",[53] a stance expressing itself as the "objectified self-enjoyment" of aesthetic perception: "To enjoy in aesthetic terms means to enjoy myself in one of those sensorially perceptible objects that are distinct from me, to project myself into it".[54]

49 Fundamental on this issue: Koss 2006.
50 Rizzolatti and Sinigaglia 2008.
51 Breithaupt 2009.
52 Comprehensive on Worringer: Böhringer 2004.
53 "das Verhalten des betrachtenden Subjekts" (Worringer 1919, p. 2).
54 "Ästhetisch geniessen heisst mich selbst in einem von mir verschiedenen sinnlichen Gegenstand geniessen, mich in ihn einzufühlen" (Worringer 1919, p. 4).

Understood in this way, empathy has something narcissistic about it: unwilling to perceive the form of the art work as something external, and antagonistic to, the self, modernist aesthetics had assimilated the work of art to the self. The act of empathy thus effectively substitutes for the work of art the varieties of an experience of it.

In Worringer's view, modernist aesthetics, on account of its structural egomania, was inappropriate for application to a great many aspects of the visual arts. In varieties of the abstraction invoked in his title, however, precisely on account of its ostensible opposition to life and emotion, there lay a true subject for the history of art.[55] For, by contrast with a diffuse form of empathy, which supplies a projection screen for the emotionally exhausted ego, the anorganic, the life-threatening and the abstract offer, in eschewing figuration, the more powerful challenge:

> [The] recollection of the dead form of a pyramid [...] tells us at once that here the desire for empathy (which, for obvious reasons, tends always to favour the organic) cannot possibly have determined the will to art. We are, indeed, prompted to the thought that there must be an urge that is directly opposed to the urge to empathy, and that seeks directly to suppress that wherein which the desire for empathy finds its own satisfaction.[56]

Worringer argued that non-representational abstraction was the primordial urge of an art that itself derived from a nameless universal fear. Ejected from the sheltering jungle into the open savannah, humanity was confronted with an endless number of visible dangers. Tactile perception and interaction ceded, accordingly, to the visual weapons of scrutiny and optical resistance. Man's horizon – subjected to an unprecedentedly sudden expansion – had to be visually tamed and restrained. Abstraction was, then, the apotropaic reaction of the primordial artist to a threatening environment.

When first published, at what was to prove a crucial, "incubatory" phase of the early-twentieth-century avant-garde, Worringer's argument in implicit support

55 Koss 2006, pp. 145–51; Koss 2010, pp. 83–94; and Mainberger 2010, pp. 293–312.

56 "[Die] Erinnerung an die tote Form einer Pyramide [...] sagt uns ohne weiteres, dass hier das Einfühlungsbedürfnis, das aus naheliegenden Gründen immer dem Organischen zuneigt, unmöglich das Kunstwollen bestimmt haben kann. Ja, es drängt sich uns der Gedanke auf, dass hier ein Trieb vorliegt, der dem Einfühlungstrieb direkt entgegengesetzt ist und der das, worin das Einfühlungsbedürfnis seine Befriedigung findet, gerade zu unterdrücken sucht" (Worringer 1919, p. 18). According to Worringer, the urge to abstraction ["Abstraktionsdrang"] finds its beauty in "the life-denying anorganic, in the crystalline or, generally speaking, in all abstract regularity and necessity" ["im lebensverneinenden Anorganischen, im Kristallinischen oder allgemein gesprochen in aller abstrakten Gesetzmässigkeit und Notwendigkeit"] (Worringer 1919, p. 4).

Fig. 59 Vanessa Beecroft, *Performance VB 45*, 47 models, Kunsthalle Wien, Vienna,
16 February 2001.

of artistic abstraction had a tremendous impact. At the distance of just over a cen-
tury, its air of world-historical pathos is off-putting; but, as a critique of the modern
concept of individuality and as an art-historical objection to the principle of
empathy, it has retained its relevance. In as far as Worringer understood the prin-
ciple of abstraction not as an emptying out of form, but as an instance of the over-
coming of fear (to set against the empathetic emotional kitsch of the notion of the
cold resilience of the unapproachable counterpart), he uttered, to all intents and
purposes, a catchword for every form of minimal art.

　　Following in this tradition the Italian artist Vanessa Beecroft has developed
since the early 1990s, a critique of empathy that employs a particular form of the
tableau vivant. Her collective living images take aim, above all, at intuitive empathy.
Because her large blocks of female bodies, resembling massed sculpted figures,
often stand still for hours on end in order to enact the transformation of organic
being into inorganic form, they bring an incisive radicality to denying any spec-
tator's attempt at an empathetic response (Fig. 59).[57] Beecroft's hybridising of the
nominally empathic quality of the living image and the crystalline abstraction of
minimalism is informed by insistently contradictory motives: a desire to attract the
viewer through the living form of the work, and a determination to disappoint the

57　　Beecroft 2003 and Hickey 2003. See also Tacke 2006, pp. 79–84 and the illuminating histo-
　　ricisation undertaken by Zapperi 2009, pp. 30–33.

Fig. 60 Charles-Nicholas Cochin, *La charmante catin*, Engraving on paper, 1731, Bibliothèque nationale de France, Paris.

viewer, in a manner both cold and domineering, from the distanced sphere of the artefact. In this respect, Vanessa Beecroft achieves a pointed reflection of the schematic image act.[58]

2. THE VITALITY OF MECHANISED MOVEMENT

A. LIFE DEFINED AS A WOUND SPRING

While living beings are involved in the creation of a *tableau vivant*, that of an automaton turns an artefact into an animated counterpart. The history of attempts to create automata – machines, in plant, animal or human form, capable of conveying the illusion of autonomous movement in at least some of their parts – dates back to the diminutive artificial creatures devised in Ancient Egypt and continues to this

58 One might well ask if Michael Fried would persist in his brilliant critique of minimal art – which asserts that this would stake its claim to distance from humanity only in a theatrical fashion, but then in fact achieve the opposite (Fried 1967) – even with regard to Beecroft's living images. For it is evident that she engages in such an aggressive form of theatricality in order, in effect, to undermine this.

Fig. 61 Still from Richard T. Heffron's
1976 film *Futureworld*.

day in the visions of androids and avatars to be found in numerous films.[59] Automata used in games, in religious ceremonies and in the theatre have always been more highly regarded than mere robots because, unlike the latter, they are not subordinate to productive ends.

In so far as automata represent active counterparts, they intensify the differentiation between a living entity and an action from which the idea of the image act derives. The autonomy of automata invests them, indeed, with something unapproachable, which may be understood as the token of a counter-world. As a result, they may set off a complex tangle of emotions, as captured in all its facets by Charles-Nicolas Cochin in the 1731 engraving *La charmante catin* (Fig. 60). This shows the appearance of a small automaton at a soirée in polite society, with onlookers exhibiting a full range of emotions and corresponding movements, from interested enjoyment, by way of an adoring reverence, to shocked recoil.[60] Through disguising its own artifice, the automaton provokes a mood of suspicion. The primordial human fear of not being able to ascertain whether a counterpart is an artefact or a

59 From the extensive literature on this subject, the following in particular should be noted: Chapuis and Droz 1959; Heckmann 1982; Beyer 1983; *Die Geschöpfe des Prometheus* 1994; Tripps 1998; Nelson 2001; Karafyllis 2004; and Marr 2004.

60 Bredekamp 2003 *Antikensehnsucht*, pp. 12–13.

creature of flesh and blood is similarly acknowledged in the removal of the face-mask in the firm *Futureworld* (Fig. 61). [61]

A mid-sixteenth-century automaton in the form of a male figure elucidates, in inimitable fashion, this ambiguous sensation. Although this is well under life-size, with a height of only 39 centimetres, it would easily have overcome this limitation on account of the vigorous fluidity of its movements (Fig. 62). Its mechanism comprises a larger sequence of interlocking wheels, a braced metal rod, and a head containing a smaller version of the same (Fig. 63).[62] Originally clothed, it was able, once activated, to move without any further external assistance within an area of 60 square centimetres, making repeated 90 degree turns.

It is astonishing, and instructive, to discover how much human energy is in fact expended in winding up the automaton's spring (Fig. 62). One is immediately reminded of a text in which Leonardo da Vinci defines energy, *forza*, as the principle of the life of an automaton:

> An intellectual capacity, an invisible, immaterial power, that, by means of outer coercion produced through movement, is imparted to the body, which is thus brought out of its natural state of rest.[63]

61 *Künstliche Menschen* 2000, p. 193.
62 The head, body and mechanical parts are original, though it appears that the head was at some point repainted.
63 "Forza dico essere una virtù spirituale, una potenza invisibile, la quale per accidentale esterna violenza è causata dal moto e collocata e infusa ne' corpi, i quali sono dal loro naturale

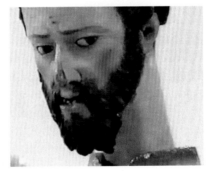

Figs. 62–65 Stills from video of c. 1978 showing a mid-16th century iron and wood automaton in the collection of the Deutsches Museum, Munich. Previous page: Curator Peter Friess winding the automaton's spring. Above: x-ray image of automaton's head. Upper right: Automaton's face. Right: Automaton's face with moving eyes and lips.

This "gives to this body an active life, a wondrous power, and compels all created things to alter their shape and location".[64]

Leonardo is here apparently thinking of the body as a clockwork mechanism, in which an invisible spring is wound up upon an individual's birth, and that, albeit invisible, thereafter unwinds in the manner of a mechanical clock.[65] Also in accord with the model of the wound and then unwinding spring is Leonardo's remark that a handicap is inherent to the mechanism, for "slowness makes it strong and speed

uso retratti e piegati" (Leonardo 1930–36, Vol. 2, 1936, p. 65, fol. 34v). On the translation, see also Dijksterhuis 1969, pp. 257–59.

64 "dando a quelli vita activa di miravigliosa potenzia; costrignie tutte le create cose a muta-zione di forma e di sito" (Leonardo 1930–36, Vol. 2, 1936, p. 65, fol. 34v).

65 These were familiar items from the mid-fifteenth century (Mayr 1987, pp. 23–26).

[makes it] weak".[66] The statement, furthermore, that "it [i.e. energy] is created through coercion, and dies through freedom"[67] can be seen to relate to the coercion in the winding up and the freedom in the winding down of a spring. The larger the spring, the faster will it unwind; the greater the energy, the more rapidly will it run out.[68]Leonardo is evidently here evoking, in stylised form, the movement of an unwinding spring as a model of life; and the end of all forms of human motion – the assertion of a vital superiority through overcoming every inner and outer handicap – is the repose to be found in death.[69] In this vivid characterisation of a complex technical process, we both see and feel the opposing forces that are here at work. No-one who has ever peered into the inner workings of an old clock will be able to escape the suggestive power of Leonardo's metaphor.

This is true to a particular degree of the Munich automaton, the elasticity of whose movements counters the impression of any element of programming. As it walks it moves its feet, each of which, in the time it takes for the spring to unwind, can be raised and then – always with a sharp click – again set down, eight times. The right hand, meanwhile, can move 40 and a half times, but the left only 22 and a half times, thereby creating the impression of unsynchronised vitality. In addition, the left arm can be raised and lowered, and even the head moved up and down and from side to side (Fig. 64), while the eyes dart almost perpetually back and forth and the mouth opens and closes (Fig. 65). The shifting glance and moving lips create an especially compelling illusion of the irrepressible nervous "rustle" of real life.[70]

It has so far not been possible to establish with any certainty the origin and intended purpose of this figure, which probably dates from the 1550s, although everything points to the likelihood that it was made for the Holy Roman Emperor Charles V, who had a particular penchant for automata. It is possible that it was made by the Emperor's engineer, Juanello Turriano, of whom a contemporary report claims: "Juanello also desired, for the enjoyment of all, to revive the technique of

66 "Tardità la fa grande, e presteza la fa debole" (Leonardo 1920–36, Vol. 2, 1936, p. 65, fol. 34v).

67 "nascie per violenza e more per libertà" (Leonardo 1930–36, Vol. 2, 1936, p. 65, fol. 34v).

68 "E quanto è magiore, più presto si consuma" (Leonardo 1930–36, Vol. 2, 1936, p. 65, fol. 34v). The apparently absurd claim in the next sentence, that it "chases away everything that opposes its annihilation" ["Scaccia con furia cio che ssi opone a ssua disfazione"] is explained in the light of the model of a spring, also in the sense that the spring comes eventually to rest through the forcible discharge of its own tension and the overcoming of its inherent handicap; in this sense it can be said to drive away that which opposes its own destruction (p. 65, fol. 34v). "It strives to triumph over and to kill its principal cause, which opposes it, and, in achieving this victory, it expires" ["desidera vincere, occidere la sua cagione, il suo contrasto, e viciendo, se stessa occide"].

69 Bredekamp 1999 Überlegungen, pp. 94–96.

70 On the issue of mechanics in general: Friess 1988.

creating statues of the sort that moved and that the Greeks therefore termed auto-mata".[71] It is possible that the Munich figure, together with its "family", formed part of the elaborate funeral that Charles V staged at the Spanish monastery of Yuste in 1558. This ceremony was nominally in honour of his father and his grandparents; but it was secretly intended as a rehearsal for his own obsequies. Comparison may here be drawn between the Munich automaton and Claus Sluter's sculptures for the tomb of Phlippe le Hardi (Philip the Bold) at the Chartreuse de Champnol in Dijon (also discussed in chapter 5), where Charles V had initially wished to be interred. A connection is suggested not only through the processional arrangement of those figures, but also on account of their almost identical size.[72]

The Munich automaton is an outstanding example of that which an independently moving object may be capable. While the *tableau vivant* stages an instance of the schematic image act through constructing a static entity out of exemplarily posed human bodies, the automaton meets the requirement of animation through artificially induced motion evoking the impression of real vitality. In this, it qualifies as a true instance of the corporeal *schema*.

B. AUTOMATA AND SPEECH

It has been proposed that automata be treated as if they were "individuals" in the legal sense: with responsibility for themselves and their own actions.[73] Recognition of this sort is understandable in as far as there have always been attempts to devise automata that could simulate speech. As revealed by the capacity of the Munich automaton to open and close its lips, this was distinct from the *tableau vivant* not only through its apparent capacity for independent movement, but also through its hint at the possibility that sounds might be emitted. In this respect the Munich figure belongs to a tradition that goes back to Antiquity.[74]

71 "Tambien ha querido Janelo por regozijo renouar las estatuas antiguas qu' se mouian, y por esso las Liamauan los Griegos Automatas" (Morales 1575, p. 341).

72 Friess and Steiner 2003, pp. 237–39. The figures in Dijon are mourners, each distinguished through his expressive gestures and, as a group of *pleurants*, presenting grief in all its varieties (Morand 1991). The Munich figure has been linked with examples now in the Iparművészeti Múzeum, Budapest; the Bayerisches Nationalmuseum in Munich; the Conservatoire National des Arts et Métiers in Paris; the Smithsonian Institute in Washington, D.C. and, recently, in private collections, some of which resemble it in detail (Friess and Steiner 2003, p. 234). On the most recently published example: *La misura del tempo* 2005, p. 453, cat. no. 148. See also Marr 2004, and Jacobs 2005, pp. 192–98.

73 Matthias 2008.

74 On Antiquity: Kris and Kurz 1934, pp. 73–76; Chapuis and Droz 1959, pp. 15–24; Hesberg 1987; Amedick 2003. There were numerous accounts of Egyptian statues capable of motion, as found in the *Automata* of Hero (Heron) of Alexandria, published in an Italian translation

From René Descartes's differentiation between the "automotive" character of the human body and the rationality of human language[75] to Alan Turing's "language test" as to whether a machine might be granted humanoid status,[76] the capacity to utter and respond to rational speech has been regarded as the essential definition of what it is to be human. In contrast to Descartes, however, Thomas Hobbes (with reference to a text of Late Antiquity, the *Asclepius*) believed that automata might be capable of rational speech, albeit without claiming that this would compromise the superior status of humanity.[77] Nor did later thought and writing on automata touch on implications for humanity's relative status. It was, rather, focused on how far the capacities of automata might be extended. And this encouraged further experimentation in ways to realise that element of vitality implicit in their autonomy.

A glance inside an automaton of the 1770s, one of a pair from the Swiss workshop of Pierre Jaquet-Droz (Fig. 66), which can dip its quill pen into an inkpot and write with it (Fig. 67), leaves little doubt as to the Cartesian irony of one of the statements that it is able in this fashion to produce: *"Cogito ergo sum"*.[78] Another of its messages reads: *"Wir sind die Androiden Jaquet Droz"* [We are the Jaquet-Droz androids] (Fig. 68). Here one is again surprised at the use (in Latin) of the first person singular and then (in German) of the first person plural. This enables the writer to suggest that it is possessed of intellectual awareness and can thus view itself objectively in order to define its own distinguishing quality. The fact that the second statement is also effectively signed presents yet another example of the "divided self" that Jan van Eyck affirmed through the signatures on his frames.

(from the Greek) in 1589; and the "resounding" Colossi of Memnon, standing on the western bank of the Nile opposite Luxor and originally erected in the fourteenth century BC as part of the vast Theban mausoleum of Amenhotep III, were never entirely lost to tradition (Franke 2003, pp. 249–50; *Wunder und Wissenschaft* 2008). There were also reports from Antiquity, and, especially, from Byzantium, of artificial animal enclosures with silver trees occupied by birds capable of moving and twittering (Canavas 2003). On the Mediaeval era: Hammerstein 1986; Tripps 1998, p. 50 (speaking angels with *ME FECIT* inscriptions); Camille 1989, pp. 245–58; *Automaten* 2003. On the griffin on the roof of the Cathedral of Pisa: Müller-Wiener 2007, pp. 153–55.

75 Of what it would, and would not, be reasonable to envisage, Descartes writes: "[...] mais non pas qu'elle les arrange diversement, pour répondre au sens de tout ce qui se dira en sa présence, ainsi que les hommes les plus hébétés peuvent faire" [... but not that it (i.e. a machine) arrange words differently (i.e. with rational discernment) in order to respond to the sense of all that which will be said in its presence, as even the dullest men can do] (Descartes, *Discours*, V, 10, 56–57).

76 Turing 1950.

77 *Hermès Trismégiste* 1980, Vol. II, *Asclépios*, viii, 23, pp. 325, line 4–326, line 15. Hobbes's model of the modern state as a living automaton endowed with reason, the Leviathan, is derived from the statue discussed in this text (Bredekamp 2006 *Hobbes*, pp. 58–60, 65–70).

78 Chapuis and Droz, undated.

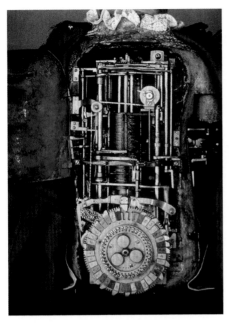

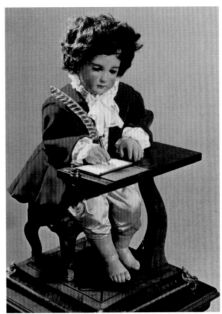

Fig. 66 Pierre Jaquet-Droz, View of the internal mechanism of the "writer automaton" of 1774 seen in Fig. 67.

Fig. 67 Pierre Jaquet-Droz, So-called "writer automaton", 1774, Musée d'art et d'histoire, Neuchâtel.

Fig. 68 Pierre Jaquet-Droz, Sample of writing produced by the "writer automaton" of 1774 seen in Fig. 67: "*Wir sind die Androiden Jaquet-Droz*" [We are the Jaquet-Droz androids], Musée d'art et d'histoire, Neuchâtel.

Fig. 69 Pierre Jaquet-Droz, Drawing of a dog produced (in 2007) by the "draughtsman automaton" (similar to that seen in Fig. 67), inscribed "mon toutou" [my bow-wow], Musée d'art et d'histoire, Neuchâtel.

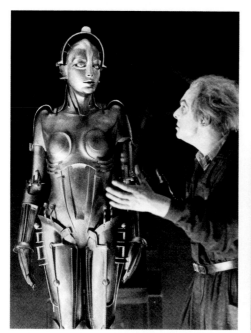

Fig. 70 On the set of Fritz Lang's 1927 film
Metropolis: the inventor Rotwang (Rudolf Klein-
Rogge) with the automaton Maria, Photograph.

Fig. 71 Still from Fritz Lang's 1927 film
Metropolis: dance of the animated automa-
ton Maria (Brigitte Helm).

The use of the first person plural implicitly incorporates the second automa-
ton (one may perhaps identify the two as brothers), which is able to draw. In being
able to wield a pencil both more and less forcefully, this automaton can produce
subtly graduated shading, the resulting drawings – that, for example, of a dog (Fig. 69)
– being true showpieces. By this means, however, the tension between an individual
and an image is extended into that between an artefact and an image. This is made
clear through the childlike inscription "mon toutou" [my bow-wow], in which this
second automaton, like the first, employs the first person singular. In alluding to the
dog it has drawn as its own possession, the automaton is revealed as aware of itself.
Speech in the first person singular and seemingly productive movement here recip-
rocally reinforce a sense of the automaton as an animated entity.

In the accomplished interplay of film, mechanised art and kinetics the twen-
tieth century came close to the refinements attained by the automata of the six-
teenth and the eighteenth centuries. The calculatingly frenzied dance performed by
the seductive automaton in Fritz Lang's *Metropolis* (Figs. 70, 71) made cinematic his-
tory. For here the figure's artificiality is so cleverly concealed as to greatly intensify
the attraction of this mysteriously alive non-human form. The automaton's hips,
which seem to move almost independently of the rest of the figure, thrust and

Fig. 72 Still from Fritz Lang's 1927 film *Metropolis*: the eyes of those entranced by the dancing automaton Maria.

writhe with a breathtakingly blatant sexuality.[79] Overwhelmed, the male spectators at first recoil, only to be once again so magnetically drawn to the sight that their eyes are, in effect, torn out of their heads (Fig. 72). Like mascots of the schematic image act, these eyes are controlled by the motions of an automaton (the epitome of the animated artefact), which here holds sway over their owners, body and soul.

Beyond cinema, the animation of automata has become a model for the active interpenetration of image and spectator in the realm of interactive art.[80] Stephan von Huene, with his kinetic and sound sculpture of 1988–93, *Dancing on Tables* (Fig. 73), achieved what may fairly be described as an optimum merging of the classical art of the automaton, an element of quotidian reality, the presence of mass media and the interactivity facilitated through electronics. Each of three of the four "dancers", all of whom stand on pedestals, comprises the lower half of an elegantly dressed shop-window mannequin; the fourth is a corresponding naked half-figure. Affixed to a wall behind these are large-format drawings of trousers resembling in

79 This motif permeates the history of automata (Prignitz 2004). On the dancing of the automaton Maria: Fritz Lang's *Metropolis* 2010, pp. 290–99. See also Huyssen 2000.

80 Fundamental on this subject: Dinkla 1997.

Fig. 73 Stephan von Huene, *Dancing on Tables,* Four half-figures on wooden pedestals, and nine (originally fifteen) framed drawings, metal, fibreglass, trousers, shoes, lighting, computerised mechanism, 1988–93, Mediamuseum, ZKM, Karlsruhe.

style and cut those here being "modelled" by the clothed half-figures. These drawings are based on the illustrations found in fashion magazines from the 1920s to the 1950s, in which the models were usually shown as mere lower bodies; this convention served the artist as a "ready-made" *schema*. Electronically programmed to alter their poses every three minutes, the automata enact their own animation, but in so restrained a manner that, with each slightest twitch, one cannot but become aware of their inherent *potentia*.

When the spectator's own movement inadvertently triggers a light impulse, which in turn sets all four half-figures into much more vigorous motion, this individual becomes an effective participant in what follows: each half-figure performs an energetic dance, clicking its toes and heels, turning out its feet, raising, thrusting, retracting, then spreading its thighs and calves and jutting its hips. This is, moreover, accompanied by the illusion of quasi-synchronicity between movement and the human voice in the form of excerpts from a recording of *Great Speeches of the Twentieth Century*. The clicking of the shod toes and heels in fact occurs a second ahead of each of the more striking sounds in the recorded excerpts – the words of American politicians such as Dwight D. Eisenhower and Jesse Jackson – in order to

compensate for the slight difference in the speed with which physical movement and the immaterial act of speech are absorbed by the mind. And, while the three clothed half-figures seem to move in time with the spoken word, their unclothed companion himself dances to recordings of Georges Bizet's *Pearl Fishers* and of Georg Friedrich Händel's *Rodrigo*. In each case, the recordings – of speech and of music – are soon perceived by the spectator as establishing a rhythm that is followed by the movement.

Having activated this sequence, the spectator is implicitly incorporated into it in all its aspects: movement, speech and music. And thus the dancing half-figures, set into motion by those observing, but in turn exerting an impact upon these, bring to the original concept of the *schema* a new validity. As true *schemata*, their impact is exemplary, albeit initially bypassing intellectual appreciation of this influence. Through their own movement they provoke in the spectators a spontaneous desire for reciprocity and so incorporate these into a subtle choreography, which in turn may prompt its human participants to ponder on this new form of human-automative interaction.[81] Stephan von Huene's *Dancing on Tables* is the modern pendant to the sculpture of Arbinas.

C. TRANSHUMAN DANCE FORMS

In embracing drawings from the world of fashion, Stephan von Huene's ensemble expressly touches on that sphere of exemplary images of the sort that one encounters in everyday life. Equally, if diversely, familiar are instances of that interface between performance art and popular culture that repeatedly returns one to the fundamental problem of the image: the fact that it is anorganic and yet is at the same time animated.[82] No performer has so fully realised the forms of the schematic image act as has the singer and dancer Michael Jackson.

On 1st October 1992, at the National Stadium in Bucharest, Jackson gave one of the outstanding performances of his life.[83] At the start he was almost catapulted, like a *deus ex machina*, on to the stage, where he then immediately assumed the immobility of a statue (Fig. 74). This transformation of an emphatically mobile

81 For more on this, see Bredekamp 1995 *Theater*.

82 For several decades the group Kraftwerk has retained a unique status because, immobilised into unapproachable living images with their own limited range of movements, its members initially appear as if about to perform music both by and for automata. As is, however, soon apparent, the allure lies in their combination of a mechanical frigidity and true romance, the impression that they are automata and yet are at the same time able to bring forth an utterly beguiling music. This effect is enhanced through the use of artificial doubles (Flür 2004, pp. 146–58). On performance art: Engelbach 2001.

83 On Jackson's appearance in Bucharest: Seibold 1992, pp. 68–71.

Fig. 74 Five stills from film of Michael Jackson's "Dangerous World Tour" concert at the National Stadium in Bucharest, 1 October 1992.

entity into the frozen form of a participant in a *tableau vivant* had something so extreme about it as to appear miraculous, an impression only amplified by the bewilderingly extended fixedness of the pose. In his very stillness, Jackson effectively dissolved the boundary between artefact and organism, deriving a magnetic presence out of his proximity to a living image. The longer he was able – seemingly

without movement and without breathing – to remain standing exactly where he was on the stage, the more urgently he posed the question as to whether he was in fact alive or was merely simulating life.

It was all the more abruptly, then, that he reverted to motion. Yanking his head to one side, a move that itself provoked in the audience an outburst of frenzy, he slowly removed his sunglasses, thus revealing his eyes in a virtually ritualistic fashion.[84] Then came the dance, in which the initial immobility, the sudden movement of the head and the time-loop quality of the removal of the sunglasses were re-expressed through the entire body. But, just as the gesture with the sunglasses itself seemed to belong within a routine that was as slow as it was precise, so too did the dancing figure remain halfway between living being and machine. The dance steps of Jackson's famous "Moonwalk", both jerkily mechanical and smoothly alive – with the dancer seeming to move simultaneously forwards and backwards – presented him in a transitional state, between android and human.[85] Alongside the elastic body of the android who resembled a human being, there appeared a human being who seemed to imitate an android.[86] The by now almost obligatory obscenity of Jackson's clutching at his genitals might in itself be viewed as an echo from the erotic dimension of automata, as evinced by the numerous copulating clocks from the eighteenth century.[87]

A great many narratives in science fiction, as outcomes of human struggles with overpowering androids, address the human fear of living images that present humanity with an unexpected mirror image and constrain it through their own, alien will. Automata like those of Jaquet-Droz, may be understood as attempts to make this fear manageable. They "play" with a natural human terror, but they may also heighten it. As a summation of the diverse forms of the schematic image act, Jackson in Bucharest in 1992 enacted the intersection of *tableau vivant* and android.[88]

84 This gesture alluded to the events of 18th February 1984, when Jackson won eight Grammy Awards, seven of which he had gone up to accept with his sunglasses in place. The actress Katharine Hepburn, who had befriended Jackson, had in the past urged him to remove them so that his fans could see his eyes. In collecting his eighth Award Jackson removed his sunglasses as a special favour to her (Jackson 1988, pp. 191–92; Taraborrelli 2003, p. 294). One may assume that very few of the Bucharest audience in 1992 would have understood this communication through the body for what it was.

85 Jackson 1988, pp. 178–83.

86 See also the account of Jackson's styles of dancing in the untitled article by Sophie Richy, in *Black and White*, VI, pp. 12–13.

87 Prignitz 2004.

88 See also, in greater detail: Bredekamp 2008 *Michael Jackson*. The posthumously released film of the rehearsals for the planned tour "This Is It", which was cancelled following Jackson's death in June 2009, reactivated all these dance moves, distributing them between two poles: on one hand, a simulated crowd of over 1000 soldier-automata, and on the other Jackson's

3. LIMINAL BODIES: FROM BEAUTY TO BIOFACT

A. PRAXITELES, PYGMALION, MOZART

THE *APHRODITE* OF PRAXITELES

A third variant of the schematic image act is to be found in the animation of sculptural figures that have a particular association with the erotic. One of the most notorious examples is the Aphrodite of Cnidos made by Praxiteles between 350 and 340 BC, which is now known through a number of Roman copies, among them the version now in the Musei Vaticani (Fig. 75).[89]

The figure cannot help but strike the observer as markedly asymmetrical in both form and pose. While the breasts appear to be those of a young woman, the relatively substantial lower torso adds a somewhat matronly quality. While the figure's right shoulder is not raised, its right hip is (contrary to what one would here expect). The slight inclination of the head conveys an air of indecision, and there is also an ambiguity about the hands. It is not clear whether the figure's left hand has just removed some drapery as Aphrodite disrobes, or is about to take hold of the discarded cloth as she dresses. The role of her right hand is correspondingly ambivalent: it is impossible to ascertain whether it is intended here chiefly to conceal the pubis or to be about to reach for the drapery. The goddess is naked, yet there is no particular emphasis on her pudenda. She is upright, and yet is manifestly not holding herself erect.

It may well have been the figure's contradictory character that repeatedly provoked commentators such as the pseudo-Lucian (an unidentified Hellenistic author of the second century AD) to confess their admiration in assertions such as: "The hard, unyielding marble did justice to every limb".[90] Perceived in such a fashion, the sculpted figure "enchained" those who visited the sanctuary of Aphrodite on Cnidos just as the veiled figure invoked in Leonardo's maxim would, many centuries later, prophesy of itself. According to the pseudo-Lucian, a certain Charicles of Corinth, out of his senses with love for Aphrodite, threw himself at the figure of the goddess, "stretching out his neck as far as he could, [and] started to kiss [her] with importunate lips".[91]

own figure inserted into a sequence from the 1946 film *Gilda*, in which he is seen alongside its ecstatically dancing star, Rita Hayworth.

89 On the history of the worship of the Praxiteles figure: Hinz 1998. On the figure itself: *Die Geschichte der antiken Bildhauerkunst*, Vol. II, 2004, p. 329.

90 Lucian 1967 *Erotes*, 13, pp. 169–171. See also Hinz 1998, pp. 17–21.

91 Lucian 1967 *Erotes*, 13, p. 171.

Fig. 75 *Venus Colonna,* Roman copy after *Aphrodite of Knidos,* by Praxiteles, Marble, 350–340 BC, Musei Vaticani, Rome.

Callicratidas of Athens, by contrast, whose passions were homoerotically inclined, was seized by a passion for the figure as viewed from the rear.[92] The temple attendant explained the presence of a slight darkening of the marble surface in the form of a stain on the inside of one thigh as follows: a highborn youth, having fallen madly in love with the statue, had succeeded in getting himself locked in the temple one night, so as to be able to make love to the object of his affections. The stain was said to be the trace "of his amorous embrace" and "the goddess had that blemish" as a mark of the outrage perpetrated upon her. The culprit paid for this with his life.[93]

Numerous variations on this story have been recounted. In Francesco Colonnna's *Hypnerotomachia Poliphili,* published in Venice in 1499, for example, there is mention of a reclining sculpture that formed part of a fountain. Representing both Mother Nature and Venus herself, this was located in the realm of the "Queen of Free

92 Lucian 1967 *Erotes,* 14, p. 171.
93 Lucian 1967 *Erotes,* 15–16, pp. 173–177.

Will". A parallel with the Aphrodite of Praxiteles is evident also in the claim that the reclining figure induced men "to become so aroused in its presence as to give way to their sacrilegious desires. And so, in masturbating, they defiled the statue".[94] Here, too, the visual power of a sculpture becomes apparent through its capacity to drive men crazy with lust. One is confronted, that is to say, with a sexually dramatised will to action originating in the living image itself.[95]

PYGMALION'S *GALATHEA*

The myth of the sculptor Pygmalion, as recounted in Ovid's *Metamorphoses*, was to prove the most influential text on this sort of physical attraction exerted by a sculpted female figure.[96] Following his rejection by a woman he had loved, Pygmalion resolves to devote himself entirely to his art. In the abstinence of his celibate life, he carves, out of ivory, a female figure, whom he calls Galathea and who is so lifelike that he falls passionately in love with it: "The face is that of a real maiden, whom you would think living and desirous of being moved, if modesty did not prevent it. So does his art conceal his art".[97]

Art conceals itself in order that its creations seem to be alive: with this formula, Ovid divulged, in a single line, the disturbing secret that an image might go beyond its own apparent status as a man-made entity. Pygmalion, while being absolutely certain that the figure he has made consists of ivory, and of ivory alone, is nonetheless inclined to believe that it is indeed more. Looking at the figure, he sees life in it; touching it, he feels a real body; and kissing it, he senses its own attraction to him.[98] So strongly does the sculptor sense the animation in his own work of art, that he proceeds to worship the sculpted figure as if were a real woman. The ivory statue then constrains him to prove his affection, and he complies with gifts of jewellery, clothing and sumptuous tapestries. These are, in effect, his tributes to the schematic image act.

Having attained an acme of intensity in his love for the sculpted figure, Pygmalion makes a sacrifice at the altar of Venus, albeit without daring to ask that the statue be brought to life. He utters, rather, the wish for a real wife resembling the

94 "gli homini in sacrilega concupiscentia di quella exarsi, il simulachro masturbando stuprorono" (Colonna 1980, Vol. I, p. 63).

95 Babich 2009, p. 130, note 5.

96 On this connection: Böhme 1997, pp. 106–19. Comprehensive on this subject: Stoichita 2008.

97 "Virginis est verae facies, quam vivere credas / Et, si non obstet reverentia, velle moveri: Ars adeo latet arte sua" (Ovid 1984, X, 250–52).

98 "[…] nec adhuc ebur esse fatetur" [Nor does he yet confess it to be ivory] (Ovid 1984, X, 255).

work of art.[99] Here we find the schematic image act in its most extreme form: the artefact establishing the norm for the real body. Venus, however, knows Pygmalion's true desire. Back in his studio, he kisses the sculpted figure reclining upon a couch and is at once aware of a remarkable change: "The ivory grew soft to the touch and, its hardness vanishing, gave and yielded beneath his fingers, as Hymettian wax grows soft under the sun".[100] When the softness of the statue takes on the colouring of flesh, the sculpted figure's own passion is manifest in corresponding physical reactions.[101] Pygmalion's union with Galathea is consummated, and after nine months a daughter, Paphos, is born.[102] Pygmalion's creation has, then, induced its own maker to actions of an increasingly significant sort: from gazing upon it, by way of touching it, to sleeping with it – now no longer it, but her.

As a narrative centred on the animation of the artefact, this myth assumed considerable importance during the Enlightenment. The story of Pygmalion's sculpted figure appeared to show that life and death were diverse states attainable by the same material. And when, in Étienne Bonnot de Condillac's *Traité des sensations* of 1754, one is invited to envisage a statue that, through its senses — and, above all, the sense of touch – acquired an awareness of itself, then it is Pygmalion's figure that one may view as godfather to this sort of sensuality.[103]

Especially notable among the numerous adaptations of the Pygmalion myth is Jean-Jacques Rousseau's *Scène lyrique de Pygmalion*, published in 1771.[104] Just as in the aforementioned case of Leonardo, a concealed work of art teasingly threatens to become a prison for the putative spectator if unveiled, so too in Rousseau's dramatic monologue the as yet unfinished work of art is at first hidden from view. In one of the drawings based on the opening scene by Jean-Michel Moreau, published in engraved form in 1775, Pygmalion is to be found looking at the curtain behind which he has hidden his own work, in order not to be distracted by it (Fig. 76).[105] It is

99 "Simile mea, dixit, 'eburnae'" [... but said 'One like my ivory maid'] (Ovid 1984, X, 276).

100 "Temptatum mollescit ebur positoque rigore / Subsidit dignitis ceditque, ut Hymettia sole / Cera remollescit" (Ovid 1984, X, 283–85).

101 "Corpus erat: saliut temptatae pollice venae. / Tum vero Paphias plenissima concipit heros / Verba, quibus Veneri grates agat, oraque tandem / Ore suo non falsa premit, dataque osculva virgo / Sensit et erubuit timidumque ad lumina lumen / Atollens pariter cum caelo vidit amantem" [Yes, it was real flesh: The veins were pulsing beneath his testing fingers. Then did the Paphian hero pour out copious thanks to Venus, and again pressed with his lips real lips at last. The maiden felt the kisses, blushed and, lifting her timid eyes up to the light, she saw the sky and her lover at the same time] (Ovid 1984, X, 287–94).

102 Ovid 1984, X, 285–98.

103 Condillac 1774, passim. See, in particular, Part II, chap.1, p. 205, on the sense of touch as "[le] sentiment fondamental". See also Bredekamp 2003 *Antikensehnsucht*, pp. 14–16; Warning 1997, pp. 234, 241.

104 Rousseau 1771. See also Blühm 1988, pp. 96–112, and Mülder-Bach 1998, pp. 94–98.

105 Rousseau 1771, pp. 1–3; Blühm 1988, Fig. 81 II.

Fig. 76 Jean-Michel Moreau, Image from the series illustrating
Pygmalion: Scène lyrique de Mr. J. J. Rousseau (1775): The sculptor Pygmalion in his
studio, Engraving on paper, 1775, Staatsbibliothek, Berlin.

Fig. 77 Jean-Michel Moreau, Image from the series illustrating
Pygmalion: Scène lyrique de Mr. J. J. Rousseau (1775): Pygmalion uncovers his
figure of Galathea, Engraving on paper, 1775, Staatsbibliothek, Berlin.

Fig. 78 Noël Le Mire, after Jean-Michel Moreau, *Pygmalion and Galathea*, Engraving of 1778, illustration in J. J. Rousseau, *Collection complète des oeuvres*, Paris 1774–83.

only later that the artist dares, in a state of extreme arousal, to open the curtain and lay bare the figure (Fig. 77). He then embarks upon its completion.[106]

The animation that follows does not, in this case, occur through the intervention of Venus. It is, rather, the outcome of the artist's own desire to live through his work.[107] In this case the sculpted figure in fact comes to life through a form of tactile self-discovery.[108] Galathea touches her own body and then utters, for the first time, the word that, since pre-Grecian Antiquity, has emphasised the self within the work: "Me."[109] Proceeding immediately to conduct the same experiment with other subjects, Galathea next touches the unfinished sculpture of a naked male figure, and immediately recognises: "That's no longer me." (Fig. 78)[110] It is thus all the more striking that when Galathea touches Pygmalion, she cries out in relief: "Ah! That's me again."[111]

With his own version of the Pygmalion myth, Rousseau ponders the autonomy of the sculpted figure. In the light of the history of verbally based reflections of the image act, it is of particular significance that the sculpted figure, in touching itself and declaring "Me", should adopt the term that, since the era of the Near Eastern

106 Rouseau 1771, pp. 4–6. See also Warning 1997, pp. 237–38.
107 Rousseau 1771, pp. 7–8.
108 Warning 1997, p. 239.
109 "Moi" (Rousseau 1771, p. 13). See also Blühm 1988, p. 102, and Warning 1997, p. 242.
110 "Ce n'est plus moi" (Rousseau 1771, p. 13).
111 "Ah! Encore moi" (Rousseau 1771, p. 14).

cultures of Antiquity, has defined the autonomous life of the image.[112] The self-discovery achieved by the living sculpture again employs that doubling of the self of which Jan van Eyck offered the most striking examples. It will equally stir recollections of the *Tu est moi* through which Niki de Saint Phalle acknowledged the divided personal union of creator and work – and all the more so in that Rousseau stages this scene as one occurring in Pygmalion's own imagination, to which the spectator has only indirect access. But what is shown proves ever more attractive to the spectator the more this last is in reality excluded. Rousseau attests to the power of the image act from the point of view of the work of art.[113]

MOZART'S *COMMENDATORE*

The obverse of Pygmalion's eroticised sculpted figure is to be found in the terrifying "stone guest", whose appearance heralds the dénoument of the two-act opera *Don Giovanni*, first staged in Prague in 1787, with libretto by Lorenzo Da Ponte and score by Wolfgang Amadeus Mozart.[114] The eponymous protagonist, a resolute libertine, has been seeking to seduce Donna Anna, daughter of a certain *commendatore* (the "stone guest" in his original, living form). Her cries for help having alerted her father, he engages the Don in a duel, during the course of which he is mortally wounded. In the second Act Don Giovanni and his servant, Leporello, meet in a graveyard where they first encounter the sculpted figure of the *commendatore*, erected to mark his grave. In the tradition of works of art invested with the capacity to speak, the inscription on the tomb reads: "Here I await the chance to avenge myself on that godless one who slew me".[115] Leporello immediately senses that it is not the dead man lying in his grave who addresses them thus, and in the first person singular, but the sculpted figure itself: "It seems to be alive! Seems to hear! And to wish to speak ..."[116]

What they now encounter is not a case of the dead awakening, but of the statue assuming a life of its own. Don Giovanni, as a figure of the Enlightenment, at first refuses to admit to being at all impressed by this. In patronisingly inviting the apparition to a banquet, he initially gives almost mocking expression to his resis-

112 Condillac 1774, Part II, chap. 4, pp. 223–24: "Elle [la statue] apprend à connoître son corps, & à se reconnoître dans toutes les parties que le composent; parce qu'aussitôt qu'elle porte la main sur une d'elles, le même être sentant se répond en quelque sorte de l'une à l'autre: c'est moi. Qu'elle continue de se toucher, partout la Sensation de solidité [...]: c'est moi, c'est encore moi". See also Warning 1997, p. 241.

113 Fried 1980, p. 103. See also Mülder-Bach 1998, p. 97.

114 Macho 2002, p. 65. On the derivation of the subject: Dieckmann 1991.

115 "Dell'empio che mi trasse al passo estremo / Qui attendo la vendetta" (Mozart 1787, II, 11, p. 70).

116 "Par vivo! par che senta! / E che voglia parlar" (Mozart 1787. II, 11, p. 70).

Fig. 79 Title page of the 1801 edition of the libretto and score of *Don Giovanni* by Wolfgang Amadeus Mozart and Lorenzo Da Ponte (first staged in 1787), incorporating an anonymous engraving of the Banquet Scene in Act II, Staatliche Graphische Sammlung, Munich.

tance; but when the statue nods and says "Yes", to signal that he accepts the invitation, the Don withdraws, evidently taken aback.[117] The action culminates with the arrival of the "stone guest" at the Don's banquet (Fig. 79).[118] Leporello, who is the first to see it, refers to it as "a man of white stone", thereby employing a term common since the fifteenth century for especially valuable monumental marble figures.[119] Notwithstanding the power of this apparition, Don Giovanni as yet remains unmoved. His emphatic declaration "the heart in my breast remains firm",[120] as also his refusal to repent, underlined through his repeated "No", leave the conflict unresolved.[121]

Here, Mozart and Da Ponte achieve a peerless reflection of the image act. In championing the warmth of his own passions over the perceived coldness of unfeeling nature, Don Giovanni fails to understand that the *commendatore*, in his own desire for revenge and his own sense of justice, is even more passionate than is he, the Don, in his libertine furore. Although the "stone guest" is slow to act, he does so with unwavering animation.

In setting Da Ponte's libretto, Mozart had the role of the *commendatore* sung by a bass voice, which would traditionally be associated with a character speaking the truth. Don Giovanni, a tenor role, embodies the Enlightenment, but is a character as lacking in insight as he is free-spirited. He is finally defeated at the hands of the "stone guest", whose own extreme tonal range itself testifies in musical terms to

117 Mozart 1787, II, 14, p. 72.
118 Not coincidentally, the title-page of the first, 1801 edition of Da Ponte's libretto (Fig. 79) bears an engraving of a later moment in this scene (Erben 2005, pp. 5–7).
119 "L'uom [...] di sasso [...] L'uomo bianco" (Mozart 1787, II, 14, p. 78). See also, on the "white man", Seymour 1967, pp. 99–100.
120 "[...] ho fermo il core in petto" (Mozart 1787, II, 15, p. 81).
121 Mozart 1787, II, 15, p. 81.

Fig. 80 Relief panel of the figure of *Gradiva*, copy of part of a Roman relief in the Musei Vaticani, Plaster, 1908, Freud Museum, London.

the curious force of the image act. When Don Giovanni, while initially laughing at the notion of a statue coming to life, is finally sent down to Hell by this very figure, one is effectively urged to recognise a version of the Enlightenment that accommodates the schematic image act. Were it otherwise – and this is the moral of the story related by Da Ponte and Mozart – any form of enlightenment would be nothing but a torso incapable of animation.

B. SURREALIST DOLLS

During the twentieth century the story of Pygmalion once again aroused a great deal of interest. The starting point on this occasion was Sigmund Freud's analysis, in 1907, of a story first published five years earlier (in the Viennese press) by the German novelist Wilhelm Jensen. This concerned a young archaeologist, Norbert Hanold, who became obsessed with the figure of a running woman, by the name of Gradiva, depicted on a Pompeian relief (Fig. 80) and with the notion that he might find her, and thereby save her from the repercussions of the eruption of Vesuvius, from which he believed her to be fleeing. In Jensen's story Hanold ultimately goes to Pompei, where he is consumed by his amorous obsession until he makes the acquaintance of a young woman who turns out to be the object of his unfulfilled

Fig. 81 René Magritte, *La tentative de l'impossible*, Oil on canvas, 1928, Municipal Museum of Art, Toyota.

youthful passion. In her Hanold recognises the figure of Gradiva from the Pompeian relief, now come to life. She, however, is able gently to make clear to him that his love for the relief figure was simply a displacement of his original attraction to her, and that this process can now be reversed. In this re-emergence of the Pygmalion motif, Freud saw the model for the process of psychoanalysis."[122]

Inspired in turn by Freud's account, the Surrealists saw in Gradiva a figure epitomising the intermediate realm between "dream and reality".[123] As formulated by René Magritte in his painting of 1928 *La tentative de l'impossible* (Fig. 81), the suspicion that one had detected in a counterpart a modern version of Pygmalion's Galathea had by this date become universally appreciable.[124] In shop-window mannequins the Surrealists saw a quintessentially modern figural form through which the Pygmalion myth, as they understood it, might be put to the test. The first Paris Exposition Internationale du Surréalisme, in 1938, thus became an occasion for related thought experiments. Engaged in these were all the Paris Surrealists, among

122 Freud 1969, pp. 78–83.
123 Huber 1993, pp. 452–54.
124 *Pygmalions Werkstatt* 2001, cat. no. 80, pp. 212–13.

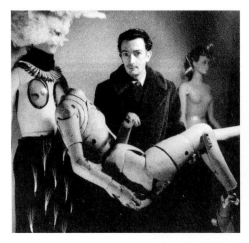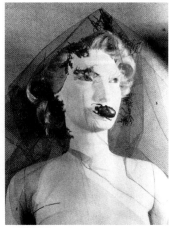

Fig. 82 Denise Bellon, Salvador Dalí with a mannequin made by Maurice Henry, Photograph, 1938/39, Private collection.

Fig. 83 Raoul Ubac, Mannequin made by Sonia Mossé (detail), Photograph, silver gelatin print, 1938, Musée d'Art Moderne de la Ville de Paris.

them Salvador Dalí (Fig. 82)[125] and Sonia Mossé, whose own doll (Fig. 83) was seemingly to provide a model, decades later, for the poster advertising the 1991 film *The Silence of the Lambs*.[126] The Surrealists felt that they were "all like Pygmalion".[127]

If Sigmund Freud's analysis of Jensen's *Gradiva* had served the Surrealists as an initial stimulus, then the dolls made by Hans Bellmer (an erstwhile pupil of George Grosz and Otto Dix) were to pose a challenge.[128] Not unlike artists such as Oskar Kokoschka, who had temporarily incorporated dolls into their lives (Fig. 84),[129] Bellmer devised, in allusion to the figure of Olimpia in E.T.A.Hoffmann's 1817 story *Der Sandmann*, a doll to be made out of screwed and bolted wooden segments, plaster, waxen fibres and other materials (Fig. 85). Its deformed, fragile body signified an act of rebellion against that blend of utility and Classicism fostered by the

125 He is here shown holding a mannequin made by Maurice Henry: *Puppen, Körper, Automaten* 1999, p. 436.

126 *Puppen, Körper, Automaten* 1999, p. 427.

127 Kuni 1999, p. 194.

128 Through the illustration of his dolls in the French Surrealist journal *Minotaure* during the summer of 1935 Bellmer was to have an influence on the Pygmalion-mania of this group of artists. See also Altner 2005, pp. 207–10.

129 In April 1919 Oskar Kokoschka, resident since late 1916 in Dresden, received delivery of a life-size doll that had been made to his precise instructions by Hermine Moos, in imitation of his former lover, Alma Mahler. This doll served as a model in several surviving paintings made over the following year or so (*Puppen, Körper, Automaten* 1999, p. 376; Sykora 1999, pp. 247–48). On the iconology of the doll in the circle of the Bauhaus: Koss 2003.

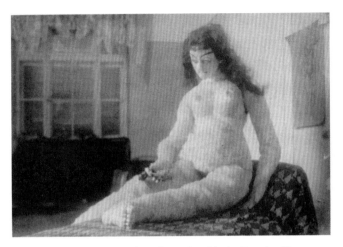

Fig. 84 Life-size doll made for Oskar Kokoschka by Hermine Moos,
Photograph, 1919, Anne Horton Collection, New York.

National Socialists.[130] Bellmer went even further in this direction with his second doll.[131] As positioned and then recorded by Bellmer in his own photograph (Fig. 86), this is striking above all for the increasingly prominent foregrounding of parts evoking breasts, a stomach, ball-jointed thighs and a vulva. For all its vulnerability and its ghastly denaturation, this doll exudes an aggressive sexuality.[132]

The original model for Bellmer's second doll was a small boxwood manne-quin from around 1520 (Fig. 88), which he had first encountered on visiting the Kaiser-Friedrich- (now Bode-)Museum in Berlin in 1935.[133] On account of the pat-terning of the grain of the wood, the back appears as if tattooed (Fig. 87); and both hands and feet are notable for their supple and slender appearance. The mannequin has ball-and-socket joints, which would have guided Bellmer in the construction of his second doll. It would appear that he was also reacting to the relatively high posi-tioning of the breasts and to both the flame-like pubic hair and the exposed, red-painted pudenda (in which he may well have sensed the menace of a *vagina dentata*).

Every attempt to elucidate Bellmer's creations is reminiscent of the concern to diffuse the impact of a scandal. His dolls are products of a Pygmalion whose fig-

130 Baackmann 2003, p. 69. See also Kuni 1999, p. 188. On Bellmer's perverted use of a swastika in 1938, attesting to a politicised element in his work: Baackmann 2003, p. 75; *Hans Bellmer* 2006, cat. no. 255, p. 85. On Bellmer in general: Foster 1993, pp. 114–22.

131 *Hans Bellmer* 2006, cat. no. 264, p. 107.

132 Baackmann 2003, pp. 74–75.

133 Jelenski 1966, p. 7. See also *Traumwelt von Puppen* 1991, p. 34, and Sykora 1999, pp. 226–28. On the mannequin: Rath 2008; on Bellmer's initial discovery of it: Rath 2008, p. 84.

Fig. 85 Hans Bellmer, *The Doll* (first version), Photograph, 1934, Private collection.

Fig. 86 Hans Bellmer, *The Doll* (second version), Photograph, 1936, Kupferstichkabinett (Stiftung Sammlung Dieter Scharf zur Erinnerung an Otto Gerstenberg), Staatliche Museen SPK, Berlin.

ures have not been brought to life by Venus, but rather by the demons of his age. It is as if they were intermediate links in a chain of activation that had its starting point in the aforementioned sixteenth-century mannequin and its later manifestation in the self-portrait dolls made by Cindy Sherman, in which the horror of Bellner's figures lives on. [134] Bellmer's dolls embody the desires of a Pygmalion who was not a sculptor, but a technician and an engineer of life; and these desires thus assumed a Surrealist form of negation. And this in turn equates to an assault upon the visually schematic union of beauty and power.

The film-maker and photographer Liane Lang achieved, in her *Faun* of 2007 (Fig. 89), a merging of elements from several instances of the schematic image act. The photograph illustrated here shows a plaster cast (made in Heidelberg) of a celebrated work of Antiquity now in the collection of the Glyptothek in Munich: the late-third or early-second-century BC Hellenistic figure known as the *Barberini Faun*, or *Drunken Satyr*. Positioned behind the plaster figure a person only partially visible, but apparently a young woman, perhaps a girl, has wrapped her arms around the satyr's upper torso and draped her legs around its hips and across the inside of its parted thighs, these intervening limbs all emerging from cloth draped around

134 Zimmermann 2001, pp. 44–54. See also the comparison with the work of Louise Bourgeois in: *Hans Bellmer* 2010.

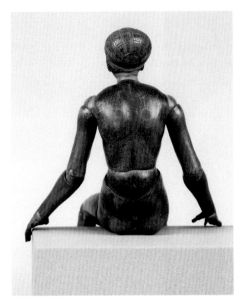

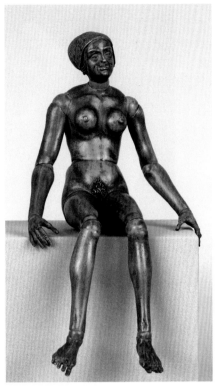

Fig. 87 Back view of mannequin seen in Fig. 88.

Fig. 88 Mannequin, Boxwood, c. 1520, Bode-Museum, Staatliche Museen SPK, Berlin.

the faun's lower torso.[135] Yet, the more one understands of the artfulness of the arrangement, the more one resists accepting this. In her own interpretation of such sculptural figures, the artist has emphasised her desire to breathe life into them: "In photographing the sculptures I wanted to re-animate them, invigorate their physical qualities".[136]

Among the many associations set off by Lang's work there may well be a distorted memory of Bellmer's dolls, as also of Pygmalion's Galatea and the Aphrodite of Praxiteles and of the almost compulsively erotic quality they share. The figure of the faun, which is itself already of an ostentatious eroticism,[137] is further enhanced in its mysterious objectivity as an instance of the schematic image act. Lang has made clear that this was precisely the aim of her arrangement:

135 Zuschlag 2010, pp. 319–22.
136 Cited after Zuschlag 2010, p. 321.
137 With regard to the faun's lazily spread thighs, Ursula Mandel (Mandel 2007), p. 145, has appositely written of a "unclasped eye-trap" ["aufgeklappter Blickfall"].

Fig. 89 Liane Lang, *The Faun*,
Photograph, C-print 2007,
Collection of the artist.

> The fact that some antique sculpture has made it [down] to us through so many changes of regime and religion, is the triumph of the object over its maker at all costs.[138]

In positioning the work not only as proof against the passage of time, but also as effectively independent of its own maker, in order to underline its autonomous vitality, the artist here captures the quintessence of the schematic image act in the form of the animated object.

138 Cited after Zuschlag 2010, p. 321.

C. Binary Centaurs

A final variant of the animation of objects does not seek to obscure or to veil the border between the living and the anorganic, but rather to sideline it. This variant found its leitmotif, in the early twentieth century, in the production of a "centaur": a hybrid creature comprised of both dead and living materials. A fusing of art and technology was to bring forth binary demi-gods combining the human and the metallic.

Italian Futurism was permeated by this notion. In his *Futurist Manifesto*, published in February 1909 (initially in Paris, and in French), Filippo Tommaso Marinetti describes how, together with friends, he gave himself up to indeterminate power fantasies, until the "famished roar of automobiles" broke through the stillness of the night. "'Let's go!' I said. 'Friends, away! Mythology and the mystic ideal are defeated at last. We're about to see the Centaur's birth and, soon after, the first flight of Angels! [...] We must shake the gates of life, test the bolts and hinges'".[139] With this wake-up call Marinetti formulated a motto for the myth of the centaur to be realised through the fusion of man and machine.[140]

An especially striking visual rendering of such hybridity is to be found in Botticelli's painting *Minerva and the Centaur* (Fig. 90).[141] This shows the Goddess of Wisdom against the background of a jagged rock-face: she has evidently succeeded in taming the centaur, in whom the dividing line between man and beast is manifest in the varying textures of skin and hide. Shortly before the publication of his *Futurist Manifesto* Marinetti had himself programmatically photographed, sitting in his car (Fig. 91), as the incarnation of a modern centaur. Behind the bonnet the coachwork curves expansively up to the driver's seat. Clasped by its encircling padded back, the driver appears to emerge out of the metal body. While his legs do have a certain amount of space around them, they nonetheless eventually disappear from view, while their own diagonal positioning reiterates that of the steering wheel shaft. In as far as these limbs may themselves be viewed as a mechanical entity, the fusion of a human body and an alien form functions rather better here than in the painting by Botticelli. Through this connection with the automobile, man creates a being in which he encounters himself as one of many components.

139 "gli automobile famelici [...] 'Andiamo', diss'io; 'andiamo, amici! Partiamo! Finalmente, la mitologia e l'ideale mistico sono superati. Noi stiamo per assistere alla nascita del Centauro e presto vedremo volare i primi Angeli! [...] Bisognà scuotere le porte della vita per provarne i cardini e i chiavistelli [...]" (Fondazione e Manifesto del Futurismo, in: *I Manifesti del Futurismo* 1914, p. 3–4; Marinetti 1972, p. 20).

140 Chief sources on centaurs: Ovid 1984, XII, 219–21, Ovid 1929, V, 379–81; and Dante, *Divina Commedia*, 1938, Inferno XII, 55–57.

141 Körner 2006, pp. 282–90; *Botticelli* 2009, pp. 214–17.

Fig. 90 Sandro Botticelli, *Minerva and the Centaur,* Tempera and oil on canvas, c. 1480, Galleria degli Uffizi, Florence.

Fig. 91 Filippo Tommaso Marinetti in his car, Photograph, 1908.

Humanised in this fashion, the car may take part in the fundamental events of a human life: birth, the experience of love, death. Marinetti's erotic approach to the "snorting beasts" that a driver will "stroke [with] amorous hands" repeatedly makes the car into a new embodiment of Galathea,[142] The car is the modern equival-

142 "belve sbuffanti [...] per palparne amorosamente i torridi petti" (*Fondazione e Manifesto del Futurismo,* in: *I Manifesti del Futurismo* 1914; p. 4; Marinetti 1972, p. 20). Mai 1981, p. 336.

ent to Pygmalion's sculpted figure, with which the human being unites in order to beget a centaur.

Marinetti's dictum that a racing car was "more beautiful than the Victory of Samothrace" was a reference to that sculpted figure of the winged Goddess of Victory conceived as having landed on the bow of a victorious battleship (Fig. 92).[143] Fedele Azari, in a photograph inscribed for Marinetti, suggestively captured the comparison of a racing car with this goddess from Antiquity (Fig. 93).[144] Because the cast shadow of a bi-plane races ahead of the car like an *alter ego*, the earthbound and the airborne vehicles seem as if converging. The former appears almost to have sprouted wings, and to vibrate and swoop like the *Winged Victory*.

The same motif was used in 1911 by the English sculptor Charles Sykes in his *Silver Lady* (Fig. 94). The figure he devised as a decorative addition to the top of the Rolls-Royce radiator cap, also appears to allude, through its formal title, *Spirit of Ecstasy*, to Marinetti's 1909 *Manifesto*. This became the sculptural emblem of a car that, at this time, was regarded as itself a perfect work of art. It was as if a small figure of the *Winged Victory* had here settled for a moment on the brow of the modern centaur.[145] In this car Marinetti's claim was both confirmed and refuted in so far as a contradiction between *Winged Victory* and technological centaur had here been resolved in a union.

Marinetti ascribed to works of art of the coming Futurist era "aggressive action, a feverish insomnia, the racer's stride, the mortal leap, the punch and the slap".[146] Futurist artists were to abandon their salon skirmishes and take to the streets, the glazed retail galleries, the piazzas; but this was also the beginning of that embrace of the precarious side of the schematic image act, which derived from the animation of the image a compulsion to regard life and death as disposable qualities of one and the same activity.

In his 1909 *Futurist Manifesto* Marinetti had already brought together the notions of motoring, speed and death: "I stretched myself out on my car like a corpse on its bier".[147] He may here have been thinking of the very first racing cars, which were shaped, in the interests of aerodynamics, rather like a coffin, as is revealed in

143 *Die Geschichte der antiken Bildhauerkunst* 2007. Text Vol. pp. 137–41. Plates Vol. fig. 155. Marinetti's phrase: "più bello della Vittoria di Samotraccia" (*Fondazione e Manifesto del Futurismo* [manifesto clause no. 4], in: *I Manifesti del Futurismo* 1914, p. 6; Marinetti 1972, p. 21).

144 *Futurismo e Futurismi* 1986, p. 423, on the life of Azari p. 425.

145 Panofsky 1993, p. 93.

146 "il movimento aggressivo, l'insonnia febbrile, il passo di corsa, il salto mortale, lo schiaffo ed il pugno" (*Fondazione e Manifesto del Futurismo* [manifesto clause no. 3]; in: *I Manifesti del Futurismo* 1914, p. 8; Marinetti 1972, p. 21).

147 "Io mi stesi sulla mia macchina come un cadavere nella bara" (*Fondazione e Manifesto del Futurismo*; in: *I Manifesti del Futurismo* 1914, p. 4; Marinetti p. 20).

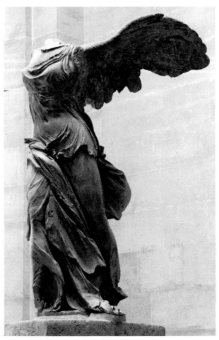

Fig. 93 Fedele Azari, Racing car with cast
shadow of a bi-plane, Undated photograph
inscribed with dedication to F. T. Marinetti.

Fig. 92 *Winged Victory of Samothrace*, Marble,
c. 190 BC, Musée du Louvre, Paris.

a photograph of the 1912 *Grand Prix* of the *Club de France* (Fig. 95).[148] For Marinetti, violence and death were the companions of speed. And this freed the driver from the constraints of circumspection and a concern for legitimacy. As escort of the automobile, death beat a path for it into the black world of the absurd, but also that of war – deemed the highest and most effective medium for Futurist art.[149] Yet Marinetti also voiced a reciprocal hope for rebirth and new life:

> After the animal kingdom we're now encountering the realm of machines. With our knowledge of and sympathy for matter – of which a scientist can know only the physical-chemical reactions – we'll work towards the creation

148 *The Machine* 1968, p. 53.

149 The now almost too familiar declaration reads: "Noi vogliamo glorificare la guerra – sola igiene del mondo – il militarismo, il patriotismo, il gesto distruttore dei libertarî, le belle idee per cui si muore e il disprezzo della donna" [We will glorify war – the world's only hygiene – militarism, patriotism, the destructive gesture of freedom-bringers, beautiful ideas worth dying for, and scorn for women] (*Fondazine e Manifesto del Futurismo* [manifesto clause no. 4]; in: *I Manifesti del Futurismo* 1914, p. 6; Marinetti 1972, p. 22).

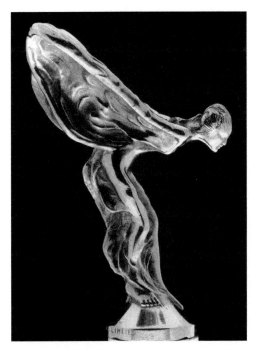

Fig. 94 Charles Sykes, *Silver Lady* devised in 1911 as a decorative addition to the Rolls-Royce radiator cap.

Fig. 95 Grand Prix of the *Club de France*, Anonymous photograph, 1912.

of *mechanical man with interchangeable parts*. We'll liberate him from the idea of death, and hence from death itself: a supreme definition of logical intelligence.[150]

The Futurist Utopia was discredited by the First World War and then by Italian Fascism, both keenly supported by Marinetti. But its intense enthusiasm for a centaur-like union of man and machine has remained potent. This has never been truer than it is in the present day, when the ability to conjure living images from assemblages of biomass has made possible a return to the futuristic myth of the centaur.[151] These artificially created images, which have nonetheless shed every element of

150 "Dopo il regno animale, ecco iniziarsi il regno meccanico. Con la conoscenza e l'amicizia della materia, della quale gli scienziati non possono conoscere che le reazioni fisico-chimiche, noi prepariamo la creazione *dell'uomo meccanico* dalle parti cambiabili. Noi lo libereremo dall'idea della morte, e quindi dalla morte stessa, suprema definizione del'intelligenza logica" (*Manifesto della Letteratura Futurista*: 12 maggio 1912 [emphases in original] in: *I Manifesti del Futurismo* 1914, p. 96).

151 Reichle 2005, pp. 136–42.

artifice, are usually considered and appraised in ethical terms. Their deeper signifi-
cance is, however, only to be grasped if they are understood as a response to the
question as to why an artificial entity may be seem to live and to act. Here, one con-
fronts the most radical variant of the schematic image act.

Fig. 96 Edward Steichen, Photograph of the 1936 display of his own delphiniums at the
Museum of Modern Art, New York.

Even for this procedure, Leonardo da Vinci can serve as a crown witness.
According to Vasari, towards the end of his life Leonardo carried out experiments on
living entities. He was attempting to cross-breed distinct types of animals so as to
create chimaeras. He succeeded, indeed, in producing a lizard with wings, these last
made out of lizard scales and other ingredients. Such confections caused visitors to
panic and run away.[152]

During the 1930s the American photographer Edward Steichen took an inter-
est, as an artist, in the breeding of plants, in the conviction that living organisms
really belonged within the realm of art. In doing so he was tacitly sanctioning a
theory of the image that directly recognised a visual counterpart as an organ capable
of life. When the plants he had raised were exhibited in 1936 at the Museum of Mod-

152 Vasari 1906, Vol. VI, p. 46. On how one might categorise Leonardo's attempts at a sort of bio-
logical art, see: Fehrenbach 2005 *Compositio*, pp. 153–55.

Fig. 97 Edgar Lissel, *Domus Aurea,* Bacteria on plaster panel, 2005.

ern Art in New York (Fig. 96) this effectively gave institutional accreditation to the notion that biological entities could also be works of art.[153]

The photographer Edgar Lissel updated this belief in using organic material as his own artistic medium. In his *Domus Aurea* project, in progress since 2005 and taking its name from the Roman Emperor Nero's famously palatial town house, he isolated bacterial cultures from the mould that, under the influence of light, had had a destructive impact upon the murals at this archaeological site. He then placed

153 Gedrim 1993. See also Reichle 2005, p. 28, and Zimmermann 2005, pp. 289–92. Fundamental on the origins of biological art in the Renaissance: Fehrenbach 2005 *Compositio.*

Fig. 98 Eduardo Kac, *The Eighth Day* (detail), Transgenic art work with biological robot (biobot), genetically modified plants, amoebas, fish and mice, audio and video recordings, 2001.

these cultures on replicas of the affected murals. As those sections of wall on which there were no paintings soon looked brighter, it was clear that the bacteria had now removed the traces of their own earlier destructive action (Fig. 97). The image had been incorporated into an organic material that created the impression that the image itself was reacting. By this means, however, the fundamental question as to whether the image was indeed a passive material or an active counterpart was answered in a new way. The work of art is here an evolving collective organism, possessed of life and yet not at the cost of aesthetic brilliance.[154] Biofacts – mediating between artefacts and living beings – are, indeed, among the products of what is now a recognised "biological movement" in the visual arts.[155]

 A separate development is to be found in "transgenic" art", which since the 1980s has engaged with the possibilities of genetics, inspired by the notion of the artist as a gardener who activates an evolutionary process in the image as a living

[154] Lissel 2008 *Return*, pp. 443–44; Lissel 2008 *Werden*, pp. 63–71.
[155] On the definition of this concept: Karafyllis 2003, pp. 16–17. Christiane Kruse has sought to establish demarcations within the existing range of images of this sort.

Fig. 99 Symbiotic Research Group, *Tissue-Culture-and-Art(ificial)-Wombs-Project*, Small dolls from Guatemala, that on the right enveloped in living cellular tissue, 1996.

counterpart.[156] *The Eighth Day* (Fig. 98), a work by the Brazilian artist Eduardo Kac, offers the visitor a collection of genetically altered plants and animals assembled under a plexiglass dome. One may see these as organic centaurs: no longer hybrids of living body and machine, but a combination of diverse biocells such as might have been invoked in a mythical narrative.[157] No less striking is the *Tissue-Culture-and-Art(ificial)-Wombs-Project* of the Guatemalan artists' collective, the Symbiotic Research Group. Here, small dolls were each wrapped in cellular tissue derived from mice. Under laboratory conditions each set of added cellular tissue grew into a gelatinous mass surrounding each doll (Fig. 99). The transparency of the growing biological layer allowed the form of each enveloped doll to remain recognisable, while

156 Reichle 2005, pp. 142–44. In the same category are the "biological sculptures" made by the artist Reiner Maria Matysik. These living works of art embrace new entities, achieved through genetic engineering, and are defined by the artist as "post-evolutionary organisms" (Reichle 2008).

157 Reichle 2005, pp. 49–76, Fig. 155. Kac is critically opposed to the technical and scholarly avant garde, not because it seems to go too far, but because it does not charge ahead far or fast enough. In arguing thus (p. 192) he effectively takes up the Futurist tradition: not, however, in order to position himself closer to the world of the natural sciences but, in a spirit of "subversive affirmation", so as to attack those barriers that have been erected in the name of ethics both within and around the laboratory.

the living image could be examined in detail, as it grew, through a magnifying glass. The programme did, however, encompass death as well as life: as if in a reversal of the creative act, the cellular tissue eventually succumbed to bacterial infection expressly introduced through the touch of a human hand.[158]

This outcome reveals that transgenic art exists beyond that diametrical opposition of art and life on which the living image has traditionally thrived. As observed, images are invested with the capacity for speech because they are in truth silent; they can be imitated by living bodies because they really consist of dead material; inner movement may be convincingly imputed to them because they are in fact immobile; and they are emotionally enlivened through artificial means because they are in themselves without feeling. The last, centaur-like special form of the image imbued with life intrudes, however, into that notional separate space that has always been reserved for the living image. The union of the machine with the living body in the notion of the early twentieth-century centaur and the fusion of organic entities in recent biological art erode the border between ostensible opposites. Here, then, the schematic image act approaches a second realm, characterised by the exchange of body and image. This brings us to the most insistently problematic aspect of the image act: the phenomenon of substitution.

158 Reichle 2005, pp. 104–07, Fig. 163.

IV

SUBSTITUTIVE IMAGE ACTS: THE EXCHANGE OF BODY AND IMAGE

I. THE MEDIA OF SUBSTITUTION

A. THE *VERA ICON*

The empowerment of the image, imbued with a life of its own, which – be it in the form of the *tableau vivant*, the automaton or the animated object – establishes a basis for the schematic image act, is also to be encountered in the case of its substitutive equivalent. It cannot, however, be too strongly emphasised that the latter is fundamentally distinct in so far as it involves not the mutual animation of image and body, but the exchange of one for the other. In the process of substitution bodies are treated as images and images as bodies. This is the image act at its most precarious. For the mutual substitution of body and image brings into play processes that range from the illustration of that which is most sacred and of aspects of the natural world, by way of variants of iconoclasm, to political and legal iconography and the contemporary "war of images". In both their productive and their destructive aspects, these subjects can hardly be of more immediate relevance to the present time.

The precondition for this phenomenon lies in a deep-seated tradition of conceiving of body and image as separate, and yet nonetheless identical. This way of thinking had diverse roots, most remarkable among them being those Christian teachings that sought to legitimise the use of images in the Early Church notwithstanding the initially iconophobic nature of Christianity.[1] It comes as no surprise to learn that, as early as the second century, the Christian scholar Clement of Alexandria had been especially disapproving of Pygmalion's Galathea and the Aphrodite of Praxiteles:

[1] Stutzinger 1985. Chrisitanity had this in common with Jewish doctrine. See *The Holy Bible* (*King James Version*, 1611), Old Testament, Second Book of Moses, 20:4. It was also (albeit less explicitly) a feature shared with Islam (Almir 2004).

[...] the celebrated Pygmalion of Cyprus fell in love with an ivory statue; it represented Aphrodite and was naked. The Cypriot was captivated by its shapeliness and embraced it. This is related by Philostephanos. There was also an Aphrodite in Cnidos, made of marble and beautiful. Another man fell in love with this figure and had intercourse with it, as Poseidippos relates.[2]

Far worse, however, than the power of Aphrodite (in both related episodes) to lure those enamoured of her beauty into "the pit of destruction" were those "pernicious" works of art that compelled men "to honour and worship them" in the conviction that they were truly alive.[3]

Compelling reasons were needed in order to be able to foil the demands of Clement of Alexandria and other ecclesiastical authorities that images be recognised as demonic. One breakthrough came about by way of the emergence of the use of the *vera icon*. For this particular means of merging body and image brought about something little short of a revolution in the theoretical foundations of the substitutive image act. Every variant of this legend, which was current from the end of the sixth century, shares the notion of an imprint of Christ's face being left upon a cloth and thereby creating the first "true image" of Him: the so-called *mandylion*, a term then signifying a small, rectangular cloth worn loosely over the head (Fig. 100). In 944 this object was formally transferred from Edessa (an erstwhile Roman frontier province, later under Arab control; now Şanlıurfa, south-eastern Turkey) to Constantinople, where each in a series of facsimilies evolved and exerted an aura of its own.[4] The western variant was initially viewed as a painted portrait; but in around 1200 it came to be perceived in much the same way as its eastern counterpart.[5] And there arose a firm belief that Christ Himself had created this "first image", as the imprint of His own face. The *vera icon* was a corporeal relic of Christ.

The western version of the legend of the *vera icon*, according to which Christ, while carrying the Cross through the streets of Jerusalem, had left the imprint of His face in the veil held out to Him by a local woman named Veronica, was given a compelling form in the late fifteenth century by Martin Schongauer (Fig. 101). In his engraving Veronica is kneeling in the left foreground and draws the already imprinted veil back from Christ while He still holds its upper right corner, so that

2 Cited, with adaptations, after Clement of Alexandria 1953, IV, 51, pp. 130/131–132/133. On the interpretation: Stutzinger 1985, pp. 232–33.

3 Cited, with adaptations, after Clement of Alexandria 1953, IV, 51, pp. 132/133–134/135.

4 This subject has of late attracted a great deal of scholarly attention. Without any attempt at being exhaustive, one would here wish to cite: Belting 1990, pp. 233–34; Lentes 1995; Belting 1998; Kessler 1998; Wolf 1998; Wolf 2002 *Schleier*, pp. 1–109; Kruse 2002; Wolf 2005; Lentes 2007; Meyer 2007; Belting 2008 (on Francis); and Wolf 2008, pp. 228–29.

5 Kruse 2002, p. 108; Kruse 2003, pp. 270–72.

Fig. 100 *Mandylion* from Edessa, Tempera on linen, affixed to gilt cedar panel, itself within a larger gilt wood panel San Bartolommeo degli Armeni, Genoa.

the cloth unfurls between them, thereby revealing the direct correlation between the face itself (as depicted by Schongauer) and the replication of that face (as a "picture within a picture").[6] Here, Schongauer demonstrates how Christ's face has been able to imprint an absolutely "true image" of itself upon Veronica's veil.

Robert Campin's painting *Saint Veronica* (Fig. 102) introduces further refinements into the rendering of this process. The saint, in sumptuous clothing, and standing on a flower-sprinkled meadow, wears also an elaborately wrapped headdress that is itself covered by a delicate cloth knotted at her throat. With the thumb and forefinger of each hand she holds up a transparent veil, upon which there is already a rather dark image of the face of Christ.[7] The sharp vertical and horizontal folds in the veil appear to extend only to the point where these meet the edges of the depicted face, prompting one to see this last as simultaneously imprinted upon the

6 Wolf 1995. In general: Kuryluk 1991.
7 For a fundamental study of this subject, see Wolf 2002 *Schleier*, pp. 201–12. See also Bredekamp 2010 *Doppelcharakter*.

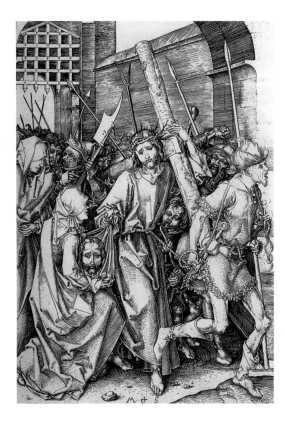

Fig. 101 Martin Schongauer,
The Passion of Christ
(Christ Carrying the Cross),
Engraving on paper, 1475/80,
Staatliche Graphische
Sammlung, Munich.

veil and floating free of it.[8] But this is not all that distinguishes Campin's painting. For Saint Veronica holds the veil not only out in front of her own body, but also sufficiently to one side that one views through it not only the rich red and green colours of her own gown and sleeves but also the predominantly golden tones of the elaborate repeating background motif of flowers and birds. The veil thus functions here as an effective window, through which various elements within Campin's composition may be observed. In art-historical retrospect one may well here be reminded of the *velum* described (in another cultural context, but at roughly the same period) by Leon Battista Alberti: that very finely woven, almost transparent cloth, subdivided by thicker threads into squares, by means of which the "visual pyramid" might notionally be bisected and on to which the objects to be depicted might mentally be "projected".[9] In this respect Campin's painting serves as a connection between the

8 On this means of encouraging the observer's response to the haptic character of the image, see Schlie 2010.

9 Alberti, *De pictura* § 31 (2006, pp. 173–79, esp. 176): "id velum" [that veil]. On this passage, see Wolf 2002 *Schleier*, p. 206.

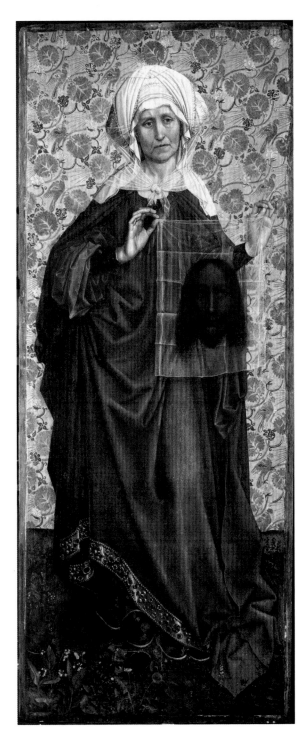

Fig. 102 Robert Campin,
Saint Veronica, Oil on
wood, c. 1430, Städel
Museum, Frankfurt am
Main.

venerable legend of the *vera icon* and the latest technical possibilities available to painters in their efforts to render three-dimensional space: a symbol, in short, of legitimised pictorial innovation.

Implicit here was also a more positive valuation of the process of reproduction in itself. As the "true image" was already understood to be a reproduction that was identical with its original, it came to be associated with reports on diverse instances of autonomous reproduction that themselves reflected positively on the overall understanding of this procedure.[10] Given the belief that the *potentia* inherent in the original could itself be preserved in the image resulting from a direct imprint, the power of the *vera icon* was in turn understood to survive its own reproduction.[11]

As in the case of the "living image", so too in that of the "true image", the entity one encounters has been generated by the organic body. By contrast, however, with the *tableau vivant*, the effectiveness of which is of limited duration (because the human body is itself able to remain absolutely still for only a brief time), the effectiveness of the *vera icon* endures because that which it preserves of the living body has become part of its own material substance. While the material substance of the *vera icon* is itself preserved, it alters significantly in the process of receiving the imprint of the organic original. The organic body is fully present within the "true image", albeit no longer comprising its original living substance. It is on this basis that the principle of the substitution of body and image is still recognised, and in fields as diverse as scientific research, systems of currency, the investigation of crime, and the modern media.

10 It was claimed, for example, that Christ's face had, of its own accord, left an imprint upon the surface of the cloth wrapped around it; and that, when the body had been walled in during dangerous circumstances, it had, entirely unaided, created an imprint upon a ceramic tile, the *keramidion* (Belting 1990, pp. 236–37; Wolf 1998, p. 158). For a reproduction of the Veronica image, see Wolf 1998, p. 156.

11 Walter Benjamin's long essay "Das Kunstwerk im Zeitalter seiner technischen Reproduzierbarkeit" (Benjamin 1974), first published, in Paris in 1936, in French translation, as "L'oeuvre d'art à l'époque de sa réproduction méchanisée" (Benjamin 1936), the title now traditionally rendered in English as "The Work of Art in the Era of its Mechanical Reproduction", still hampers the scope for an adequate understanding of this phenomenon. For a critique of Benjamin's notion of an opposition between "aura" and "reproduction" (a notion justified in neither icono-theological nor historical terms), see Beck and Bredekamp 1975, p. 89; Bredekamp 1992 *Benjamin*; Didi-Hubermann 2008 *La ressemblance*, pp.14–16, and Trinks 2008, pp. 198–200. On the preservation of substance within the reproduction, see: Kessler 1998. Fundamental on the subject of performativity: Pentcheva 2006. See also Ferrari 2005.

B. Nature printing

Through recourse to naturally occurring forms of imprint, the principle of the legend of Saint Veronica entered the realm of scientific research. Just as the imprint of the face of Christ was preserved upon Veronica's veil when this had been brought briefly into contact with it, so too might the imprint of diverse natural objects be preserved upon certain types of fabric or paper when these had been brought into contact with them. By this means, the atmospheric connection between image and body became the basis for a living, and thus active, presence that made for a valuable natural-historical document.

Having its origins in the Constantinople of the twelfth and thirteenth centuries, this technique emerged from a culture in which the tradition of the *vera icon* had assumed a particular significance. To begin with, the technique was chiefly used to achieve the imprint of plants. An individual leaf would first be pressed, then left to dry, then stained with rust and oil so that, laid between two sheets of paper and the whole put through a press, a direct imprint of each side would be found on the sheet that had been in direct contact with it.[12] The rust here used to blacken the surfaces of the leaf, so as to ensure that their imprint be transferred to the paper, corresponds to the dirt on Christ's face that ensured its imprint upon Veronica's veil. This was, however, the sole addition required in a printing procedure that might otherwise be understood as "autonomous".

One of the earliest surviving examples of this technique is the sheet in Leonardo da Vinci's *Codex Atlanticus* bearing the imprint of a leaf of the sage plant (*Salvia officinalis*) (Fig. 103). This reveals very clearly to what degree the natural object may be said to have been preserved in its own right.[13] In the imprints made by Jean-Nicolas La Hire in around 1720 (Fig. 104) the technique achieved a breathtaking quality, which was not to be outdone either by the 1733 publication of the Erfurt natural scientist Johannes Hieronymus Kniphof, or by that produced in the late eighteenth century by the Regensburg apothecary David Heinrich Hoppe. In their virtually transparent delicacy, La Hire's imprints may strike the early-twenty-first-century viewer as reminiscent of the first X-ray images.[14]

12 On this technique and its development: Nissen 1966; Lorch 1980; Heilmann 1982; *Natur im Druck* 1995; Lack 2001; Lenné 2002; *Objects in Transition* 2007; *Natur im Kasten* 2010, pp. 79–96. On the superb nature prints made by Peter Heckwolf, see: *Natur im Kasten* 2010, pp. 98–119.

13 Leonardo da Vinci, *Codex Atlanticus*, fol. 72v–a; illustrated in: Emboden 1987, p. 155. See also Lack 2001, p. 140.

14 On La Hire, see Lack 2001, p. 145. On Kniphof in 1753, see Schaldach 1988; and Geus 1995, p. 12–14. On Kniphof's technique of maintaining, even on occasion contriving, an effect of authenticity, see Habel 2010; and Klinger 2010, pp. 83–85. On Hoppe's work of 1790, see Lack 2001, p. 197.

Fig. 103 Leonardo da Vinci, Leaf of a sage plant (*Salvia officinalis*), Nature print, *Codex Atlanticus*, Biblioteca Ambrosiana, Milan.

Fig. 104 Jean-Nicolas La Hire, Leaves of the tropical vine "balsam apple / pear" (*Momordica vulgaris*; later *charantia*), Partially coloured nature print, c. 1720, Handschriften-sammlungen, Österreichische National-bibliothek, Vienna.

Implicit in the unique status of the veil bearing the imprint of Christ's face was the problem of how an imprinted image of this sort might be produced many times over. After numerous attempts on the part of a good many experimenters, Alois Auer, Director of the k.k. Hof- und Staatsdruckerei (Imperial Royal Court and State Printing House) in Vienna succeeded, in the mid-nineteenth century, in having all manner of natural objects engraved in a lead plate, then having direct or galvanised prints made from these.[15] By this means it was possible to attain reproductions of a haptic immediacy, not only of the leaves of plants but also of every other possible sort of object that occurred in nature and that was susceptible to compression. The slip-case of nature prints that Auer produced in 1853 contained not only a

15 Auer, unaccountably, terms his own technique "Naturselbstdruck" instead of "Naturdruck" (Geus 1995, p. 24). See also *Die Entdeckung der Pflanzenwelt* 2009, pp. 119–29.

Twelve Shillings.
To counterfeit is *Death.*

Burlington in New-Jerfey,
Printed by J. Collins, 1776.

Fig. 105 (left) Constantin von Ettings-hausen, Veining of a leaf of the species *Microtropis coriacea* of the Celastaceae family, Nature print, 1856.

Fig. 106 (above) Twelve-shilling bank note issued in Burlington, New Jersey 1776, Münzkabinett, Staatliche Museen SPK, Berlin.

series of plants, but also fossils, and parts of the bodies of animals, including the wing of a bat.[16] In describing his own technique, Auer emphasised that the printing process had been effected "through the original itself [...] without any need for a drawing or engraving supplied by the hand of man, as had been the case in the past".[17]

16 Heilmann 1982, pp. 122–23; *Objects in Transition* 2007, p. 22, cat. no. 2.12.

17 "[...] durch das Original selbst [...] ohne dass man einer Zeichnung oder Gravure auf die bisher übliche Weise durch Menschenhände bedarf". Cited after Heilmann 1982, p. 141.

Once again it was the iconic original, and hence the direct presence of natural animation within the image, that became the goal of scientific research.[18]

A truly historic moment in the application of this method was achieved in the 1850s with the prints of plants that the botanist Constantin von Ettingshausen commissioned to accompany his own publications (Fig. 105). In order to extend his research into the morphology of the veining of the Celastraceae family of plants into their fossilised forms he added imprints of those plant fossils that had come to light in Austrian coal seams. Through the nature printing process these fossil imprints acquired such a remarkable air of plasticity that they could be experienced as veritable high reliefs. They struck the eye itself, indeed, as a velvety substance embossed upon the sheet; and this impression was confirmed when the surface (as if it were an image devised for the blind) was caressed by the finger tips. According to Ettingshausen, in the degree of "presence" susceptible to being conveyed in this fashion there lay "truth" of a higher order than either verbal description or the invocation of scientific terminology could supply.[19]

The possibilities offered by the identification of body and image were also used by those concerned with devising secure forms of paper currency. Employing processes evolved by the Nuremberg copper-engraver Michael Seligmann and others, in the mid-eighteenth century the American natural scientist and statesman Benjamin Franklin had bank notes featuring nature-printed leaves produced for use in some of the American colonies (Fig. 106). Their motifs possessed a high degree of distinctiveness that itself served as a hint to prospective swindlers that forgery would prove difficult, if not impossible.[20] Over the following decades this procedure was adopted ever more widely among the colonists.

Franklin's own contribution consisted in having the leaves first cast in metal in order to facilitate the printing of much larger editions. To begin with a leaf would be bonded to a cloth, and the whole then cast in plaster, from which mould a metal plate would be cast and this in turn mounted on a wooden printing block. By this means, however, there again arose a connection between body and cloth on the model of the *vera icon*. As the rectangular form of the resulting bank notes reproduced the rectangular from of the cloth with which the leaf had been bonded, the material structure of the latter itself contributed to the authenticity of this form of currency.[21]

18 In the work of Carlo and Agostino Perini this technique achieved, in competition with other media, a peak of objective presence (*Natur im Druck* 1995, p. 58).

19 Ettingshausen 1857, pp. 45, 64.

20 *Natur im Druck* 1995, p. 45. Example: Geus 1995, pp. 17–19. *Objects in Transition* 2007, p. 19, cat. no. 2.8. In general: Newman 1990.

21 Bernasconi 2010.

i h gfedc b a

i hg fed c b a

Fig. 107 Late
19th-century finger
prints gathered for the
prosecution of crime.

The bank notes that had ensured greater protection against forgery through a connection between cloth and nature print made possible for the first time a stable, supra-regional currency and a system of finance based on a related degree of trust. In becoming a monetary form of the *vera icon*, this paper currency assumed a *potentia* of its own. Through their authenticity the notes strengthened the political awareness of the American colonies, in so far as each of these also drew its social consciousness from the particularities of its own natural environment. For this reason, in the years preceding the Declaration of Independence in 1776, bank notes used in America owed to the nature print process the significant contribution they were to make to an evolving national identity. Transformed into images, reproduced extensively, and with a high circulation, the printed leaves thus became "true images" of America.[22]

22 Bernasconi 2010.

That which nature-printed leaves were to the emerging sense of an American nation finds its equivalent, at the level of the human individual, in the finger print. The technique of dactyloscopy, which dates back to the time of the Assyrians and the Babylonians and was especially eagerly employed in Ancient China, made it possible to identify the imprint of a particular set of finger tips with the bearer of that particular pattern. Towards the end of the nineteenth century this was an important element in fighting crime, in which role it has since become indispensable (Fig. 107).[23] Through the nature print that is the imprint of the unique pattern of an inked finger, every individual can produce a unique "true image". Finger-printing served, and continues to serve, in the surveillance and the conviction of those suspected of committing a criminal offence; and this still determines how it is viewed. But, through its derivation from the primordial form of the *vera icon*, it can also be associated with the unmistakable individuality of a natural entity transformed into an image, in which one may see both the production of an icon and the bestowal of an element of dignity. In every case one is concerned with that effect of an image that is achieved through a body suddenly becoming a pictorial entity and, by this means, the medium of a dual existence.

C. PHOTOGRAPHY

This is also true of photography. When, in February 1947, the inventor of the Polaroid technique, Edwin Lands, publically announced the production of a self-portrait that had come about in a fashion as direct as it was mysterious, without any processing in the dark room and without any human intervention in the laboratory, it was hardly necessary to spell out a notional connection with the *vera icon* (Fig. 108). As if he had himself adopted the hand movements of Veronica and of Christ in Schongauer's engraving (Fig. 101), Lands as recorded here looks at the miraculously appearing portrait of himself. All surviving descriptions of this moment have emphasised the stirring element in the scene.[24] The event also had a particular magic because, through it, the primal experience of photography – the technically realised production of a "true image" – seemed to be recaptured, albeit now as the outcome of a procedure of apparently heightened authenticity.

The first of the images to be brought about through light and rendered capable of being preserved, which the Frenchman Joseph Nicéphore Niépce had probably been able to produce since 1822 and for which he later coined the term *héliographie*, derived from a 1650 portrait engraving of Cardinal Georges d'Amboise. Through being smeared with wax, the engraving had been rendered translucent so that, dur-

23 Heindl 1922; Becker 2005, pp. 114–35.
24 Wensberg 1987, p. 15. See also Jelonnek 2010.

Fig. 108 Edwin Lands presenting his own Polaroid self-portrait in February 1947.

ing its exposure to sunlight, light rays were able to pass through the unmarked areas, hitting and thus hardening the layer of bitumen that had been spread on a glass plate. Subsequently, those sections of the bitumen layer that had not thus become hardened were washed off, leaving on the glass plate only a rendering of lines and shapes that corresponded to those seen in the engraving: a new and enduring image. It was in essence after this model that there came about, probably before August 1826, the "icon of the history of photography" (Fig. 109): a view of the poultry yard and the surrounding fields of Niépce's country estate at Le Gras,[25] the bitumen-coated surface in this case being of pewter and the image of the sunlit subject intensified in passing through a lens fixed into the side of a box, within which the plate was carefully positioned.

In January 1839, the French theatre and diorama painter Louis Jacques Mandé Daguerre (who had briefly collaborated with the now deceased Niépce) announced a

25 Newly reconstructed by Lack 2010. Fundamental on the prehistory of photography: Geimer 2010, pp. 21–55.

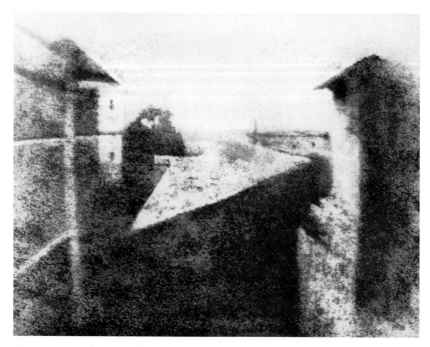

Fig. 109 Joseph Nicéphore Niépce, View of the poultry yard at his house near Le Gras,
Heliograph on pewter, 1826, Gernsheim Collection, University of Texas at Austin.

new photographic technology, subsequently known as "daguerreotype". Later that
same month the independent English scholar William Henry Fox Talbot reported to
the Royal Society of London on a new method he termed "photogenic drawing". Both
processes were understood as a form of imprint created not in the conventional way,
using some sort of physical pressure, but through the medium of light in interaction
with a light-sensitised surface. Talbot was himself deeply moved by the element of
the seemingly miraculous in what could now be achieved. In the notably poetic text
of the section of his presentation to the Royal Society entitled "On the Art of Fixing
a Shadow", he exclaimed:

> The phenomenon which I have very briefly mentioned ["photogenic draw-
> ing"] appears to me to partake of the character of the *marvellous*, almost as
> much as any fact which physical investigation has yet brought to our knowl-
> edge. The most transitory of things, a shadow, the proverbial emblem of all
> that is fleeting and momentary, may now be fettered by the spells of our
> *natural magic* [...].[26]

26 Talbot 1839, p. 6.

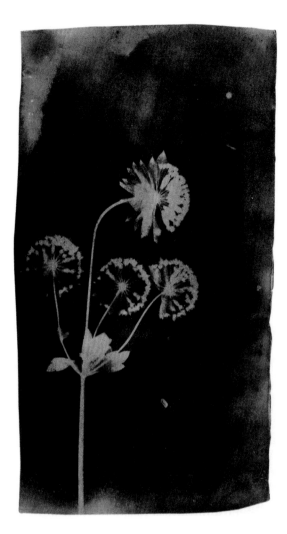

Fig. 110 William Henry Fox
Talbot, *Great masterwort*
(*Astrantia major*), Photo-
genic drawing contact
negative, 1838, Royal
Photographic Society, Bath.

Talbot regarded his experiments with "photogenic drawing" (a technique he had
first perfected in 1838) as a continuation of the nature print process, and he was
indeed himself highly regarded as a botanist. So it is not surprising that plants were
prominent among his first photographic subjects.[27] His record of a great masterwort,
or "melancholy gentleman" (*Astrantia major*), produced in November 1838 (Fig. 110),
recalls the nature prints of earlier centuries.[28] It was, however, with the more delib-
erately "invented" and more scientifically sophisticated paper-sensitising process

27 Smith 1993, pp. 39–41, note 59; Lack 2003, p. 91.
28 Lack 2003, p. 90.

that Talbot first perfected in the summer of 1840, making crucial use of gallic acid, and which he called "calotype" (from the Greek *kalos*, beautiful), that he was able to make his name. Here, after a very much briefer exposure to sunlight, an image would be imprinted on the sensitised paper in a "latent" state, as yet invisible to the human eye, and would be only thereafter "developed out" through further chemical rinsing of the paper surface, the images obtained in this fashion generally proving far more stable than those derived through "photogenic drawing". While both the earlier and the later photographic processes produced, in the first instance, images that were negative renderings of what the human eye had seen, in both cases a "positive" paper contact print might be obtained through effectively repeating the exposure process so as to produce the "negative of a negative".[29]

It was in order to advertise the advantages of his own processes over that of Daguerre (whose technique had meanwhile rapidly established itself as an intriguing form of portraiture, but offered little scope for further adaptation or wider dissemination) that Talbot resolved to issue what was to become the world's first commercial publication to be illustrated with photographic images, in the form of salt paper contact prints derived from "calotype" negatives. As *The Pencil of Nature*, this appeared in six instalments (more were initially planned) between June 1844 and April 1846, each comprising a number of photographic images (there were to be twenty-four in total) accompanied by texts. The initial instalment also contained "Introductory Remarks" and "A Brief Historical Sketch of the Invention of the Art". Here, Talbot was to insist that the images presented were not the work of an artist but were "impressed by Nature's hand".[30] This new pictorial medium made it possible to create works of a higher order, works informed as much by an aura akin to that of the *vera icon* (itself produced not "by Nature's hand") as by the "presence" achieved through nature prints. For what had previously been the outcome of the pressure of a plant upon a suitably prepared surface could now be achieved through "the mere action of Light upon sensitive paper".[31]

The fact that Talbot's statement was to be understood in a religious as well as in a naturalistic or realistic sense is underlined by an image made in 1839 by the German physicist Johann Carl Enslen (Fig. 111), which in 1840 was acquired by

29 The use of the terms "negative" and "positive" in the context of photography was first suggested by Talbot's friend the polymath Sir John Herschel, in a paper read to the Royal Society on 20th February 1840. See Schaaf 2000, pp. 19 and 236, note 47.

30 Talbot 1844, "Introductory Remarks", para. 3.

31 Talbot 1844, "Introductory Remarks", para. 2. See also Geimer 2001 *Photographie*, p. 141. In this case nature works in an even stronger way than it is required to do in the case of a nature print, though itself alone. See also Stiegler 2006, pp. 43–45.

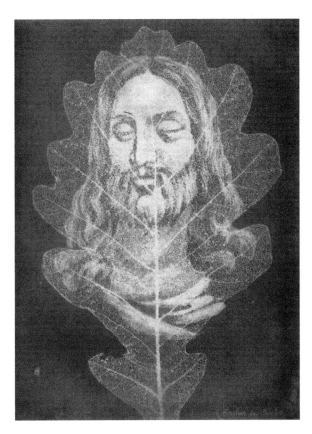

Fig. 111 Johann Carl Enslen, *Head of Christ in an oakleaf,* Lithograph overprinted with a photographic image, 1839, Universitätsbibliothek, Tübingen.

Talbot.[32] A sheet bearing a lithographic image of Christ's head had here been used as the sensitised surface to be imprinted with the photographic image of an oak leaf so that, at least in the upper half of the sheet, the plant form appears as if it were an undulating halo around the divine face. The simulation of a nature print is here suggestively combined with an image drawn from the same shared origin in the iconographic tradition of Veronica's veil. Here it is made clear in exemplary fashion how deeply the early exponents of photography understood it as the heir to a process with its origin in the *vera icon* and its traditions moulded by the nature print. Discussion of the Turin Shroud – which strikes us now as resembling a photographic

32 Enslen's authorship is attested both through his signature and through a second copy that, together with other such works, has been preserved (Oettermann 1989, and Oettermann 1995). See also Arnold 1989, and *Objects in Transition* 2007, p. 15.

negative produced through radiation, then rendered again positive – also con-tributed to integrating photography into the tradition of the "true image".[33]

Representatives of those natural sciences most concerned with morphology, as also of medicine and of art history, have consistently seized on the promise of "substitution" implicit in photography. In 1863, speaking as a pioneer in the use of photography in the natural sciences, Joseph von Gerlach enthused about the scope this offered for a genuine self-representation of the object;[34] and in 1865 the art his-torian Herman Grimm characterised the album of photographs of works of art as "perhaps more important today than the largest galleries full of originals".[35] Fifteen years later the bacteriologist Robert Koch spoke in much the same tone: "The photo-graphic image of a microscopic object is, in certain situations, more important than this object itself".[36] The notion that a depicted reality was materially embodied in the photograph recording it extends right into the latest theories of photography, which start from the assumption that a photograph establishes a magical connec-tion with the reality of the long-lost object depicted there, and not least that there is an "indexical" relation between the two.[37]

A counter-movement has, nonetheless, never tired of emphasising, in opposi-tion to the idea of a substantial proximity between the original object and the derived image, the constructed quality of the photograph and, above all, of criticis-ing the notion of the unconditional "presence" of the image. That a photograph rep-resents a photograph and not, for example, the mediated true presence of another object or body, has become one of the commonplaces of constructivist photographic theory; and there have been countless attempts to point out the essentially fictional quality of posed, simulated or manipulated photographs.[38] In questions of law it is usually necessary to supply circumstantial authentication for photographs sub-mitted as evidence. This form of testimony was substantially debated and codified in the context of the Nuremberg Trials of 1945–49 and during the Frankfurt Ausch-witz Hearings of 1963–67.[39]

33 Fundamental: Geimer 2001 *Nicht von Menschenhand*, and Geimer 2010, pp. 175–251. See also
 Belting 2005, pp. 66–67, on, among other subjects, André Bazin's linking of photograph and
 body in the manner of a reliquary (Bazin 1999, [1945]).
34 Gerlach 1863, Introduction.
35 Grimm 1865, p. 38.
36 Koch 1881, p. 11; on this: Bredekamp and Brons 2004, and in general: Daston and Galison 2002.
37 Krauss 1985. As initially used, the concept related to photographs as testaments to ephem-
 eral performances of 1976. As a term used more generally in photographic theory it is over-
 loaded (Wittmann 2010, pp. 3–4).
38 *Alles Wahrheit! Alles Lüge!* 1996.
39 Brink 1998. On current practice: Leitner 2007.

This relativisation is, however, countered by the fact that, notwithstanding all evidence to the contrary, it is impossible to shake off the assumption that what one sees in the photographic image is a corporeal trace of what is depicted there. Roland Barthes's own theory emphasised this insistently in regard to the photograph of his own deceased mother.[40] And, in principle, it is the case that hope invested in the identity of body and image has flourished above all in situations of danger and uncertainty. As mentioned at the start of this book, today as in the past it is above all in times of social upheaval and those marked by collective crime that both individuals and societies are moved to see in photographs an authentic image of reality.

One of the most disturbing episodes in the history of photography is associated with those few shots from the concentration camp at Birkenau that were taken, at the risk of their own lives, by members of one of the Sonderkommandos. When, in 1941, a strict ban on photography had been imposed, flouting this ban and then having photographic evidence smuggled out of the camp was seen as the last possible chance to secure proof of the reality of the "killing machine". In those photographs that did eventually reach recipients capable of understanding their terrible significance the victims, although by then long dead, were regarded as themselves in a certain sense "present".[41]

This insuperably extreme instance is related to the original motif of the "true image". The first pictorial medium is the product of a religious drama, and all further visual mediators derive to some degree from this starting point. But, even if the *vera icon*, in its identifying of body and image, has provided a basis for the exchange of these two entities, this does not mean that similar forms of cohesion were not possible, be it in European Antiquity or within other cultures. And if the connection of image and body in what follows will be considered both in its stabilising and creative as well as in its destructive aspects, then nor does this mean that the Christian legend of the original image is alone responsible for both extremes. But one is, nonetheless, left with the extraordinary fact that the aspect of the corporeal and the reliquary in the *vera icon* and the consequent appreciation for reproductions have always privileged the invention of ever more reproductive techniques, albeit with-

40 Barthes 1980. On this: Lethen 2006.

41 Didi-Huberman 2003, pp. 35–36. As this connection between body and image was one that had evolved within Christian-Byzantine tradition, Didi-Huberman has been accused of re-invoking the cult of relics, and this has led to far-reaching reflection regarding how close to reality is this medium. Didi-Huberman's conclusion had been methodically prepared through his own earlier work on the process of imprinting: his long introductory essay for the catalogue of the Paris exhibition he curated in 1997, *L'Empreinte*, is republished in *La resemblance* 2008. See also Geimer 2007, pp. 120–22; Geimer 2009, pp. 45–51. On the relationship between reality, photography and painting, with attention to the paradigmatic case of Théodore Géricault's *Raft of the Medusa*, see also Trempler 2005, pp. 193–99.

out a definitive rejection of the hope to find, in the reproduced image, "truth" in the original sense. This fundamental motif, of regarding body and image as interchangeable, is the basis of the substitutive image act.

2. Forms of Substitution in a Social Context

A. Communal symbols

One realm in which the substitution of body and image occupies a dimension of its own is that of symbols of sovereignty. At least metaphorically, these have always derived their authority from the notion that they are the substitutive reproduction of a "true image". It is after this pattern that, to this day, every type of authoritative document bears a seal.[42] The image on the seal serves as an act of law in a form as similarly direct as does an act of speech in the naming and launching of a ship. It certifies and authorises documents, objects and spaces.

Much the same occurs, *mutatis mutandis*, in the case of coins, which operate in reference not to other objects, but only to their own materiality. They are derived from the notion of being formally impressed repositories of the "true image". A valuable, mid-tenth-century gold coin from the reign of the Byzantine Emperor Constantine VII bears, on one side, an image of Christ and, on the other, an image of the Emperor, in each case understood as an authentic representation (Fig. 112).[43] As the "true images" have been stamped in the metal, such a coin becomes a visible and tangible object of a certified value. Without these images the material value of a coin has to be verified and negotiated. Once stamped with them, however, it becomes the object of an assumed transfer protected through trust that defines and stabilises its worth. In as far as images make the gold coin into a customary method of payment, defined in terms of cultural and ecclesiastical authority, currency depends on the trust that is conveyed by the images as regards the determination of value. The stronger the authorisation, the more complex and the more proof against forgeries will be the image. Like seals that are sufficient unto themselves, coins are an elementary form of the image act that guarantees both possession and exchange. As demonstrated by Benjamin Franklin's nature prints, paper currency functions in accordance with the same socially accepted understanding.

This sphere, which has conditioned almost all forms of rule and systems of law, from the earlier types of human society to the media democracies of today, was

42 *Treasures of Mount Athos* 1997, pp. 433–507. See also Pentcheva 2006, p. 634. On the seal: Wenzel 1995, p. 67.

43 Pentcheva 2006, p. 635.

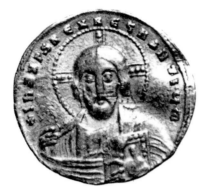

Fig. 112 Coin bearing images of Christ and of the Byzantine Emperor Constantine VII
(r. 945–959), Gold, mid-10th century, Dumbarton Oaks, Washington, D.C.

considered by two philosophers – one of the early Modern period (Thomas Hobbes)
and one of the early twentieth century (Alfred North Whitehead) – in a manner that
retains to this day an exemplary relevance. Although neither employed a term
strictly equivalent to *substitutive image act*, it is nonetheless clear that they were
both thinking in terms of such an entity.

This is especially true of Hobbes, whose theory of vision was concisely
defined, in January 1645, in a letter to his friend Samuel Sorbière:

> Vision (*visio*) comes about through the action of a shining and illuminating
> object, and that action is a local motion caused by a continual pressing of the
> medium from the object to the eye.[44]

Seeing, accordingly, is a human reaction to the pressure unleashed by objects as
their pulsating surfaces give off light, and conveyed to the eyes through the ether. It
is an enforced action. As everything embraced within the concept of the "political"
similarly comes about through pressure exerted in space, then images (which
humanity encounters incessantly and everywhere) represent, for Hobbes, the most
comprehensive concept of the "political" that it is possible to imagine. It is hardly a
coincidence that no philosopher or theoretician of the state either before or after
Hobbes has made a greater effort to establish visual strategies as the core of a politi-
cal theory.

44 "Visio fit per actionem objecti siue lucidi siue illuminati, estque illa actio motus localis fac-
 tus per medij pressionem ab objecto ad oculum continuam" (Hobbes to Sorbière, 8 January
 1657, in Hobbes' *Correspondence* 1994, Vol. 1, no. 112, p. 428; trans. p. 429). On the "pressure"
 involved in vision, see Springborg 1997, pp. 283–84, 287–88. On the theory of the image: Jacob
 and Raylor 1991, pp. 228–29.

Fig. 113 Abraham Bosse, Frontispiece (detail) to Thomas Hobbes,
Leviathan, London 1651.

In his exposition of the motivating scope of images, Hobbes reaches beyond
the limits of what one may physically perceive in nature. He chose the sight of dark
clouds to develop what may here be understood as his own version of a notion of the
image act. For, just as when one looks upon such clouds, the rain that is sure to fall
enters the view in the form of anticipation, so too are entire sequences in turn
associated with this rain; and these sequences then transform "marks" (the images
derived from an individual's memory) into "signs" (generally relevant tokens of
action).[45]

The image of Leviathan (Fig. 113) has completed such a progress from "mark"
to "sign". In as far as Hobbes's frontispiece has become a "sign" of the state, it
acquires, be it through familiarity or through an effect of shock (the two possibil-

45 Hobbes, *De Corpore II*, 1–2, in Hobbes, 1839–1845, Vol. 1, p. 15 (on definition: Vol. 1, p. 14). See
also Malet 2001; Malcolm 2002, pp. 226–27, and König 2008, pp. 336–48.

ities offered by the printed image) a character that is related to action. It becomes a trigger for action that is not, or not primarily, limited to or by language.[46] Without negotiated agreements, articulated in words, there can be no life in common; but these words are unlikely to be effective, to be adhered to, if they are not protected and supported by weapons and by images. As, according to Hobbes, all the achievements of civilisation are at all times countered by the natural passions, the deployment of "terror" on the part of a recognised authority is required if these achievements are to be fostered.[47] Contracts, according to a key sentence in *Leviathan*, are in perpetual danger of being broken by their signatories "if there is no visible Power to keep them in awe".[48]

Hobbes's considerations on what may here be understood as the workings of the image act had the goal of positioning the visual presence of Leviathan as a form of shield against the threat, in mid-seventeenth-century England, of Civil War. All the organs of the state and, at their inception, all civilisations, form part of this moving image. This fundamental concept of democracy was later regarded as so excessively mighty that it had to be protected against itself through a separation of powers. Hobbes's presentation has, nonetheless, exerted an almost perpetual influence upon theories of the state right up to the present day.

Whitehead's theory of "symbolically conditioned action" transferred Hobbes's reflections to the context of modern democracies, in the process re-defining the socially motivating images not as sacrosanct entities, but rather as symbols that were themselves subject to change. His most vivid example of the validity of symbolic forms comprises entities that effectively combine to create those military guidelines that enable troops in life-threatening situations to act not as individuals possessed of free will, but as members of a cohesive unit. Flags and banners, in addition to the synaesthesia of the beating of drums and sounding of trumpets combined with those pictorial symbols through which military units define themselves, establish for Whitehead the foundation of such corporate military activity. It is through these means that symbols of a state's authority are preserved in precarious circumstances.[49] If, however, the historical conditions alter, claimed Whitehead, the pictorial symbols must accommodate themselves to the change. Societies collapse

46 The prevalent interpretation of *Leviathan* as a machine for discourse tending in the direction of a compendium of linguistic and analytical principles ignores this substantial aspect of Hobbes's *magnum opus* (Bredekamp 2006 *Hobbes*). For further discussion on this point, see Manow 2007.

47 "[…] the terror of some power […]" (Hobbes 1991 [1651], *Leviathan*, XVII, p. 117).

48 Hobbes 1991 [1651], *Leviathan*, XVII, p. 117.

49 Whitehead 1928, pp. 88–89.

if, under altered conditions, such symbols are not also susceptible to the "freedom of revision".[50]

This interplay between images conducive to action and retroactive strategies in support of the community brings into focus the manner in which the image act functions, even where the concept itself is not explicitly invoked. In speaking not of static entities, but of the necessity, over long periods of time, for communities to accommodate themselves to images, and images to communities, Whitehead introduces a category of symbolic mobility that touches on the complex system of political iconography as it has been developed, among art historians, since Aby Warburg's work on the imagery of the Reformation.[51] Here, one finds in particular the idea that images not only sustain communities, but also, through their political character, generate goals for the sake of which action is taken. Images can oppose reality in an exigent fashion.[52] Politics requires images, it gives rise to images; but it can also follow where images may lead.

B. PICTORIAL PUNISHMENT

In the expectation that images and bodies enter, to a certain degree, into a relationship of reciprocal identity, representation may be seen to tip over into substitution. This process is especially clear in the law. For one is here concerned with a sphere in which images and bodies may well be treated in a substitutive manner.

Until some way into the nineteenth century images in which a punishment was shown being carried out in a legally regulated fashion were used as entirely valid substitutes for the individual who in reality had yet to be apprehended and punished. The fact that a depiction of the punishment of a criminal or a traitor was itself regarded as an act of law was spelt out, in 1697, in Jacob Döpler's *Theatrum poenarum*:

50 Whitehead's remarks on the necessity of symbols for the functioning of societies may be recognised as paradigmatic (Whitehead 1928, pp. 70–104, here in particular p. 104).

51 Warburg 1998, Vol. 1, 2, pp. 483–558. It is here possible to cite only a few exemplary texts from the extensive research on political iconology. On the programmatic aspect: Warnke 1993; Warnke 1994, Diers 1997. On landscape: Warnke 1992; and *Politische Räume* 2003; on gesture *Politische Kunst* 2004; on the Early Modern Period: *Krieg der Bilder* 1997; on the twentieth century: *Mythos der Nationen* 2004. In addition, in each case under the appropriate heading: *Handbuch der politischen Ikonographie* 2011.

52 Warnke 1997, p. 183. It is in this that there lies the quintessence of the analysis of Peter Paul Rubens's *Medici Cycle* (Warnke 1997, pp. 160–99). See also Hogrebe 2006, pp. 195–97.

Fig. 114 Scene of executions by hanging and by firing squad, Engraving on paper (detail) published in Hans Friedrich von Fleming, *Der vollkommene Teutsche Soldat*, Leipzig 1726.

It is praiseworthy and well-advised that one should try, before a court of law, such hardened miscreants (be they living or dead) and, at the end of the trial, with a verdict having been formally pronounced, proceed by carrying out in full the announced punishment on the painted portrait of that individual.[53]

This type of legal practice long remained in force in Prussia. The exchangeability of image and body was, indeed, emphasised in the statute book *Allgemeines Landrecht* [General Law of the State] of 1794: "If someone, having been found guilty of high treason, has evaded corporal punishment through flight or has died before the enforcement of the verdict, then, exceptionally, the punishment corresponding to

53 "So ist löblich und wohl eingeführt, dass man solchen ausgetretenen Missertätern, sie mögen lebendig oder tot sein, den Prozess mache, und nach Endigung dessen, auch geschehenem rechtlichen Spruch, die Execution, und was sie vor eine Strafe verdienet, in ihrem gemalten Bildnis ergehen und vollstrecken lasse." (Döpler 1697, p. 626, cited after Preisendörfer 2000, p. 286). On the practice in general, see Ortalli 1979; Edgerton 1985; Freedberg 1989, pp. 249–63; Lentz 2004.

the individual's status and means, as also the incurred corporal punishment, shall be carried out upon his portrait".[54]

This linkage between body and image is made especially clear in an engraving from the early eighteenth century (Fig. 114). Attached to the cross-beam of a tall

Fig. 115 Illustration from a defamatory letter addressed by Count Johann III of Nassau-Dillenburg to Duke Johann of Bavaria, Count of Holland, Watercolour, c. 1420, Hessisches Hauptstaatsarchiv, Wiesbaden.

gallows projecting to the right is the head-and-shoulders portrait of the miscreant, while in the foreground his accomplices are being executed by a firing squad.[55] It is clear that, as the depicted punishment anticipates the physical apprehension of the chief culprit, a court martial is here availing itself of, and thereby re-confirming, the legal power of the substituted image.

The same legal capacity for visualisation was possessed by defamatory images, which were usually intended to constrain a formally sentenced individual to act in accordance with the wishes of the plaintiff. The right to prepare illustrated insults or to publically display such defamations was thus very often integral to

54 "Wenn jemand, der des Hochverrats schuldig befunden wird, sich der körperlichen Strafe durch die Flucht entzogen hat oder vor Vollstreckung des Urteils gestorben ist: so soll, ausser der übrigen die Ehre und das Vermögen betreffenden Ahndung, auch die Execution der verwirkten Leibesstrafe an seinem Bildnisse vollzogen werden." (*Allgemeines Landrecht*, Part II, Section 20 § 99, cited after Preisendörfer 2000, p. 286).

55 Brückner 1966, fig. 16, p. 274.

Fig. 116 Illustration from a defamatory letter addressed by Hans Besenrade to Asche von Cramm, Watercolour, 1524, Geheimes Staatsarchiv, Staatliche Museen SPK, Berlin-Dahlem.

drawing up a contract. If a debtor was not in a position to pay his creditor the agreed sum, the creditor had the right to post an image that dishonoured the debtor.[56] The defamatory watercolour made in around 1420 and directed by Count Johann III of Nassau-Dillenburg against the defaulting Duke Johann of Bavaria, Count of Holland, shows the latter forcing his own over-sized seal into the hindquarters of a sow (Fig. 115). Linked with the insult was the threat that this image might be displayed anywhere.[57]

The letter accompanying a defamatory image of this sort explained that the plaintiff would expose the three high-ranking debtors through publically displaying such images until the debt had been repaid.[58] These images were able to fulfil their function above all through serving not as an arbitrary form of denunciation, but as the instrument of a recognised legal process.

56 Brückner 1966, p. 219.
57 Lentz 2004, no. 23, pp. 177–78, unnumbered colour plate.
58 Lentz 2004, no. 89, pp. 238–9, unnumbered colour plate.

This practice was all the more impressive in that it was increasingly used in relation to socially asymmetrical relationships. It is apparent that defamatory letters served as a means of upholding the rights of the bourgeoisie against those of the nobility. When a watercolour made in 1524 shows the parts and limbs of the quartered corpse of a member of the noble Cramm family gruesomely displayed on hooks along the crossbeam of a gallows (Fig. 116), one would be justified in assuming that the social hierarchy as traditionally understood has here been drastically turned upside down.[59] Images of this sort offered socially inferior individuals or institutions an effective means of reversing the conventional social asymmetry to their own advantage.

In societies in the West the legally standardised practice of substituting images and bodies for each other came to an end with the invention of photography. The turning point came in France in 1858, when the relatives of the celebrated actress Elisabeth Rachel Félix, who had recently died at the age of only 36, were able, through a court order, to prevent the publication of a photograph that Charles Nègre had taken of her on her deathbed. This ruling effectively secured legal protection, on behalf of the depicted person, for such a photograph. The ban on publication of the photographic image, in the 1858 case, was intended to protect the personality of the individual who, being deceased, had already in effect become an image of herself.[60]

In Germany a similar incident made it possible to arrive at a legal definition of an individual's rights regarding images of himself. A photograph taken, without authorisation, by Max Priester and Willy Wilcke, of the former German Imperial Chancellor Otto von Bismarck in the early hours of 31st July 1898, on the bed in which he had died in the preceding night (Fig. 117) became the object of an embittered lawsuit. When the case came to court the two defendants were found guilty of a violation of the privacy of the deceased through publishing their photograph, and were accordingly both given prison sentences. The photographic image was here in effect restored to the image that the deceased person had now become. The person and the image were, *post mortem*, once again defined as a single entity, albeit not through the carrying out of a punishment, but in terms of an individual's (even a deceased individual's) legal rights. The image legally belonged to the image of the deceased. A substitution of image and body had thereby come about in which the latter was firmly subordinated to the former.[61]

59 Lentz 2004, no. 85, pp. 234–35, unnumbered colour plate.

60 *Le dernier portrait* 2002, pp. 159–60; Sykora 2009, pp. 67–68. See also Bartnik 2004, pp. 28–29, 230–32, referring in addition to the ban on drawings.

61 On this case, see, most recently, Girardin and Pirker 2008, pp. 50–53; Sykora 2009, pp. 68–79, here in particular p. 73.

Fig. 117 Max Priester and Willy Wilcke, Otto von Bismarck on his deathbed, 31 July 1898, Photograph, Archive of the Otto-von-Bismarck Foundation, Friedrichsruhe bei Aumühle.

This case served as a catalyst for legal considerations on the feasibility of locating images within the domain of the protection of the individual personality. Two years earlier, in 1896, Hugo Keyssner had formulated a doctrine which was to determine all subsequent debate on this matter: "The representation made by the artist belongs, from the moment of its creation, to its original or to the person who commissioned it". It was as if Keyssner were here saying that Saint Veronica's veil bearing the image of Christ's face ought, legally speaking, to be handed back to Christ. "The archetype holds sway over its own replica".[62]

As the person portrayed was thereby addressed as the archetype, and thus implicitly situated on the same conceptual level as the replica, the legal dimension of the substitutive image act was reinforced. On the other hand, this also necessarily brought an end to the practice of pictorial punishment, for the reproduction could no longer be employed as a substituted double. The court ruling had merged the portrait (understood in the tradition of the *vera icon* motif) with the depicted person to such an extent that it became impossible to employ the image as a legal means of distanced substitution for the person's body. A later legal restriction ensured that individuals of contemporary historical significance were less strongly protected than were persons who, from the pictorial point of view, had nothing to protect but themselves and their outer appearance. It is also telling that legal protection was

62 Keyssner 1896, p. 2. On this and on subsequent practice regarding legal verdicts, see also Bartnik 2004, pp. 13–18.

Fig. 118 Nastasja Weitsz, Alexander Litvinenko on his deathbed in London, November 2006, Photograph.

upheld even more insistently in the case of suspected offenders, in order to avoid the pillory effect that had earlier belonged to the practice of pictorial punishment.[63]

The publication of images in connection with legal procedure has, however endured in the case of "wanted" posters and their medial extensions, even though their use is limited to suspects in cases of especially serious crime.[64] Here, the practice endures of rendering the miscreant present through an image. In the photographs on "wanted" posters one finds a weakened form of the substitutive image act: the image is here displayed in the hope that one may at length be able to exchange it for the body, "dead or alive".

The technological means now so widely available have posed new problems for legal practice. On one hand the legal right to one's own image, assured through the European Court for of Human Rights, has been strengthened in the wake of its collision with the ruling previously issued by the German Federal Constitutional Court in the case of Princess Caroline of Monaco. For now, even photographs of persons of contemporary historical significance that have been taken in a public place may not deliberately be published.[65] On the other hand, the ubiquity of both publically and privately operated surveillance cameras and the possibility of using the

63 Bartnik 2004, pp. 169–70.
64 Bartnik 2004, pp. 221–23. On the prehistory of this process: Groebner 2004.
65 Verdict of 24th June 2004. For the history and an appraisal, see Klett 2007.

camera facility of mobile phones to take photographs of people and to disseminate these through the internet represent a source of images which itself forces the administration of justice on to a structurally conditioned defensive.

However strenuous the attempt to suppress traditional forms of pictorial punishment, there is little likelihood of delimiting punishment exercised through images in non-state institutions and independent associations, let alone through the uncontrolled dissemination of private images. The legal system would seem, indeed, to be challenged by the sheer number of individual cases.[66] The consideration that person and image constitute a relatively closed module of dignity has the effect of diffusing pictorial punishment back into its pre-modern form, even though this has never been legally codified. With this, however, one touches upon the question of the illegal substitutive image act, which has become one of the most pressing problems of contemporary society.[67]

An example of the interplay between the visual and the actual use of violence towards certain groups or individuals arose in 2006 with the case of the Russian dissident Alexander Litvinenko. As recorded on video, his image was being used for target practice during the training of élite military units even before he was radioactively poisoned in London by agents of the Russian Secret Service. On 24th November 2006, one day after his death, a photograph taken very shortly before that of the manifestly fading Litvinenko – who looks at the camera from his bed, physically weakened but mentally unbowed (Fig. 118) – was released internationally for publication in the press, in order that it in future serve as a symbol of resistance against the suppression of the freedom of thought and speech.[68] The ban on the publication of the photograph of Bismarck on his deathbed, with which the notion of the individual's legal right to an image of himself had made its debut in the late nineteenth century was now, in the early twenty-first, countered by its reversal in a deliberate act of publicity in order to articulate a lasting accusation directed against the murderers.

C. Varieties of Iconoclasm

A similarly uncontrollable phenomenon, on occasion officially instigated and in other cases flaring up in anarchic fashion, is iconoclasm. This represents an application of pictorial punishment, which seeks – in times of strong religious, social and political conflicts, and mostly without legal sanction – to impact those

66 Steinhauer 2007, pp. 239–40, with a summary of recent literature.
67 See below pp. 186–92.
68 On the episode in its entirety, and its iconographic consequences in both legal and symbolic terms, see Behrmann 2009.

who are viewed as opponents through damaging or destroying the images most closely identified with them. In iconoclasm the substitutive image act is manifest, in its brutally unmasked form, at its most destructive.

On a page of the ninth-century Chludov Psalter from Moscow (Fig. 119) the substitutive potential of iconoclasm is visualised in a paradigmatic fashion. At the upper right we find Christ on the Cross. And, as is revealed by the spurting blood, the lance-bearer positioned to the left has already inflicted the wound in His side. Simultaneously, the man positioned to the right offers Christ a sponge soaked in vinegar impaled on a pike. In the lower register of the illumination the more forward placed of the two figures on the left uses a cloth attached to the point of his own lance to deface with lime a circular image of Christ.[69]

The accompanying inscription leaves one in no doubt that the two iconoclasts are here equated with the tormentors of Christ: "These mix gall and wine", one learns with regard to the men with a lance and a sponge on a pike, while those figures seen at the lower left are referred to in the words "And these mix water and lime and smear it on to His face".[70] In analogy with the re-enactment of transubstantiation in relation to an icon through the practice of mixing particles of the painted body of Christ into the wine at an evening meal, these scenes evince an identification of image and body in the visual rendering of Christ's death on the Cross.[71]

The equating of body and image has, ever since the era of the ninth-century Byzantine Iconoclasm, made Western European history into a battlefield for the substitutive image act.[72] In Kuttenberg (now Kutná Hora, Czech Republic), for example, during the early-fifteenth-century Hussite Wars, a person's position on questions relating to images was, literally, a matter of life or death: every citizen not in possession of an image of a saint was suspect, and so was killed.[73] In France in 1560, in a converse situation that was no less extreme, a group of Huguenots plundered the Cathedral, the Episcopal Palace and the Chapter House in Nîmes-la-Romaine in the Bas-Languedoc, then threw all that they had seized on to a bonfire in front of the Cathedral: images, liturgical robes, reliquaries and archival records. The destruction of the pictorial documentation of what would have been perceived as a detested church for the upper classes and of the legal records of its right to pos-

69 Corrigan 1992, pp. 140–42; Belting 2005, p. 202; *Byzantium* 2008, pp. 70, 100–01, cat. no. 50.

70 Bredekamp 1975, pp. 148–49.

71 Bredekamp 1975, p. 149.

72 On the Byzantine Iconoclasm: Grabar 1957; Bredekamp 1975; more recent literature: Thümmel 2005, and Lange 2007. For an overview: Réau 1959; *Bildersturm* 1973; Freedberg 1989; *Bilder und Bildersturm* 1990; Besançon 1994; Christin 1991; Schnitzler 1996; *Bildersturm* 2000; *Iconoclash* 2002. Still unsurpassed on the conceptual aspect: Michalski 1990.

73 Bredekamp 1975, p. 271.

Fig. 119 Christ on the Cross and the actions of iconoclasts, Illumi-
nations in the Chludov Psalter, 9th century, State Historical Museum
of Russia, Moscow.

session took place here in an ostentatious reversal of the burning at the stake of
fellow believers, and was described by an eye-witness in the following year as part
of the Huguenot "wars of extermination against the monuments".[74]

Among the examples included in Richard Verstegan's *Théâtre des cruautés des
hérétiques de notre temps*, published in Paris in the sixteenth century, Huguenots are
seen destroying the funerary monuments of the French king Louis XI in Cléry in
1562 (Fig. 120).[75] As the adherents of belief in icons are in the very same moment

74 "[…] ces guerres d'extermination contre les monuments" (Réau 1959, Vol. I, p. 93).
75 Verstegan 1995 [1587], p. 103.

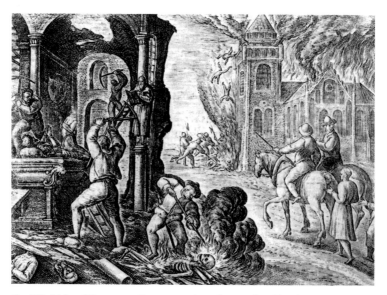

Fig. 120 Richard Verstegan, The Destruction of Graves in Cléry, from *Théâtre des cruautés des hérétiques de notre temps*, Paris 1587, Cabinet des Estampes, Bibliothèque nationale, Paris.

being thrown from the top of a church tower, this is in effect an equally deadly equating of image and person. In another source one reads of the desecration of graves: "and when they had seized him with the violence of an executioner, they chopped off his arms, his legs and finally his head".[76]

Catholics, accordingly, felt the attacks on their images to be direct assaults upon their own bodies Already during the Iconoclasm in Bohemia, Catholics had described sculptural works as living martyrs because the Hussites, as was remarked in outrage, carried out punishments upon them, "as if they believed they were striking living persons".[77] According to a report from France, the Huguenots "leave not a single image without its head chopped off, as if each figure were a living saint and capable of feeling".[78]

In a manner reminiscent of those devising gradations of corporal punishment, iconoclasts repeatedly proceeded in full awareness of questions of form. In

76 "et comme s'ils eussent tenu vif entre les mains de bourreaux, luy couppèrent les bras, les jambes et à la fin la teste" (Claude de Sainctes, cited after Christin 1991, p. 133).

77 "[...] quasi illi putarent se vivos homines". (Palacký 1873, Vol. I, p. 34; on the assault in its entirety: pp. 33–37). See also Bredekamp 1972, p. 138.

78 "Ils ne laissèrent pas une image sans lui abattre la teste, comme à un sainct vif et sensible" (Réau 1959, Vol. I, p. 70).

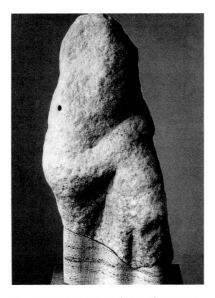

Fig. 121 Sculpted stone figure of Venus or Diana, reduced by iconoclasts to a mere torso, Rheinisches Landesmuseum, Trier.

Fig. 122 Mutilated face of the Virgin Mary, formerly in the Castle in Prague, Limewood, c. 1420, Alšova jihočeská galerie, Hlubokà nad Vltavou.

the Rheinisches Landesmuseum in Trier there is a sculpted figure of Venus or Diana, which over the centuries had been placed in chains and exposed to the stone-throwing of pilgrims, with the result that it had at length been reduced to a mere torso (Fig. 121).[79] Iconoclasm evolved as a process of verbal deformation. A similar exposing of material is to be found in a Virgin and Child at the Castle in Prague, which was mutilated by Hussites, who laid bare the unpainted wood beneath (Fig. 122).[80] Even more attentive to form were the attacks on those sculptures that, after being defaced or mutilated, were burned in front of the Cathedral in Bern (Fig. 123).[81] Over time there evolved an effective iconoclastic codex of permissible assaults, the images being punished as if they were themselves criminals. Among the most striking testaments to this practice is the portrait of an abbess at Münster Cathedral, whose face is covered with the traces of sharp blows (Fig. 124).[82] Repeatedly, the senses were attacked through the relevant organs: in order, for example, to stigmatise the Catholic Church for its fixation on the visual, the eyes of those depicted would be

79 Gramaccini 1996, p. 41. For a comprehensive account of the triumph and ultimate decline of iconoclasm in the case of the figure of Sainte Foy at the Abbaye in Conques, see Fricke 2007.
80 Bredekamp 1975, pp. 298–99.
81 *Bildersturm* 2000, no. 153, pp. 318–19.
82 Warnke 1973, p. 93, fig. 9.

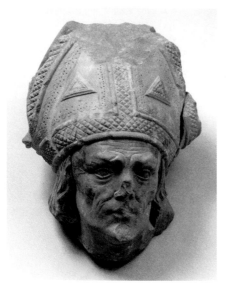

Fig. 123 Head from the sculpted figure of a
Bishop, found outside Bern Cathedral,
Sandstone, *c.* 1510/20, Historisches Museum,
Bern.

Fig. 124 Mutilated face from the
gravestone of an Abbess, Cathedral of
St. Paul, Münster.

scratched out (Fig. 125).[83] And in the case of the Protestants, whose trust was placed
in the word, the ears would be cut off and hung on a line in order to denounce the
privileging of sound above sight.[84] The struggle over images was a war in which
what could be read or heard was ranged against what could be seen: a battle of words
and sounds versus sights.

In all these instances there is evident the dilemma of iconoclasm: the fact
that it strengthened that which it denied. For the iconoclast believed images to be
lifeless and yet, in destroying them as if they were living criminals, traitors or her-
etics, he imparted to them the life he had just denied them. Measured in terms of
the degree of his activity in relation to the image, the iconoclast may be seen to be
more strongly motivated by these very images than were those who worshipped
them. In their belief that, along with the image, that which it represented was also
destroyed, iconoclasts are the agents of the destructive aspect of the substitutive
image act.[85]

83 *Bildersturm* 2000, no. 166, p. 336.
84 Réau 1959, Vol. I, p. 72.
85 Didi-Huberman 2003, pp. 84–85. See also Reck 2007, pp. 243–44.

Fig. 125 Master Seewald, *Mass of Saint Gregory*, detail showing some figures
with their eyes scratched out, Oil on pine, 1491, Stadtmuseum, Münster.

The pictorial-theological incentive of iconoclasm is never entirely absent;
and in Asia in particular it retains all its vigour.[86] It is, however, even more aston-
ishing that neither have those instances of iconoclasm that were not chiefly relig-
ious in their motivation reduced in their scale. The waves of iconoclasm set in
motion by the French Revolution of 1789, the Russian Revolution of October/Novem-
ber 1917, the Chinese Cultural Revolution of 1966, or the collapse of the Soviet Union
in 1991 have been among the most turbulent and transformative in history.[87]

86 *Iconoclash* 2002, pp. 40–59 (Pema Konchok).
87 *Bildersturm in Osteuropa* 1994; Gamboni 1997.

Fig. 126 Barnett Newman, *Who's Afraid of Red, Yellow and Blue III*, Oil on canvas, 1967/68 (with slash sustained in attack of 1986), Stedelijk Museum, Amsterdam.

A new element entered the equation, in the era of Modernism, when icono-clastic assaults were aimed at the artistic character of their objects, meaning that each of these images was not attacked as a substituted body but rather in its own right. Among the cases to have aroused most attention are the attacks committed during the 1980s on two of the four canvases of Barnett Newman's *Who's Afraid of Red, Yellow and Blue* series of 1966–70: the third (1967; Stedelijk Museum, Amster-dam; Fig. 126) and the fourth (1969–70; Neue Nationalgalerie, Berlin).[88] The question posed by Newman's paintings might, at face value, be seen to imply that there was indeed, in this case, a possibility of being filled with fear. But not every spectator recognised that the picture titles were intended both allusively and ironically. Since it was first exhibited, in 1950, Newman's work was repeatedly seen to embody a degree of outright provocation that some – among them scholarly commentators, and not only gallery visitors – felt as acutely as corporeal pain. And, on more than one occasion, a rhetorical attack on these works was followed by their being slashed.[89] The attackers involved had not understood that it was necessary to ensure a certain distance, both literal and mental, between themselves and the ostensible source of their discomfort. It was indeed in this way that the Berlin attacker justified his own

88 Gamboni 1997, p. 208. On the destruction, and the problems posed by the restoration, of the third version, see Matyssek 2010.

89 Matyssek 2010, pp. 2–4.

action: in his assault on the painting he claimed to have responded to its own terror-inducing power with an act of comparable violence.[90] The ban, since the Enlightenment, on recognising the ability of the image to think and speak, might well be seen to have induced observers, as a form of compensation, to respond with physical action. The person who had committed the attack in Berlin was in fact mentally disturbed; but the motivation came from a deficit inherent in Modernism.

Bodies, even when themselves a concrete presence, can already be images: this was indeed presupposed in the notion of the *vera icon*. Bodies can be destroyed in the name of images: in this there lies the reciprocal perversion of the principle of the *vera icon*. Images can be damaged and destroyed in place of persons or as if they were persons: this is the basis of iconoclasm. In all these processes there prevails a substitutive practice that, even when not understood as such, may nonetheless issue in an attack of one kind or another.

It is, however, out of the very logic of these processes that there emerges the notion that images ought to be formally granted a "right to life" such as would make the relationship between body and image definable in terms of mutual autonomy rather than by degrees of substitution. In this lies the most immediate and most pressing reason for developing a related political theory of the image act, able to take its stand between the two extremes in the exchange of body and image.

3. Dominion, Insurrection, War

A. Versatile sovereignty (Capua)

Motivating symbols of sovereignty, legally codified pictorial punishments, and acts of iconoclasm manifest in times of conflict represent three variants of the substitutive image act in which images and bodies can be exchanged, after the model of the *vera icon*, in such a way that individuals can be worshipped, punished or attacked as if they were images, and vice versa. One can find testaments to this practice in every period of history, and we can find them to this day. In order to be able to understand how these function within their respective historical contexts, three exemplary cases will here be presented: the City Gate of Capua as an instance of versatile pictorial sovereignty in the Middle Ages; the Pazzi Conspiracy and its consequences as an example drawn from the Renaissance; and the current "war of images" as a no less paradigmatic chain of events embracing iconoclasm and media conflict.

90 Gamboni 1997, p. 195.

The outstanding example of the effect that Hobbes and Whitehead recognised in the communicative logic of images, is the City Gate of Capua (around 25 kilometres north of Naples), erected in 1234–39, on the orders of the Holy Roman Emperor Frederick (Friedrich) II Hohenstaufen (Fig. 127). In the striking formula devised in 1987 by the historian Ernst Kantorowicz, the impression made by this structure (of which very little now remains) would have been little short of that of a

Fig. 127 Carl Arnold Willemsen, Reconstruction drawing of the Porta Capuana, 1928.

new legal dispensation.[91] The façade of the outer side of the Gate, elegantly narrow and set between the two huge towers, was decorated with a complex programme of sculptural ornament hierarchically arranged above the main register in relation to the centrally positioned, seated figure of the Emperor. Placed within the tondi above the entry arch there were three sculpted portraits. The most centrally positioned of these depicted the large head of *Iustitia Caesaris*, and the two to either side the judges subordinate to her.[92]

91 Kantorowicz 1987, p. 485. On the precise location of the Mediaeval structure; see also Belting 1997, pp. 97–98. On Capua: Verzar and Little 2006; *Kaiser Friedrich II* 2008, p. 365.

92 Michalsky 1996, pp. 138–39. Recently this head has been reinterpreted as male, and identified with that of the Emperor himself (Staats 2009, pp. 13–14, figs. 7–8). See also, however, the rejection of this proposed re-reading in Poeschke 2009.

Fig. 128 Seated figure of the
Holy Roman Emperor
Friedrich II Hohenstaufen
from the Porta Capuana,
drawn by Jean Baptiste Séroux
d'Agincourt, Pen and ink on
paper, late 18th century,
Biblioteca Vaticana, Rome.

Of the over-life-size figure of the Emperor, placed above the central portrait
tondo, only a few fragments have survived, the sole indication as to its original
appearance (except for the tentative reconstruction drawing itself, Fig. 127) being a
sketch made before the Gate was severely damaged in 1799, during the incursion of
French militias in the course of the Napoleonic Wars (Fig. 128).[93] This may well illus-
trate the general disposition of the figure, but not the striking presence that the
Emperor's sculptors had reportedly been able to convey.[94] An at least atmospheric
impression may, however, be derived through the head of a man from the same
period (Fig. 129). Its severe frontality, in addition to its vibrant gaze and its forehead

93 See *Kaiser Friedrich II* 2008, pp. 366–67.
94 *Kaiser Friedrich II* 2008, pp. 362–64.

Fig. 129 Head of a man, from southern Italy, Marble, 13th century, Bode Museum, Staatliche Museen SPK, Berlin.

clasped by short, curling locks of hair, hint at something of that complex presence of which contemporary sources speak.[95]

According to the Dominican friar Jacobus de Cassalis, writing in the late thirteenth century, all four full-length figures surrounding that of the Emperor were distinguished by the fact that each, being accompanied by an inscription, seemed to speak.[96] Taken together with the somewhat variant description already provided in 1266 by Andreas of Hungary (initially the envoy of two Hungarian kings, and later serving in Naples as court chaplain to Charles of Anjou, King of Sicily), this information allows us to reconstruct a choreographic sequence of imputed declarations.

The mighty personification of *Institia Cesaris* opened the series of four forceful pronouncements. "By right of imperial dominion shall I serve as guardian of the kingdom".[97] The theme was then taken up by the Emperor, seated directly above, and

95 Statnik 2002, p. 16.
96 Claussen 1990, pp. 20–21. On the distribution of the inscriptions, see Michalsky 1996, p. 148, note 15.
97 "Cesaris imperio regni concordia fio" (Andreas von Ungarn 1882, p. 571). An alternative record has "custodia" (custodian) in place of "concordia" (Michalsky 1996, p. 148, note 15; see also, however, the distinct argument offered by Staats 2009, p. 14). The translations employed here, and in what follows, are those supplied by Staats and Michalsky.

also speaking in the first person singular, who issued the threat: "Those I find to be inconstant shall I drown in disgrace".[98]

Andreas of Hungary expressly invokes the terrifying effect of the figure of the Emperor and his simulated pronouncement:

> The arms reaching forwards, each hand with two fingers extended, the mouth as if haughtily thundering out the wording of an arrogant threat, because this was of course inscribed there so as to cow all those hastening through the gate and all those to whom it was read aloud.[99]

In addition, the two judges whose heads were positioned to upper left and right of the arch set out for those addressed in this fashion the alternatives of security and punishment. While the judge on the left signalled the reconciliatory aspect of salvation in proclaiming "All those may safely enter who strive for a pure life", the judge on the right countered this with "He who proves disloyal shall fear arrest and imprisonment".[100]

Here in Capua, then, as earlier in the case of the figure of Phrasiklea (Fig. 17), one finds an evocation of the interplay between a sculptural work apparently filled with life and the capacity to speak through the device of a textual inscription implicitly intoned by that very same speaking sculpted figure. The effect is here further enhanced in that those speaking utter their lines in the first person singular and from a literal and symbolic position of authority, addressing directly those who approach, and thereby even further strengthening the imperative character of their statements. They here served as mediators of an imperially sanctioned image act.

B. REVOLT (FLORENCE)

The notion that images can be fully valid bodies in another form and consistency led not only to the practice of iconoclasm but also to the diametrically opposed alternative: that absent individuals or institutions might be rendered present with the help of images. To this belongs the practice of the votive cult, in which persons, or parts of their bodies, were displayed in the effort to bring about their true healing or to ensure that a successful recovery from illness would endure.

98 "Quam miseros facio quos variare scio" (Andreas von Ungarn 1882, p. 571).

99 "[...] extensis brachiis duobusque digitis, quasi os tumide comminacionis versiculos intonantem, quia etiam ibidem ad metum transeuntium ac eorum quibus recitantur sunt consculpti" (Andreas von Ungarn 1882, p. 571). See also Claussen 1990, p. 20.

100 "Intrent securi qui querunt vivere puri / Infidus excludi timeat vel carcere trudi" (Andreas von Ungarn 1882, p. 571).

This type of votive practice could be used both for individuals in their own right and for individuals in their capacity as holders of some form of office; yet, when the body of someone of consequence and power entered the equation, this form of exchange assumed a political, legal and military dimension. In contrast to the stable signs of order represented by seals, symbols of state and forms of currency, this type of substitutive image act is mostly employed in dramatically critical situations. The sequence of events set off by the Pazzi Conspiracy, in the history of the Republic of Florence, will serve here as an example.

The starting point for this episode lies in the conspiracy against Medici rule hatched in 1478 by the rival clan of the Pazzi. On 26th April of that year, during Mass at the Cathedral in Florence, the only event attended by the Medici without their bodyguards, Giuliano de' Medici was stabbed and killed by Bernardo di Bandino Baroncelli. Giuliano's elder brother, Lorenzo il Magnifico, was himself not mortally wounded during the attack, and so he was at once able to embark upon pursuing forms of revenge.

These were to comprise a double-edged use of the substitutive image act. While the enemies of the Medici were executed, both bodily and pictorially, Lorenzo appeared in public both in person and in the form of life-size wax figures. These, in accordance with the "two bodies theory", presided in Lorenzo's place on certain official occasions, thereby standing in for him in attesting to the intactness of his own office.[101] One of these effigies was dressed in the blood-spattered clothes in which Lorenzo had appeared, shortly after the stabbing, at a window of the Palazzo Medici, in order to prove to the Florentine populace that he had himself escaped with his life. As this wax figure was set up next to the wonder-working crucifix in the keeping of the nuns of the Convento di Chiarito, Lorenzo's portrait took on, in addition to the character of a votive image, also the aura of miraculous salvation. A second figure was positioned in front of the Madonna of the church of Santa Maria degli Angeli in Assisi, and a third at SS Annunziata: the Servites' church, much associated with the Medici, in which a votive cult in existence for over two centuries had ensured the accumulation of a veritable cabinet of wax figures.[102] The wax figures of Lorenzo de' Medici were seen as capable of healing the real wounds of the living image. In as far as these effigies admitted the intactness of Lorenzo il Magnifico, they operated as a compelling assertion that Medici rule was just as unharmed as was each of these.

101 Giorgio Vasari reports that Orsini Benintendi made three votive figures which so closely re-sembled Lorenzo de' Medici that "non si può veder meglio, ne cosa piu simile al naturale" (Vasari 1906, Vol. III, p. 374). See also Freedberg 1989, pp. 225–26; Kohl 2007, pp. 90–91. On the "two bodies theory"; Kantorowicz 1990 [1957].

102 Waldmann 1990, p. 35; Kress 1996, pp. 175–84; Bredekamp 2000 Medici; Belting 2002, p. 34; Panzanelli 2008, p. 17. On the subject of wax effigies in general, see also Kornmeier 2008.

They thereby triggered, however, a chain reaction that characterised one of the most dramatic episodes in the history of Florence.[103]

The adopted counter-measures succeeded in the apprehension of the conspirators. Within a few days over seventy individuals, among them the Archbishop of Pisa, had been executed, and their corpses were then hung in the windows of the Palazzo della Signoria and of the Bargello; and by mid-May a great many more executions had taken place, on occasion followed by ghastly defilements of the corpses.[104] Simultaneously, the healing function of images was transformed into part of the punishment, for the celebrated Florentine artist Sandro Botticelli was commissioned to paint, in fresco, defamatory images of the chief conspirators, who were members of the Pazzi family, and their accomplices above the main door of the Dogana, which stood next to the Palazzo Vecchio.[105] An anonymous inventory of Botticelli's work drawn up in the early sixteenth century offers a remarkably laconic description of this image:

> In 1478 he painted on the façade of the former Palace of Justice above the Dogana, Jacopo, Francesco and Rinato de' Pazzi and Francesco Salviati, Archbishop of Pisa, and both of those by the name of Jacopo Salviati (one being the brother and the other the brother-in-law of the said Francesco) and Bernardo Bandino, hanging by the neck, and Napoleone Francese, hanging by one foot.[106]

A drawing of the 1490s, now ascribed to Filippino Lippi, perhaps alludes to such a form of defamation (Fig. 130): it shows the figure of a miscreant, with contorted face, dangling upside down with one foot secured by a rope to a beam.[107]

103 It would be possible to trace an inherent practical purpose in those representational wax figures made, in all likelihood, after the Pazzi Conspiracy and serving as tokens of loyalty (Bredekamp 2000 *Medici*, p. 293). See also Botticelli 2009, pp. 134, 166 and 174–75.

104 Landucci 1883, pp. 17–22.

105 On 21st July 1478 Botticelli was paid for his fresco of the murderers ("in pingendo proditores"). On this and what follows, see also Bredekamp 1995 *Repräsentation*, pp. 30–41; Körner 2006, pp. 86–96. On Florentine pictorial punishment in general, see Edgerton 1985.

106 "Dipense nel 1478 nella facciata dove gia era il bargiello sopra la doghana, Messer Jacopo, Franco. et Rinato. de Pazzi, et Messer Franco. Salviati archiveschovo di Pisa, et dui Jacopo Salviati, l'uno fratello et l'altro affine di detto Messer Franco. et Bernardo Bandini, impicchati per la gola, et Napoleone Frazesi impicchato per un pi" (*L'Anonimo Magliabechiano* 1968, pp. 113–14.)

107 Paris, Musée du Louvre, Département des Arts Graphiques (Körner 2006, p. 90; *Botticelli* 2009, pp. 174–75). An impression of this sort of public disgrace is also conveyed by Andrea del Sarto's later drawings of figures dangling upside down and depicting soldiers who in 1530 had committed high treason and had then fled Florence (Freedberg 1989, p. 250; Körner 2006, p. 91).

Originally, Bernardo di Bandino Baroncelli, the individual who had stabbed Giuliano de' Medici, was shown in Botticelli's fresco, like Napoleone Francese, upside down, so as to signify that both had succeeded in fleeing Florence. In accordance with the usual practice of adding inscriptions to such images, Lorenzo il Magnifico had a defamatory poem added to this depiction of his brother's escaped murderer. This read: "I am Bernardo Bandino, a new Judas, / At the church I was a murderous traitor, / And I must therefore expect an even more terrible death".[108] In accordance with the fresco of the man hanged upside down, the prophecy of the last line was intended to voice the certainty that Bernardo di Bandino Baroncelli would in due course be apprehended and tried before a court of law.

After the fugitive culprit had, in the following year, been captured by the Turkish Sultan and extradited to Florence, the prophecy stated earlier in both image and text was fulfilled. On 28th December 1479, five days after Bernardo di Bandino Baroncelli had been delivered to the Florentine authorities, he was executed, and he was then hanged from a window of the Bargello, directly above his own defamatory image (which showed him hanging upside down). Leonardo da Vinci made a drawing of him (Fig. 131).[109] With this consummation of the punishment, however, the prognostic content of the original defamatory image had become superfluous. It was now possible, and desirable, to replace the depiction of what had been hoped for with a rendering of the punishment as it had in fact been carried out. Botticelli was now commissioned to paint Bernardo di Bardino Baroncelli in that upright position that Leonardo had himself sketched. The transition from legal wishful thinking to admonitory recollection was evident in the exchange of two distinct types of image.

The impact of Botticelli's defamatory images within Florentine society can only be imagined; but concerning their effect in the wider world there is some documentation. How far they were received as a provocation by the opponents of the Medici, and thus also by the Roman Curia, was to emerge when they became an issue in the peace negotiations following the war that broke out between Rome and Florence after the Pazzi Conspiracy. When the Roman delegation had demanded that at least Botticelli's defamatory image of the Archbishop of Pisa be erased, the authorities in Florence announced, in April 1480, that this demand had been met:

108 "Son Bernardo Bandinj, un nuouo giuda / Traditore micidiale in chiesa io fuj / Ribello per aspettare morte piu cruda" (*L'Anonimo Magliabechiano* 1968, pp. 114–15.) On the interplay of text and image, see Wenzel 1995, pp. 65–66.

109 Körner 2006, p. 89. On this case and further examples: *Renaissance Faces* 2008, pp. 53–54.

Fig. 130 Filippino Lippi, Young man hanging upside down, suspended by the foot, Pen and ink and watercolour on paper, 1490s, Département des Arts graphiques, Musée du Louvre, Paris.

Fig. 131 Leonardo da Vinci, The hanged murderer Bernardo di Bandino Baroncelli, Pen and ink on paper, 1479, Musée Bonnat, Bayonne.

We have had the image of the Archbishop of Pisa erased, and we have also removed everything that might in any way have dishonoured the Archbishop's office.[110]

It was only after this announcement that the two parties to the war entered into concrete peace negotiations, which were to be concluded the following December.

110 "Habbiamo facto levare la pittura dell'Archievescovo di Pisa, a tolto via ogni cagione che potessi in alchuno modo de dedecorare il grado Archiepiscopale" (Uccelli 1865, p. 173).

This, however, was not to be the end of pictorial politics as played out in the wake of the Pazzi Conspiracy. For it is clear that when Botticelli was sent to Rome the following year, 1481, this was an act of pictorial diplomacy. For he would there join Domenico Ghirlandaio, Cosimo Rosselli and Perugino in supplying painted compositions for the walls of the Sistine Chapel, newly extended by Pope Sixtus IV (Francesco della Rovere) in order to show the entire world that the war with Florence had not so much hampered him as spurred him on.[111] It was entirely fitting in this context that it should be Botticelli (who had painted the incriminating image of the Archbishop of Pisa) who should be required to paint, for the Sistine Chapel, that fresco of the "Punishment of Korah and his Accomplices"; his composition featuring a centrally positioned Arch of Constantine in front of which the prophet Aaron (traditionally viewed as the Old Testament prefiguration of the Pope) was seen engaged in destroying his enemies.[112]

By this means an image brought an end to the belligerent consequences of the Pazzi Conspiracy, the suppression of which had given rise to an unusual wealth of instances of the substitutive image act: the survival of the ruling Medici in both body and waxen images, the punishment of the conspirators in both body and fresco, the diplomatic erasure of one of the defamatory images, and the pictorial sealing of the peace in the palace of the enemy. In all these varieties it was images that appeared as motivating substitutes for persons, just as these last could, correspondingly, be strengthened or executed by way of images. In political votive practice, in the pursuit of justice, in the law, in war and in diplomacy there appeared variants of the substitutive image act.

In 1536 there came about a significant sequel.[113] The sculptor Benvenuto Cellini was commissioned to provide, for Duke Alessandro de' Medici (grandson of Lorenzo il Magnifico), a glorification equal in splendour to that he had earlier created for Pope Clement VII (Fig. 132). It was resolved that Alessandro's cousin, the young and talented Lorenzino de' Medici, should devise a model for the design of the verso of the portrait medallion. This choice was, however, a risky one in so far as Lorenzino, moved by an insuperable hatred of all authority, had already demonstrated his iconoclast sympathies.[114] He took his time in responding to Cellini's request; and, on the latter's subsequent urging, he answered that he was himself engaged day and night on a design for this medal, and that the entire world would surely admire his work.

Lorenzino in fact realised his dark promise through exchanging his pencil for a dagger. In an act that has gone down in the annals of tyrannicide, the hated

111 Monfasani 1983, pp. 12–13; Hegarthy 1996, p. 273.
112 Ettlinger 1965, pp. 105–06.
113 For further discussion, see Bredekamp 1995 *Repräsentation*, pp. 46–54.
114 Bredekamp 1992 *Angriff*.

Fig. 132 (above left) Benvenuto Cellini, Silver medallion with profile portrait of Pope Clement VII, c. 1523/1525, Münzkabinett, Kunsthistorisches Museum, Vienna.

Fig. 133 (above right) Giovanni dal Calvino, Two daggers flanking a Phrygian cap, Verso of portrait medallion for Lorenzino de' Medici, 1537, Münzkabinett, Staatliche Museen SPK, Berlin.

Medici duke, Alessandro, was murdered through being attacked with a knife.[115] In Rome one of the exiled Florentines, the republican Francesco Soderini, triumphantly told Cellini: "This is the other side of the medallion for that treacherous tyrant, which your Lorenzino had promised!"[116] To the propaganda of the recto (propaganda of the image) Lorenzino's response had been the propaganda of the verso (propaganda of the act).

As if to push this exchange of image and body to its limit, Lorenzino, who, after the attack on Alessandro, was hailed by exiled Florentines as the "new Brutus",[117] had a portrait medallion of himself made, its own verso showing two murder weapons (Fig. 133). A dagger intended as that used in the murder of Caesar, a pictorial symbol of freedom, was here implicitly aligned with the weapon used in the murder of Alessandro. Political murder was thereby passed off as iconographic *inventio*, which was again able to honour the murderer through an image, with image and action entering into a new symbiosis. The murder of Alessandro, quite apart from its political motivation, also evinced a dual pictorial character: it was a realisation of the verso of Cellini's medallion and it supplied the motif treated on the verso of Lorenzino's own plaquette in praise of himself as a "new Brutus".

115 Bredekamp 2011 *Brutus*.
116 "Quest' è il rovescio della medaglia di quello iscellerato tiranno, che t'aveva promesso il tuo Lorenzino de' Medici" (Cellini 1996, I, 89, p. 322).
117 Giovio 1564, Vol. 2, pp. 508–09. See also Gordon 1975, pp. 238–39.

In the end, however, Lorenzino, too, both in an image and in his own person, was to become a victim of this transfer mechanism. After the murder of Alessandro, his successor as hereditary Duke, Cosimo I de' Medici, ordered that a defamatory image of the culprit – "hanging upside down, suspended from one foot" – be painted on the walls of the Florentine Fortezza di Basso.[118] The legal force of this image was realised in this case in Venice. After precipitate flight and honourable invitations had taken Lorenzino to Bologna, Venice, Mirandola, Turkey and France, then again to Venice, he was on 26th February 1548 stabbed to death by Cosimo's mercenaries. The connection that had prevailed between Botticelli's defamatory painting and the Pazzi Conspirators was now repeated in the case of Lorenzino. The exchange of the drawing for a deadly act ensured that the traitor would be killed, first in pictorial form and then in person.[119]

C. A PICTORIAL GLOBAL CONFLICT (BAMIYAN)

As in the case of Florence, this third example will focus on a series of specific, interrelated events. Here, however, these belong to the very recent past. Although in fact still too recent to be appraised with full historical objectivity, these early-twenty-first-century developments can already be understood as complying with the now familiar model: merely recounting them is enough to reveal the simultaneously calculated and unscrupulous adoption by all parties to the evolving conflict of an approach fully cognizant of the phenomenon of the image act.[120]

The events in question have been characterised as representative of an "asymmetrical war", a concept that also assumes images to be among the means through which to engage in conflict.[121] This concept derives from that tradition established in the asymmetrical use of defamatory images. And in conflicts characterised by an inequality of armaments, it expects images themselves to function, in a direct sense, as weapons.[122] Those possessing technologically inferior weaponry will seek to extend the nature and the scope of the battlefield, and to deploy across this newly extended territory means other than just the conventional guns, tanks or

118 "Fu prima, come traditore del suo signore e padrone, dipinto nella fortezza a capo di sotto impiccato per un pie" (Varchi 1858, p. 425).

119 The practice, as found in Botticelli's work, of employing images as substitutes for individuals who had incurred punishment was also applied retroactively. Giorgio Vasari's fresco of the 1572 massacre of French Huguenots that began on the eve of the Feast of Saint Bartholomew (24th August) signifies an implicit legitimisation of persecution and mass execution (Behrmann 2008).

120 For further discussion, see: Bredekamp 2003 Marks. See also Ginzburg 2008, pp. 26–27, and Binder 2009.

121 Bredekamp 2003 Marks; Münkler 2004.

122 Janzing 2005; Trempler 2006.

aircraft. The novel character of the conflict as it has unfurled lies in the fact that eyes (even, indeed, the eyes of those with no prior stake in the dispute) become, in as far as they can be reached through the mass media, both a means and an end in this new unboundedness.

The international resonance of the dynamiting of the two huge Buddha statues at Bamiyan in March 2001, undertaken in accordance with the iconoclastic decree issued shortly before by Mullah Mohammed Omar, was greatly enhanced, as had been intended, through the dissemination of related reports, images and footage in the press and media (Fig. 134).[123] It was part of the strategy of the Taliban to link their acts of iconoclasm with the communicative capacities of advanced technology so as to strike at the enemy in a way that could not be ignored. The combination of the violent act and the *horror vacui* provoked by its outcome ensured that reports of the event would induce an international shudder far beyond the territorial limits of the action itself.[124]

The question as to whether the assault upon the two Buddha statues (Fig. 135) was intended as a symbolic prelude to the attack on the Twin Towers in New York the following September (Fig. 136) has yet to be resolved – a part of the mystery that still surrounds both events. The history of iconoclasm nonetheless reveals that acts of this enormity tend not to differentiate between works of art and human lives.[125] Those who destroyed the statues were, in any case, effectively setting in motion the creation of a sequence of motivating images, no less stirring than shocking. Through their record of destruction, these images were long to remain capable of legitimising both strategies and actions.

The subsequent offensive, conducted by the United States and its allies under the motto "shock and awe", was also a displaced reaction to the horror of the falling Towers. The forces of this Coalition, victorious in their first, Afghan Campaign (2001–02), subsequently turned their attention to Iraq. And it was here that they themselves also began to resort more insistently to a pictorial war. In Baghdad there was much destruction (also carried out by local residents) of murals and paintings in the former palaces of Saddam Hussein. But it was above all through the triumphantly disseminated (but soon as often questioned as approved) images of the toppling, on 9th April 2003, of the 12-metre-tall statue erected to Saddam in Firdos Square that the Coalition sought to affirm and broadcast its military superiority.

123 This image published in Flood 2002, p. 655. On the dynamiting of the Buddha statues: *Iconoclash* 2002, pp. 75–77 (Pierre Centlivres), pp. 218–20 (Jean-François Clément), pp. 221–23 (Jean-Michel Frodon).

124 Flood 2002, p. 655.

125 Numerous examples in Bredekamp 1975. On iconoclasm in the nineteenth and twentieth centuries: Gamboni 1997.

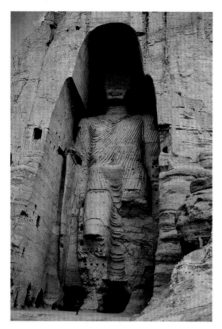

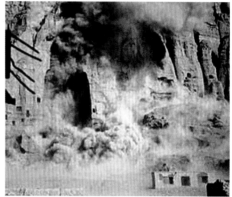

Fig. 134 One of the two 5th-century colossal statues of the Buddha, Bamiyan, Afghanistan, carved into sandstone cliffs, Photograph, 1967.

Fig. 135 Video still of the dynamiting of one of the two colossal Buddha statues at Bamiyan, March 2001, CNN.

From the start, however, it had been clear that the Coalition's military victory had been accompanied by panicking under-achievement in the "war of images". The American Department of Defense, for example, had committed an incomprehensible error in publishing, in January 2002, images of detainees in the camp at Guantánamo Bay, failing to grasp that the demoralisation of the defeated, regardless of the crimes imputed to them, would call forth a reflexive sympathy for these individuals.[126] The same is true of the images of human rights violations against inmates at the prison at Abu Ghraib, of which reports first emerged in late 2003.[127] These were immediately, and correctly, recognised as the lapses of a demoralised army. Assessed, however, in terms of the function of images in the waging of war, these might well have derived from the practice of using photographs of executions or torture, to serve as a sort of talisman, believed to provide protection in apotropaic fashion. It is such a practice that is now understood to account for the otherwise inexplicably large number of photographs found in the wallet of a German soldier killed in action

126 Janzing 2005, p. 22.
127 See also Richard 2006; Limon 2007; Eisenman 2007; Binder 2009, pp. 191–94; Mitchell 2009.

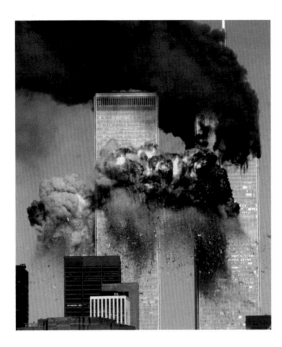

Fig. 136 Attack on the
World Trade Center, New York,
11 September 2001,
Photograph.

during the Second World War, which recorded the execution of partisans.[128] From
the point of view of the instigators, such images of torture were possibly regarded as
pictorial protection against an incomprehensible enemy.

If, in the case of the photographs from Abu Ghraib, an effect of this sort had
been intended, this was foiled through their aforementioned publication. Further
dissemination was forbidden by a decree, on the explicit grounds that this would
put the lives of American soldiers at risk. Once again, image and life were short-cir-
cuited in order to conduct, be it defensively or offensively, further phases of the "war
of images".[129] This was the motivation for the very public parading, in December
2003, of the captured Saddam Hussein, complete with a view into his mouth, illumi-
nated by a torch during a routine medical examination, and the equally unlawful

128 Hoffmann-Curtius 2002; on variants on this practice since the Middle Ages: Groebner 2003;
 and, during the First World War: Holzer 2000.
129 The bill of indictment presented by the American Civil Liberties Union on 13th September
 2006 (06-3140-cv, United States Court Appeals for the Second Circuit) may also be seen as a
 collection of diversely articulated acknowledgements of the image act, among them Barack
 Obama's response of 21st May 2009: "Nothing would be gained by the release of these photos
 that matters more than the lives of our young men and women serving in harm's way" (reply
 of *Amicus Curiae* [...] Ist June 2009 (06-3140-cv, United States Court Appeals for the Second
 Circuit, p. 5). The verdict did not follow this reasoning, but it nonetheless rejected the charge
 with a reference to the need to protect "privacy interests" (543 F.3d 59, 36 Media L. Rep. 2377).

photograph of his execution, on 30th December 2006.[130] The photographs published six months earlier of the corpse of Abu Musab Al-Zarqawi, first "Emir" of Al Qaeda in Iraq, had already testified to an attempt to achieve supremacy in the "war of images" through an apotropaic contravening of the Laws of War.[131]

By now, however, a new approach was already beginning to emerge, making better use of the technologies of global communications so as to further exploit the removal of geographical boundaries. Between acts of violence such as the activities of a lynch mob and their photographic dissemination there has probably always existed a sort of feedback mechanism, in as far as photographs have been regarded as an element of the execution and their viewing as an extended form of participation in the depicted action.[132] This last component now became a device that encircled the globe. Starting with the murder of the Italian security guard Fabrizio Quattrocchi and the American radio engineer Nick Berg (in April and in May 2004, respectively), numerous hostages were killed precisely so that pictures of these executions might then be *shown*. By this means, however, the practice, repeatedly encountered over the centuries, of the transformation of the bodies of enemy soldiers and officials into trophies in the service of deterrence, as recorded by Francisco de Goya in some of the plates of his *Desastres de la guerra* [Disasters of War],[133] was transformed into the practice not of treating individuals as images because they had been killed, but rather of killing them in order to be able to employ them as images.[134]

This distinction was to prove decisive regarding the reception of images of this sort. Since the elaboration of a theory of terror in the nineteenth century, the propaganda of action has not been limited to securing the approval of contemporaries. The effect sought was, rather, the creation of a general climate of fear.[135] In this logic the thrust lay, and still lies, in cancelling the distance between action and image and in the dissemination of this last as comprehensively as possible. If crimes such as torture and execution are committed with the express aim of having them viewed, then the distance between action, image and the act of viewing is removed. And, as the videos in question can be called up on the internet, the action effectively becomes an internationally accessible event, and every potential viewer an effective participant. This is a politics of the image act that has perfected the aim of eliminat-

130 Maak 2007.
131 *Der Spiegel*, no. 24, 12th June 2006, p. 102.
132 Felfe 2010.
133 Francisco José de Goya y Lucientes, *Desastres de la guerra*, plates 36, 37, 39 in Sánchez and Gallégo 1995, pp. 114–16. On Goya's response to war: Sontag 2003, pp. 44–47.
134 On the problem of showing images of these actions, see also Bredekamp and Raulff 2005; Schümer 2006, p. 40; Trempler 2006, pp. 118–19; Geimer 2007, pp. 122–29.
135 Laqueur 1977, pp. 47–50.

ing distance. Images are the spear-points of the attempt to render the conflict unbounded by means of the sense of sight. With the gaze high-jacked as an instrument of participation, the observer becomes complicit.[136]

The violent disputes of 2005–06 surrounding the Danish caricatures of Mohammed, which cost the lives of numerous individuals, served to draw attention to this politicisation of the acts of showing and looking at the point where the reproduction meets the eye of the viewer. While the right to publish caricatures and the right to look at them is assumed by some, for their opponents both actions, and above all the former, occupy the sphere of criminality.[137]

In the conduct of war using advanced technology the substitution of bodies for images ultimately becomes a systematic component of the use of weapons. It is here that one encounters an extreme form of the perplexity so characteristic of the age: even as visual theory ceaselessly emphasises the fictional character of images, one finds that one is comprehensively observed, from iris recognition to the surveillance of every sort of public space. In the military sphere this is happening in the process that has been termed the "Medusa effect": the attempt to close the gap between the deployment of troops and their visual presence in command centres, where the resulting images can be simultaneously and continuously monitored. In the American Apache weapons system, for example, the self-regulating images converge with the observations of the pilots so that images and real life merge. In this way the face of the Medusa kills perpetually and unflinchingly while ever more sophisticated technologies ensure that no-one is able to look her in the face during this act.[138]

All these processes underline the fact that the exchange of body and image is ubiquitously employed as a means of war, even though such exchange is not covered by the Geneva Convention. It thus seems imperative that an effort is now made to take substitutive image acts seriously from a historical point of view, and to recognise them, define them, and vigorously engage with them in their destructive aspect. The extreme forms of substitution demand that the separation of image and body becomes a priority in the interests of life-preserving enlightenment.

The substitutive image act issues in contradictory outcomes. Through the pressure on the body to take the form of an image, it testifies to the latter's authenticity and autonomy. It thereby permits and prompts one to honour symbols of sovereignty and images of Justice as fully valid substitutes for bodies. However, the substitution of persons in images also facilitates iconoclasm; and the interpretation of bodies as images can, in extreme cases, mean that individuals are treated in an

136 Bredekamp and Raulff 2005; see also Mondzain 2002.
137 Schirrmacher 2009. Fundamental on this conflict: Eriksen and Stjernfelt 2008.
138 Werckmeister 2005, p. 23; Werckmeister 2010.

iconoclastic fashion. This final outcome can attain that pitch of violence captured by Goya in his aforementioned *Desastres*. It is from this most destructive aspect of the substitutive image act that there emerges the imperative of a political theory and a comprehensive practice of distance. In the present day these appear as far from realisation as they are urgently required.

*

The schematic and substitutive forms of the image act are defined by the fundamentally, if variously, physical quality of their interaction with those encountering them. In the case of the intrinsic image act the corresponding interaction, while no less powerful in its effects, is primarily intellectual and aesthetic. While context is invariably of some import in the former instances, the intrinsic image act, as its denomination suggests, exerts its impact through the power of inherent formal qualities. It is here, above all, that the compulsive power that defines the image act is best able to conspire with the vigour of the human imagination.

V

INTRINSIC IMAGE ACTS: IMAGE AS FORM

I. THE IMAGE AS BEHOLDER

A. MEDUSA AS SCULPTRESS

On 5th February 2003, at the United Nations Building in New York, there occurred a situation that, albeit seemingly trivial, was to prove highly illustrative in its absurdity. A press briefing about the talks then in progress on plans to invade Iraq was to be held in a frequently utilised site on the second floor, which is adorned with the famous tapestry of Picasso's *Guernica*. Lest the anti-war message of that celebrated composition too provocatively contradict the altogether different line that they were taking, those in charge concealed the tapestry behind a blue cloth, itself supporting a board with the UN logo (Fig. 137). The warning in Leonardo's maxim about the danger of a potent image thereby received a striking confirmation.[1]

Yet, even within this particular early twenty-first-century political and military context, the decision to conceal the *Guernica* tapestry at the UN Building was by no means an isolated example of individuals seeking to defend themselves against the power of an image. When the huge statue of the Iraqi dictator Saddam Hussein that stood in Firdos Square in Baghdad was toppled on 9th April 2003, American troops covered its face with the Stars and Stripes.[2] This procedure was widely interpreted as an act of triumphalism; but, in terms of the history of the gaze and the image, it should, rather, be seen as a token of self-defence. The face of the statue, which had to be hidden, took on the same meaning as the face of a man about to be executed and whose eyes would traditionally be covered. For such covering was not in order to spare him the sight of those gathered to witness his death, but so as to

1 On the *Guernica* tapestry itself: Marks 1995, pp. 121, 163. On the decision to conceal it: Schweitzer and Vorholt 2004. On techniques for concealing images: Beyer 1993.

2 In order to encourage the impression that the United States army had achieved not a conquest, but a liberation, the Stars and Stripes was rapidly replaced by the Iraqi flag.

Fig. 137 Press conference held in front of the concealed tapestry of Pablo Picasso's painting *Guernica*, at the United Nations Building, New York, 5 February 2003, Photograph.

protect the members of the firing squad from the gaze of the dying man.[3] The American soldiers in Baghdad were simply acting in accordance with this age-old notion of warding off of the "evil eye".

Fear of the danger implicit both in the gaze of the image and in the very action of gazing derives from the myth of the Medusa. She was one of the Three Gorgons, whose appearance was reputed to be so ghastly that anyone who looked them in the face was immediately turned to stone. Only Perseus, son of Zeus and Danae – and equipped, by his divine father, with a helmet of invisibility and, by the goddess Athena, with a brightly gleaming shield – was able to behold the Medusa through the ruse of looking at her face only as reflected in the surface of this shield, and so to resist petrification even while severing her snake-haired head from her body.[4] The severed head of the Medusa nonetheless retained its capacity to turn to stone all those who looked directly at her face. And from this point on the narrative focus effectively shifts from the Medusa as a mythical creature to her head and her petrifying face as an image (the head having become an image in being separated from the body). The enduring threat of petrification associated with this image – a

3 On this type of gaze: Frey 1953, pp. 251–52.
4 Apollodorus 1921, Vol. I, II, iv.1—II, iv.3 (pp. 152/153—160/161).

danger never entirely absent from the image act – was now itself a protagonist.[5] This aspect of the legend is treated with unsurpassed brilliance by the Neapolitan poet Giambattista Marino in some of the verses evoking diverse paintings and works of sculpture gathered in his two-volume 1620 publication *La Galeria*. In one of several poems entitled "Medusa", which describes a sculpted figure, he has the severed head itself speak:

> Ah, take flight, or at least avert your wandering eyes!
> For, while I am of marble, my own eyes emit a fatal power
> That can transform a living body to stone.[6]

In order not to be himself turned to stone, Perseus places the severed head of the Medusa in a knapsack (given to him, on the instructions of Athena, by the Hesperides). And in this one can detect the first manifestation of that concealing device, by means of which humanity would ever after continue to seek to protect itself against the power of the "Medusa's gaze" in its diverse forms.

One of the daring feats that Perseus is thus able to accomplish earns him the right to claim the Princess Andromeda (already promised to another suitor) as his bride. As recounted by Ovid, in Book V of the *Metamorphoses*, in one of the most violent extended scenes in all the literature of Antiquity, the battle over Andromeda into which her wedding feast swiftly descends at length leaves Perseus cornered, so that he has no choice but to withdraw the Medusa's head from the knapsack in order to put an end to each of those attacking him. Not recognising the significance of this brandished trophy, each man who looks at the face of the Medusa is instantly turned to stone – as if she were a sculptress working instantaneously and they were figures in marble, each preserved forever as posed in the moment of his fatal glance.[7]

Later depictions of this episode have usually avoided confronting the observer with the head of the Medusa. Contemplation of the horror of petrification was encouraged rather than identification with the process, or indeed its victim. It was this development that Jacques Lacan had in mind in speaking of the pacifying aspect of the work of art. Metaphorically embodied in the shining shield that Athena gave

5 Belting 2001, pp. 143–46; Mack 2002.

6 "Ah fuggi, o torci i vaghi lumi indietro, / che le ben marmo io son, virtù fatale / Spero da gli occhi, ond'ogni corpo impetrò" (Marino 1675, "Medusa" (1), p. 277). Fundamental on Marino's concept of the image: Cropper 1991.

7 Ovid, *Metamorphoses* 1977, Book V, lines 177–249. On the linguistic intensification employed in this passage: Kruse 2003, pp. 379–400. Ovid in fact specifies (lines 208–209) that, in all, a hundred of those attacking Perseus lost their lives (those who had looked the Medusa in the face), while a further hundred in fact survived (those who, by chance or design, had not done so). Among the former is Perseus's chief rival for the hand of Andromeda, the cowardly Plineus.

Fig. 138 Peter Paul Rubens, *Head of the Medusa*, Oil on canvas, between 1610/25, Kunsthistorisches Museum, Vienna.

to Perseus, art is able to show a reflection of the head of the Medusa; but this reflection will not kill those who look at it.[8] This, however, is not to say that the resulting images were without at least a hint of danger. In the 1590s Caravaggio depicted the Medusa's face as if howling in horrified recognition of her own now compromised powers: her head severed from her body and her capacity for petrification brought into play only when and where Perseus himself requires. Several decades later Peter Paul Rubens made his own rendering of the head of the Medusa so revolting to look upon (Fig. 138) that it was at first thought imperative to conceal it. And Gustave Courbet's mid-nineteenth-century, realist equivalent for the mythological Medusa's head – a composition comprising the lower torso and exposed pudenda of a reclining artist's model, mock-heroically titled *L'Origine du monde* – was itself concealed by Lacan, who at one point owned the picture.[9] Here, one encounters yet again the terror of the gaze of the work of art, that reflection of the gaze of the Medusa.

8 Siegfried Kracauer would seem to have had such a notion in mind in describing the empty cinema screen (as it awaited the image yet to be projected on to it) as "Athena's polished shield" (Kracauer 1960, p. 305). On the history of representations of the head of the Medusa: Lavin 1999; Cole 1999; Wolf 2002 *Schleier*, pp. 345–55.

9 On Caravaggio: Ebert-Schifferer 2009, p. 105; on Rubens: Kruse 2003, p. 395, 400. On Courbet's *L'Origine du monde*: Metken 1997. See also Roudinesco 1993, pp. 248—49. Lacan, it is here claimed, acquired the Courbet picture in around 1955 and had the lost wooden concealing panel (the *cache en bois*) replaced and then decorated, by the artist André Masson,

This terror can, however, be deflected into a form of praise for artistic skill, in which the work of art is held to seem so alive that it has the power to astound into silence and immobility all those contemplating it. And there are, indeed, many descriptions and reports that attest to this very measure of animation.[10] These culminate, in the 1540s, in a poem by Giovanni di Carlo Strozzi (a leading figure among the Florentines then living in exile) on Michelangelo's sculpted, semi-reclining female figure of *Night* in the Medici Chapel of San Lorenzo in Florence. This figure, claims Strozzi, is not made of stone but is simply asleep. Anyone doubting this should wake her, and she would then surely speak with him. In the manner of the Pasquino, the figure of *Night* answered Strozzi through a poem subsequently written by the artist. This asked the visitor to be so good as to whisper in her presence. For, on account of the current misery of the world, she would prefer to continue sleeping.[11]

This restraint, and implicit immobilisation, of the observer may itself be understood as a preliminary to his petrification, paradoxically incurred through the intense animation of the work of art. Marino, in his aforementioned volume *La Galeria*, was also insistent upon this aspect of the "Medusa effect":

> The figure here portrayed
> Resembles the Medusa.
> The sculpture is so devised that it shifts before my eyes.
> And already I feel that I, too, am transformed.
> In appearance, I have become a solid rock,
> But within I am all fire. [...]
> And gazing has so robbed me of my senses
> That it seems I have become like the statue, while it has come to life.[12]

In another poem Marino again allows life to become marble, and marble life:

> Oh, skilful sculptor, you make the marble so lifelike
> That those who are themselves alive resemble marble.[13]

with an abstract composition that cleverly incorporated elements of the original, erotic image. This last would be uncovered only on special occasions.

10 Fundamental: Jacobs 2005; on the topoi of animation: pp. 8–9.

11 Vasari 1906, Vol. VII, p. 357; see also Jacobs 2005, pp. 43–44.

12 "La figura ritratta / Medusa mi rassembra. / La scultura e sì fatta, / Ch'altrui cangia le membra. / Già già sento cangiarmi à poco à poco / Da fuor in macigno, e dentro in foco / [...] E si di sento lo stupor mi prima, / Ch'io son quasi la statua, ella par viva" (Marino 1675, "Nel medesimo soggetto" [i.e. the figure of a beautiful woman], pp. 310–02).

13 "Saggio Scultor, tu cosi'l marmo avivi, / Che son di marmo à lato al marmo in vivi" (Marino 1675, "Medusa" [2], p. 277).

The form-giving power of the artist fills his work with such intensity of life that those truly of flesh and blood appear, by comparison, as if turned to stone. This formula, too, emphasises the "Medusan" origins of the intrinsic image act, which is generated by the gaze of the work itself.[14]

The myth of the Medusa recalls, nonetheless, even in those of its variants that glorify art, that their origins, too, lay in a fear of death and the attempt to achieve a certain distance from this fear. The means employed tend to consist in both dispelling dread and intensifying it. Aby Warburg believed that this contradiction was not one that could be automatically resolved within any given work of art, but would always leave it open it to new, unexpected interpretations. Warburg's concept of art (briefly discussed at the end of this chapter) remains a paradigm in any consideration of the image act.[15]

B. THE CHIASMUS OF GAZES

One form in which the myth of the Medusa repeatedly recurs in ever new variants in works of art is to be found in situations in which the spectator, even while confident of having the upper hand in terms of observation, nonetheless also has a powerful sense of being observed by a depicted individual.

The starting point here is the very widely shared belief in the danger to be associated with being the object of a gaze. This is especially intense in the case of reactions to individuals to whom are attributed, in the form of the "evil eye", powers of the sort associated with the Medusa. Such persons, it is supposed, are in a position to bewitch those who are the object of their gaze.[16] In the context of the homeopathic, and by extension apotropaic, "Doctrine of the Signatures" – the notion that *similia similibus curantur* [like cures like], which may be traced back to Pliny the Elder, and according to which daemonic powers are susceptible only to their equivalent – much was made of mirrors and artificial eyes, which were thought to exert a contrary power that provided protection against the "evil eye".[17] In due course, such artefacts were themselves thought to possess a specific power of the gaze – and one, moreover, that did not remain limited to the merely counter-daemonic. As it was believed that some objects were capable of emitting rays that were a form of sight, the outcome was interpreted as an effective exchange of gazes – a chiasmus, or

14 Fried 1980, p. 92; Shearman 1992, p. 47–49, 55; Mitchell 2005, p. 36; Nagel 2009, pp. 195–96.
15 See below, pp. 253–64.
16 On this matter Frey 1953 remains a fundamental study, in particular pp. 250–51. See also Nagel 2009, pp. 194–95; and, from an ethnological point of view, Hauschild 1982; and Gravel 1995.
17 See also Flood 2006; and Kessler 2008, pp. 117–22.

crossing effect – in which seeing and being seen were understood as complement-ary aspects of the same process.

The colossal, enthroned figure of the Emperor Constantine from the Basilica of Maxentius in the Roman Forum – of which it was claimed that, when it fell, Rome itself, and the entire world, would come to an end – has gigantic eyes, with pupils glancing diagonally upwards, which were intended to appear as if truly capable of seeing (Fig. 139).[18] If pre-modern theories of sight start from the assumption that

Fig. 139 Eyes of the former colossal seated figure of the Emperor Constantine, Marble, *c.* 315, Musei Capitolini, Rome.

this is an emanation of light, *lumen*, emitted by the eye, which is then beamed back to it by the objects observed,[19] then it must also be taken into account that, through the notion of the apotropaic gaze, this pre-modern understanding of sight will itself have crossed with the originally Epicurean belief that a gaze, like other forms of influence, may actively originate within an object.

More concrete evidence of individuals looking at works of art and feeling suddenly seized by an alien force is supplied in numerous accounts of the perceived movements of the eyes, and even the heads, of those depicted.[20] Complementing such accounts are reports of an observer's compulsion to respond to the implicit movement of the eyes of the depicted face, as evinced in the case of the Madonna of Essen, dating to around 990 (Fig. 140).[21] It was said that anyone looking at her would find themselves helplessly imitating her own alternately piercing and flickering gaze.

This reciprocity between gazing and the situation of being the object of a gaze, of autonomous action and the exertion of a counter-pressure, was emphasised in the mid-fifteenth century, in the writings of both Leon Battista Alberti and the

18 Safran 2006, pp. 54–55; Parisi-Presicce 2007.
19 On Robert Grosseteste (an early theorist of vision): Hahn 2000, pp. 174–75. Cf. on the history of the theory of vision: Hagner 1992/93.
20 Freedberg 1989, p. 303.
21 Fehrenbach 1996.

Fig. 140 *Madonna of Essen* (detail), Wooden core with gold-leaf plating and cloissoné enamel eyes, c. 990, Treasury, Cathedral, Essen.

German philosopher and theologian Nicholas of Cusa (also known by the Latin form of his name: Nicolaus Cusanus).[22] Deeply familiar with both Italian and German art, Nicholas influenced the art theory of his time through his considerations on the phenomenon of crossing, or chiasmus, in vision. These are above all to be found in his text of 1453 *De visione Dei* [The Vision of God], which was evidently itself influenced by the practical aesthetics of devotional images.[23] In this text Nicholas supplies an answer to the question as to how the world created by God must appear to Him, if it is to remain recognisable as an emanation of His own infinite capacities. According to Nicholas, in every created thing there must be evident that form of possibility that attests to the infinity of God.

In this context the image bears witness to divine self-recognition and the transitory character of all created things. The image is not static, it is active. In accordance with the notion, deriving from Antiquity, that depicted faces appear to follow those who look at them, in the manner of a shadow, whatever position is adopted by the observer, Nicholas explains this essence of all created things by reference to a series of examples, among which a *vera icon* and a self-portrait by Rogier

22 On Alberti: Sanvito 2007, pp. 190–92.
23 Stock 1989, pp. 55–59; Sanvito 2007, pp. 195–210, which is also enlightening on what follows.

van der Weyden are of particular note. Although neither of these specific works appears to have survived, the effect invoked can be observed in the portrait of 1433 by Jan van Eyck discussed in chapter 2 (see pp. 54–56 and Fig, 30).[24]

The face depicted by Van Eyck is striking for its air of scrutiny, for the irregularly positioned eyes, the long nose and the pursed lips. In the taut skin of the cheeks and the temples with their barely perceptible veins and hint of lines, there is a palpable animation; and it may well be this aspect of the gaze that Nicholas of Cusa had in mind when speaking of the picture that he promises to send to those he addresses in his text:

> Regardless of the place from which each of you looks at it, each will have the impression that he alone is being looked at [...] First of all, then, marvel at how it is possible that [the depicted face] behold each and every one of you all at once. For the imagination of the brother who is standing in the east does not at all apprehend [the] gaze that is being directed toward a different region, viz. toward the west or the south.[25]

Having considered the matter in relation to every possible standing position, Nicholas arrives at the conclusion that the picture effectively acts autonomously. Regardless of the locations and movements of the observers, it looks at all of these at once; but, from the point of view of the individual, it appears to look only at him. Nicholas is of course aware that the painting is a creation of man. But he is also aware that it will only divulge its deeper identity when it encounters an entity with *potentia* equal to its own. He accordingly evokes the situation in which the gaze of the depicted individual and that of the observing individual meet and cross. Through this form of chiasmus he apprehends the paradox that a painting, albeit ostensibly devoid of organic life, can nonetheless be active, in accordance with the established notion of a gazing and creating God.[26]

24 It is presumed that the Rogier van der Weyden portrait survives in the form of a Flemish tapestry now in the Hôtel de Ville in Brussels (Liess 2000, Vol. 2, pp. 772–75). On these examples, see also Stock 1989, pp. 51–53. See also the profound analysis in Stoellger 2008, pp. 193–204.

25 "[...] intuebitque ipsam et quisque vestrum experietur ex quocumque loco eandem inspexerit et quasi solum per eam videri [...] Primum igitur admirabimini quomodo hoc fier possit quod omnes et singulos simul respiciat. Nam imaginatio stantis im oriente nequaquam capit visum plagam versum scilicet occasum vel meridiem" (*Nikolaus von Kues* 1989, Vol. III, *De visione Dei*, Praefatio, p. 96; trans. Nicholas of Cusa 1988, Vol. II, *The Vision of God*, Preface, pp. 680–81).

26 On this and on the relationship between Nicholas of Cusa and Alberti: Wolf 1999 *Cusanus*. See also Fehrenbach 2005 *Kohäsion*, pp. 1–3; and Belting 2008, pp. 240–46.

Of particular significance among the later attempts to address this problem is that of the French phenomenologist Maurice Merleau-Ponty. In the essay *L'Entrelacs – Le Chiasme* [Intertwining – Chiasmus] (included in *Le visible et le invisible*, left unfinished in 1961), he develops, from the notion that seeing is a form of touching, the converse notion that the object seen in turn exerts, through its own tactile resistance, a form of visual pressure upon the viewer. The visible object thereby constrains the viewer "as a result of its sovereign existence".[27] As if seeking to paraphrase Nicholas of Cusa, Merleau-Ponty speaks of the viewer as suffering the act of seeing, so as to feel, as is sometimes said of painters, "observed by things".[28]

For Nicholas of Cusa, however, such a concept does not stand alone. It served, rather, as a testament to the infinite possibilities open to God. It thus enabled him, in a second text with implications for art theory, *Idiota de mente* [The Layman on Mind], to set forth his case in an unprecedentedly consequential manner. According to Nicholas, a portrait that achieves an unrelenting similarity to its subject is "dead". A depiction that could be described as "alive" would, rather, be a work that openly exhibited aspects of dissimilarity with the depicted individual, even in the process of striving to approximate an overall similarity. The only partial success in depiction serves here as a model for the situation in which perfection remains the goal towards which all effort and movement continue to strive. According to Nicholas, the painted image that is the less good likeness is the more truly "alive – was such that when stimulated-to-move by its object [the individual], it could make itself ever more conformed [to that object]."[29] Animation, that is to say, is movement prompted from within that leads to the notion of infinity. And herein lies the *potentia* that Nicholas of Cusa associates with the image.

In order to be able to maintain this sort of recognition of God, the work of art must evolve capacities of its own. These lie not in the representation of a static surface, but in that of an inner movement. This alone opens the medium to the recognition of God. The capacity of the painting that is alive (i. e. a human being) is "[...] the more perfect *qua* imitating, to a greater degree, the art of the painter".[30] With its urge to movement emerging from within, the less like work of art imitates not only

27 "comme une suite de son existence souveraine" (Merleau-Ponty 1964, p. 173).
28 "regardé par les choses" (Merleau-Ponty 1964, p. 183). On the treatment of this sort of visual chiasmus, see also Didi-Huberman 1992, and Didi-Huberman 2002.
29 "[...] viva scilicet [...] talis, quae se ipsam ex obiecto eius ad motum incitata conformiorem simper facere posset, [...]" (Nikolaus von Kues 1989, Vol. III, *Idiota de mente*, Chap. 13, p. 592; trans. Nicholas of Cusa 1988, Vol. I, *The Layman on Mind*, Chap. 13, p. 582). On the interpretation: Wolf 1999 *Cusanus*, p. 202.
30 "[...] perfectiorem quasi artem pictoris magis imitantem" (*Nikolaus von Kues* 1989, Vol. III, *Idiota de mente*, Chap. 13, p. 592; trans. Nicholas of Cusa 1988, Vol. I, *The Layman on Mind*, Chap. 13, p. 582).

the infinity of God but also the possibilities inherent in art.[31] This is owed to a capacity that it employs on its own account. This artistic capacity in turn becomes a catalyst for inner movement. In reaching this conclusion, Nicholas of Cusa becomes the outstanding theoretician of the intrinsic image act.[32]

C. THE *COUP D'ŒIL* OF THE WORK OF ART

The arguments of Nicholas of Cusa were to have far-reaching consequences. His notion of the gaze emitted by the work of art and conditioned by its particular form was expanded three centuries later by the German polymath Gottfried Wilhelm Leibniz into a general theory of perceptions and, simultaneously, into a far more precise understanding of a particular form of the gaze.

Leibniz, too, was concerned with imaginatively reconstructing the divine act of seeing. This he understood as distinguished through the fact that its action was entirely free of stasis and it could, therefore, be envisaged as engaging, at any given moment, in a transition from a perception of details to an appreciation of the infinity of the whole. For that reason, natural objects already possessed a transitory power, which was not dependent upon the divine observer, but came from by the objects themselves. Leibniz's definition of the autonomous activity of the world that surrounds humanity depends upon his concept of the *petites perceptions*, which exert a subliminal influence on human beings in the sense that this influence goes entirely unremarked. For this reason the *petites perceptions* are of the utmost importance. For it is they that encourage "the impressions made upon us by the bodies that surround us and that in themselves embrace infinity: the connection that each human being enjoys with the universe in its entirety".[33] While man's constructive understanding of these is necessarily limited, they nonetheless have an impact upon his overall capacity for knowledge.

Leibniz initially used the example of acoustic signals, such as the murmuring of the sea (to which humanity becomes so used that it no longer consciously hears it) in order to elucidate the way that the *petites perceptions* function.[34] But he subsequently turned to images and objects drawn from what he repeatedly invoked as the "Theatre of Nature and Art", for illustrative objectifications.[35] Once created,

31 On this point: Wolf 1999 *Cusanus*, pp. 207–08. See also Niklas Luhmann's formula of the "inner ornament" (Luhmann 1995, pp. 198, 350–51, 367–69).

32 See also Michael Fried's concept of "absorption" (Fried 1980).

33 "[...] ces impressions que les corps, qui nous environment font sur nous & qui enveloppent l'infini; cette liaison que chaque être a avec tout le reste de l'univers" (Leibniz 1765, *Nouveaux Essais*, Avant-propos, p, 100).

34 Trabant 2003, pp. 180–82.

35 Bredekamp 2004 *Fenster.*

Leibniz argued, these endure without any assistance from man, serving to teach him to see, as if with the "piercing eyes of God", which can read "in the slightest substance [...] the entire sequence of events in the universe".[36]

These natural entities offer humanity a foretaste of the intuitive, unlimited clarity that led Leibniz, in his *Essai de Théodicée* of 1710, to his concept of the *coup d'oeil*, the instantaneously, all-embracing gaze.[37] This gaze, which both absorbs and comprehends everything at a stroke, derives from a crossing of the gazes emitted by innumerable objects, analogous to the continuous influences absorbed through the aforementioned *petites perceptions*. It delivers a totality, in terms of every sort of detail, and at the same time, the ability to know everything in a single instant. This is chiasmus in its most consummate form.

It has not yet proved possible to ascertain whether or not Claude-Nicolas Ledoux, an architect associated with the French Revolution, knew of the considerations of Nicholas of Cusa or of Leibniz. He was nonetheless able, in his engraving of the *Coup d'œil of the Theatre at Besançon* (Fig. 141), to achieve a visual formula that one is tempted to read as a commentary on Leibniz, and that seems to relate, albeit more distantly, to Nicholas of Cusa. The image was included in the volume that Ledoux published in 1804: *L'architecture considerée sous le rapport de l'art des moeurs et de la législation*.[38] The print shows an eye, in the iris of which is reflected the interior of the theatre at Besançon built, to Ledoux's design, between 1775 and 1784.[39] Above the numerous parallel rows of seats in the stalls one sees the curve of the lower section of an amphitheatre. Through the centre of the pupil run two tiers of boxes; and between the upper edge of the pupil and the upper eyelid a higher section of the amphitheatre leads up to an imposing series of columns, apparently modelled on those at the Teatro Olimpico in Vicenza. Above the eye cavity the eyebrow sweeps dynamically from right to left.

Notwithstanding this last feature, the eyeball itself evinces less an organic than a stony quality. One is, therefore, inclined to assume that it is that of an actor who occupies the stage not as a living presence, but as a sculpted figure. As the eye looks out from the stage, it reflects the auditorium in its iris. As the reflected area

36 "[...] dans la moindre des substances, des yeux aussi perçans que ceux de Dieu pourroient lire toute la suite des choses de l'univers" (Leibniz 1765, Nouveaux Essais, Avant-propos, p. 10).

37 "Théodore vit toute sa vie comme d'un coup d'oeil, & comme dans une représentation de théâtre" (Leibniz 1712 (2nd edn.), *Essai de Théodicée*, Troisième Partie, § 415, p. 617). See also Siegert 2003, pp. 156–58.

38 Ledoux 1997 [1804], p. 217 (title-page), p. 225 (engraving).

39 The engraving had been made in 1776 (Langner 1960, p. 165, note 20). On the theatre: Steinhauser 1975, pp. 346–47. On the engraving: *Revolutionsarchitektur* 1970, p. 122. Its significance in the visual iconography of the French Revolution is discussed in Herding 1990, pp. 38–54. Important for the present interpretation: Geissmar 1990, p. 37.

Fig. 141 Claude-Nicolas Ledoux, *Coup d'œil of the Theatre at Besançon,* Engraving on paper, 1776, published in *L'architecture considerée sous le rapport de l'art des moeurs et de la législation,* Paris 1804.

does not, however, extend beyond the circle of the iris, there persists the impression of a living organ of sight that in turn contradicts the notion of a sculpted entity.

The eye's capacity to be both stony, like those of the aforementioned colossal statue of Constantine (Fig. 139), and yet able, as an implicitly living organ, to see, is underlined by the presence of a beam of light, which appears to fall diagonally into the theatre interior from some form of skylight.[40] The beam, however, in appearing to originate at a point behind the eye's pupil, would seem to obey the laws of perspective no more than does normal human vision.[41] Rather, as Ledoux himself explained in his text, one encounters an "enlivening beam of light", without which

40 This is in fact an *opaion* such as is to be found in the Pantheon in Rome. The theatre designed by Ledoux for Besançon, however, has neither such a feature nor a corresponding opening in the space between the stage and the auditorium (Pross 2000, p. 461). A further problem lies in the fact that the beam of light emanating from the iris cuts across the lower eyelid. The combination of its emerging from beneath the upper eyelid and then falling across the lower eyelid also suggests the possibility both of a beam of light falling from outside into the eye's field of vision and of a beam signifying vision and emanating from the iris. In the view of Gert Mattenklott, this representation of a theatre appears "as if illuminated by a searchlight beam" (Mattenklott 1982, p. 64). Hans Belting, similarly, sees here a "beam of light" that one might well associate with the "'supervision' that is mentioned in the text" (Belting 2008, pp. 214–17, here, p. 215).

41 Geissmar 1990, p. 37.

Fig. 142 Torso found in
the ruins of Miletus,
Marble, 480–470 BC,
Musée du Louvre, Paris.

"everything would be steeped in a dismal and joyless darkness".[42] This illumination penetrates, unhindered, into all spheres of the depicted setting, but it also has its invisible point of origin within the eye, thereby resembling that divine power described by Nicholas of Cusa in *De visione Dei*.[43]

As the auditorium is empty, the living eye of the statue engages in a dialogue only with the elements of the interior that are reflected in it. Yet, within this vast space, its gaze also embraces the presence of spectators in its potential aspect.[44] Equipped with this powerful seeing eye of stone, the theatrical stage observes all

42 "sans ce rayon vivifiant tout seroit dans l'obscurité pénible et languissante" (Ledoux 1997 [1804], p. 217).

43 "Le premier cadre fut sans doute celui que vous voyez; il reçoit les divines influences qui embrâasent nos sens , et répercute les mondes qui nous environment. C'est lui qui compose tous les êtres, embellit notre existence, la soutient et excerce son empire sur tout ce qui existe" (Ledoux 1997 [1804], p. 217).

44 Pross 2000, pp. 457–58.

future spectators, and knows all that may be known and that will in due course be reflected in it. Ledoux's engraving is an image of the chiasmus of gazes, in which that of the spectator crosses with that of the artefact.

Just over a century later, in 1908, this philosophical / theological principle was to find a compelling reflection in German literature: in the opening poem of the second series of Rainer Maria Rilke's *Neue Gedichte*. Echoing the subject matter of the opening poem of the first series (1907), this is titled *Archaïscher Torso Apollos* [Archaic Torso of Apollo].[45] It had its starting point in Rilke's own encounter with a specific sculpted Greek marble figure of the fifth century BC, which had been discovered in the ruins of Miletus in 1872 and had entered the collection of the Musée du Louvre in Paris the following year (Fig. 142). Drawing on what he had learnt from the sculptures of his revered Auguste Rodin (on whom he had recently published a monograph, and to whom the second series of the *Neue Gedichte* is dedicated), Rilke had, with unswerving interpretative flair, recognised in the torso an instance of the dissolution of the heretofore prevailing severely archaic style through an emphasis on the functions of particular muscles and sinews and through a clearly articulated standing pose.[46] Struck by this evidence of the beginnings of an internal movement within a still essentially rather rigid body, its surface, moreover, grown porous through centuries of abrasion, Rilke characterised the torso as "gleaming" like a "candelabrum", and its breast as capable of "dazzling" the onlooker:

> We never knew his tremendous head,
> wherein the eyeballs ripened. But
> his torso gleams still like a candelabrum,
> in which the gaze, its power barely reduced,
> endures and sparkles. Else how could the bow
> of the chest so dazzle you and, in the slight turn
> of the loins, how could a smile make straight for
> that core, that once held the organs of procreation.[47]

45 Rilke 1908. *Neue Gedichte II*, p. 1. The interpretation proposed by Wolfgang Braungart 2005, pp. 232–33, complements that offered here.

46 *Die Geschichte der antiken Bildhauerkunst*, Vol. II, 2004, pp. 1–2.

47 "Wir kannten nicht sein unerhörtes Haupt,
 darin die Augenäpfel reiften. Aber
 sein Torso glüht noch wie ein Kandelaber,
 in dem sein Schauen, nur zurückgeschraubt,
 sich hält und glänzt. Sonst könnte nicht der Bug
 der Brust dich blenden, und im leisen Drehen
 der Lenden könnte nicht ein Lächeln gehen
 zu jener Mitte, die die Zeugung trug."
 (Rilke 1908. *Neue Gedichte II*, p. 1).

Such motifs may, indeed, be said – and this is Rilke's guiding idea – to embody the persisting gaze of the long lost head. And, in this respect, the torso, albeit manifestly but a fragment, is nonetheless in truth complete:

> Else this stone would stand disfigured, and
> below the shoulder there'd be just a slow drop,
> and it would not so shimmer like the hides of beasts of prey;
> and it would not beam out from every pore
> like a star: for there is no inch of this surface
> that does not see you. It's *you* must change your life.[48]

Like the body of the mythological giant Argus, studded with its hundred eyes, the torso becomes an entity that gazes out from every pore. And, by this means, the sculpted figure gains that dimension that prompts the poet to sense in it the imperative of transformation.

The year 1908 also saw the posthumous publication of the lectures given in Vienna in the winter of 1894–95 by the art historian Alois Riegl on the still unfashionable subject of the evolution of Baroque in Rome, in which he had formulated an effective rejection, or at least questioning, of the intellectual point of view implicit in central perspective. Riegl saw concentrated in this last all that was most vampiric in the Early Modern period: its readiness to override chronological and formal distinctions in its passion to absorb all that it required. As central perspective related all aspects of any environment to a single point, it became all too easy to lose any awareness that objects possessed an existence independent of the observer.[49] The last two lines of Rilke's poem effectively voice the same perceptual leap. They eschew the point of view governed by central perspective in order to free both eye and mind to attend to the unfixably shimmering and hence living and multifarious surfaces of the autonomous artefact. What is shocking about Rilke's poem is not the assertion "It's *you* must change your life", but rather the reason advanced for this: "there is no inch of this surface / that does not see you".

Here, Rilke extends the ubiquitously gazing eyes of which Nicholas of Cusa had spoken in *De visione Dei* to an entire body. Such gazing works of art attest to the

48 "Sonst stünde dieser Stein entstellt und kurz
 unter der Schultern durchsichtigem Sturz
 und flimmerte nicht so wie Raubtierfelle;
 und bräche nicht aus allen seinen Rändern
 aus wie ein Stern: denn da ist keine Stelle,
 die dich nicht sieht. Du musst dein Leben ändern."
 (Rilke 1908. *Neue Gedichte II*, p. 1).

49 Riegl 1908, pp. 51–53. Riegl had died, aged only 47, in early 1905.

fact that they are able to see entirely on their own terms, without the adjunct of inscriptions or corporeal or mechanical apparatus. In doing so they are the custodians of the intrinsic image act.

2. THE DYNAMICS OF FORMAL SELF-TRANSGRESSION

A. THE TRANSITION OF THE POINT

It is in the formal qualities of works of art that appear to gaze out at the observer that their own true eyes are to be found. In explaining the dual character of the image in terms of form itself, Leonardo da Vinci also evolved for this a theoretical basis. According to Leonardo, painting is "not alive in itself, but is able to express [è *esprimitrice di*] living things".[50]

In Leonardo's view, it is in the duality of being dead and yet capable of giving expression to life that there originates that power that may be associated with the act of *pro ommatoun poiein*, of "setting before the eyes", invoked in Aristotelian rhetoric.[51] In its pictorial intensity, the act of "setting before the eyes" is suggestive of the dynamism of life itself.[52] And, for Leonardo, the illusion of movement was to become one of the key criteria for the inner vitalisation of any given work of art.[53] Unlike language, images are imbued with the capacity of seeming to perpetuate movement and, by this means, to keep "alive" the bodies represented in them.[54]

This conclusion is justified by the fact that, in the point as understood in mathematical terms – defining the transition from nothingness to a line and, through its movement, producing the structure of a painting – stasis and sequence, immateriality and materiality are interrelated.[55] The immaterial point, perceived as the start of the painting process, is the element of a perpetual transgression, pushing beyond itself into its opposite and supplying, through this dynamism, the basis for that thrilling quality that seizes the spectator. Never satisfied, it emerges from

50 "in sé non è viva, ma esprimitrice di cose vive" (Leonardo 1995 *Trattato*, § 372, p. 187). See also Fehrenbach 2002, p. 174, and Fehrenbach 2005 *Kohäsion*, p. 2.
51 "pro ommatoun poiein" (Aristotle 1926, *Rhetoric*, III, xi, 1, line 2). See also Campe 2008, p. 45. See above, pp. 8–9.
52 Aristotle here introduces the notion of the statue, in which "the inanimate becomes animate": "to aphukhon de emphukon" (Aristotle 1926, *Rhetoric*, III, x. 7, line 11). On these ideas regarding animation, see Campe 2008.
53 Fehrenbach 2002, p. 175.
54 "resta in essere, e ti si dimostra in vita quel che in fatto è una sola superfizie" (Leonardo 1995 *Trattato*, § 25, p. 26). See also Fehrenbach 2002, p. 176.
55 Fehrenbach 2002, p. 199.

nothing to expand into infinity, as if this were its antipode. And, out of this very process, it draws an inexhaustible vitality.[56]

Through his control over what can be accomplished with the movement of the point, the painter *creates* – and in the most direct sense of this term. For, according to Leonardo: "[...] if [he] wishes to see things of great beauty that are capable of making him fall in love with them, he is able to create such things; and, if he wishes to see uncanny things that terrify him, or comical or risible things, or things that call forth true compassion, he is able to create these, too, as their Lord and God".[57] There are powers of such violence that it would be impossible to evoke them fully using words; but they can be evoked with the help of the visual arts.[58]

For Leonardo, it is in this that there lies the central problem as regards image theory. The drawn representation of natural forces of overwhelming power, be they internal or external, does not so much aim at a perfect rendering in the tradition of *mimesis*, but emerges through a process of *creatio*. Drawings such as Leonardo's evocation of the swirling torrents of a flood (Fig. 143) spring from the imagination; but they are impossible to forget for anyone who has once encountered them. In this dual function, they recall those powerful images that were banned in Plato's *Republic* because, in addition to evoking the tumults of nature, they also called forth the ferocity of humankind. Much the same could, however, be said for images of the sort that are no less overwhelming on account of their great beauty. In either case one would be justified in speaking of an "affective *raptus*" that does not imitate reality, but veritably generates it.[59]

Leonardo's idea that the point, through oscillating between nothingness and a line, is able to convey a sense of thrilling movement in a picture, gave rise to a tradition of identifying transitory possibilities in even the very smallest pictorial elements. Around 1600, the Dutch mathematician and engineer Simon Stevin quantified this approach by equating the *punctum physicum* with indivisible zero. The English scientist, scholar and architect Robert Hooke, by contrast, showed in 1665, with the aid of a microscope, that even the smallest point can be subdivided, and that it is precisely from its indeterminate boundaries that its dynamism derives. It was this notion that inspired Richard Feynman's inauguration of nanophysics in 1959.[60]

56 Fehrenbach 2002, pp. 204–06; Fehrenbach 2015. See also Frosini 2003, pp. 225–32.

57 "Se'l pittore vol vedere bellezze che lo innamorino, lui è signore di generale, et se vol vedere cose mostruose che spaventino o che sieno bufonesche, e risibili o veramente compassion-evole, lui n'è signore et Dio" (Farago 1992, p. 194). See also Gombrich 1966.

58 Leonardo 1995 *Trattato*, § 65, p. 59. See also Gombrich 1966, pp. 58–63, esp. p. 63.

59 Fehrenbach 1997, 322–23, and p. 330.

60 On this intellectual tradition: Schäffner 2003.

Fig. 143 Leonardo da Vinci, Rocky landscape succumbing to the swirling torrents of a flood, Black chalk, pen and ink on paper, *c.* 1515, Collection of Her Majesty Queen Elizabeth II, Royal Library, Windsor.

Without making any explicit reference to Leonardo, Roland Barthes identified the leonardesque notion of the multi-functionality of the point – tiny and indeterminate and, on that account, both agile and thrilling – as the essential characteristic of photography: that capacity of the *punctum* to "fascinate" in such a way that, be it "vacant" or "brief and active", it is always as if hunched in readiness, like a beast of prey about to pounce.[61] The most insignificant detail – a particular belt buckle, or the curious shape of someone's fingernails – was capable of so "instantaneously" overpowering the observer, and with such force, that even the precaution of preliminary thorough study could not protect him from it.[62] The observer is of course aware that the eyes of a photographed subject, even though they seem to fix upon him, do not really see him. But he will nonetheless feel as if ambushed by that

61 "poindre" (Barthes 1980, p. 79). "La lecture du punctum [...] est à la fois courte et active, ramassée comme une fauve" (Barthes 1980, p. 81).

62 "fulgurant" (Barthes 1980, p. 74). On this matter: Fried 2005. See also Göttel and Müller-Helle 2009, pp. 53–54. On Barthes's *punctum*, see also Sykora 1999, pp. 66–73; Wolf 2002 *Das, was ich sehe*, pp. 101–07; Stiegler 2006, pp. 344–49; and *Fotogeschichte (punctum* issue) 29 (2009), no. 114; Felfe 2011.

gaze.[63] Barthes's leonardesque concept of the point is, moreover, equipped so as to resemble a compendium of image acts. Be it as a quality latent in the formal possibilities of the image, or in making a sudden assault upon the spectator, or in taking its time, but nonetheless leaving its mark upon the memory, the point is imbued with the same power that Rilke found in the countless eye-pores of the archaic torso. It should therefore come as no surprise that Barthes's reflection on the photographic point ends witn a phrase that incidentally recalls the sense of necessity at the end of Rilke's poem: "I had no option but to contradict myself".[64]

B. THE AGILITY OF COLOUR

Comparable circumstances in which a motoric impulse in the spectator is triggered by formal qualities within the work of art itself arise in connection with the way paint of a distinctive colour used in a picture interacts with that picture's support, and how far the support (be it board, canvas or another material) can be regarded as itself a body: whether, that is to say, the work of art plays an active part in the real world, while the real world acts directly upon the work of art.

In a Crucifixion probably painted in Bohemia around 1400 (Fig. 144) one finds hints at an approach to this problem: for the rendering of the blood of the crucified Christ is such that this does not always drop as if through the air from His wounds, but seems to flow down the surface of the grounded panel. Notwithstanding the admittedly more prominent instance of the blood flowing from the wound in Christ's side (which quite convincingly disappears beneath the loincloth to reappear between the knees), it is notable that the blood flowing from the nail wounds in both of Christ's hands (in particular that at the upper right) seems not so much to drip off the depicted sides of the horizontal wooden beam as to flow down the surface of the painting. It is as if the grounded panel has here become the flesh of the crucified Christ in another guise. In contrast to the case of Christ pressing His face into Veronica's veil, here both of the physical elements combining to create the image of Christ have themselves become His body. In around 1440 Fra Angelico appears to have applied a variant of the same principle in a Crucifixion of his own (Fig. 145). Here, while the Cross itself and the body of Christ are not chromatically very distinct from the tone of the prepared vellum surface, the bright red used for the blood dripping or flowing from Christ's wounds delivers an all the more harrowing contrast, especially in the lower part of the image.[65]

63 Geimer 2009, pp. 134–38.
64 "Je devais faire ma palinodie" (Barthes 1980, p. 96). See also Hoffmann 2009, p. 10.
65 Didi-Huberman 1995, pp. 253–54.

Fig. 144 Anonymous, probably painted in Bohemia, *Christ on the Cross*, Tempera on wood, *c.* 1400, Gemäldegalerie, Staatliche Museen SPK, Berlin.

In the late fifteenth century Hans Holbein the Elder perfected this approach in several of the twelve panels of his so-called *Grey Passion*, which initially formed the wings of a triptych with a (now lost) sculptural centrepiece, and which addresses the liturgical and metaphysical problem of the presence of Christ.[66] Within his sequence of images Holbein has sought to resolve the contradiction that the body of Christ is visible in each of the depicted episodes, but not (yet) present in His true Divinity (Fig. 146) He is present in that sense in the wine and the host of the Sacrament, but is there never physically visible. Holbein's use of *grisaille* not only enables him to avoid the verisimilitude of flesh tones, but also affirms that painting may simulate the physical qualities of its sister art, sculpture.[67] Holbein does not, how-

66 On this and on what follows: Prinz 2007.
67 Fundamental on *grisaille* painting: Blumenröder 2008. See also Prinz 2007, pp. 14–19.

Fig. 145 Fra Angelico, *Crucifixion,* Pen and ink with wash, yellow watercolour and red body colour on vellum, 1438/46, Albertina, Vienna.

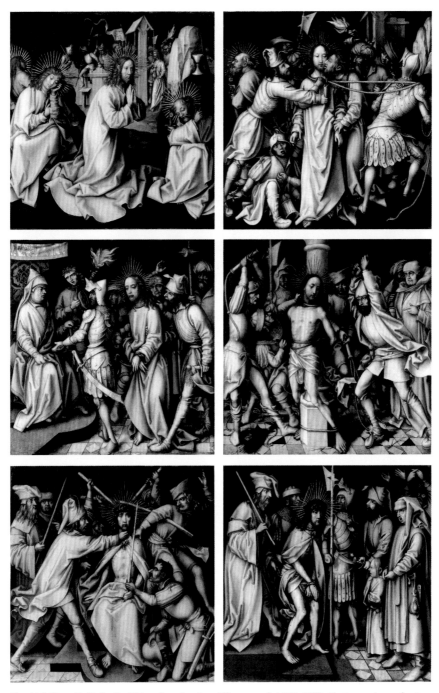

Fig. 146 Hans Holbein the Elder, *Grey Passion*, Oil on wood, 1494–1500, Photomontage of outer panels, Staatsgalerie, Stuttgart.

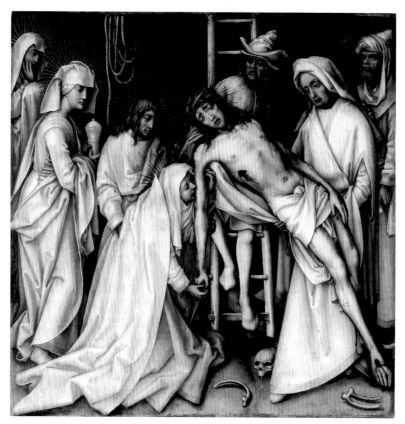

Fig. 147 Hans Holbein the Elder, *Deposition*, one of inner panels of the *Grey Passion,*
Oil on wood, 1494–1500, Staatsgalerie, Stuttgart.

ever, settle here for a mere implicit substitution of sculpture for painting. As is soon
evident, the blood that flows from Christ's wounds is real enough. However, as in
the *Deposition* from the interior section of the altar piece (Fig. 147), this blood flows
from the body on to the panel that serves as a support, as if this were itself a con-
tinuation of the divine corpse. This effect is especially evident around the arms and
the feet, as also in relation to the wound in Christ's side, where the blood appears
especially dark, almost encrusted on the panel, as if the flow had settled and coagu-
lated there. Yet again, paint here becomes blood to an unusual degree. In the *Ecce
Homo* from the outer section of the altar piece (Fig. 148) the red stains of martyrdom
appear partly still to adhere to Christ's body, but partly to have become detached in
that they appear alongside it as autonomous symbolic testaments to His suffering.
According to the legend of Saint Veronica, she was able to preserve a physical trace
of Christ upon her veil; yet each of the panels of Holbein's altar piece serves, in itself,

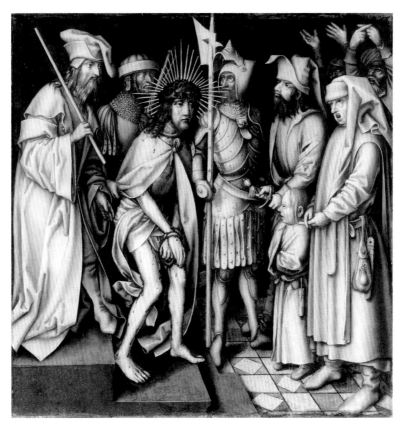

Fig. 148 Hans Holbein the Elder, *Ecce Homo*, one of outer panels of the *Grey Passion*,
Oil on wood, 1494–1500, Staatsgalerie, Stuttgart.

as an effective *vera icon*. In the *Ecce Homo*, for example, some flecks of blood in
Christ's hair overlap His halo, while the blood flowing down the sides of His legs
seems only in part to adhere to these rather than to the surface of the panel itself.
This effect is especially striking in several cases – for example, alongside Christ's
right heel – where what is seen is far more convincing as a blood stain on the panel
than as a stain on Christ's limb.[68]

Even centuries later artists had not ceased to find new ways to both pose and
answer the original, religious questions. In February 1951 the as yet virtually
unknown Yves Klein was already anticipating aspects of what would become a fun-
damental preoccupation in a poem in which he evoked, a through the colours blue
and red a "wounded" sky from which blood flowed:

68 Prinz 2007, p. 21.

Fig. 149 Yves Klein, *Anthropométrie* performance at the Galerie
Internationale d'Art Contemporain, Paris, 9 May 1960.

One day the Blue Sky fell down to earth
and from its Wounds blood gushed forth.
It was dazzling and sparkling Red.
There was also some black There where it coagulated.
A pool of Blood. [...]
And in the peace of the blue reigned the anger of the Red.[69]

While Klein's non-figurative *monochromes*, with which he first came to public atten-
tion in Paris in the mid-1950s, were initially in diverse colours, after 1957 Klein very

69 "Un jour Le Ciel Bleu est tombé sur la terre / et de la Blessure le sang a jailli / c'était du Rouge
éclatant brilliant et petillant / il y avait du noir aussi Là, ou il se coagulait une mare de Sang
[...] / et dans la paix du bleu regnait le colère du Rouge" (cited after *Glaube Hoffnung Liebe Tod*
1995, p. 446; Eng. trans. cited from *Yves Klein* 1994, p. 25).

Fig. 150 Yves Klein, *Anthropométrie,* Oil on paper, 1960, Galerie
Internationale d'Art Contemporain, Paris.

deliberately embarked on a "blue period", as signalled in exhibition titles and in the
formal registration of "International Klein Blue" (IKB). Although other colours (above
all, pink and gold) were also to feature prominently, the preference for monochrome
endured; and in 1961 Klein was to observe:

> As I continued to paint in a single colour, I almost automatically arrived at a
> zone of the immaterial, and this made me aware that I was a European, a true
> Christian, who believed – and with good reason – in the 'Resurrection of the
> Body, in the Resurrecton of the Flesh'.[70]

[70] "Pendant que je continuais toujours à peindre monochrome, presque automatiquement j'ai
atteint l'immatériel qui m'a dit que j'étais un Occidental, un chrétien bien-pensant qui croit avec
raison à la 'résurrection des corps, à la résurrection de la chair'" ("Yves le monochrome 1960.

Klein's *anthropométries*, first publically presented (in "performance" style) in Paris in March 1960, were mostly impressed upon large sheets of white paper by naked female models smeared in blue paint (Figs. 149, 150). Here, the female body became that which the face of Christ had been in the case of Veronica's veil, likewise producing a direct imprint, with the important distinction that here blue supplied a symbol of reconciliation, in place of the red associated with the blood of Golgotha and a metaphor of cruelty.[71]

The anthropométries were products of a division of labour between the directing, male artist and the executing, paint-covered female body. In reaction to this perceived discrepancy the artist Carolee Schneemann, in December 1963, produced similar works using her own body as the means of creating an image that she had herself devised, in her capacity as the artist. It is additionally significant that, in doing so, she should resort to the terminology of the image act. While Klein, she observed, had employed the female body as an "active" object, she (as herself the artist) was using her own body in this way.[72]

A further intensification was introduced when female artists such as Yoko Ono started painting with the blood that had oozed from their own self-inflicted wounds. At each stage of this continuous radicalisation of pictorial means through the introduction of the living body, those concerned had increasingly distanced themselves from the original, religious context, only to find its essence – that of creative suffering – inescapable as they approached the implicitly absolute self-sacrifice of painting in blood: "Keep painting till you die".[73]

Since the inauguration of Dada the principle of artistic self-sacrifice has been countered by a preference for creating conflicts within the image itself. This alternative tradition was effectively founded by the German artist Otto Dix, in whose *Sex Murderer (Self-Portrait)*, painted in 1920, the ostensibly bloody hand- and fingerprints served as tokens of the authenticity of the subject's role as both culprit and artist.[74] In the "smoke drawings" that Stephan von Huene made in 1963–64 the use of the artist's own body – in this case the imprint of his hands – became a highly artificial process, formally contextualised by the image itself (Fig. 151). In these

Le vrai devient réalité", *Zero* [July 1961], n.p., cited after Klein 2003, p. 208). On the interplay of immateriality and corporeal directness in Klein's work: Wagner 2010, pp. 54–55.

71 On the history of the *anthropométries: Marie Raymond – Yves Klein* 2006, pp. 142–56. See also Wolf 2002 *Schleier*, p. 349.

72 "The nude was being used in early Happenings as an object (often an active object). I was using the nude as myself – as the artist" (Schneemann 1997, p. 52). See also Kubitza 2002, pp. 49–50.

73 Yoko Ono, cited after Kubitza 2002, p. 69.

74 Strobl 1996, pp. 145–46. See also Uppenkamp 2010.

Fig. 151 Stephan von Huene, *Smoke drawing*, 1964, Private collection.

works, which usually evince a surreal eroticism, the evoked bodies are both seg-
mented and, at the same time, often intersected by curved shapes, but they ulti-
mately receive, through the artist's own finger- and hand-prints, an internal con-
sistency. The rust that is used to create the working surface provides a layer into
which outlines can be scratched. On top of this, however, the body can be added
directly in an autonomous act of drawing. All the elements thus combine to make
these works into a precious organ of reflection for that surface tension that has fea-
tured in the visual arts since the earliest dissemination of the legend of Veronica.[75]

In addition to the *vera icon* (bearing the face of Christ), motifs such as the
wounds He received (to hands, feet and torso) and the so-called "Instruments of the
Passion" also served artists in their experiments with the reality of the image sup-
port. The nails, the scourge, the Crown of Thorns, the sponge, the lance and the
wounds of martyrdom were, from the fourteenth century, repeatedly employed, as if

75 Bredekamp 2002 *Tiefe*, p. 136; Müller 2010, pp, 63–67.

Fig. 152 Illuminated manuscript from Villers with *arma Christi*, 1520,
Bibliothèque Royale, Brussels, Ms. 4459–70, fol. 150.

in a form of collage, as the *arma Christi* (Fig. 152).[76] Such precursors of the artistic
technique of montage, might even, on occasion, approach the realm of abstraction.
This occurred, for example, when so-called "spear pictures" (incorporating the
wound inflicted by the lance of Longinus) were removed from their context and
presented in isolation (Fig. 153).[77] Significantly, here only the (heart-shaped) bloody
edges of the wound are coloured, while the wound itself is presented as a real slit cut
into the paper, as if this last were indeed Christ's flesh. The principle that any depic-
tion of Christ is always both an image and possessed of a corporeal authenticity was
here transferred to the wound in His side. Here, the image support itself assumes
the redeeming immediacy of the body of Christ.

76 Suckale 1977, pp. 180–83.
77 Lentes 1995, p. 153; Wolf 1999 *Herz*; Tammen 2006.

As demonstrated by instances from the twentieth century, artists continued to draw on this motif. A no less striking evocation of the wound in Christ's side was created by Lucio Fontana out of the very materials of painting (Fig. 154). As in the case of the spear picture from the Late Middle Ages, Fontana uses the image itself to

Fig. 153 Anonymous, *The Sacred Heart*, Coloured woodcut on paper with excised section, probably before 1470, Albertina, Vienna.

Fig. 154 Lucio Fontana, *Concetto spaziale / Attesa*, Acryllic on canvas, 1960, Collection of Teresita Fontana, Milan.

overcome its role through generating a space behind the canvas that is visible and, above all, implicitly palpable in the slight swelling and parting of the slit. The work of art thereby becomes a haptic embodiment of the wound.[78]

78 *Luther und die Folgen für die Kunst* 1983, p. 656. Arnulf Rainer, in some of his "overpaintings" and "woundings", pursued the Veronica principle to its very origins – and beyond. In 1972 he appeared with his head thrust into what would seem to be a stocking. Its agonisingly tight mesh strangulated his face, and a cross, reminiscent of Golgotha, was marked on his forehead in the photographic record of this action. Rainer's procedure effectively reversed the traditional relationship between body and image. Whereas Veronica's veil bore the trace of the face imprinted upon it, in Rainer's action a cloth is imprinted upon a face, here indeed grotesquely compressing that part of the body that it served to envelop (*Glaube Hoffnung Liebe Tod* 1995, p. 427).

Fig. 155 Anselm Kiefer, *Iconoclastic Controversy*, Oil on canvas, 1977, Van Abbemuseum, Eindhoven.

A rendering of the wound in Christ's side that is all but unsurpassed in com-
bining art and pictorial theology – its nominal context being eighth- and ninth-cen-
tury Byzantium – is Anselm Kiefer's *Iconoclastic Controversy* of 1977 (Fig. 155). The
picture shows a gigantic painter's palette, which has become the target of surround-
ing tanks, while the names of celebrated iconophiles (among them John of Dam-
ascus) appear in white, and those of prominent iconoclasts (among them Theo-
philus) feature in black. The palette is itself a palimpsestic battlefield, with paint
oozing like blood out of the cracks on its surface – each of these yet another recol-
lection of the wound in Christ's side.[79]

Colour, in its capacity to ensure the cohesion of the various elements within
any given picture, is possessed of an intrinsic power to ensure that the canvas (as a
permanent reflection of the motif of Veronica's veil) becomes a body. The practice,
since the time of Giotto, of grounding the intended painting support in such a way
as to foster the amicable coexistence of the colours employed, had the effect of
developing a link between heterogeneous elements in order (in line with the Aristo-

79 *Luther und die Folgen für die Kunst* 1983, pp. 109 (image) and cat. 527, p. 639.

Fig. 156 Jacopo Pontormo,
Pygmalion and Galathea,
Oil on wood, 1529/30, Palazzo
Vecchio, Florence.

telian concept of life) to contrive that sort of artful vitality that painting alone could achieve.[80] In the paintings of Raphael this approach attained such perfection that Giorgio Vasari spoke of them as being produced with "living flesh" (*carne viva*), rather than with colour.[81]

Jacopo Pontormo's treatment of the myth of Pygmalion, painted in 1529/30 (Fig. 156), plays a programmatic role in the history of the use of animating colour.[82] Within an expansive landscape setting, an ox, offered up in sacrifice, is being burnt on an altar. Pygmalion himself, seen in the right foreground, and identified by his sculpting tools placed on a stool to the left, turns adoringly to the female figure standing, in contrapposto, on a stone base, her androgynous body (with arms positioned in reverse of those of Michalengelo's *David*) alluding to the supposed bi-sexual perfection of humanity in its primordial form.[83] The transformation of the

80 See also the comprehensive analysis in Fehrenbach 2003, and in Fehrenbach 2005 *Kohäsion,* pp. 7–16

81 "Paiono di carne viva che lavoratori di colori" (Vasari 1906, Vol. IV, p. 321). See also Fehren-bach 2005 *Kohäsion,* p. 23.

82 Blühm 1988, pp. 34–44; Kruse 2003, pp. 374–77; Stoichita 2008, pp. 128–30.

83 Orchard 1992, p. 57.

sculpted figure into a living woman does not merely occur only here through the intervention of the Goddess of Love, but is already taking place through what we observe of the figure's colouring. It is through colour alone that Pygmalion's sculpted figure is transformed into that state in which it is able to enrapture the spectator. Form itself here creates a counterpart for humanity, a partner that signals its own animation in terms of what is sensually perceptible.[84] This notion also informed the work of Caravaggio and his followers.[85]

Similarly, albeit with a greater implicit intensity, it was said of Titian: "He is not a painter, and his capacity is not for art, but for amazement ["*miracolo*"]".[86] The poet Giambattista Marino further heightened this description in defining a picture by Titian of Saint Sebastian as painted in such "vibrant colours" that it was a wonder that it could not speak and feel.[87] Of a self-portrait by Titian, Marino claimed that it was yet again this quality that allowed the work to declare: "I am alive".[88] Titian's ability to create something living out of dead matter is here not related to the surface of the depicted body, but to the entire material substance of the image. And, in the conviction that the time recorded in the image is not entirely tied to the lifespan of the subject,[89] colour itself is freed from any exclusive connection with the motif and its context. The clearest testament to this process is to be found in Titian's preference for using a spatula in place of a brush.[90] In his treatment of the right arm of the inverted body of the subject in the celebrated late canvas now in Kroměříž, *The Flaying of Marsyas* (Fig. 157), Titian activates the autonomous agility of colour with a radicality that borders on abstraction.[91] The same is true of the rendering of the sky and the atmosphere in the case of paintings such as the *Nymph and Shepherd* in Vienna (Fig. 158) and the *Danae* in Madrid.[92]

From this point it is but a short step to the dissolution of colour and subject and thereby to the undisguised reflection of the capacity implicit in the former. In the work of Rembrandt this status is fully achieved. In late paintings such as the *Stormy Landscape* now in Braunschweig (Fig. 159) he brings forth a veritable battlefield of formal entities that assert themselves purely as such, thereby emphasising the *potentia* of the image. Repeatedly, colour may be found to lead a life of its own

84 Stoichita 2008, p. 130.

85 Rosen 2009, pp. 46–63.

86 "Tiziano non è dipintore e non è arte virtù sua ma miracolo" (Speroni 1978, p. 547). On this Krüger 2001, pp. 220–21, and Fehrenbach 2005 *Kohäsion*, p. 4.

87 "In sì vivi colori [...] splende [...] l'imago" ("S.Bastiano di Tiziano", Marino 1675, p. 69).

88 "[...] io vivo" ("Tiziano di sua mano", Marino 1675, p. 199).

89 Boehm 1985, p. 197.

90 Fehrenbach 2005 *Kohäsion*, p. 6, with regard to Dresden portrait of an unknown man.

91 Bohde 2002, p. 337.

92 Oberthaler 2007, p. 120; Checa 2007, p. 221.

Fig. 157 Titian, *The Flaying of Marsyas* (detail), Oil on canvas, *c*. 1575/76,
Obrazárna Archibiskupý Zámek, Kroměříž.

until its very strength is such that its role in a composition may become just as
sculptural as it is painterly.[93]

In 1785/86 the English artist Alexander Cozens placed at the heart of the "new
method" he had devised another approach to painting beyond the imitation of
nature. The outcome of his deliberations and experiments had been a series of
watercolours generating what were effectively abstract landscapes out of a mass of
non-objective and largely random splashes of paint, or "blots". In order to emphasise
the material autonomy of his "blot" version of *Hannibal Crossing the Alps* (Fig. 160),

93 Ziemba 1987, pp. 117–20; Wellmann 2005, pp. 156–57. The principle is especially apposite in
the case of the Rembrandt pupil Arent de Gelder (Suthor 2010, pp. 247–51).

Fig. 158 Titian, *Nymph and Shepherd* (detail), Oil on canvas, 1570–1575, Kunsthistorisches Museum, Vienna.

Fig. 159 Rembrandt, *Landscape with a Storm* (detail), Oil on wood, c. 1657, Herzog Anton Ulrich-Museum, Braunschweig.

Fig. 160 Alexander Cozens, *Hannibal Crossing the Alps* (verso), Brush and black ink, in "blot" technique on crumpled paper, c. 1776, Victoria and Albert Museum, London.

Cozens also crumpled, then again smoothed out, its paper support, thereby allowing this, too, to speak in its own terms.[94]

In China, non-intentional procedures of this sort, often carried out by an artist in a state of inebriation, and used as a way of allowing him to act as a conduit for powers beyond his own, were in due course documented so as to serve as a further element in art education. A text of around 840, composed in the style of a laboratory report, on the work of the eighth-century artist (and poet) Wang Wei in the *pomo*, or "broken ink", style, records the artist's practice as follows:

> When Wang was ready to paint a [silk] scroll, he would start to drink; and, when he was sufficiently inebriated, he would spray ink on to the silk, laughing and singing all the while. Then he would stamp the ink into the silk with his feet or rub it in with his hands, and only then [would he] use his brush to roughly smear it in, using a combination of light and dark tones. And out of the images achieved by this means, there would emerge mountains, cliffs, clouds and rivers.[95]

Such an approach, albeit with roots in other traditions, also became one of the defining elements of mid- and later-twentieth-century Modernism in the West. Its influence has repeatedly been emphasised in the work of John Cage, not least by the composer himself.[96] And the same is true of the artist Jackson Pollock. The latter's claim to be acting as a medium for the energy present in art is suggestively close to the motivation of the aforementioned Chinese frenzy painter: "I have no fear of making changes, destroying the image, etc., because the painting has a life of its own. I try to let it come through".[97] Once again, this had little to do with ceding control to an element of chance, being rather a case of the artist enacting those powers that passed through him.[98] In the "dripping" technique that Jackson favoured chiefly in 1946–50 (Fig. 161), the paint appears to accrue in an almost autonomous fashion across the canvas, so that the medium of the image act is here to be identified not only with the accomplished work but already with its creation.[99]

94 *Entdeckung der Abstraktion* 2007, p. 75, cat. no. 30; and see also pp. 72–84.

95 Cited from Chu Chong-hsuan's compendium for painters of around 840, after: Lachman 1992, p. 501.

96 For critical commentary on this aspect of his work, see Bredekamp 2005 *Cage*.

97 Cited after Lachman 1992, p. 508.

98 Lachman 1992, pp. 503 and 510.

99 Fried 1965, pp. 10–19. See also Meister and Roskam 2007, pp. 227–29; and Kamel 2008, p. 31. On the highly stylised photographs from the studio: Wagner 2010, p. 52. On the issue of Baroque in relation to the *Informel: Augenkitzel* 2004.

Fig. 161 Jackson Pollock in his studio at work on a "drip" painting, Photograph by Hans Namuth, 1950.

Less than a decade later the aforementioned philosopher Merleau-Ponty did not feel it out of place to speak of the talismanic power of colour,[100] here indeed employing concepts that the early-nineteenth-century German philosopher Georg Wilhelm Friedrich Hegel had himself chosen to use. In the latter's Lectures on Aesthetics, given in Heidelberg and (chiefly) Berlin between 1818 and 1829 and first published posthumously, in several volumes, after 1835, he had not hesitated, with Early Netherlandish painting in mind, to speak of "the magic of the colour". According to Hegel, the "secrets of its spell" lay in the fact that its effects were not only dependent on the visible means of its application. Rather, it was the accumulated,

100 "[...] ce talisman de la couleur" (Merleau-Ponty 1964, p. 173).

impenetrable totality of colour applied, through diverse brushstrokes, that gave rise to all the miraculous "glistening and gleaming".[101]

Jan van Eyck's aforementioned painting of 1433 (Fig. 30), on account of its compelling treatment of the fur, the almost photorealistic lines around the eyes, and the haptic quality of the headgear, may perhaps here serve as an example of what Hegel had in mind. In effectively putting the painted surface in the place of the artist at work with his brush, Hegel concludes – in initiable style – by making the subject (that is, the observer) the object of the artist's work:

> [...] it is the entire subjective skill of the artist which, as skill and [as] using the means of production vividly and effectively in this objective way, displays its ability by its own efforts to generate an objective world.[102]

Yet again, the painting is found to express not a reflected externalisation of the artist's emotions in material form, but the active achievement of the work itself. Subjective skill is here admired entirely in terms of all that is "vivid" and "effective" in the image. In connection with the "magic of the colour" in Early Netherlandish painting, Hegel refers to that autonomy of the image invoked as a metaphor in numerous forms of verbal expression, and not least in inscriptions and in posited utterances. These paraphrase Hegel's allusion to the "secrets" of the "magic", not in order to uncover these "secrets", but in order to emphasise that they are part of the living presence of the work. What is here at play is, and remains, "magic", accessible (in Hegel's enlightened view) only in so far as no attempt is made to rationalise its ungraspability. The philosopher's talk of "magic" is a conceptual incunabulum of the image act of autonomous colour.

C. The Multiple Perspectives of Drawing

No form, however, embodies with such incomparable autonomy that principle of the influence exerted on observers by the work of art (expounded by Nicholas of Cusa in relation to the portrait) as does the drawing. Its capacity is exemplified in an episode of Plutarch's life of Alexander the Great. Having conquered Egypt and then (on inspiration drawn from Homer's *Odyssey*) having chosen a particular coastal site for

101 "Blinzen und Glinzern"; "die Magie der Farbe und die Geheimnisse ihrers Zaubers" (Hegel *Aesthetik* 1837, II, iii, 3, 3a, p. 225; Eng. trans. cited after Hegel *Aesthetics* 1975, p. 599).

102 "[...] es ist die ganz subjective Geschicklichkeit welche sich auf diese objective Weise als die Geschicklichkeit der Mittel selbst, in ihre Lebendigkeit und Wirkung durch sich selbst eine Gegenständlichkeit erzeugen zu können kund thut" (Hegel *Aesthetik* 1837, II, iii, 3,3a, 226; Eng. trans. cited after Hegel *Aesthetics* 1975, p. 600).

Fig. 162 H. W. Brewer, Reconstruction drawing of Old Saint Peter's in Rome, 1892.

the Greek city he wished to found, Alexander ordered that a plan be "drawn in conformity with this site".

> As there was no chalk at hand, they took barley-meal and marked out [a plan] with it on the dark soil [...] The king was delighted with the design; but suddenly birds from the river and the lagoon [...] settled down upon the place like clouds and devoured every particle of the barley-meal so that even Alexander was greatly disturbed at the omen.[103]

The site being so very promising, construction nonetheless soon went ahead (although Alexander was not to see this particular city with his own eyes). But Plutarch's account of the accidental loss of the plan leaves no doubt as to the almost talismanic power of the drawn scheme in architectural history.

This component has rarely been more clearly articulated than in the case of the resolution reached in Rome in 1505 to demolish parts of Old St. Peter's (Fig. 162) and, in their place, to erect a new Basilica.[104] This ambitious undertaking effectively

103 *Plutarch's Lives* 1919, VII, *Alexander*, xxvi, pp. 298/299–300/301.
104 On the reconstruction drawing (here Fig. 162): Bannister 1968.

assured several generations of architects of employment related not only to the con-
struction but also to the demolition; and many of them supported and greatly
enlivened the undertaking through submitting sketches. And it was here that the
drawing achieved its paradigmatic breakthrough.[105]

An example such as Bramante's plan of the New Saint Peter's (Fig. 163), drawn
on vellum, is distinguished (at least to the eye of art-historical retrospect) by the
nuanced magnificence of its execution and the calm confidence of its overall
appearance. Although it in fact preserves a stage of work that was not realised, it
may nonetheless be said to have fulfilled its role as an influence on the overall out-
come in so far as it conditioned subsequent phases of both planning and building.
Bramante's creative defiance is especially apparent if one examines a detail of
another drawing: his superimposition of elements of the proposed new ground plan
on that of the old Basilica (Fig. 164). It is at first glance evident that Bramante's intro-
duction of four massive crossing piers fatally disrupts the outline of the long choir
of the older building. These new elements testify to how the drawing allows its
maker, and in due course those to whom it is shown, not only to imagine the
unthinkable, but also to regard this last as realisable through re-directing the move-
ments of their eyes as they scan the record of the original ground plan.

The nervous spontaneity of Bramante's drawn lines offers an extreme
instance of how undisguised his determination was to replace the old with the new.
Working in a counter-clockwise direction and employing, at each turn, a more
assertive stroke, Bramante establishes the canonical form of his crossing piers,
which were here intended to strike the fabric of the old Basilica like an arrow in the
flesh. These were the sign that the Old St. Peter's had to fall. No detail is more telling
in this context than is the south-eastern crossing pier (that appearing in the upper
left quadrant), which already implicitly eliminates the Old Basilica's inner row of
columns. The fate of the Old St. Peter's was thereby sealed.

This particular example of destruction and new building shows that the
effectiveness of a drawing does not depend on the pre-existing reality that it chal-
lenges, be this the stony grandeur of a palace or the ephemeral pen strokes of an
earlier drawn plan. In all media, on all scales and at all levels of quality, drawn
images are able to participate in the dialectic of destruction and creation. An irre-
sistible temptation allows the drawing to act as a wall-breaker, in the face of which
a Basilica from Late Antiquity – that building in which the work of church and state
was daily accomplished – can offer no more resistance than can a sheet of paper.
After several decades of confusion, such as was inevitable in this context, there

105 Bredekamp 2008 *Sankt Peter in Rom*, pp. 25–35.

Fig. 163 Donato Bramante, Design for the ground plan of New Saint Peter's (detail), Pen and ink on vellum, 1505, Gabinetto Disegni e Stampe, Galleria degli Uffizi, Florence.

Fig. 164 Donato Bramante, Parts of a proposed ground plan for New Saint Peter's superimposed on the existing ground plan of Old Saint Peter's, Pen and ink on paper, 1505, Gabinetto Disegni e Stampe, Galleria degli Uffiizi, Florence.

emerged Michelangelo's own New St. Peter's: the apotheosis of the drawing as a *tour de force*.

Formal self-transgression is also to be encountered in terms of three-dimensional space and its perspectival exploitation. An enigmatic example of this way of posing the related problem is to be found in an anonymous painting of the late six-

Fig. 165 Anonymous, *The Holy Family with a View of Verona*, Oil on canvas, 1581, Allen Memorial Art Museum, Oberlin College, Ohio.

teenth century (Fig. 165).[106] In the immediate foreground is a *cartouche*, or identifying label, affixed at the base of what appears to be a painted composition. This *cartouche* is itself rendered as if it had become partially detached, its left end curling forwards and, by dint of the sunlight entering at the left, casting a shadow to the right. Inscribed "Verona", the *cartouche* appears to inform the spectator as to the subject matter of the composition. From this point on, however, expectations are repeatedly disappointed or confused. For in the sky above the panoramic view of the named city there loom figures of the Virgin Mary, her husband Joseph, the infant Christ and, to the left of this last, a young boy who may well be John the Baptist. Their presence here is not only of a ghostly quality; it is also distinctly uncanny. For two of them are found to continue in the painting that lies beneath the foreground canvas, the heads of both Mary and Joseph being visible above its rolled upper edge. One is thus momentarily prompted to see the lower part of the figural composition,

106 *The Age of the Marvelous* 1991, plate 14, cat. no. 199, pp. 432–33. See also Krüger 2001, p. 44, and, on the concept of the "construction of reality" ["Wirklichkeitskonstruktion"], passim. On the phenomenon in general, see Ebert-Schifferer 2002.

Fig. 166 Pere Borrell del Caso, *The Flight from Criticism,* Oil on canvas, 1874, Banco de España, Madrid.

as visible only through the foreground canvas, being part of a painting that lies behind it. As the foreground canvas cannot, however, be transparent, one is then forced to consider the possibility that the figures exist, simultaneously, both above the foreground view of Verona and in the painting that lies behind this. There thus arises the notion of a dual existence, making it impossible to determine which is the (foreground) painting and which the (background) panel, which is the (initial) picture and which its (subsequent) copy, which is the vision and which the reality. This conundrum is thoroughly intrinisic to the image.

In the *Flight from Criticism* (Fig. 166), painted in 1874 by Pere Borrell del Caso, a wide-eyed adolescent is about to clamber out of a picture frame in order to engage, as the embodied animation of the image, with the three-dimensional world of the spectator.[107] The motif appears to be the model for every one of art history's many subsequent instances of the image attempting to step out of itself. In its extended significance, however, it serves not only as an element of the *paragone* (here reclaiming for painting the right to occupy and act in real three-dimensional space) but also, and above all, as a demonstrable form of engagement in a process of overcoming

107 *Deceptions and Illusions* 2002, p. 285, no. 76 (Janis Tomlinson); Hedinger 2010, p. 10.

that plane upon which the geometrised construction of the image occurs and, effectively, freezes. The adolescent breaks through that tableau into which all his bodily forces would otherwise have been locked in their relation to central perspective. His refusal to surrender to this planarity can be read as a motto for all endeavours to challenge the validity of this formal tradition.

This had of course already been achieved by the first artists who had learnt to employ central perspective, who did so with an all but insuperable perfection, and who then almost immediately – as demonstrated by the example of Botticelli's *Mystic Nativity* of 1500 – discarded it, in favour of a thematically and narratively determined perspective.[108] It is among the greatest achievements of European painting that, no sooner had it evolved central perspective, than it began to use this as the medium of a constructive game that freed depicted space from the precision that would otherwise have been expected of it.

The anti-perspectival reflection of the autonomy at work within the image becomes especially clear in the realm of architectural drawing.[109] And here it serves to highlight the conflict between the desire to understand architecture *in* an image and the desire to understand it *as* an image,[110] even though its corporeal and haptic dimensions remain unaccommodated by either option. The contingency of those sensorially perceived occurrences that emerge through the interplay between architecture and bodily movements[111] is not to be grasped through central perspective, which relates to architecture only from a single observer's point of view; and this has therefore only been hesitantly employed for such a purpose. Since the work of Robert de Cotte, who from 1708, under Louis XIV, refined the regularisation of French architecture, this scepticism has continued to grow, reaching a peak in the era of Modernism.[112] Walter Gropius, for example, in his 1923 prospectus for the architecture course at the Bauhaus, formulated a rejection of vanishing point perspective in favour of axiometry, in order to allow things their own freedom, so that these might be shown "as they are" ["wie sie sind"].[113]

The critique of the pictorial construction of architecture corresponds to Walter Benjamin's theory of perception. As featured in his essay on the "work of art", this distinguishes between an "optical" and a "tactile" response to the built environment, respectively associated with alert "attention" and relaxed "distraction", the latter being a response that he finds increasingly reflected, by the 1930s, in the

108 Körner 2006, pp. 374–75.
109 Linfert 1931; Bredekamp 2004 *Gehry*.
110 See also the reconstruction of this notion in Reudenbach 1979.
111 Linfert 1931, pp. 143–44.
112 Linfert 1931, pp. 147–52.
113 Gropius 1923, p. 15.

Fig. 167 Hermann Finsterlin, Sheet with S-curve drawings, Pencil, crayon, ball-point pen on tracing paper, c. 1920, later re-worked, Westfälisches Landesmuseum für Kunst und Kulturgeschichte, Münster (on long-term loan from Cremer Collection).

"mindless" mass consumption of cinema.[114] Benjamin had here drawn on the work of the art historian Carl Linfert, who had in turn found his own chief inspiration in that of Alois Riegl. The objects of Linfert's attention were architectural drawings that had climbed out of the golden cage of central perspective in order to find their own starting points, in a multi-perspectival fashion, in the buildings themselves. This approach enabled architectural drawing to become a reservoir of the formally autonomous image act.[115]

A milestone in this capacity is to be found in the tradition (originating in Albrecht Dürer's marginal drawings) of oscillating S-curves, such as were realised three-dimensionally in the biomorphic architectural foms devised by Eric(h) Mendelsohn, or as were almost whimsically extended in the sheets of sketches made by

114 Benjamin 1974, pp. 465–66 (1st version: "die Zerstreuung"); 504–05 (2nd version: "die Zerstreuung"); 735–38 (French trans.: "la distraction").

115 Benjamin 1972, pp. 367–69, 373–74. See also Kemp 1973, pp. 31, 44. Linfert's letters to Benjamin: "Was noch begraben lag" 2000, pp. 114–29. See also Linfert 1931, p. 149.

Fig. 168 Charles Sanders Peirce, Sheet with drawings, Pencil on paper, Houghton Library, Harvard University, Cambridge, Mass.

the architect Hermann Finsterlin (Fig. 167).[116] Although a concrete connection is not here proposed, these last appear very similar to the markedly diverse sketch sequences in which the philosopher Charles Sanders Peirce repeatedly sought to capture the dynamic architecture of his own throught process (Fig. 168). In view of his conviction that stability was only a misleading snapshot of the reality of continuous dynamism, it was inevitable that his way of thinking should resist the prevailing approval for central perspective. His drawn variants on the S-curve, numbering over

116 On Dürer: Bach 1996. See also *Hermann Finsterlin* 1988, Pehnt 1998, pp. 153–548; and *The Drawings of Eric Mendelsohn* 1969. These have found a striking continuation in the drawings of William Kentridge: Breidbach 2010.

40,000 (which have heretofore attracted barely any serious scholarly attention, let alone been published), may be understood as attempts to evade the influence of central perspective and to generate their own style of thinking out of the universal formal motif of *natura naturans*.[117] Peirce's largely misunderstood concept of indexicality

Fig. 169 Frank Gehry,
Sketch for a Museum of
Tolerance for Jerusalem,
Felt-tip pen on paper, 2002,
Private collection.

(as the object of a semiotic theory of drawing) takes into account the performative play of things as measured in relation to living bodies. His model is not any contemporary theory of signs, but the body-related semiotics of the physicians of Antiquity, such as Galen.[118] Peirce's drawings should, in this sense, be understood as the indices – self-generating, arising in part by chance but, precisely on that account, symptomatic – of a nature to be found in continuous physical and mental movement.

In architectural history it would be fair to say that elements that are characteristic of Frank Gehry's drawings – the hand movements that seem to think as they execute lines, that circle back upon themselves, that twist and turn in a

117 Fundamental on Peirce's philosophy of drawing: Pape 2008 and Krois 2009 *Image Science*, pp. 205–14. For an attempt to define the fields of Peirce's activity as a draughtsman, see Engel, Queisner and Viola 2012.
118 Krois 2009 *Image Science*, p. 208, and Wittmann 2010, p. 2.

sequence of S-curves, that paraphrase central perspective – have now become a universal form. One of the sketches made in connection with a Museum of Tolerance planned for Jerusalem (Fig. 169) achieves its distinctive rendering of three-dimensional depth through an improbably logical tangle of lines issuing from a single, continuous gesture, each circling or spiralling hand-movement falling within the radius of a propped elbow.[119]

Unencumbered by either external delimitation or any sense of resting upon a fixed base, the model as envisaged floats freely in space. The two outward pointing loops to the lower left might well suggest a shadow meeting a plane; but the dominant impression is, nonetheless, of an object rising in two distinct stages, albeit without any firmly fixed point of departure. From a circular pedestal there emerges an initially tentative tower, albeit one hardly less intertwined and crumpled than is its base. The strokes themselves – curving, circling, swirling, meandering, occasionally sharply bending and, above all, issuing in serpentine forms – generate a sense of tissue within the internal structure, but in the drawing as a whole prompt, rather, the impression of an entity that vibrates and pulsates. They seize upon the contingency of those aforementioned sensorially perceptible occurrences that emerge through the interplay between architecture and bodily movements. Gehry's drawings never seek to make the edifice fit the experience of the subjective observer. Their aim, rather, is to convey its autonomous objectivity to the observer's imagination. In this achievement Gehry's sketches are incarnations of the formally autonomous image act in its multi-perspectival aspect.

3. The Irresistibility of Form

A. The persistence of the figure

A further aspect of the active role of form in a work of art lies in its capacity to persist, as an emotionally freighted visual memory, through subsequent realisations in a great variety of media. In this there is to be found a further dimension of the power exerted by form that Leonardo characterised as its capacity to capture the artist's imagination.[120]

In the summer of 1993 the architect Frank Gehry, in the company of the art historian Irving Lavin, visited the French city of Dijon. While there, he came upon the imposing tomb of Philippe le Hardi (Philip the Bold), who had been an immensely powerful Duke of Burgundy in the late Mediaeval period. Planned for, and long

119 Bredekamp 2004 *Gehry*, pp. 17–18.
120 See above, pp. 3–4.

housed in, the Carthusian monastery on the outskirts of the city, the Chartreuse de Champmol, the tomb was vandalised during the French Revolution and, following reconstruction and reassembly, is now in the former Dijon palace of the Dukes of Burgundy. Gehry noted in particular the funeral procession circling the high pedestal that bears the effigy: diversely dressed and posed *pleurants*, or mourners, each carved in alabaster and around 40 cm. in height.[121] He was especially struck by the immense pathos conveyed by the undulations of these figures' heavy, voluminous drapery, itself an innovation of Claus Sluter (who in 1389 had been appointed principal sculptor to the Dijon court). These undulations seemed to Gehry to observe formal criteria not unlike those governing the membranes he employed in his work as an architect. Gehry was especially moved by the cowl-like head-covering of one mourner (Fig. 170), which seemed to epitomise the capacity of such drapery to envelop, and almost conceal, the human figure, while itself conveying, indeed intensifying the burden of grief.[122]

Having derived undulating forms of his own from this example, Gehry went on to explore how these might be used in a great many diverse contexts, among them his scheme (initiated in 1989) for the Lewis Residence in Lyndhurst, Ohio, the spaces of which reiterate the swelling and dipping of Sluter's draperies (Fig. 171). These experiments issued in the emphatically theatrical velvet model of 1994 (Fig. 172), which is among the most elaborate and sumptuous ever made in the Gehry workshop.[123] By way of the intermediary of fibreglass structures, such models gradually gave rise to a series of autonomous sculptures, using other materials with their own associations. These were often powerfully evocative of the skulls of primeval creatures (Fig. 173).[124] After a further series of intermediate stages over several years these sculptures were in fact to achieve architectural form – not, however, at the Lewis Residence (that project remained unrealised), but in an entirely different context and with an altogether new purpose.

Gehry had been commissioned to design a bank building for Berlin to be erected on an elongated north-south site opening on to the southern side of Pariser Platz, thus diagonally across from the Brandenburg Gate (Fig. 174).[125] In keeping with the strict formal requirements for any architectural addition to such a historically resonant location, the bank's northern façade was imposingly plain and orthogonal, although its large, unframed windows, recessed with increasing depth, subtly

121 It is possible that figures from this procession served as a model for the Munich automaton (see above, pp. 100–03).

122 Once back in Los Angeles, Gehry immediately obtained a copy of the recent Sluter monograph by Kathleen Morand (Morand 1991). See Lavin 2003, pp. 42–43; and Lavin 2004, p. 442.

123 *Frank Gehry, Architect* 2001, p. 157.

124 *Frank Gehry at Gemini* 2001.

125 *Frank O. Gehry* 2001.

Fig. 170 Claus Sluter, Figure from the procession of mourners forming part of the funerary monument to Philippe le Hardi, Duke of Burgundy, Alabaster, 1380–1410, Musée des Beaux-Arts, Dijon.

hinted at the presence of a huge, invisible bubble swelling over the monumental city square. The interior, with its several tiers of offices set around a vast atrium, could hardly have supplied a greater contrast, and not least on account of the remarkable feature that loomed at its southern extremeity: appearing to hover between an arching glass roof and a curved glass floor was an undulating shell of stainless steel, which re-worked, on a very much larger scale, the sculptural forms indirectly derived from the inspiration Gehry had found in the drapery of Sluter's mourners. Even during the construction phase the evolving edifice had featured a curious canopy (Fig. 175). This was in due course extended forward so as to enclose a predominantly wooden interior (the bank's conference hall) that overlooked the atrium through a recessed glass wall (Fig. 176). Through the emotional impact on Gehry of the drapery of Sluter's figures and the persistence of its expressive formal qualities in his imagination and in his subsequent practice, a sculptural innovation from late-Mediaeval Burgundy was to re-emerge as the most breath-taking feature of an addition to

Fig. 171 Frank Gehry,
Model for the Lewis
Residence in Lyndhurst,
Ohio, 1993/94, Collection of
the architect.

Fig. 172 Frank Gehry,
Velvet model for the Lewis
Residence in Lyndhurst,
Ohio, 1994, Collection of
the architect.

Fig. 173 Frank Gehry,
Colorations (from a series of
twelve), Laminated
fibreglass, with colour
pigment, 2000, Private
collection.

Fig. 174 Frank Gehry, DZ Bank AG, Pariser Platz, Berlin, Principal (northern) façade.

Fig. 175 Frank Gehry, DZ Bank AG, Pariser Platz, Berlin, Atrium under construction.

Fig. 176 Frank Gehry, DZ Bank AG, Pariser Platz, Berlin, Atrium with completed conference hall, Photograph, 2000.

early-twenty-first-century Berlin. It is hard to envisage a more telling demonstration of the insistence of form as a creative force.

B. THE MODEL AS GUIDE AND SHACKLE

One of the most notable manifestations of the intrinsic image act is the model. In conceptual terms a model can function as both a guide and (inadvertently) a shackle. And, without an awareness of this duality, the model cannot be fully understood.

The English word "model" (derived, through French, from the Italian term *modello*, itself derived from the Latin *modulus*, which was in turn a diminutive of *modus*, measure) signifies the reduction in scale of a perceived norm.[126] The model offers a reduction of all measurable aspects of the norm, in order to make it easier to grasp complex situations or dimensions that might otherwise exceed the average capacity of human comprehension. The origin of the concept of the model reveals how essential to it is the notion of diminution. Even in the case of one-to-one models – the props used on a film set, or for the purposes of demonstration in an architectural context – the principle of diminution still applies.

The essence of the model as it has been employed for millennia is to be found in surviving records of the reduced-scale versions of proposed architectural designs (Fig. 177).[127] Because of the usually high costs of erecting a building of any scale and

Fig. 177 Model of a house from Egypt (Thebes), c. 1981–1975 BC, Metropolitan Museum of Art, New York (Rogers Fund, Edward S. Harkness Gift).

126 Lepik 1994. See also Mahr 2009, for a forceful exposition of the problem of the character of the model when taking into account the complex uses to which a model may be put.

127 *Architekturmodelle* 1995, p. 10.

sophistication, decisions regarding the acceptance, alteration or rejection of what is proposed will, on the whole, need to be taken on the basis of a model, making their provision an essential element of architectural planning. It is after this pattern – with the model serving as a preview of what is to follow – that models are to be encountered in every possible context. Notwithstanding its familiarity, the model is never entirely removed from an element of the magical. For it is out of its own deficient relationship to pre-existing reality that it conjures the promise (by way of clear visualisation, as a basis for meticulous planning, as a guarantee of secure construction) of a substantial addition to that reality.

This is also true of models as employed in the sciences. Because of the complexity and contingency of their practitioners' respective fields, no method that scientists adopt can function without models. Yet, by the same token, no scientific model is without its dangers as well as its magnificence. An especially compelling demonsration of this is to be found in Charles Darwin's diagram of the process of "natural selection", which is among the most important models ever devised (Fig. 178).[128] This diagram may, without doubt, be understood as the visual symbol of his work in its entirety, for language would be unable to encapsulate the full complexity of nature. If the history of the interrelationships within a single ancient family may be such that these can only be clearly followed through an image (a "family tree"), then this was all the more so in the case of the numerous families of the species, which would be possible to visualise without a diagram.[129] Where Darwin in On the Origin of Species, explains the principle of "natural selection" in the chapter so titled, he is in fact describing his own diagram. Nature in its entirety was to be understood only in terms of such a visual model.[130]

In its superb mixture of abstraction and vividness, Darwin's model of "natural selection" illustrates the capacity of the diagram to muster a seemingly unlimited amount of information in such a way that it is rendered comprehensible.[131] In

128 Each of the broken lines that takes off at the bottom of the diagram represents a species in existence at this point. As each of these persists into the (unspecified, but vast) chronological period indicated by the lower horizontal bands (I rising through X), it is soon clear that two species (A and I) are dominant, reproducing themselves in ever new variants. By the much later chronological period represented by the upper horizontal bands (XI through XIV) it is clear that those lines ultimately deriving from the original form of species A and I have thickened and straightened and have prevailed at the expense of their neighbours. Except for the descendents of the stable species F, all that now survives are variants of the two dominant species. (Darwin 2001 [1859], pp. 116–26).

129 Darwin 2001 [1859], p. 431. See also Bredekamp 2005 Darwins Korallen, pp. 51–54.

130 Bredekamp 2006 Bilder in Evolution.

131 Fundamental on the philosophy of the diagram: Stjernfelt 2007, pp. 89–116. On the history of diagrams of fields of knowledge: Siegel 2009.

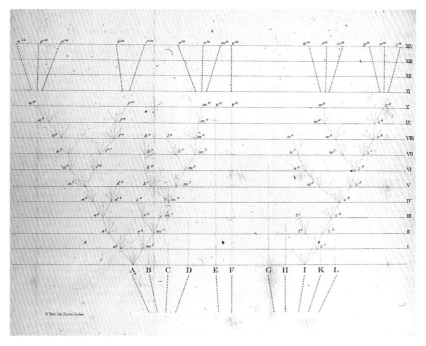

Fig. 178 Charles Darwin, Model of "natural selection", later published in *The Origin of Species*, London 1859.

this it is an example of the model that may even be characterised as both co-oper-ative and wilful. For the boon of its sparkling clarity is accompanied by the danger of its power to seduce. By virtue of the compelling brilliance of their construction, models may become fetishes in fields of research that in reality comprise utterly indigestible masses of data. This is also the case with Darwin's model of "natural selection" in as far as it resembles a tree.

In the schematic polish of its repeatedly branching structure, Darwin's dia-gram seemed so precisely to correspond to an abstracted version of a well-turned-out tree, that the question as to whether or not it actually symbolised an arboreal form was never raised. However, because the model of the tree of life has proved so popular among evolutionary biologists, diagrams based on a tree were, and indeed still are, produced. And this in spite of their obvious disadvantages: the implicit origins in a nominal single root (whereas a tree's roots, like its branches, are in real-ity multiple), and the high crown of foliage suggesting growth in a single direction, upwards (which Darwin himself categorically denied.). Darwin's diagram thus tes-tifies to the fact that models can come to rank higher than the reality they purport to represent in abstract form. Objections to the tree model insistently raised by evol-

Fig. 179 Odile Crick, Model of the "double helix" structure, illustrating an article of April 1953 in the British science journal *Nature*.

Fig. 180 William Hogarth, Title page of the first edition of *The Analysis of Beauty*, 1753.

utionary biologists themselves looked for a long time as if they were up against a brick wall.[132]

A comparable capacity for both clarification and (misleading) suggestion was to be a feature of a no less celebrated model: that of the "double helix", in the form in which it accompanied the text of an article – at only two pages as concise as its argument was far-reaching – published in 1953 in the British science journal *Nature* by the future Nobel Laureates James D. Watson and Francis H. Crick, a form in fact devised by the latter's wife, Odile Crick (Fig. 179). In the late 1930s Odile Crick had trained as an artist, and it is unlikely that she would not at some point have become aware of the aesthetic and intellectual significance invested in the spiral form. For William Hogarth it had embodied the beauty of nature as a whole, and it thus appeared on the title-page of the 1753 first edition of his *Analysis of Beauty* (Fig. 180). For Paul Klee it had characterised the process of thought itself, and in this capacity

132 Doolittle and Bapteste 2007; Dagan, Artzy-Randrup and Martin 2008. See also Bredekamp 2009 *Das Prinzip der Metamorphosen*.

Fig. 181 Charles Darwin, Third diagram of evolution from Notebook B, Pen and ink on paper, 1837, Cambridge University Library.

it featured in the *Pädagogisches Skizzenbuch* he published in 1925.[133] At all events, in devising her model of the double helix as a two-fold version of the venerable symbolic spiralling line, Odile Crick created a true icon of science. In order that it be absolutely clear that her diagram did not illustrate nature itself, but was an abstract model (which must, of necessity, be systematically deficient in order to serve as such), the accompanying caption stated that the appealing and intriguing image was "purely diagrammatic".[134] Over time, however, the perceived significance of this prudent qualification diminished in almost inverse proportion to the proliferation of virtually unbounded hopes invested in the diagram itself. Recognition that the seemingly mechanical stability of the double helix did not correspond to the persisting mystery regarding its actual inner functioning nor to the apparent dynamism of its interaction with the environment, was not to gain widespread accept-

133 Klee 1925, p. 6. It may be of significance in this context that an English version of Klee's volume (translated by Lucia Moholy-Nagy) was published in London in 1949; and that an exhibition devoted to Hogarth, presented at the Tate Gallery, formed part of the Festival of Britain celebrations during the summer of 1951.

134 Watson and Crick 1953, p. 737. Fundamental on the constructed model: Chadarevian 2007.

ance until the late 1990s.[135] The precaution of the words "purely diagrammatic" had succumbed to the fetishisation of an image.

One would, then, be justified in asserting that models best serve the cause of enlightenment where verbal explication and visual impact are integrated to that end. Here, too, Darwin may be seen to have created a sort of icon, in inscribing the words "I think" above one of the most striking sketches ever committed to paper (Fig. 181). For this is no more and no less than the first formulation of a model for evolution tending simultaneously in all directions and anarchically contingent; a model based, accordingly, not on the form of a tree, but on that of coral.[136] Anticipating later reflections on the network, or rhizome, character of both nature and culture, this model also effectively pre-empts and counters every form of Social Darwinism.[137] Admittedly, there has yet emerged no incontrovertible evidence as to whether the text here in fact represents the author's own statement or, rather, the equivalent of a speech bubble containing a statement that he is imputing to his own diagram. The draughtsman writes: "I think"; but, because these two words appear directly above the sketch, they may alternatively (or simulataneously) be read as a first-person-singular statement by the diagram about itself. In potentially assuming both roles, the words "I think" may, in the present context, be seen to take their place among the numerous comparable phrases that allow the diverse products of human ingenuity to express themselves in the first person singular (Figs. 21–38). Darwin's sketch, as small as it is epoch-making, supplies a further vivid demonstration that humanity thinks through images, which are its own products and yet are possessed of a true autonomy.

In order to render vast quantities of data manageable and to fulfil numerous simultaneous tasks, models necessarily compromise. In doing so they also achieve a certain distance from the distress, even terror, attendant upon every human encounter with the profound unknowability of reality. The diminution inherent in the model gives rise to a psychological surplus, which in turn encourages a readiness to perceive, and indeed enjoy, the model, notwithstanding its recognised abstraction, as a physical entity. It is the creative energy released by this contradiction that fuels the intrinsic image act. In this respect the model may be viewed as its quintessence.

135 Fox Keller 2000, pp. 144–45, and passim; Müller-Wille and Rheinberger 2009, pp. 102–04.
136 Bredekamp 2005 *Darwins Korallen*.
137 See also Bredekamp 2005 *Darwins Korallen*; and Bredekamp 2009 *Das Prinzip der Metamorphosen*.

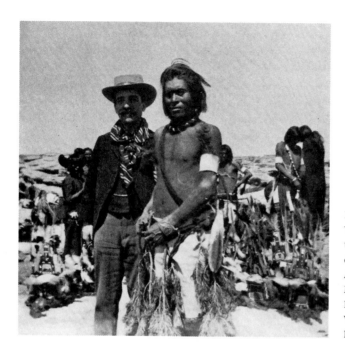

Fig. 182 Aby Warburg with an unidentified Hopi dancer at Oraibi, Arizona, May 1896, Photograph, Warburg Institute, London.

C. THE PATHOS FORMULA AS THE POWER OF DISTANCE

The overcoming of dread as the ultimate purpose of the images that humanity produced was the theme to which all of Aby Warburg's research and writing was devoted. In pursuit of this theme – which he saw as the heart of an all-encompassing theory of the image that embraced the criteria of the image act – his enquiries took him from the primeval origins of human image-making to the technologically advanced illustrated press of his own day.

When, during his travels of 1895–96 in New Mexico and Arizona, Warburg had himself photographed with a Hopi dancer (Fig. 182) or even sporting one of the ceremonial Hopi masks, he was doing far more than merely accumulating exotic holiday souvenirs.[138] In these south-western states of North America, equipped with relatively superficial and erratic information on the native cultures that survived alongside those of incoming European settlers, Warburg brought curiosity and imagination to what he found. Central to this novel experience, and for his later intellectual response to it, was the opportunity to observe elements of the extended

138 Warburg 1979, p. 323. See also the illustration with a mask: Warburg 1988, p. 62. For Warburg's diary covering the months of his American trip, in addition to numerous related photographs, taken by him and by others, see: *Photographs at the Frontier* 1998.

Fig. 183 (above left) Hopi dancer during serpent ritual, Photograph, 1924, Library of Congress, Washington, D.C.

Fig. 184 (above right) Drawing from a report of 1894–95 on "Hopi Snake Ceremonies" by the anthropologist Jesse Walter Fewkes.

Hopi serpent ritual, which ceremonially enacted and thereby (the Hopi believed) magically protected the relationship between man and both an intractable natural environment and terrifying supernatural powers. Comprising three chief phases – the initial, highly precarious capture of the snakes; the dances (predominantly processional in character, with semi-entranced stamping motions) through which participants demonstrated their practical mastery of, and spiritual communion with, the snakes (Fig. 183);[139] and the no less important final act of again releasing these creatures – the ritual led Warburg to grasp how inextricably interlinked were its experiential and its ideological components. Stylised Hopi renderings of snakes in the form of jagged lightning bolts, as recorded by earlier visitors (Fig. 184),[140] testified to the Hopi belief that, upon their release, these would mediate between spirits dwelling underground and those in the heavens, drawing down lightning and, in due course, the always much-needed rain. In Warburg's eventual formulation, the experience of emerging unscathed from the serpent ritual encouraged the Hopi to see the initially dreaded snakes as symbols not of death, but of life, their potency resolved into images and, as such, distanced (not least to the benefit of their human allies) from all that was fatal in the realm of nature.

Warburg's own cultural theory, which had been sharpened through such ethnological experience, differed from Claude Lévi-Strauss's ostensibly related theory of masks in that it did not take its starting point in the model of structural lingusi-

139 Warburg 1988. See also the Italian edition of the images: Warburg 2006, here p. 109, with a photograph from 1924. On the serpent ritual in its historical context: *Schlangenritual* 2007.
140 Ehrenreich 2007, p. 39.

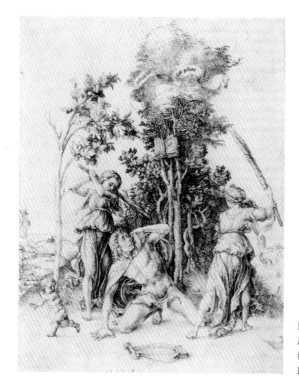

Fig. 185 Albrecht Dürer, *The Death of Orpheus*, Pen and ink on paper, 1494, Kunsthalle, Hamburg.

titcs, but rather in a theory of expression derived from the study of corporeal *schemata* and human gestures and actions.[141] Such interests led Warburg in due course to discover an alternative theory of language that complemented his own inclination to approach the entities he studied in terms of the preservation and further transmission of energy. Warburg's application of this theory is clearly demonstrated in his analysis of Albrecht Dürer's 1494 drawing of *The Death of Orpheus* (Fig. 185). Focusing on the schematised poses of the kneeling Orpheus and the mercilessly beating maenads, Warburg pursued possible sources for these among the models that would have been available to Dürer himself. For Warburg, Dürer's drawing was an exemplary document of this Nuremberg artist's own engagement with the *schemata* of Antiquity and their reformulation in the Italian art of Dürer's own time. Warburg was, however, less interested in the genealogies of each of the formal motifs than in the wilful stylistic leaps that had ensured a marked increase in expressive power upon their reappearance in other, later contexts: the means, in

141 Krois 2002, pp. 301–06. Lévi-Strauss later distanced himself from this universal explanatory model (Lévi-Strauss 1993).

short, whereby they accomplished an apotheosis of the "peripatetic superlatives of Antiquity's language of human expression".[142]

In here employing the term "superlatives", Warburg reveals his attention to the work of the German linguist Hermann Osthoff, who had explained the leaps between distinct word roots accompanying the process of intensification in Indo-European languages (as in the sequence "good – better – best") in terms of the increasing proximity to the speaker of each word in the sequence. According to Osthoff, in their approach towards the superlative, the roots in question tore themselves out of their standard "posture", so as to enter into a special relationship with the speaker. Because Osthoff, like Karl Vossler (a linguist, and in particular a Romanist, in whose work Warburg found even greater inspiration) believed an autopoetic energy to be at work in the formation of such linguistic irregularities, neither scholar saw the need for a prioritising of the speaker (as has been the trend since J.L. Austin's theory of the speech act) or the neutralising universal formula of a code (as found in structural linguistics). Their way of thinking about the unforeseeable autonomous movements within language encouraged Warburg to engage in the otherwise potentially problematic comparsion between linguistic and artistic forms, which was to ensure much greater awareness of the *potentia* inherent in the visual arts.[143]

Warburg's central notion, which first emerged in his analysis of the afore-mentioned Dürer drawing, was that of the "pathos formula" ["Pathosformel"].[144] As regards its two ostensibly contradictory components, Warburg opposed "pathos" (as the momentarily exaggerated corporeal reaction of a spirit in distress) to the ethos of a consistent element of character subordinate to the emotional control of a "formula". This terminological intersection, so rich in scope for conflict, supplies the context for an unending series of new combinations, in which both components – the "pathos" as well as the "formula" – may feature, each in some measure disturbed in itself and thereby fostering further reflection. It is this process that, in Warburg's view, enables the *Pedagogue* (one of the Niobids), traditionally depicted as overcome by the fear of death (Fig. 186), to resurface as a victorious *David*, his hand raised in a restrained salutation (Fig. 187). It is this capacity for inversion that marks the distance between the notion of the "pathos formula" and that long-pre-exising scholarly

142 Warburg 1998, Vol. I, 2, p. 449.
143 See also the critical objection of Krois 2002, p. 298, and the comprehensive analysis of Guillemin 2008, pp. 617–21.
144 Warburg 1998, Vol. I, 2, p. 446. On the pathos formula: Warnke 1980; Barasch 1985; Port 1999; Port 2001; Krois 2002; Pfisterer 2003; Zumbusch 2004, pp. 166–85; Mainberger 2010, pp. 326–32; and Schneider 2012.

Fig. 186 *The Niobid Pedagogue*, Roman copy after Greek original, Marble, c. 330/320 BC, Galleria degli Uffizi, Florence.

Fig. 187 Andrea del Castagno, *David*, Tempera on leather affixed to wood, c. 1450, National Gallery of Art (Widener Collection), Washington, D.C.

notion of the topos.[145] "Pathos formulae" derive their energy not, for example, from the constructive sites of a stable ethos, but from fragile and unstable states of intense emotional arousal. "Pathos formulae" do not, over the course of time, stabilise; rather, they repeatedly re-adjust themselves under the pressure of an internal or an external danger. In this respect they may be recognised as energetic assets in the interplay of *schemata* and emotional excitement.

"Pathos formulae" achieve their most refined impress in the psychic-dynamic exaggeration of the treatment of hair and drapery as a means of expressing inner energies. Warburg identified a telling instance in a particular sarcophagus from Antiquity (Fig. 188), as recorded and adapted in an anonymous pen-and-ink drawing from the Renaissance (Fig. 189). While the woman depicted at the centre of this drawing, her drapery lifted by the breeze and wafting backwards, is derived from the corresponding figure on the sarcophagus (Fig. 188, far left), her similarly backward wafting hair is an addition. This development of the "emphatically animated accessory" became, for Warburg, the crucial instance that convinced him that Antiquity was not, as traditionally supposed, a reservoir of placid grandeur, but rather the instigator of fleeting episodes of unrest. It was above all this that distin-

145 Fundamental on this aspect: Settis 1997. See also Port 1999, p. 11; and Port 2001, p. 230.

Fig. 188 Drawn record of a carved relief of *Achilles on the Island of Skyros* on a sarcophagus from Antiquity, Pen and ink on paper, Woburn Abbey.

Fig. 189 Free drawing after the sarcophagus relief recorded in Fig. 188, Pen and ink on paper, late 15th century, Musée Condé, Chantilly.

guished Warburg's model of Antiquity from that proposed by the revered mid-eighteenth-century antiquarian Johann Joachim Winckelmann. For Warburg a connection between Antiquity and the art of later ages did not ensure a modicum of pacification; on the contrary, it guaranteed greater emotional intensification. It was not a recipe for resolution and composure; it favoured, rather, a nervous agitation.[146]

FLORIDO VERI. S.

Fig. 190 Primavera, Goddess of Spring, sacrificing at an altar, Woodcut on paper, Illustration in *Hypnerotomachia Poliphili*, Venice 1499.

Warburg's key historical witness to this was Leon Battista Alberti, who in his treatise *De Pictura* [On the Art of Painting], saw not only the face and the gestures, but in particular also the lively rendering of hair and drapery, as capable of expressing the movements of the soul.[147] The goddess of spring, Primavera, who is shown in an illustration to the novel *Hypnerotomachia Poliphili* (published in 1499) sacrificing the season's flowers in pious concentration and calm, and with drapery that falls in motionless folds, nonetheless has hair that is shown as if lifted by a breeze (Fig. 190).[148] That enlivening of the object at the root of every form of the image act

146 Warburg 1998, Vol. I, 1, p. 5. See also Weigel 2003; and Mainberger 2010, pp. 243–55, also on what follows.
147 "[...] et capillorum [...] et vestium motus in picture expressi delectat [...]" [the represented movements of the hair [...] and of clothes give a pleasing impression in a painting] (Alberti 2006, II, § 44 and 45, pp. 219–25, esp. 222–23).
148 "cum volante trece" (Colonna 1980, Vol. I, p. 186). See also Warburg 1998, Vol. II, 1, pp. 18–19. On the identification of Colonna: Stewering 1996. The author describes this principle with reference, for example, to two Victories, whose "capigli solute et discalciate" [loosened, wind-tousled hair"] recalls their own recent and successful struggle (Colonna 1980, Vol. I, p. 43). As the drapery of two "nimbly dancing nymphs imitates expressively the movement of the agitated forms" ("cum nymphei habiti imitandi expressamente la moventia dilla agitata forma"), this drapery, too, assumes an active role in the scene. (Colonna 1980, Vol. I, p. 46).

Fig. 191 Stills from video of of Pipilotti Rist's performance of 1997, *Ever is Over All* *(Smashing Girl)*.

is to be found in the turbulence of the imagination manifest in the conceptual gyrations of Finsterlin, Peirce or Gehry (Figs. 167–169) as much as in the nervous agitation of "animated accessories". Warburg's sensitivity to exaggerated forms of movement has obvious relevance for the structural aspects of serial photography and of film; and it is on this account hardly surprising to find that his influence on these has persisted.[149] Thus, Pipilotti Rist's purposefully striding and gleefully dis-

149 Comprehensive on this: Didi-Huberman 2003, pp. 117–270; on serial photography: Didi-Huberman and Mannoni 2004, pp. 281–335. Fundamental on film: Michaud 1998, and Sierek 2007.

inhibited maenad of 1997 may readily be seen as a beneficiary of Warburg's perspectival leap (Fig. 191).[150]

In thus probing seemingly peripheral entities, Warburg effectively formulated an image-related parallel to Sigmund Freud's arguments for psychoanalysis. This similarly recognised that crucial evidence as to the psychic condition of an individual lay not in those zones that readily attracted an observer's attention, such as the face or the controlled movements of the hands, but rather in what was ostensibly "peripheral": the much subtler shifts of emphasis within gesture or speech.[151]

Warburg's attention to the autonomous movement of subsidiary forms signified, in addition, a reformulation of the aesthetic of empathy. In his doctoral dissertation, Warburg had referred to Friedrich Theodor Vischer and his son Robert Vischer, according to whom the imaginatively observing subject employs a form of "self-projection" into an object in order fully to accommodate its existence.[152] Yet Warburg had sensed that this seemingly unselfish aesthetic nonetheless amounted to a subject-centred view of the world. The outcome, on his part, was a shift of perspective. At the centre of his own considerations Warburg placed not the empathy of the observer, but the capacity of the artist to animate the work.[153] Images, in his view, must evince *energeia* in order to be able to establish an appropriate space for reflection. It was within this context that Roland Barthes evolved his aforementioned theory of the *punctum*.[154]

As Warburg recognised, the fragility of "pathos formulae" meant that their relevance had to be reaffirmed and redefined in relation to each new cultural context in which they might be applied. In his last work, the image atlas *Mnemosyne*, Warburg employed sequences of images in order to pursue the oscillations between the capacity and the failure of these to generate spaces for reflection.[155] Especially telling is his decision to include an illustrated page from the *Hamburger Fremdenblatt* for 29th July 1929 (Fig. 192, centre right). One of the photographs reproduced here shows the Pope of that period (Pius XI) during a procession. Several photographs show golfers (male and female, alone or in a group); in others we find the Mayor of Hamburg, a French delegation to the city's port, a boat race, a student fraternity gathering, a group of young people setting off on a trip to England, a celebrated swimmer and two race horses.[156] Warburg has here made a point of displaying the

150 Diers 2006, pp. 322–28.

151 Freud 1969, p. 207. On this: Ginzburg 1979, pp. 62–65; and Weigel 2003, pp. 96–102.

152 Warburg 1998, Vol. I, 1, p. 5.

153 Mainberger 2010, pp. 13, 140–42.

154 See above, pp. 211–12.

155 Warburg 2000, p. 133. See also Hensel 2005 *Aby Warburgs Bilderatlas*.

156 This mixture was the outcome of a revolution, above all in the Berlin daily press, whereby a combination of images, generally with little or no obvious thematic interconnection, were

Fig. 192 Plate 79 from Aby Warburg's image atlas *Mnemosyne*, 1929, Photograph, Warburg Institute, London.

entire, seemingly meaningless page in order to discover what was indeed the mean-
ing of that which he had himself termed a "salad of images" ["Bildersalat"]. Every
one of the depicted scenes and individuals had some significance for him as a vari-
ant on the acknowledgement and honouring of celebrity. And so the famous sports-
man may momentarily impinge upon the record of that Vicar of Christ, on whose
watch the status of the Vatican fundamentally altered.[157]

For Warburg such a page from a newspaper was just as important as a fresco
by Raphael precisely because the *energeia* of "pathos formulae" may also be manifest
in entities that seem marginal, even worthless. Warburg's analysis of such news-
paper collages taught him that these revealed no stable pattern, but rather, under the
persistent pressure of an internal or an external danger, a continuous sequence of
fragile and effortfully schematised states of emotional arousal; and that, in this
sense, they remained a sort of serpent ritual, just as likely to fail as to succeed.[158]
For, as the plates of Warburg's *Mnemosyne* image atlas reveal, the images absorb into
themselves those conflicts that they are intended to resolve. With their animated
accessories and their "pathos formulae", they are not intact or articulate in them-
selves. Rather, they broadcast their own unstable inner lives into the world beyond.
The seemingly playful motifs ultimately derive from the combined psychology and
physiology of punishment, of struggle and of terror, in order to be able to serve as
forms of orientation, archive or release. In this they offer a model of how one might
hope to better master the globalised images of the present time.[159]

Warburg's role as a guide to later generations of art historians can be
measured, not least, in that he looked far beyond the limited categories of the visual
arts that, in his day, were traditionally studied, remaining convinced that proper
objects of research for an art historian included, for example, corporeal gestures,
types of dress, tapestries, festive processions, forms of propaganda, postage stamps

allowed to take over a space formerly reserved for text, so that every encounter with a pub-
lication such as the *Berliner Illustrirte Zeitung* took on an almost dadaistic quality. It appears
that the images were indeed selected less on account of their content than in the light of
formal considerations. See also Molderings 1995, pp. 126–27; *Kiosk* 2001, pp. 108–59.

157 Fundamental on this plate and further examples: Schoell-Glass 1998, pp. 233–43; Schoell-
Glass 1999. Earlier in 1929, through a series of agreements with the Italian government for-
malised in the Lateran Treaties, the Vatican had become an autonomous entity in relation to
the modern Italian state (founded in 1861). In return, however, it had agreed to relinquish
control of the Papal States.

158 Settis 1997, pp. 49–50.

159 Using Warburg's own categories, Lydia Haustein has made a splendid start in addressing this
issue (Haustein 2008).

and, as in this case, the illustrated press. He thereby located within the remit of art history that general concept of the image that he had initially found approved by Alberti. Also falling within Warburg's scholarly purview were all sorts of utensil, from cult objects to truly everyday implements, their utility and materiality, in his view, in no way hindering them from possessing an insistent life.[160] And if the art historian were thereby constrained to apply the same concern with intrinsic reflectivity to both artefacts and "true" works of art, this would not at all signify a demeaning of art but, on the contrary, a recognition of the need to take seriously even what might heretofore have seemed the most insignificant or otherwise improbable entities.[161]

Warburg was of course aware that images, while a means of achieving distance from nature, might themselves generate a form of nature, which would thus reduce, and ultimately eliminate, any such distance. Bodies can, in their own presence as real entities, themselves be images: this was the fundamental presumption of the *vera icon*. Bodies can be destroyed in the name of images: in this there lies the perversion of substitution. Images can, however, also restrain that destructive power through a strategy of release: it is this possibility that is inherent in all "pathos formulae".[162]

In such images the counter-position to the destructive forms of the substitutive image act finds its own theoretical model. It is this model that justifies the notion of a "right to life" that should be granted to images. In seeking to develop inner potential, each individual must take into account the fact that a given image may be accessed only in so far as it is assumed to have a right to itself. Without the intrinsic formal power of the image, humanity is deprived of the counterpart that offers it a distanced reflection of itself. No-one was as conscious of this as was Aby Warburg; and, on that account, he occupies a rather lonely position within a history of image theory that is now two and a half thousand years old. He is the distant monument to the inage act. Yet, in this role, he does not stand atop a column. He serves, rather, as a ship's figurehead, in apotropaic eye-contact with the waves of destruction.

160 The history of this paradox has been researched by Kohl 2003. On the potentially fetishistic character of things: Böhme 2006. This argument also serves as a model for the present work. In contemporary art the metaphysical aspect of things has itself become a leitmotif, as in the work of Thomas Demand. (Pack 2008; on the theoretical aspect: pp. 273–77).

161 In this Warburg's belief parts company with Gadamer's distinction between "weak" and "strong" images (Gadamer 1960 *Wahrheit*, p. 143). On this, see Boehm 1996, pp. 101, 106.

162 Probably the most profound "Warburgian" analysis of a single image is supplied by Schoell-Glass 1998, pp. 87–105. More generally on this point: Habermas 1997, pp. 8–10.

VI

CONCLUSION: THE NATURE OF THE IMAGE ACT

1. EVOLUTION AND THE IMAGE ACT

For Aby Warburg the conversion of movement into a distancing image, such as he had encountered when watching the Hopi serpent ritual in the 1890s in Arizona, was a true passage from one state of being to another. In observing the gestures and dance forms he had already perceived the beginnings of pictorial possibilities. Much the same could be said of Ernst Cassirer, for whom the circumstances of the spirit *vis à vis* the body represented "the first [...] pictorial model for a purely *symbolic* relationship [...]".[1] In the same sense Edgar Wind claimed that the strongest psychic expression came closest to the symbolic, for: "Every form of expression through muscular movement is metaphorical".[2]

In these considerations, all formulated between 1925 and 1930, is to be found the nucleus of that Philosophy of Embodiment that, for some time now, has presented one of the most compelling challenges to cultural theory. One of the forms it takes is a concern with "proximity to life" ["Lebensnähe"], assumes that, already in the first moment of sensorial perception, there takes place a process of semantic classification, therein linking corporeal activity and the formation of concepts. In the "scenic" registration of any given context, this process of classification is directly steered by objects; and, in this, it accomplishes in general terms what it is that distinguishes the image act.[3]

1 "Das Verhältnis von Seele und Leib stellt das erste Vorbild und Musterbild für eine rein *symbolische* Relation dar [...]" (Cassirer 1929, Vol. III, p. 117). On Cassirer's biology: Krois 2004. On the interconnection between the concept of the symbol in the work of Warburg and of Cassirer: Zumbusch 2004, p. 240. This might be complemented by Matthias Jung's work on the "anthropology of expression", in Jung 2011 (on Cassirer: p. 336). See also Meuter 2006.

2 "Aller Ausdruck durch Muskelbewegung ist metaphorisch" (Wind 1931, p. 175). On this matter, see also Krois 2002, p. 296.

3 Hogrebe 2009, pp. 33, 88–89.

Equally close to this is the anthropological exploration of corporeal-gestural forms of communication and expression.[4] These raise the question as to the pre-human heritage of corporeal semantics and its transformation into emotional expression and pictorial form. Warburg devoted himself unreservedly also to this question. His key here was Charles Darwin's study of 1872, *The Expression of the Emotions in Man and Animals*, which he had read (in its German translation) during a short, first period of art-historical study in Florence in the late 1880s, noting this in his diary, along with the comment: "At last a book which helps me".[5]

Nearly forty years later, in 1927, in the log book of what had by then become established in Hamburg as the Kulturwissenschaftliche Bibliothek Warburg (KBW) [Warburg Library for the Study of Culture], he noted that, in exploring what he termed his "biological psychology of the dynamics of the forms of Antiquity",[6] he had taken his starting point in the writings of Darwin and of the physiognomist Theodor Piderit. Because he regarded the Darwinian theory of corporeal semantics as the designation of a symbolic battlefield, which complemented his own concept of the "pathos formula", Warburg saw in the mimicry and gestures to be observed in the animal kingdom a prerequisite of his own image theory. On account of this proximity to Darwin's theory of expression and its extension into an autonomous image theory, Warburg realised that he, too, was in effect concerned with an immense span of time reaching far beyond the boundaries of the human realm into that of animals. This in turn helped Warburg recognize that it was the deliberation of human creativity, that surplus of the image shaped by human hands – not manifest in the mechanics of instinct, and not addressed by Darwin – which extended from corporeal gesture, by way of the entirety of corporeal choreography in the formalised celebration of festivals, to the "pathos formula" of the work of art.[7]

Two years after Warburg had made his aforementioned entry in the KBW log book, his assistant Gertrud Bing summarised Darwin's research into mimicry in order, in conclusion, to argue, in analogy with Warburg, that their own methods effectively began where Darwin's had left off. She made a distinction between mimicry (a moderate form of action, though barely susceptible to the will, and creating a type of image that was simply inherited by the body) and gesture (the product of symbolic thinking that was able to incorporate, to a desired end, body, expression

4 Tomasello 2008. A further step might comprise the consideration, beyond communication and expression, of the shared handling of the autonomous artefact (Hogrebe 2009, pp. 51, 69, note 98).

5 "Endlich ein Buch, das mir hilft" (Eng. trans. cited after Gombrich 1970, p. 72).

6 "[...] biologische[n] Psychologie des antikisierenden Dynamogramms" (Warburg 2001, p. 123).

7 On Darwin and Warburg, see Didi-Huberman 2001, pp. 218–23; Villhauer 2002, pp. 44–48, 131; Zumbusch 2004, pp. 171–79.

and effect). It was with reference to gesture that, going beyond Darwin, one might interpret works of art such as the *Laocoon*, which in their element of exaggeration had advanced from mimicry to expression. Warburg's comment on this was: "really masterly!"[8]

Warburg might have drawn even more thoroughly on Darwin if the latter's theory of "sexual selection" had not already, indeed even within its author's own lifetime, been cast aside. The older Darwin grew, the more intensely was he pre-occupied with a concept of evolution as a gigantic theatre of images. This theory enabled him to explain the almost insanely overwhelming superfluity of natural forms – with which anyone is confronted who has spent even just half an hour look-ing intently at a garden that has been allowed to grow wild.[9] For Darwin evolution was by no means to be explained purely in terms of the "survival of the fittest", of those members of the various species equipped with muscles and intelligence, but equally by the lottery of "sexual selection". This last, however, related to the power of attraction exerted by particular forms. According to Darwin, the long-term alter-ations of evolution were explained by a type of mating that took its bearings from the attractiveness of living beings perceived as images.

Darwin pursued this principle throughout the animal kingdom, from the lowlier species upwards. Particularly instructive for him were butterflies, reptiles and birds.[10] The eyes on the primary wing feathers of the Great Argus pheasant (*Argusianus argus*), had preoccupied him since 1838.[11] He recorded this marvel of "ornament" in nature in careful drawings (Fig. 193). Almost overcome with emotion, he remarked that each of the eye spots exhibited lit and correspondingly shaded sides as these would appear if their surfaces were in fact rounded and the sun were shining down upon them. There arose the impression of "shading that gives so admirably the effect of light shining on a convex surface".[12] With the idea that this

8 "wirklich virtuos!" (Warburg 2001, p. 494).

9 Darwin saw "sexual selection" as a complementary alternative to "natural selection". This was to be repeatedly confused, by both contemporaries and later generations, with Herbert Spencer's harsher formula of "the survival of the fittest" (Spencer 1898 [1864], Vol. I, § 164, p. 530). It was only in the fifth edition of the *Origin of Species* (1869, p. 72) that Darwin adop-ted this notion. But by 1871 he was already observing, in self-critical mood: "I perhaps at-tributed too much to the action of natural selection and the survival of the fittest" (Darwin 2003 [1871], p. 61). See also Menninghaus 2003, p. 67.

10 On butterflies: Darwin 2003 [1871], pp. 311–23. On the connection between butterflies and birds: Darwin 2003 [1871], p. 330; on reptiles: Darwin 2003 [1871], p. 358. In general: Darwin 2003 [1871], pp. 613–14.

11 Darwin 2003 [1871], pp. 427–43. See also Menninghaus 2003, p. 69; Voss 2003, Smith 2006, pp. 132–36, and Munro 2009, pp. 266–68.

12 Darwin 2003 [1871], p. 436. No less moved, he observes at another point that this is "just as an artist would have shaded them" (Darwin 2003 [1871], p. 441). See also Voss 2003.

Fig. 193 Eyes in the primary wing feathers of
the Great Argus pheasant (*Argusianus argus*),
as drawn by Charles Darwin, Illustrated in *The
Descent of Man*, London 1871.

Fig. 194 A spicebush swallowtail caterpillar
(*Papilio troilus*) in intimidating mode.

shaping of form could no more have come about without a concept than could Raphael's Madonnas, Darwin effectively implied a connection between the forms of nature and works of art.[13]

This type of reasoning was later to be employed by the naturalist and intermittent Surrealist Roger Caillois, who regarded as genuine works of art the three essentially "pictorial" animal devices – adornment, camouflage, intimidation – of which, for example, the medusa-like spicebush swallowtail caterpillar (*Papilio troilus*) is capable (Fig. 194).[14] According to Darwin, the plumage of birds was the image-bearing "canvas", upon which evolution had left its mark no less emphatically than it had on its bearers' capacity to adapt to an altered environment. It is variation that

13 Darwin 2003 [1871], p. 434.
14 Caillois 1960, pp. 54, 151, fig. 18.

makes the body, as an image, into an object of attraction, to be employed in the search for a mate. If, for Darwin, these images, defined as variation, recur as the agents of evolution, they follow in a stylistic history of taste. According to Darwin, birds love variation, but only in small doses, being not attracted by the sudden advent of "an entirely new style of colouration".[15] It is in accordance with this principle of *incremental* alteration that fashions evolve in human society.

Even in its beginnings, then, humanity was incorporated into this process; but it occupied a special place within it: through the limitation of thick hair growth to just a few areas of the body, there was a much greater expanse of human skin that could serve as a support for images. Darwin, following in this matter his "second sun", the early-nineteenth-century geographer and botanist Alexander von Humboldt, saw the transformation of human skin from a protective membrane into an image support as a precondition for the capacity of primitive man to evolve the skills of the painter.[16] From painting the skin, by way of tattooing, the cutting and styling of hair, decoration through the attachment of feathers, pieces of metal or stones, to the infinite forms of clothing, the human body became an object for "ornamentation". Painted plaster casts prepared during the course of ethnographic expeditions served to illustrate its refinements (Fig. 195).[17] In order to make their bodies into an object of design, men and women painted themselves "in the most diversified manner".[18] And so was accomplished the transition to an image in the narrower sense.

Hardly any other theory allotted a higher status to the significance of natural design than did Darwin's principle of "sexual selection". This second pillar of Darwin's theory of evolution sees the development of the species as an unrelenting manifestation of the image act (in the form of choice in response to attraction) extending over millions of generations. This enormous time scale, however, implies that its origin lies beyond the timeframe of the existence of humankind. With such a concept of evolution as a laboratory of the image act, humanity is once again displaced from its privileged position in the cosmos. In Darwin's view, even aesthetic sensibility is ultimately propelled by the motor of "natural selection".

Darwin was not, however, concerned here with a sort of second tier of "fitness", but rather with the search – splendid in its very futility – for the beautiful form of the sexual partner. In this case "beauty" by no means signifies that which is beautiful in the classical sense, but that which is strikingly particular and varied

15 Darwin 2003 [1871], p. 495. On taste, see also Menninghaus 2003, p. 72.
16 Darwin 1988, p. 42 ("second sun"); on the notion of the skin as a surface for painted decoration: Darwin 2003 [1871], p. 574, with reference to Humboldt 1819, p. 522. See also Humboldt 1991, Vol. II, p. 850.
17 Papet 2002, pp. 28, 31, 44, cat. no. 47.
18 Darwin 2003 [1871], p. 574. See also Menninghaus 2003, and Menninghaus 2010. On the principle: Belting 2001, pp. 34–38.

and which, through its consequent attraction, triumphs over physical power: "The power to charm the female has sometimes been more important than the power to conquer other males in battle".[19] By way of the category of "beauty" as "variability", the natural process of transmutation is freed from remaining necessarily subordinate to specific purposes and goals. The genetic control of the corporeal form is the brush with which nature urges on the mutation of the species.

With his central concepts of "variability" and "ornament", Darwin might almost have been referring to Immanuel Kant; but it is significant enough that his own terms do indeed derive from the realm of art.[20] There is little doubt that Darwin's notion of equating "beauty" and "variability" derives from William Hogarth's mid-eighteenth-century association of "beauty" and "variety" (Fig. 180).[21] By the time Darwin was at work, however, the concept of "ornament" was widely associated, at least in Great Britain, with the writings of the architect and designer Owen Jones, who had first come to prominence through his contribution to the planning and implementation of the Great Exhibition presented in London in 1851, above all through the diverse interiors he had contrived for the vast exhibition pavilion temporarily erected in Hyde Park.[22] In 1856 Jones issued his lavishly illustrated *Grammar of Ornament*: a comprehensive history of the ornamental forms employed by all known cultures; and this was to become one of the most successful publications of the Victorian era.[23] The second part of Darwin's *Descent of Man*, published in 1871, might even be understood as its author's attempt to offer support, from the evidence of nature, for Jones's own thesis. Darwin's argument here, that the *ornamental* forms of animals found a continuation in the ornamentation of the human skin, had been

19 Darwin 2003 [1871], p. 227. The repeatedly emphasised interpretation of "beauty" as "variability" is concisely summarised in the statement: "Sexual selection primarily depends on variability" (Darwin 2003 [1871], p. 319). The pursuit of "variability" can, however, issue in the grotesque: Steimel 2010.

20 On Darwin and Kant: Menninghaus 2010, p. 141. In a celebrated passage in the *Kritik der ästhetischen Urteilskraft* [Critique of Aesthetic Judgement] (1790), Kant states that the "sense of delight experienced by taste" ["Wohlgefallen des Geschmacks"] is increased when objects are accompanied by *parerga* [ornamental accessories; embellishments] that are not entirely attuned to their inner character, but constitute, rather, an independent addition. As well as referring to columnar forms used in the framing of paintings and works of sculpture, Kant mentions the "drapery of statues" ["Gewänder an Statuen"]. With this, there emerges that motif that Darwin was himself to pursue, from the use of ornament, by way of the painted decoration of the skin, to clothing (Kant, *Kritik der ästhetischen Urteilskraft*, I, i, 1, 3, § 14, in: Kant, *Kritik der Urteilskraft* 1957, p. 306). See also Derrida 1973, pp. 79–85.

21 *Hogarth and his Times* 1997, pp. 168–69.

22 One of the first mentions of "ornament" occurs at Darwin 2003 [1871], p. 297. On "decoration": Darwin 2003 [1871], p. 381. On the art-theoretical derivation of these concepts: Menninghaus 2010, pp. 140–44.

23 Jones 1856. See also Flores 2006.

Fig. 195 Alexandre Pierre Marie Dumoutier, Cast of the head of Matua Tawai, Ikanamawi Island, New Zealand, Painted plaster, 1838, Musée de l'Homme, Paris.

anticipated by Jones in as far as his volume of 1856 opened with a chapter on the "Ornament of Savages" in which the first illustration was a line drawing of a "Female Head from New Zealand", the face decorated with elaborate tattooed patterns, such as had become known through the discoveries and documentation of ethnographic research expeditions (Fig. 195). [24]

As already observed, the principle of "sexual selection" was, for Darwin's contemporaries, an idea that proved difficult to countenance. Their discomfort at this sort of natural image theory led to its being cast into the shade or incorporated within the concept of the "survival of the fittest."[25] Outsiders such as Ronald A.

24 Jones 1856, p. 1. Just as Darwin was himself inspired, in evolving his notion of "sexual selection", by the applied arts of the mid-nineteenth century, so in turn was his work, through its impact on Ernst Haeckel's serial publication of 1899–1904, *Kunstformen der Natur* [Art Forms in Nature], to exert a strong influence on the exponents of *Jugendstil* and *Art nouveau* (Breidbach 2004, pp. 272–73).

25 This was initially explained in terms of the theory of investment, according to which the female would associate the likelihood of a particularly large progeny (an evolutionary advantage) with the overtly sumptuous male (Trivers 1972). This was followed by reference to

Fisher did, however, work to reinvigorate it. With the pictorial activation of evolution, he emphasised those motifs of abundance and the sheer wastefulness of forms that could by no means be confined to the mercantilist approval of adaptation and "fitness." This liberation from the mechanical rules of a purpose in itself supplies, according to Fisher, an explanation for that vector of increased evolutionary speed that, as "runaway selection," represents a sort of frenzy of the image act in nature.[26] Similarly, the evolutionary biologist Adolf Portmann saw in the independent power of form the model for understanding nature and, above all, the evolution of the organic world; it was upon this notion that Hannah Arendt based her study of consciousness.[27] More recently, Darwin's concept of "sexual selection" has been recognised within the narrow realm of evolutionary biology,[28] and this is especially true of those research projects that do not reconcile "sexual selection" with "natural selection", but have emphasised the antagonistic "hybrid" interaction between the two.[29]

Bridge-building between the animal kingdom and the human realm of the sort that has of late occurred would at first seem to stand – as previously did the forms of expression in gesture – in contradiction to the definition, established in Chapter 1: that, in order fully to be regarded as an *image*, an entity must enice a minimum of human intervention. But what is specific about the human impress is in fact by no means disallowed by the Darwinian derivation of the principle of the image act from the evolutionary emergence of the organic body: it is, rather, the case that this principle supplies a basis for the understanding of the human contribution. And in this one finds the justification for that element of dissent, on the part of both Warburg and Cassirer, as regards Darwin. This lay in their own emphasis on the

the handicap theory, which positively interpreted characteristics of seemingly meaningless formal superfluity as signs that their bearer could afford them on account of his "fitness" (Zahavi 1997; Cronin 1991). The sense of method implicit in Darwin's own theory of "sexual selection" was thus effectively turned upside down (see also Levine 2003; Menninghaus 2003, pp. 98–103, and Bredekamp 2007 *Darwins Korallen*, pp. 275–77)

26 Fisher 1999 [1930], p. 137. See also Menninghaus 2010.

27 Portmann 1967; Arendt 1978. On this connection: Silverman 2000, pp. 129–31.

28 Gould and Gould 1989, pp. 182–97; Darwin 2003 [1871], intr., pp. xi–xxix, here: pp. xiii, xxvii; Elsner 2005. See also the carefully argued studies of Hill 2006, as also of Griffith and Pryce 2006, in addition to the unreserved affirmation of Darwin's conviction in Junker and Paul 2009. In the case of Winfried Menninghaus (Menninghaus 2003), a highly regarded scholar of language and literature has undertaken the most ambitious attempt at a reformulation since the work of Fisher and Portmann.

29 Particularly illuminating is the research into the fish genus *Xiphophorus*, some species of which have an elongated "swordtail" (hence their common appellation), which renders them less mobile and more easily visible and thus an easier prey but, on the other hand, offers the female an advantage in mating (notable among the extensive related literature: Meyer 1997; Meyer, Salzburger and Schartl 2006).

specific contribution of humanity: beginning with corporeal gesture and issuing at length in an artificial image that becomes, in turn, the principle of distanced proximity. Artefacts have freed themselves from a direct connection with images painted on the human body to the extent that, in them, the occurrence of both form and effect is autonomously enacted.[30]

These liberated entities range from the semantic surplus of simple tools to the creative mobility of artistic motifs, but also to the substitution of image and body. In their diversity, however, they could not be effective without a mode of behaviour already maintained over a vast stretch of time, and consistently motivating individuals to action. The origins of this mode of behaviour are just as difficult to establish as are those, for example, of time and gravity, but its effects can be described.[31]

2. THE PLAY OF IMAGES IN NATURE

Not limited to the sense of sight, Darwin's principle of "sexual selection" embraces the very "will" of organisms, which cannot see but do possess a sense for what is in some way particular – in this respect comparable to the *appetition* that Leibniz attributed even to monads of the lowest order.[32] Behind the question of the capacity of animals to create images there lies, accordingly, a further question that arises no less imperatively out of the systematics of the image act. This concerns the pictorial affinity of the anorganic world .

The Roman poet and philosopher Lucretius, in his didactic text of around 60 BC, *De rerum natura* [On the Nature of Things], devised a response that remains, in many respects, unsurpassed. In the literary sparkle of its atomistic image theory, it has held its own, even down to the present day, in the face of all other scientific theories.[33] Towards the opening of the fourth book Lucretius expounds his theory of images freeing themselves from things in the manner of skins being shed. Just as

30 Fundamental on this subject: Neuweiler 2008.

31 See also Kant, who speaks of gravity in the sense of a *parerga* of those mysteries that cannot be fathomed, but can be empirically described (*Die Religion innerhalb der Grenzen der blossen Vernunft*, Allgemeine Anmerkung [Kant 1968, Vol. VIII, p. 805, note]).

32 Leibniz 1736, *L'Analyse des Êtres Simples & Réels. Ou la Monadologie* [...], Chap. I § 7 and § 11, pp. 3, 6.

33 Franz 1999, p. 586. On the influence of the image theory of Lucretius on philosophy in the Modernist Era, above all on Henri Bergson's attempt to reconcile materialism and idealism, on ideas regarding Brownian Motion, or on Stochastics and Chaos Theory, see Franz 1999, pp. 581–613. See also the superb first "philosophy" of photography (Kemp 1980, p. 114) evolved by Oliver Wendell Holmes, Sr., who took his starting point in the persistent validity of Lucretius (Holmes 1859, p. 738). See also Köhnen 2009, p. 368.

burning wood gives off smoke, just as steam rises from the surface of warm water, just as cicadas shed their "skins" in summer, just as calves, during their birth, lose their outer covering, and just as the snake exfoliates itself by rubbing up against thorny plants so that its discarded sheath is soon seen floating on the breeze, so "images must also be thrown off from things, from the outermost surface of things".[34] In terms of this atomistic view of the world, Lucretius points out what might be called a physical power in images: the pressure that they exert upon the retina in order to provoke a reaction there. As images represent the various types of "skin" incessantly shed by bodies, they constitute a corporeal connection between object and observer, with the result that the act of looking becomes a particular form of the experience of being grasped by that at which one looks.[35] The pressure of the image brings about a haptic reaction as a form of corporeal compulsion. Observers are, quite literally, seized by images.

According to Lucretius, the natural entities are, in their relentless movement, additionally an occasion for astonishment. Clouds offer visions from a distant realm, visions of images restlessly and perpetually forming and re-forming. Grimacing giants, mountains and the boulders ripped from their slopes, every sort of monster – all emerge out of the scraps of clouds: "[...] how easily and quickly these images arise, constantly flowing off from things and gliding away".[36]

This sort of pictorial generation presupposes the role of nature as a playful creator of images. It impressed artists and art theorists in equal measure because it appeared as if directly connected to the power of the imagination: the horseman to be discovered in the cloud formation in the background of Andrea Mantegna's painting *Saint Sebastian* (Fig. 196) is an image inspired by Lucretius.[37] Alberti, likewise, saw in irregularly shaped objects such as the roots of trees or lumps of earth, outlines that might, through slight alteration, be rendered more shapely so as to seem "complete". It was in this that Alberti's original concept of the image had its origins.[38] As,

34 "[...] tenuis quoque debet imago / ad rebus mitti summo de corpore rerum" (Lucretius, *De rerum natura* IV, 54–64 [Lucretius 1924, pp. 250/251–252/253]).

35 For Didi-Huberman it is in this tactile act of seeing that is to be found the experience of being-seen-by-the-object (Didi-Huberman 1992, p. 192). On the atomistic tradition, see Lindberg 1976, pp. 2–3.

36 "[...] Nunc ea quam facili et celeri ratione geriantur / perpetuoque fluant ab nebus lepsaque cedant" (Lucretius, *De rerum natura* IV, 143–144 [Lucretius 1924, pp. 258/259]).

37 The same is true of Mantegna's *Triumph of Virtue* in the Musée du Louvre, Paris, in the cloud formations of which there appears a face. Fundamental on this matter: Janson 1961; Janson 1973; Berra 1999; on Mantegna in particular: Hauser 2001. On the issue of chance images and the sudden switch away from scepticism towards such a source of inspiration, see Suthor 2010, pp. 240–46.

38 See above, pp. 16–17, on Alberti, *De Statua* § 1 (Alberti 1999, pp. 22/23). On this point, and on what follows, see also Berra 1999, pp. 360–62.

Fig. 196 Andrea Mantegna, Horseman in the clouds, detail from: *Saint Sebastian*, Oil on wood, 1457–59, Kunsthistorisches Museum, Vienna.

in Alberti's view, "Nature itself shows pleasure in acting as a painter",[39] the human act of painting may, in turn, find a model in this superb instance of artistic playfulness. Between the forms of natural things and those made by man there is no opposition, but rather a continuity.[40]

In his account of Botticelli's method of using chance occurrences as a way of coming up with new ideas for the landscape elements in his paintings, Leonardo da Vinci speculated that such an end might indeed have been achieved through the following means: a sponge, saturated with paint in various colours, would be thrown against a wall, so that the spots and splashes left on the wall might then be taken as sources of inspiration – the painter might, that is to say, have perceived in accidental marks of this sort an entire cosmos of human heads, animals, cliffs, seas, clouds

39 "Ipsam denique naturam pingendo delectari manifestum est" (Alberti, *De Pictura*, § 28 (Alberti 2006, pp. 167–70, here p. 169).

40 Bätschmann 2000, p. 31; Hensel 2005, pp. 670–71; with regard to fossils: Kapustka 2009, pp. 276–77, 285.

and forests.[41] Leonardo was, admittedly, sceptical as to whether landscape painting could really succeed through this means; but, for his own theory of images, this source of inspiration was of great value because its forms corresponded, in their haziness, with the visible "skins" shed, according to Lucretius, from the surfaces of things. Their outlines evinced a sense of softness, of transience, of disruption, as also of surprise and continuous metamorphosis. The flying sheaths of light and colour flitted through the air, much in the way of sounds, smoke and steam, on occasion merging and, when coming into contact with matter, also altering their shapes. This, indeed, produced the illusion that they were "hazily" streaming out of things.[42] It is in this that the diffuse quality of the enlivening *sfumato* in Leonardo's own paintings consists. When Leonardo had one feature in a painted composition seem almost to merge into the next, as if viewed through a fine film of floating atoms, this corresponded to the sheaths of light evoked by Lucretius. The same is true of the restlessly active principle of image-creating nature, the definition of which Leonardo paraphrased out of *De rerum natura*.[43]

Through the mediation of Alberti and Leonardo, Lucretius's poem continued through the centuries to serve as a vivid exposition of nature, both protean and generative, as a model for art. In the late eighteenth century, for example, Alexander Cozens, with Leonardo's images of nature in mind, defined his own "blot" watercolours (Fig. 160) as "a production of chance, with a small degree of design".[44] A direct, if long unremarked, path links this with the *faible* of Modernism for the autonomous power of abstract form.[45]

At the start of the twentieth century the French biophysicist Stéphane Leduc effectively drew on this tradition in seeking to define the origin of life in terms of the spontaneous emergence of images. He saw the forms that he had contrived, through processes of osmosis, out of inorganic structures, as evidence that such entities were themselves possessed of an iconopoeic drive, within which life was

41 Leonardo da Vinci 1995, § 57, p. 54.

42 "vapor atque aliae res / consimiles ideo diffusae e rebus abundant" (Lucretius, *De rerum natura*, IV, 91–92 [Lucretius 1924, pp. 254/255]).

43 "Guarda il lume e considera la sua belezza. Batti l'occhio e riguardalo. Ciò che di lui tu vedi, prima non era, e ciò che di lui era, più non e" [Look at the light (of the sun) and consider its beauty. Close your eyes for just a moment, and then look at it again. That which you see of it now was not there before, and that which was there before no longer exists] (Leonardo da Vinci 1988, fol. 49v; transcription: p. 82). See also Lucretius, *De rerum natura*, V, 290–293 [Lucretius 1924, pp. 360/361]. On this matter: Fehrenbach 2015, pp. 29–30. On the principle, see also Ebert-Schifferer 2008, pp. 116–17.

44 Cited after Janson 1961, p. 265, and: *Entdeckung der Abstraktion* 2007, p. 73. See also Busch 1995, p. 213. In general: Gombrich 1960, pp. 181–91.

45 *Entdeckung der Abstraktion* 2007.

contained.[46] Mediating between biology and art theory, Leduc's morphology of life sought to develop image acts out of things themselves, as the fundamental urge to action that was inherent to them. Leduc made a name for himself as father of the concept of "synthetic biology"; but historians of science generally view his theory of pictorially generated life as one of a long list of gallant errors. In drawing attention to an unresolved problem it has, however, retained its value.[47]

As a category that embraces the forms of both nature and art, the concept of "chance" has played a key role in much of the art of the twentieth century; a great deal of the work of Hans Arp or of Marcel Duchamp, for example, may be understood in terms of an experimental urge to clarify whether or not one is dealing with a universal aesthetic category.[48] This is no less true of Jackson Pollock, who has left his mark on the alliance between the artist and nature as herself a generator of images, with the characteristic concision of the words: "I am nature".[49] Pollock's success in activating paint is seen as an outcome of the personal union of the artist and nature-as-an-artist, an affirmation of the bond between the images of nature and those of art.

Also belonging within this tradition is Charles Sanders Peirce, according to whom the spontaneity of matter as described by Lucretius leads one to suppose that flitting atoms indicate a trace of life: "they are not absolutely dead".[50] "Chance" is a concept accessible to mathematics, through which the freedom and the spontaneity of matter can be described.[51] It is this designation that establishes the context within which the random images of Lucretius are just as able to develop their protean play as are the images of the draughtsman's own thoughts (Fig. 168). If one considers Peirce as a philosopher thinking through drawings,[52] seeking relentlessly to imitate those images in the clouds evoked by Lucretius, then one may recognise him as the protagonist *par excellence* of the image act.

The notion of the image act, as anticipated by Lucretius, Darwin and Peirce, and which exceeds the scope of the human, touches on the definition of life. Understood as tenacity, possessed of self-determination, capable of growth and reproduction, with a particular relationship to time and mortality, life can, certainly, be recog-

46 Leduc 1911.
47 Fox Keller 2010, pp. 12–18.
48 Molderings 2010, pp. 49–56 and passim.
49 Cited after Boehm 2008, p. 40. See also Meister and Roskamm 2007, pp. 246–50.
50 "I make them swerve but very very little, because I conceive they are not absolutely dead" (Peirce 1992, pp. 260–61).
51 Peirce 1992, p. 261; Peirce 1931–1958, Vol. I, § 132 and § 403, pp. 54, 220. See also Pape 2008, and Krois 2009 *Image Science*, pp. 204–05.
52 See above, pp. 240–41.

nised, but not explained, and the borders of its proper realm are porous.[53] For the controversy as to whether natural forms are to be seen as lifeless or, as Peirce expresses it, "not entirely dead", is related to the various explanations as to how life has come into being. If one believes the origin of life to lie in a sudden metaphysical spark, then matter can be defined as in itself dead. If, however, one assumes that life arose out of matter incrementally, then the principle of life must be seen as inherent to the vitality of matter. As evinced by some of the most recently expounded theories, this dilemma endures.[54]

The ideas of Lucretius, Darwin and Peirce, and indeed of Warburg, extend into those core aspects of "matter" and "life" that categorically resist definitive explanation. Yet, as analysts of pictorial autonomy – be it in the realm of anorganic matter, the animal kingdom, or the sphere of human culture – these thinkers all attest to the general validity of the notion of the image act.

The image act, in all its contexts, reveals itself as a universal quality, which, in Peirce's sense, belongs among the "truths" that are dependent not on human intellect, but on nature.[55] Without needing to touch upon the question of the existence of a deity, the phenomenon of the image act can be absorbed into a cosmology that denies philosophical validity to a contradiction between mind and matter, seeing this contradiction as no more than the product of Modernist panic at "all last principles that are not dead".[56] In the concept of "semantic plasticity" [*Semantische Plastik*], where the image act also has its place, we find the beginnings of a form of enlightenment that is not afraid of the principle of life.[57]

Through this genealogy of the principle of the image act, the definition initially introduced – that one may speak of an "image" as soon as there is evidence of a minimum of human intervention – becomes problematic. Once again, however, this notion does not fade; rather, it becomes stronger. All the energies of the image act in nature, which Lucretius so eloquently develops out of the flitting of the atoms of light, and which Darwin was inspired to find in the principle of "sexual selection", have their own equivalents in the realm of the artefact. Although they are autonomously active entities, images also constitute a bridge between the organic and the anorganic. It is for this reason that they have become a thorn in the side of aesthetics.

53 Chargaff 1993/94, pp. 13–14. See also Brenner 2007, pp. 141–54, 167–69. On the approach followed here, see also Gerhardt 2000, pp. 96, 124, and in particular 111–12.

54 Fox Keller 2010, pp. 25–26, speaks of "smart matter".

55 Nagel 1999, p. 188, with reference to Peirce.

56 Nagel 1999, p. 195. For another line of argument in the same direction, see also Hogrebe 2006, p.59.

57 Hogrebe 2006, pp. 24, 56–67, with regard to Plato, *Timaeus* 55e; Cudworth 1977 [1678], Vol. I, p. 172; Novalis 1960–2006, Vol. III, 1968, p. 123; Gadamer 1960, p. 450; Verspohl 1986.

3. IMAGE-ACTIVE ENLIGHTENMENT

During the winter semester of 1958/59, at the University of Frankfurt am Main, Theodor W. Adorno embarked upon an attempt to determine the relationship between a work of art and those encountering it, from the point of view of the arte-fact, and thereby to develop a corresponding aesthetic.[58] In Adorno's view, a work of art is not directly addressed to an observer; it is, rather, "a force field in its own right",[59] which, "when looked at, becomes more or less alive".[60] Such a perception would, however, bring about an idiosyncratic freedom from certain constraints. Observers who "experience the work of art as something that is alive in itself"[61] would be both startled and altered in the security of their habitual stance.

Adorno's demand "that one co-create the work of art as if one were inside" it, that one, as it were, "live inside it",[62] sounds not unlike a formulation relating to the schematic image act in its variant as the *tableau vivant*. And one is prompted to think of the intrinsic image act when Adorno goes on to speak of the "power" of the work of art, "of its autonomy, that is to say how far it may in itself, in every detail, determine its own formal principles".[63] Finally, it would seem as if Leonardo's maxim, with its encapsulation of the essence of the image act, had served as god-father when Adorno claims that the experience of the artist is to be understood "as an act that is consequent upon the work of art", as the completion of that which "the work of art in truth decides for itself".[64]

58 Also aimed in this direction are formulations such as "Kunst [...] denkt selber" [art (...) thinks itself], which pervade Adorno's unfinished, posthumously published *Ästhetische Theorie* (Adorno 1970, p. 152).

59 "[...] in sich ein Kraftfeld" (Adorno 2009 [1958/59], p. 168).

60 "[...] unter den Augen gewissermassen lebendig wird" (Adorno 2009 [1958/59], p. 248).

61 "[Betrachter die] das Kunstwerk als ein in sich Lebendiges erfahren" (Adorno 2009 [1958/59], pp. 197, 269–70).

62 "[...] dass man das Kunstwerk mitvollzieht, indem man in dem Kunstwerk drin ist, dass man – wie man es ganz schlicht nennen mag – darin lebt" (Adorno 2009 [1958/59], p. 188). Adorno's demand is that the individual, "in the pulse, in the rhythm of [that individual's] own life, be altogether at one with the life of the work of art" ["(...) in dem Puls, in dem Rhythmus des eigenen Lebens ganz und gar eins wird mit dem Leben des Kunstwerks"] (Adorno 2009 [1958/59], p. 196).

63 "[der] Kraft [des Kunstwerks]" and "[...] von seiner Autonomie, also davon, wieweit es ver-mag, in sich selbst sein Formgesetz bis in alle Einzelheiten hinein auszuprägen" (Adorno 2009 [1958/59], p. 193).

64 "[...] als ein Akt des dem Kunstwerk Folgeleistens" and "[...] das Kunstwerk von sich aus ei-gentlich entscheidet" (Adorno 2009 [1958/59], p. 189). The statement that works of art are of an active passivity ["aktiver Passivität"] also possesses the force of a condensed formulation of the image act (Adorno 2009 [1958/59], p. 190).

Adorno defines works of art in general as "artefacts" since he wishes to emphasise their dual character: formed out of inert matter, they are at the same time, possessed of an intrinsic "force field".[65] In contradistinction to Hegel's definition of art as the "sensorial rendering of the idea", Adorno insists that it is "through the artefact, its problems, its material",[66] that the power of the "force field" is generated. As has been shown, this basic characteristic applies to all images. If, in the case of a possible future of critical thinking, it were to be demanded that an "emancipatory interest" be defined, then these statements of Adorno's could claim to be doing just such a thing.[67] This would constitute not only a new aspect, but also a recognition of the fact that the world of communicative interaction is both pervaded and enhanced by images. Herein there would be an element of that "enlightenment" that Jürgen Habermas expounded with an eye on Warburg, which "is assured of its own roots in the phobic beginnings of the process of civilisation".[68]

In the wake of an era of linguistic analysis preoccupied with cultural codes, several recent undertakings have sought to start from scratch in exploring and determining the intractable "force fields" of the body and of the artefact; and these efforts may be seen to be aiming in the same direction as that urged in this volume. Without exception, these new moves recognise the need to bid farewell not only to cerebrocentrism, but also to the dichotomies of mind / body, subject / object, and

65 "Artefakt"; "Kraftfeld" (Adorno 2009 [1958/59], p. 168).

66 "[...] durch das Artefakt, seine Probleme, sein Material"(Adorno 2009 [1958/59], p. 135). In the same sense, also p. 134. Robert Spaemann similarly speaks of art as an "attempt to simulate the being of the self. The image has a sort of being in itself, indeed it has its own desires" ["[...] Versuch, Selbstsein zu simulieren. Das Bild hat eine Art Selbstsein, es verlangt ja etwas"] (Spaemann 2010, p. 194). The phrase that follows, "Art is always simulation" ("Kunst ist immer Simulation"), here functions much in the manner of one of those notorious expository retreats, which were discussed in Chapter 1. The question should not be posed in terms such as: In circumstances where art must take the place of a loved one, may the work of art then be regarded as simply a simulation? (Spaemann 2010, p. 195). The question should, rather, be phrased along the lines of: Should military personnel on active service be expected to put their lives at risk in defence of the Musée du Louvre? Those answering in the negative would implicitly be denying the fundamental principle that entities of exceptionally high status are superior to the life of the individual. On these grounds, however, torture itself would be allowed in cases where it seemed likely to result in a saving of human lives.

67 Honneth 2007, p. 55.

68 "[...] ihrer eigenen Wurzeln in den phobischen Anfängen des Zivilisationsprozesses vergewissert" (Habermas 1997, p. 29; see also p. 3, on the "obligation to oneself" ["Selbstverpflichtung"]. A "representative public presence" ["representative Öffentlichkeit"] (Habermas 1969, pp. 16–18) could equally be the model for a critical theory extended to consider the phenomenology of the image act, by analogy with the notion of "objectification" ["Objektivierung"] in language theory (Habermas 1997, p. 18).

humanity / nature. They have, accordingly, evolved the image theory of deixis,[69] and they seek a reformulation of the "presence of the work".[70] They also aim at the re-evaluation both of language as a pan-sensorial system of articulation,[71] and of historical instruments above and beyond written sources.[72] In the realm of aesthetics numerous attempts are underway to overcome the concept of representation and, thereby, to make it easier to grapple conceptually with problems such as the constraints of terminology and, at the same time, to train the sensibility so that it is better fitted to respond to the exceptional case, the individual work and the "semantics of things".[73] This is above all true of the aforementioned, scenically substantiated philosophy of "proximity to life"; while the principle of "Beuysianism" [*Beuysianismus*] is fired by an especially deep regard for the autonomy of artefacts.[74] This would, indeed, appear to be the very sign of that modernity which takes seriously the realm of the image act, in the sense evoked by the words of Joseph Beuys: "Whatever the wood or the stone itself wishes, that's what I'm after".[75]

Finally, it is the Philosophy of Embodiment that is the larger field within which an understanding of the image act, as expounded here, finds its true intellectual home.[76] One of its distinctive elements is the theory of the corporeal *schema*, which it assumes to be the summation of all unconscious control of pose and movement (such as the process of walking); another is the theory of the corporeal "image", in which it sees the conscious perception of an individual's own body. In as far as the corporeal "image" comes about through a totality of sensory impressions, it offers the basis for the production of other images, as also for the semantic recognition of

69 Boehm 2007, p. 25–29. On the world-constructing physics of images: Gadamer 1960, pp. 145–47. See also Boehm 1996, pp.109–10.

70 Gumbrecht 2004; Gumbrecht 2009, pp. 88, 93. From the point of view of the theatre, see also Fischer-Lichte 2004, pp. 255–61; in summary form: p. 169.

71 Krämer 2005; see also Jäger 2001, and Stetter 2005, p. 115. For a fundamental discussion of Bühler 1978 [1934], see Meyer-Kalkus 2001, in particular pp. 144–84.

72 A useful summary of these new approaches is provided in Paul 2010.

73 Wiesing 2004 *Pragmatismus*; Seel 2007; Trautsch 2008, p. 50; Waldenfels 2008, p. 60; Schaub 2009.

74 On "Lebensnähe", see Hogrebe 2009, pp. 33, 88–89; on "Beuysianismus", see Hogrebe 2010 (in which this term is introduced); see also Hogrebe 2006, p. 65–66.

75 "[Was] das Holz oder der Stein will, aus sich heraus, dem spüre ich nach" (cited in Harlan 1988, p. 37). On this matter, see Hogrebe 2010.

76 Lakoff and Johnson 1999. See also Janich 1989, and Neuweiler 2008, for the matter viewed from the evolutionary biologist's position. Also of relevance here would be a consideration of research into mirror neurons, which of necessity takes into account the impact of the counterpart. A direct continuation here would, however, only be possible when it has been established how the functioning of artificial images can be distinguished from that of natural phenomena (Freedberg and Gallese 2007). Freedberg is currently preparing a comprehensive study of this matter with regard to works of art.

other images. We may conclude from this process, so fundamental for the evolution of self-consciousness and self-distancing, that the interaction of the body and images constitutes the precondition of the capacity to think. This, then, would stand in agreement with the notion of the emergence of primitive man as *homo faber*.[77] As such, he created a world of artefacts. Although produced subjectively, these were subsequently encountered – in a process that recalls the echo-orientation employed by bats – as part of an autonomous objective world.[78] Between images and human individuals there emerge resonances of perception that belong within the cognitive-theoretical context of enactivism.[79]

If, in 1912, Aby Warburg issued his warning about the "prejudice" of the "border police" in duty along the supposed dividing lines between the various disciplines,[80] then the new approaches briefly outlined here – each constituting a cosmos of its own – give grounds for hoping that the exploratory impulse that prompted the anxiety of such monitors has by no means grown weaker. For the latest innovators can lay claim to a compelling form of cultural theory not limited to a single discipline (in this their endeavours echo those associated with the KBW in its Hamburg years), and they operate on the upper reaches of the issues they address: territory to which the bureaucrats of the schools and the disciplines have no access.

On this matter Aby Warburg and Ernst Cassirer were of the same mind: convinced that man, from the point of view of his first corporeal forms of expression, is to be understood as an *animal symbolicum*. Outside this symbolic context, there is no "world" for him to discover. Within it he can operate, in keeping with his dialectical character, only in relation to the sphere of formed images. These furnish his antagonistic environment with both elements that may be owned and those that are inaccessible. From this point on, the *animal symbolicum* is confronted with images as impulse-givers of the image act.[81] Encountered by an individual alert to every scope for sensorial and imaginative interaction, images can reveal, on account of all that is latent within them, an *energeia* that redeems the concept of life as an entity that is autonomous, mutable, reproducible and mortal. It is in the right to life that images may thereby claim for themselves that there arises the command that one care for them, use them, but also address them critically.

77 Krois 2010, pp. 224–34, also Krois 2006, Krois 2007, Krois 2009 *Beginnings*, and Krois 2009 *Image Science*. See also the perspectives developed in Arteaga 2010. See also above, p. 11–14.
78 Hogrebe 1994, pp. 154–55, with reference to Aristotle's *Metaphysics*, 993b, 7–12. See also Hogrebe 2007, p. 11, and Schwemmer 1997, p. 25.
79 Varela, Thompson and Rosch 1991; Noë 2004; Thompson 2007; and Arteaga 2010.
80 "grenzpolizeiliche[n] Befangenheit" (Warburg 1998, Vol. I, 2, p. 478).
81 Zumbusch 2004, pp. 241, 341, in connection also with Walter Benjamin.

Images do not derive from reality. They are, rather, a form of its condition. Images, through their own potency, empower those enlightened observers who fully recognise this quality. Images are not passive. They are begetters of every sort of experience and action related to perception. This is the quintessence of the image act.

Postscript: The Eye in Flight

To the lower left of a self-portrait in the form of a small, roughly oval bronze plaquette, devised by Alberti in the mid- to later 1430s (Fig. 197), there hovers, between the chin and the knotted neckerchief, an eye in flight: the artist's personal symbol. This frequently analysed impresa is imbued with the tension implicit in the very cleft it occupies. For it mediates, in terms of the image act, between the sombre domain of the substitutive and the utmost radiance of the intrinsic.[1]

The emblem would initially seem to accord with Alberti's conviction that the eye, here distinguished through its eagle's wings, was "the first and foremost of the body's organs – both a king and, one might even say, a god".[2] At the end, however, of the manuscript of Alberti's treatise *Della famiglia* [On the family] – which largely concerns the upbringing and education of children, and advises on how they be taught to restrain their violent passions – there is a further eye in flight that, in its own, drawn form (Fig. 198),[3] detracts from the majestic impression made by the first. In the drawing one can more easily note that filaments dart flickeringly forward, while three cords waft back from the rim of the lower lid. It is here clearer than in the plaquette that both these last and the elongated entities at the back of the eye may signify ruptured bundles of tendons and nerves. In the bronze version of the eye in flight the entities at the back of the eye are thicker and more numerous and, as such, they give a stronger impression of being extensions of those at the

1 *The Currency of Fame* 1994, p. 43, Comprehensive regarding interpretation: Pfisterer 1998, and Wolf 2002 *Schleier*, pp. 267–68. See also: Belting 2008, pp. 229–34. The interpretation presented here differs from those found in the aforementioned texts in that it regards the omnipotent organ of sight as a flying wound. For more detailed discussion of this aspect: Bredekamp 2007 *Bilder*, pp. 9–22.

2 "Oculo potentius nihil, velocius nihil, dignius nihil; quid multa? Ejusmodi est ut inter membra primus, praecipuus, et rex, et quasi deus sit" (Alberti 1890, p. 229). See also: Chapeaurouge 1983, pp. 3–4.

3 Florence, Biblioteca Nazionale, cod.II.IV.38, fol. 92r.

Fig. 197 Leon Battista Alberti,
Plaquette with a self-portrait,
Bronze, 1435–1438, National
Gallery of Art (Kress Collection),
Washington, D.C.

Fig. 198 Leon Battista Alberti, Eye in flight
with the motto *QVID TVM*, Pen and ink on
paper, 1438, Biblioteca Nazionale Centrale,
Florence.

front. As a whole, these fibrous forms appear to relate to Alberti's motif of the *circulum rationis* [circle of understanding]. This he conceived as surrounded by snares that it was imperative to extirpate: "the fishhooks of overpowering passion, the sparks of unsuppressed anger, the flames of carnal desire".[4] Through its wings, the eye is here designated as divine; but its tentacles are symbols of all too human compulsions and debilitating lusts. It is this conflict that Alberti acknowledges with the menacing Latin inscription featured in the drawing: "QVID TVM".[5]

Alberti's eye in flight does not only look; it also functions by feeling its way along its own flight path, thereby harnessing both optical and haptic forms of perception. Nor, significantly, does the eye in flight look straight ahead; rather, it stares sideways at those who observe it. An anatomically correct rendering of the eye would show it gazing directly ahead (as is indeed the case with Alberti's own left eye

4 "Hic vero hamos voluptatum, igniculosque irarum et cupiditatum flammas exterminandas dicimus" (Alberti 1890, p. 233). In the first summarising enumeration of the corresponding images it is noted that the flames and hooks surround the circle: "Extra circulum vero hamus et flammula incensa est" (Alberti 1890, p. 229).

5 One may assume that this derives from one of the darkest of Alberti's tales (Jarzombek 1989, pp. 30–31, 63–64; and Jarzombek 1992).

in the bronze self-portrait); but in this direction the forward darting filaments of the winged eye themselves serve for orientation (Fig. 199).[6] Through combining the anterior bundle of feeling fibres with the sideways glance of the eyeball itself, Alberti makes his emblematic eye into a sensory organ that supplements the capacity to see with the capacity to touch. In this interplay of the visual and the haptic Alberti's eye is possessed of a philosophical significance that links it to the image theory of Lucretius, as also to Peirce's icon. In this respect it constitutes an insight of supra-historical validity.[7] And more recent investigation into why certain individuals may be moved to tears on looking at paintings when there is no discernible external cause for such a reaction (a phenomenon most frequently registered in response to

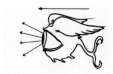

Fig. 199 Markus Rath, An eye in flight looking forwards (left) and Alberti's emblematic eye looking to the side and feeling its way along its own flight path (right), Drawing.

the floating, iridescent monochrome planes in the work of Mark Rothko) would seem to substantiate the capacities imputed to the eye in Alberti's emblem.[8] As already noted, an even more intense impact upon the eyes of onlookers is occasioned by the dancing automaton in Fritz Lang's *Metropolis* (Figs. 71, 72). In these eyes' irrepressible desire not only to look but also to touch they have entirely escaped from their owners' heads.

Alberti's emblem powerfully suggests how an eye may be torn out of its socket through the sheer attraction exerted by what that eye may chance to see, and in such a way that the tentacles embodying the passions are themselves also swept away. It offers a dramatic enactment of Leonardo's image of the captivity that may lie in wait for those entranced through looking at a particularly alluring painted portrait. The eye's ascent and elevation are fuelled by all that it has seized from the objects observed. But this power is thus inextricable from the eye's susceptibility to

6 This diagram, illustrating the change of perspective and the consequence for our understanding of Alberti's emblem, derives from Markus Rath (Rath 2009).

7 Krois 2006, pp. 178–79; Krois 2009 *Image Science*.

8 Elkins 2001, pp. 1–2: one of the individuals so affected, Jane Dillenberger, described her reaction as an optical-tactile experience, her account reading almost like a commentary upon Alberti's eye in flight: "I felt as if my eyes had fingertips moving across the brushed textures of the canvases". See also: Krois 2006, pp. 186–87.

horror as well as to delight. Autonomous as an organ of flight, the eye also suffers, as an observing wound. Already present in Alberti's emblem is the *energeia* that recurs, at around the same time, in the impenetrable first-person-singular statements of those portrayed by Jan van Eyck, and which, several centuries later, would lead Niki de Saint Phalle to identify the work of art with her own, assaulted body. Alberti's eye delivers a paradigm of the essence of the gaze as itself an autonomous artefact: it soars aloft, discovering the entire world, yet is at the same time in distress. Like Leonardo's maxim, Alberti's emblem ultimately attests to the insuperable ambiguity of the image act.

Acknowledgements

Axel Honneth invited me to present and discuss the ideas that lie at the heart of this volume in the context of the 2007 Adorno Lectures (given in Frankfurt am Main), and I am especially grateful for the warm hospitality he evinced in organising that series of events. Without that additional stimulus I would have been less able, in the years since, to re-work and extend my original texts into the form they have now assumed.

In 2006 Jens Halfwassen had afforded me the opportunity to give the Hans-Georg Gadamer Lecture in Heidelberg, in the context of which I was able to set forth my initial thoughts on the subject.

In the years 2005-08, together with Reinhart Meyer-Kalkus in the focus group *Bild* [The Image] at the Wissenschaftskolleg in Berlin, I was able to debate numerous issues with representatives of diverse disciplines, among them Gottfried Boehm, Karl Clausberg, Luca Giuliani, Dieter Grimm, Wolfram Hogrebe, John Michael Krois, W.J.T. Mitchell, and Christoph Möllers. No less fruitful was the working group on Lucretius, in which, in addition to Reinhart Meyer-Kalkus, participants included Stephen Greenblatt, Oliver Primavesi, and Christof Rapp. As always, the librarians of the Wissenschaftskolleg have provided an invaluable service.

My text (while any faults that may persist are, of course, my own) has benefited from the generous advice and assistance of my colleagues. Maria Luisa Catoni checked and greatly improved the sections on Classical Antiquity; Sybille Krämer enabled me to better understand Plato's Simile of the Divided Line; Manfred Bierwisch and Jürgen Trabant brought their formidable expertise in linguistic analysis to bear in a careful reading of Chapter I; Gerhard Quaas and Bernhard Roosens advised me on the selection of *"me fecit"* weapons; Martina Müller-Wiener assisted me through her extensive knowledge of Islamic artefacts; and both David Freedberg and Martin Warnke provided deeply valued advice on the text in its entirety. This has also benefitted through the profundity of Reimut Reiche's critical commentary on my Adorno Lectures (Reiche 2008).

Herbert Beck, Frank Fehrenbach, Petra Gehring, Frank O. Gehry, Andreas Gelhard, Carlo Ginzburg, the late Stephan von Huene, Fritz-Eugen Keller, Petra Kipphoff, Hannelore Krois, Ulrich Kuder, H. Walter Lack, Ingo Langner, Marilyn Aronberg Lavin and Irving Lavin, Axel Meyer, Katja Müller-Helle, Felix Prinz, Johannes Riedner, Salvatore Settis, Carlo Severi, Ulrike Tarnow, Asmus Trautsch, Bernhard Waldenfels, Lambert Wiesing, Gerhard Wolf, Wolfgang Wolters, Torsten Wunsch, and Robert Zapperi have supplied further assistance and advice.

Members of Humboldt University's departments *Requiem* and *Das Technische Bild* [*The Technical Image*], in addition to the Institute of Art and Image History as a whole, and in particular Carolin Behrmann, Matthias Bruhn, and Stefan Trinks, have repeatedly offered stimulating insights and constructive criticism. Glenn Vincent Kraft devised the graphic presentation of the table that appeared towards the end of Chapter VI; and much of the photographic illustration is owed to the technical and aesthetic skills of Barbara Herrenkind. Eva Gilmer carefully and sensitively prepared the text for its publication by Suhrkamp Verlag. Also of importance has been the input, both intellectual and organisational, of the students who, over the years, have served me as assistants: Wiebke Borutzky, Sara Hillnhütter, Nadine Lauterbach, Alexis Ruccius, Julia Schmidt, Maja Stark, and Marco Strobel. Financial support for this assistance was available thanks to funds drawn from the Max-Planck-Forschungspreis awarded to me in 2006 by the Max-Planck-Gesellschaft and the Humboldt-Stiftung.

With John Michael Krois, whom I had the good fortune to meet when we were both Fellows at the Wissenschaftskolleg in Berlin in the academic year 1992/93, I was able continuously to discuss the thoughts set down here, be it in conversation, in the seminars that we led jointly, and in particular in the context of the important research group *Bildakt und Philosophie der Verkörperung* [*Image Act and Philosophy of Embodiment*], which we co-founded in 2008. Our collaboration was, indeed, such that it would be fair to say that, where the text is at its most convincing, this valued colleague may truly be considered its co-author.

Many crucial alterations of, and improvements to, my text are owed to members of the aforementioned research group, which was a crucial addition to the German scholarly community: Alex Arteaga, Evelyn Baakes, Franz Engel, Alexandra Enzensberger, Ulrike Feist, Joerg Fingerhut, Franziska Greiner-Petter, Yannis Hadjinicolaou, Rebekka Hufendiek, Marion Lauschke, Moritz Queisner, Juliane Scharkowski, Pablo Schneider, and Jörg Trempler. My thoughts on the relationship between the "speech act" and what I initially termed the "picture act" were significantly influenced by Jan Konrad Schröder. Without the assistance of Markus Rath I might well have given up, on account of the scale of my regular teaching load and my various administrative duties. It is here very much the case that all those who have contributed to this project, irrespective of the exact nature and scope of their

input, may truly be said to have written themselves into the resulting book. In this genuinely communal effort it seems to me that the idea of the university, notwithstanding the very diverse positions of its members – who are, after all, traditionally viewed as comrades-in-arms – is more alive than its enemies would have us believe.

In 2015 the opportunity to re-issue my volume *Theorie des Bildakts* (Suhrkamp Verlag, 2010) as a revised edition, *Der Bildakt* (Wagenbach Verlag), also permitted the correction of minor textual errors and the addition of new items to the Bibliography. Since then my collaboration, no less enjoyable than enlightening, with Elizabeth Clegg on the present, English edition has been crucially supported by the valuable input of Katharina Lee Chichester, Tarek Ibrahim, Cheryce von Xylander and Laura Windisch, and the help of my student assistants Pauline Bossauer, Kristyna Comer, Amelie Ochs, Anne-Kathrin Segler, Kay Usenbinz, and Frederik Wellmann. Particular thanks are due to Stefanie Meisgeier and Kolja Thurner for countless hours of relentless correcting and to Petra Florath, who brought considerable patience as well as her outstanding creativity to the book's layout and design.

Berlin, July 2017

BIBLIOGRAPHY

The presence of accents is not taken into account in this alphabetical listing. Thus: "Bartonek" precedes "Bätschmann"; "Schulz" precedes "Schümer".

Entries identified by title, rather than by author(s), are listed under the initial letter of the first substantive or adjective. Thus: *The Sacred Made Real* is listed under "S"; *Das Technische Bild* is listed under "T".

Where several publications by the same author are cited, these appear in chronological order of their publication. In the case of modern editions of much older texts (for example those from Classical Antiquity), these are listed in alphabetical order by title.

In view of the unusual length of this Bibliography, it has been restricted to the original-language version of each item cited, and has not (with certain exceptions) been further extended through the addition of existing English translations of non-anglophone texts.

Abel, Günter, *Sprache, Zeichen, Interpretation*, Frankfurt am Main 1999
— *Zeichen der Wirklichkeit*, Frankfurt am Main 2004
Actus at Imago. Berliner Schriften für Bildaktforschung und Verkörperungsphilosophie, ed. Horst Bredekamp, John Michael Krois and Jürgen Trabant, Berlin 2011–2016
Adler, Hans, *Die Prägnanz des Dunklen. Gnoseologie – Ästhetik – Geschichtsphilosophie bei Johann Gottfried Herder*, Hamburg 1990
Adorno, Theodor W., *Ästhetische Theorie*, ed. Gretel Adorno and Rolf Tiedemann (= *Theodor W. Adorno: Gesammelte Schriften*, Vol. VII), Frankfurt am Main 1970
— */ Siegfried Kracauer. Briefwechsel 1923–1966*, ed. Wolfgang Schopf, Frankfurt am Main 2008
— *Aesthetik (1958/59)*, ed. Eberhard Ortland (= *Theodor W. Adorno. Nachgelassene Schriften*, Part IV: *Vorlesungen*, Vol. III), Frankfurt am Main 2009
The Age of the Marvelous, exh. cat., ed. Joy Kenseth, Hanover, N.H. 1991
Alberti, Leon Battista, *Leonis Baptistae Alberti. Opera inedita et pauca separatim impressa*, ed. Hieronymo Mancini, Florence 1890
— *l Nuovo "De Pictura" di Leon Battista Alberti / The New "De Pictura" of Leon Battista Alberti*, Latin (and Tuscan and Italian) text and Eng. trans. by Rocco Sinisgalli, Rome 2006
— *De Statua*, Latin text and Eng. trans. by Mariarosaria Spinetti, Naples 1999
Alias Man Ray. The Art of Reinvention, exh. cat., ed. Mason Klein, New Haven and London 2009

Alles Wahrheit! Alles Lüge! Photographie und Wirklichkeit im 19. Jahrhundert. Die Sammlung Robert Lebeck, exh. cat., ed. Bodo von Dewitz and Roland Scotti, Amsterdam and Dresden 1996

Almir Ibrić, *Das Bildverbot im Islam. Eine Einführung*, Marburg 2004

Das alte Griechenland, ed. Adam Heinrich Borbein, Munich 1995

Altner, Marvin, *Hans Bellmer: Die Spiele der Puppe. Zu den Puppendarstellungen in der Bildenden Kunst von 1914–1939*, Weimar 2005

Amedick, Rita, "Wasserspiele, Uhren und Automaten mit Figuren in der Antike", in: *Automaten in Kunst und Literatur des Mttelalters und der Frühen Neuzeit*, ed. Klaus Grubmüller and Markus Stock, Wiesbaden 2003, pp. 9–47

Andreas von Ungarn, "Descriptio victoriae Karolo Provinciae comite reportatae", in: *Monumenta Germaniae Historica, Scriptores*, Vol. XXVI, 1882, pp. 559–80

Andres, Glenn M., John M. Hunisak and Richard A. Turner, *The Art of Florence*, Vol. II, New York et al. 1994

Animatinonen / Transgressionen. Das Kunstwerk als Lebewesen, ed. Ulrich Pfisterer and Anja Zimmermann, Berlin 2005

L'Anonimo Magliabechiano, ed. Annamaria Ficarra, Naples 1968

Apollodorus, *The Library [...]*, Greek text and Eng. trans. by James George Frazer, London and New York 1921 (Loeb Classical Library)

Architekturmodelle der Renaissance. Die Harmonie des Bauens von Alberti bis Michelangelo, exh. cat. ed. Bernd Ebers, Munich and New York 1995

Arena, R., "Pantares o Panchares?", *Zeitschrift für Papyrologie und Epigraphik*, LXIII (1986), pp. 181–82

Arendt, Hannah, *The Life of the Mind*, New York 1978

Aristotle, *The Poetics [...]*, Greek text and Eng. trans. by Stephen Halliwell, Cambridge, Mass. and London (Loeb Classical Library) 1995

— *The "Art" of Rhetoric*, Greek text and Eng. trans. by John Henry Freece, London and New York (Loeb Classical Library) 1926

Arnold, Harold J. P., "A Problem Resolved", *British Journal of Photography*, 18 May 1989, pp. 25–27; and 25 May 1989, pp. 20–21

Arteaga, Alex, "Sensuous framing. Grundzüge einer Strategie zur Konzeption und Verwirklichung von Rahmenbedingungen des Wahrnehmens", doctoral dissertation, Humboldt-Universität Berlin 2010

Assmann, Jan, "Viel Stil am Nil?", in: *Stil: Geschichten und Funktionen eines Kulturwissenschaftlichen Diskurselements*, ed. H. W. Gumbrecht and K. L. Pfeiffer, Frankfurt am Main 1986, pp. 519–37

— "Die Macht der Bilder. Rahmenbedingungen ikonischen Handelns im Alten Ägypten", in: *Visible Religion. Annual for Religious Iconography*, VII (1990), pp. 1–20

— *Ägyptische Geheimnisse*, Munich 2004

Augenkitzel. Barocke Meisterwerke und die Kunst des Informel, exh. cat., ed. Dirk Luckow, Kiel 2004

Austin, John L., *How to Do Things with Words*, Cambridge, Mass. 1962

Automaten in Kunst und Literatur des Mittelalters und der Frühen Neuzeit, ed. Klaus Grubmüller and Marcus Stock, Wiesbaden 2003

Baackmann, Susanne, "Symptomatic Bodies: Fascism, Gender and Hans Bellmers's Dolls", in: *Writing against Boundaries. Nationality, Ethnicity and Gender in the German-speaking Context*, ed. Barbara Kosta and Helga Kraft. Amsterdam and New York 2003, pp. 61–79

Babich, Babette, "Die Naturgeschichte der griechischen Bronze im Spiegel des Lebens. Betrachtungen über Heideggers ästhetische Phänomenologie und Nietzsches agonale Politik", in: http://fordham.bepress.com/phil_babich/1(2009) (accessed 20. 05. 2010)

Bach, Friedrich Teja, *Struktur und Erscheinung. Untersuchungen zu Dürers graphischer Kunst*, Berlin 1996

Baer, Eva, *Metalwork in Medieval Islamic Art*, New York 1983

Bahnsen, Ulrich, "Das Geheimnis der Gravuren", in: *Die Zeit. Welt- und Kulturgeschichte*, Vol. I, Hamburg 2005, pp. 543–47

Bakewell, Liza, "Image Acts", *American Anthropologist*, C/1 (1998), pp. 22–32

Bannister, Turpin C., "The Constantinian Basilica of Saint Peter at Rome", *Journal of the Society of Architectural Historians*, XXVII (1968), pp. 3–32

Barasch, Moshe, "'Pathos Formula': Some Reflections on the structure of a concept", in: *Hebrew University Studies in Literature and the Arts*, XIII / 2 (1985), pp. 251–65

Barck, Joanna, *Hin zum Film – Zurück an den Bildern. Tableaux vivants: "Lebende Bilder" in Filmen von Antamoro, Korda, Visconti und Pasolini*, Bielefeld 2008

Barkan, Leonard, *Unearthing the Past: Archaeology and Aesthetics in the Making of Renaissance Culture*, New Haven and London 1999

Barthes, Roland, *Fragments d'un discours amoureux*, Paris 1977

— *La chambre claire. Note sur la photographie*, Paris 1980

Bartnik, Marcel, *Der Bildnisschutz in deutschen und französischen Zivilrecht*, Tübingen 2004

Bartonek, Antonín and Giorgio Buchner, "Die ältesten griechischen Inschriften von Pithekoussai (2. Hälfte des VIII bis VI Jhs.)", *Die Sprache*, XXXVII / 2 (1995), pp. 129–231

Bätschmann, Oskar, "Einleitung", in: Leon Battista Alberti, *De Statua. De Pictura. Elementa Picturae. Das Standbild. Die Malkunst. Die Grundlagen der Malerei*, ed. and trans. Oskar Bätschmann and Christof Schäublin, Darmstadt 2000, pp. 13–140

Bauch, Kurt, *Das mittelalterliche Grabbild. Figürliche Grabmäler des 11. bis 15. Jahrhunderts in Europa*, West Berlin and New York 1976

Baumgarth, Christa, *Geschichte des Futurismus*, Reinbek bei Hamburg 1966

Bazin, André, "Ontologie des fotograpfischen Bildes", in: Wolfgang Kemp, *Theorie der Fotografie III, 1945–1980*, Munich 1999 [1945], pp. 59–64

Beck, Herbert and Horst Bredekamp, "Die mittelalterliche Kunst um 1400", in: *Kunst um 1400 am Mittelrhein. Ein Teil der Wirklichkeit*, exh. cat., ed. Herbert Beck, Frankfurt am Main 1975, pp. 30–98

Becker, Peter, *Dem Täter auf der Spur. Eine Geschichte der Kriminalistik*, Darmstadt 2005

Vanessa Beecroft. Performances 1993–2003, exh. cat., ed. Emanuela di Lallo, Milan 2003

Behrmann, Carolin, "Triumph and Law. Giorgio Vasari's 'Massacre of St. Bartholomew's Eve' and the Iconology of the 'State of Exception'", in: *Power and Image in Early Modern Europe*, ed. Jessica Leigh Goethals, Valerie McGuire and Gaoheng Zhang, Newcastle-upon-Tyne 2008, pp. 2–15

— "Bild – Actus – Ausnahme. Zur Ikonologie des Ausnahmezustandes", in: *Ästhetik der Ausschliessung. Ausnahmezustände in Geschichte, Theorie, Medien und literarischer Fiktion*, ed. Oliver Ruf, Würzburg 2009, pp. 81–94

Belting, Hans, *Bild und Kult. Eine Geschichte des Bildes vor dem Zeitalter der Kunst*, Munich 1990
— "Images in History and Images of History", in: *Ernst Kantorowicz. Erträge der Doppeltagung: Institute of Advanced Study, Princeton; Johann Wolfgang Goethe-Universität, Frankfurt*, ed. Robert L. Benson and Johannes Fried, Stuttgart 1997, pp. 94–103
— "In Search of Christ's Body", in: *The Holy Face and the Paradox of Representation*, ed. Herbert L. Kessler and Gerhard Wolf, Bologna 1998, pp. 1–11
— *Bild-Anthropologie. Entwürfe für eine Bildwissenschaft*, Munich 2001
— "Repräsentation und Anti-Repräsentation. Grab und Portrait in der Frühen Neuzeit", in: *Quel Corps? Eine Frage der Repräsentation*, ed. Hans Belting et al., Munich 2002, pp. 29–52
— *Das echte Bild. Bildfragen als Glaubensfragen*, Munich 2005
— "Franziskus. Der Körper als Bild", in: *Bild und Körper im Mittelalter*, ed. Kristin Marek et al., Munich 2006, pp. 21–36
— "Die Herausforderung der Bilder. Ein Plädoyer und eine Einführung", in: *Bildfragen. Die Bildwissenschaften im Aufbruch*, ed. id., Munich 2007, pp. 11–23
— *Florenz und Bagdad. Eine westöstliche Geschichte des Blicks*, Munich 2008
— and Dagmar Eichberger, *Jan van Eyck als Erzähler. Frühe Tafelbilder im Umkreis der New Yorker Doppeltafel*, Worms 1983
— and Christiane Kruse, *Die Erfindung des Gemäldes. Das erste Jahrhundert der niederländischen Malerei*, Munich 1994
Benjamin, Walter, "L'oeuvre d'art à l'époque de sa reproduction mécanisée", French trans. Pierre Klossowski, *Zeitschrift für Sozialforschung*, V / 1 (1936), pp. 40–66
— "Das Kunstwerk im Zeitalter seiner technischen Reproduzierbarkeit", in: id.: *Gesammelte Schriften*, Vol. I / 2, ed. Rolf Tiedemann and Hermann Schweppenhäuser, Frankfurt am Main 1974, pp. 431–69 (first version), 471–508 (second version), 708–39 (French trans. of 1936)
— "Strenge Kunstwissenschaft", in: id.: *Gesammelte Schriften*, Vol. III: *Kritiken und Rezensionen*, ed. Hella Tiedemann-Bartels, Frankfurt am Main 1972, pp. 363–69 (first version); 369–74 (second version)
Bergson, Henri, *L'Évolution créatrice*, Paris 1907
Bernasconi, Gianenrico, "Authentizität und Reproduzierbarkeit: Naturselbstdrucke auf amerikanischen Geldscheinen des 18. Jahrhunderts", in: *Bildwelten des Wissens. Kunsthistorisches Jahrbuch fur Bildkritik*, Vol. VIII / 1: *Kontaktbilder*, ed. Vera Dünkel, Berlin 2010, pp. 72–82
Berns, Jörg Jochen, "Schmerzende Bilder. Zu Machart und Mnemonischer Qualität monströser Konstrukte in Antike und Früher Neuzeit", in: *Schmerz und Erinnerung*, ed. Roland Borgards, Munich 2005, pp. 25–55
Berra, Giacomo, "Immagini casuali, figure mascoste e natura antropomorfa nel'immaginario artistico Rinascimentale", in: *Mitteilungen des Kunsthistorischen Institutes in Florenz*, XLIII / 2–3 (1999), pp. 358–419
Besançon, Alain, *L'image interdite. Une histoire intellectuelle de l'iconoclasme*, Paris 1994
Der Betrachter ist im Bild. Kunstwissenschaft und Rezeptionsästhetik, ed. Wolfgang Kemp, Berlin 1992
Betts, Richard J., "Titian's Portrait of Filippo Archinto in the Johnson Collection", *The Art Bulletin*, XLIX / 1 (1967), pp. 59–61

Beutekunst unter Napoleon. Die "französische Schenkung" an Mainz 1803, ed. Sigrun Paas and
 Sabine Mertens, Mainz 2003

Beyer, Andreas, "'Apparitio Operis'. Vom vorübergehenden Erscheinen des Kunstwerks", in:
 Mo(nu)mente. Formen und Funktionen ephemerer Denkmäler, ed. Michael Diers, Berlin 1993,
 pp. 35–50

Beyer, Annette, *Faszinierende Welt der Automaten: Uhren, Puppen, Spielereien*, Munich 1983

The Holy Bible (King James Version, 1611), London and New York 1922

Bierwisch, Manfred, "Probleme und Rätsel der natürlichen Sprache", in: *Berlin-Brandenbur-*
 gische Akademie der Wissenschaften, Berichte und Abhandlungen, Vol. VII, Berlin 1999,
 pp. 163–97

Bild und Bestie. Hildesheimer Bronzen der Stauferzeit, exh. cat., ed. Michael Brandt, Hildes-
 heim 2008

Bilder und Bildersturm in Spätmittelalter und im der frühen Neuzeit. Arbeitsgespräch der Herzog
 August Bibliothek Wolfenbüttel, 14.–17. September 1986, ed. Bob Scribner and Martin
 Warnke, Wiesbaden 1990

Bildersturm. Die Zerstörung des Kunstwerks, ed. Martin Warnke, Munich 1973

Bildersturm in Osteuropa, ed. ICOMOS, Munich 1994

Bildersturm. Wahnsinn oder Gottes Wille?, exh. cat., ed. Cécile Dupeux et al., Bern 2000

Das bildnerische Denken: Charles S. Peirce, ed. Franz Engel et al., Berlin 2012

Bill Viola, exh. cat., ed. David A. Ross and Peter Sellars, New York 1997

Binder, Werner, "'Politische Metaphysik' und die Ikonographie der Grausamkeit. Carl Schmitt,
 Leo Strauss und der Bilderkrieg im Irak", in: *Grausamkeit und Metaphsik. Figuren der*
 Überschreitung in der abendländischen Kultur, ed. Mirjam Schaub, Bielefeld 2009, pp. 179–96

Bisanz, Elize, *Malerei als écriture. Semiotische Zugänge zur Abstraktion*, Wiesbaden 2002

Bley, Hartwig, "'Bernhardus me fecit' – Die romanischen Löwenkopf-Türzieher in Frecken-
 horst", *Westfalen*, LXVIII (1990), pp. 185–95

Blickzähmung und Augentäuschung. Zu Jacques Lacans Bildtheorie, ed. Claudia Blümle and Anne
 von der Heiden, Zürich and Berlin 2005

Bloch, Peter, "Der Stil des Essener Leuchters", in: *Das erste Jahrtausend. Kultur und Kunst im*
 werdenden Abendland an Rhein und Ruhr, Düsseldorf 1962

Bloch, Peter, *Romanische Bronzekruzifixe*, Berlin 1992

Blommaert, Philip, *Geschiedenis der Rhetorykkamer: De Fonteine, te Gent (gesticht den 9 Decb.*
 1448), Ghent 1847

Blühm, Andreas, *Pygmalion. Die Ikonographie eines Künstlermythos zwischen 1500 und 1900*,
 Bern, New York and Paris 1988

Blumenröder, Sabine, *Andrea Mantegna – die Grisaillen. Malerei, Geschichte und antike Kunst im*
 Paragone des Quattrocento, Berlin 2008

Blümle, Claudia, "Der allgegenwärtige Blick des Richters. Juridische Evidenz bei Albrecht Dürer
 und Lucas Cranach d. Ä", in: *Movens Bild. Zwischen Evidenz und Affekt*, ed. Gottfried Boehm
 et al., Munich 2008, pp. 408–30

Bodily Extremities. Preoccupations with the Human Body in Early Modern European Culture,
 ed. Florike Egmond and Robert Zwjinenberg, Aldershot and Burlington, Vt. 2003

Boehm, Gottfried, *Bildnis und Individuum. Über den Ursprung der Portaitmalerei in der italieni-*
 schen Renaissance, Munich 1985

— "Im Horizont der Zeit. Heideggers Werkbegriff und die Kunst der Moderne", in: *Kunst und Technik. Gedächtnisschrift zum 100. Geburtstag von Martin Heidegger*, ed. Walter Biemel and Friedrich-Wilhelm von Herrmann, Frankfurt am Main 1989, pp. 255–84

— "Die Wiederkehr der Bilder", in: *Was ist ein Bild?*, ed. Gottfried Boehm, Munich 1994, pp. 11–38

— "Zuwachs am Sein. Hermeneutische Reflexion und bildende Kunst", in: *Hans-Georg Gadamer: Die Moderne und die Grenze der Vergegenständlichung*, ed. Bernd Klüser, Munich 1996, pp. 95–125

— "Repräsentation – Präsentation – Präsenz. Auf den Spuren des Homo pictor", in: *Homo pictor*, ed. Gottfried Boehm, Munich and Leipzig 2001, pp. 3–13

— *Wie Bilder Sinn erzeugen. Die Macht des Zeigens*, Berlin 2007

— "Die Form des Formlosen – Abstrakter Expressionismus und Informel", in: *Action Painting. Jackson Pollock*, exh. cat., ed. Ciuha Delia, Basel 2008, pp. 38–46

Boerner, Bruno, *Bildwirkungen. Die kommunikative Funktion mittelalterlicher Skulpturen*, Berlin 2008

Boghossian, Paul A., *Fear of Knowledge: Against Relativism and Constructivism*, Oxford 2006

Bohde, Daniela, *Haut, Fleisch und Farbe. Körperlichkeit und Materialität in den Gemälden Tizians*, Emsdetten and Berlin 2002

Böhme, Gernot, *Theorie des Bildes*, Munich 1999

Böhme, Hartmut, "Antike Anthropogenie-Vorstellungen in Ovids Metamorphosen: Prometheus – Deukalion – Pygmalion", in: *Pygmalion. Die Geschichte des Mythos in der abendländischen Kultur*, ed. Mathias Mayer and Gerhard Neumann, Freiburg 1997, pp. 82–125

— *Fetischismus und Kultur. Eine andere Theorie der Moderne*, Reinbek bei Hamburg 2006

Böhringer, Hannes, "Einführung", in: Wilhelm Worringer, *Schriften*, 2 vols., ed. Hannes Böhringer, Helga Grebing and Beate Söntgen, Munich 2004, pp. 15–30

Botticelli. Bildnis, Mythos, Andacht, ed. Andreas Schumacher, Frankfurt am Main 2009

Braungart, Wolfgang, "Prägnante Momente. Rainer Maria Rilkes Archäischer Torso Apollos und das Ende ästhetischer Beliebigkeit", in: *Der Bildhunger der Literatur. Festschrift für Gunter Grimm*, ed. Dieter Heinböckel and Uwe Werlein, Würzburg 2005, pp. 229–36

Bräunlein, Peter J., "Bildakte. Religionswissenschaft im Dialog mit einer neuen Bildwissenschaft", in: *Religion im kulturellen Diskurs / Religion in Cultural Discourse. Festschrift Hans G. Kippenberg zu seinem 65. Geburtstag / Essays in Honor of Hans G. Kippenberg on the Occasion of his 65th Birthday*, ed. Brigitte Luchesi and Kocku von Stuckrad, Berlin and New York 2004, pp. 195–231

Bredekamp, Horst, "Autonomie und Askese", in: *Autonomie der Kunst. Zur Genese und Kritik einer bürgerlichen Kategorie*, Frankfurt am Main 1972, pp. 88–172

— *Kunst als Medium sozialer Konflikte. Bilderkämpfe von der Spätantike bis zur Hussitenrevolution*, Frankfurt am Main 1975

— "Wasserangst und Wasserfreude in Renaissance und Manierismus", in: *Kulturgeschichte des Wassers*, ed. Hartmut Böhme, Frankfurt am Main 1988, pp. 145–88

— "Der simulierte Benjamin. Mittelalterliche Bemerkungen zu seiner Aktualität", in: *Frankfurter Schule und Kunstgeschichte*, ed. Andrea Berndt et al., Berlin 1992, pp. 117–40

— "Lorenzinos de' Medici Angriff auf den Konstantinbogen als 'Schlacht von Cannae'", in: *L'Art et les révolutions. XXVIIe congrès international d'histoire de l'Art, Strasbourg, 1.–7. septembre 1989*, Section 4: *Les iconoclasmes*, Strasbourg 1992, pp. 95–115

— *Repräsentation und Bildmagie der Renaissance als Formproblem*, Munich 1995
— "Theater der Unterleiber. Über Stephan von Huenes 'Tischtänzer'", in: *Stephan von Huene.*
 'Tischtänzer', ed. Petra Oelschlägel, Ostfildern (Ruit) 1995, pp. 53–57
— "Demokratie und Medien", in: *Bürger und Staat in der Informationsgesellschaft*, ed.
 Enquete-Kommission Zukunft der Medien in Wirtschaft und Gesellschaft. Deutschlands
 Weg in die Informationsgesellschaft. Deutscher Bundestag, Bonn 1998, pp. 188–94
— *Thomas Hobbes. Visuelle Strategien. Der Leviathan: Urbild des modernen Staates. Werk-*
 illustrationen und Portraits, Berlin 1999
— "Überlegungen zur Unausweichlichkeit der Autonomen", in: *Puppen Körper Automaten*
 – Phantasmen der Moderne, exh. cat., ed. Pia Müller-Tamm and Katharina Sykora, Düssel-
 dorf 1999, pp. 94–105
— "Das Mittelalter als Epoche der Individualität", in: *Berlin-Brandenburgische Akademie der*
 Wissenschaften: Berichte und Abhandlungen, Vol. VIII (2000), pp. 190–240
— "Die Medici, Sixtus IV und Savanorola: Botticellis Konflikte", in: *Sandro Botticelli. Der*
 Bilderzyklus zu Dantes Göttlicher Komödie, exh. cat., ed. Hein-Thomas Schulze Altcappen-
 berg, Ostfildern (Ruit) 2000, pp. 292–97
— "Leviathan und Internet", in: *Schnittstelle: Medien und Kulturwissenschaft*, ed. Georg
 Stanitzek and Wilhelm Vosskamp, Cologne 2001, pp. 223–31
— "Die Tiefe der Oberfläche / The Depth of the Surface", in: *Stephan von Huene – Tune the*
 World. Die Retrospektive / The Retrospective, exh. cat., Ostfildern (Ruit) 2002, pp. 130–69
— *Antikensehnsucht und Maschinenglauben. Die Geschichte der Kunstkammer und die Zukunft*
 der Kunstgeschichte, 4th edn., Berlin 2003
— "Marks and Signs. Mutmassungen zum jüngsten Bilderkrieg", in: *FAKtisch. Festschrift für*
 Friedrich Kittler zum 60. Geburtstag, ed. Peter Berz, Annette Bitsch and Bernhard Siegert,
 Munich 2003, pp. 163–69
— "A Neglected Tradition? Art History as *Bildwissenschaft*", *Critical Inquiry*, XXIX/3 (2003),
 pp. 418–28
— "Observations on the Natural History of the Web", in: *Representing the Passions. Histories,*
 Bodies, Visions, ed. Richard Meyer, Los Angeles 2003, pp. 103–25
— "Bildakte als Zeugnis und Urteil", in: *Mythen der Nationen. 1945 – Arena der Erinnerungen* ,
 ed. Monika Flacke, Vol. I, Mainz 2004, pp. 29–66
— *Die Fenster der Monade. Gottfried Wilhelm Leibniz' Theater der Natur und Kunst*, Berlin 2004
— "Frank Gehry and the Art of Drawing", in: *Gehry Draws*, ed. Mark Rappolt and Robert
 Violette, London 2004, pp. 11–28
— *Darwins Korallen. Die frühen Evolutionsdiagramme und die Tradition der Naturgeschichte*,
 Berlin 2005
— "John Cage and the Principle of Chance", in: *Music and the Aesthetics of Modernity. Essays*,
 ed. Karol Berger and Anthony Newcomb, Cambridge, Mass. and London 2005, pp. 99–107
— "Modelle der Kunst und der Evolution", in: *Modelle des Denkens. Streitgespräch in der*
 Wissenschaftlichen Sitzung der Versammlung der Berlin-Brandenburgischen Akademie der
 Wissenschaften am 12. Dezember 2003, Debatte, Heft II, Berlin 2005, pp. 13–20
— "Kunsthistorische Erfahrungen und Ansprüche", in: *Bild und Medium. Kunstgeschichtliche*
 und philosophische Grundlagen der interdisziplinären Bildwissenschaft, ed. Klaus Sachs-
 Hombach, Cologne 2006, pp. 11–26

— *Thomas Hobbes. Der Leviathan. Das Urbild des modernen Staates und seine Gegenbilder 1651–2001*, 3rd edn., Berlin 2006

— "Bilder in Evolution und Evolutionstheorie", in: *Evolution und Menschwerdung. Vorträge anlässlich der Jahresversammlung der Leopoldina vom 7. bis 9. Oktober 2005 zu Halle / Salle*, ed. Harald zur Hausen, Halle 2006, pp. 195–215

— "Bild – Akt – Geschichte", in: *GeschichtsBilder. 46. Deutscher Historikertag vom 19. bis 22. September in Konstanz. Berichtsband*, ed. Clemens Wischermann et al., Constance 2007, pp. 289–309

— "Darwins Korallen und das Problem animalischer Schönheit", in: *Bilderwelten. Vom farbigen Abglanz der Natur*, ed. Norbert Elsner, Göttingen 2007, pp. 257–80

— *Bilder bewegen. Von der Kunstkammer zum Endspiel*, ed. Jörg Probst, Berlin 2007

— "Denkende Hände. Überlegungen zur Bildkunst der Naturwissenschaften", in: *Räume der Zeichnung*, ed. Angela Lammert, Carolin Meister, Jan-Phillipp Frühsorge, and Andreas Schalhorn, Nuremberg 2007, pp. 12–24

— "Das Bild des bulgarischen Staatskörpers als Organ der Gewalt", *kritische berichte*, XXXVI / 2 (2008), pp. 31–35

— "Der König der Könige als simulierter Android", in: *Der Mensch als Konstrukt. Festschrift für Rudolf Drux zum 60. Geburtstag*, ed. Rolf Füllmann et al., Bielefeld 2008, pp. 15–44

— "Michael Jackson in Bukarest", in: *TABU. Interkulturalität und Gender*, ed. Claudia Benthien and Ortrud Gutjahr, Munich 2008, pp. 205–17

— *Sankt Peter in Rom und das Prinzip der produktiven Zerstörung. Bau und Abbau von Bramante bis Bernini*, 3rd edn., Berlin 2008

— "Das Prinzip der Metamorphosen und die Theorie der Evolution", in: *Berlin-Brandenburgische Akademie der Wissenschaften. Jahrbuch 2008*, Berlin 2009, pp. 209–47

— "Wider die Bildangst der Sprachdominanz", in: *"Der Mensch ist nur Mensch durch Sprache". Zur Sprachlichkeit des Menschen*, ed. Markus Messling and Ute Tintemann, Munich 2009, pp. 51–68

— "Der Doppelcharakter des Schleiers", in: *Festina Lente. Festschrift für Hubert Burda zum 70. Geburtstag*, Munich 2010, pp. 20–27

— *Theorie des Bildakts. Frankfurter Adorno-Vorlesungen 2007*, Berlin 2010

— "Die Latenz des Objekts als Modus des Bildakts", in: *Latenz. Blinde Passagiere in den Geisteswissenschaften*, ed. Hans Ulrich Gumbrecht and Florian Klinger, Göttingen 2011, pp. 277–84

— "Brutus", in: *Handbuch der politischen Ikonographie*, ed. Uwe Fleckner et al., Vol. I, Munich 2011, pp. 186–92

— "Das Modell als Fetisch und Fessel", in: *Nova Acta Leopoldina*, new series CXIII / 386 (2012), pp. 61–99

— "Der Muschelmensch. Vom endlosen Anfang der Bilder", in: Horst Bredekamp, Dagfinn Føllesdal and Udo Di Fabio, *Transzendenzen des Realen*, ed. Wolfram Hogrebe, Göttingen 2013, pp. 13–74

— "The Picture Act: Tradition, Horizon, Philosophy", in: *Bildakt at the Warburg Institute*, ed. Sabine Marienberg and Jürgen Trabant, Berlin 2014, pp. 3–32

— "Doppelmord an Mensch und Werk", *Süddeutsche Zeitung*, 12 January 2015, p. 9

— and Franziska Brons, "Fotografie als Medium der Wissenschaft – Kunstgeschichte, Biologie und das Elend der Illustration", in: *ICONIC TURN. Die neue Macht der Bilder*, ed. Christa Maar and Hubert Burda, Cologne 2004, pp/. 365–81

— and Dorothee Haffner, "Wem gehört die Mona Lisa?", in: *Geistiges Eigentum. Streitgespräch in der Wissenschaftlichen Sitzung der Versammlung der Berlin-Brandenburgischen Akademie der Wissenschaften am 14. Dezember 2007 und am 4. Juli 2008, Debatte*, Heft VII, Berlin 2008, pp. 61–73

— and Ulrich Raulff, "Handeln im Symbolischen. Ermächtigungsstrategien, Körperpolitik und die Bildstrategien des Krieges", *kritische berichte*, XXXIII / 1 (2005), pp. 5–11

Breidbach, Angela, "Thinking Aloud: Two Suites by Wiliam Kentridge", in: *Print Quarterly*, XXVII / 2 (2010), pp. 131–43

Breidbach, Olaf, "Naturkristalle – zur Architektur der Naturordnungen bei Ernst Haeckel", in: *Architektur weiterdenken. Werner Oechslin zum 60. Geburtstag*, ed. Sylvia Claus et al., Zürich 2004, pp. 254–75

Breithaupt, Fritz, *Kulturen der Empathie*, Frankfurt am Main 2009

Brenner, Andreas, *Leben. Eine philosophische Untersuchung*, Bern 2007

Briganti, Giuliano, *La Maniera Italiana*, Rome and Dresden 1961

Brink, Cornelia, *Ikonen der Vernichtung Öffentlicher Grebrauch von Fotografien aus national-sozialistischen Konzentrationslagern nach 1945*, Berlin 1998

Brinkmann, Vinzenz, Ulrike Koch-Brinkmann and Heinrich Piening, "Das Grabmal der Phrasikleia", in: *Bunte Götter. Die Farbigkeit antiker Skulptur*, exh. cat., ed. Vinzenz Brinkmann and Andreas Scholl, Berlin 2010, pp. 77–83

Brown, Jonathan, *Francisco de Zurbarán*, New York 1974

Brückner, Wolfgang, *Bildnis und Brauch. Studien zur Bildfunktion der Effigies*, West Berlin 1966

Bruhn, Matthias, *Bildwirtschaft. Verwaltung und Verwertung der Sichtbarkeit*, Weimar 2003

— *Das Bild. Theorie – Geschichte – Praxis*, Berlin 2009

Büchsel, Martin, "Das Ende der Bildmythologien. Kritische Stimmen zur deutschen Bildwis-senschaft", *Kunstchronik*, LXVII / 7 (2014), pp. 335–41

Bühler, Karl, *Sprachtheorie. Die Darstellungsfunktion der Sprache*, Stuttgart 1978 [1934]

Burda, Hubert, "Wer sieht sich wie und möchte welches Bild fur sich? Über die Selbstinszenie-rung in Portraitsbildnissen von Jan van Eyck bis Andy Warhol", in: *Bild / Geschichte. Festschrift für Horst Bredekamp*, ed. Philine Helas et al., Berlin 2007, pp. 549–62

Burda-Stengel, Felix, *Andrea Pozzo und das Videokunst. Neue Überlegungen zum barocken Illusionismus*, Berlin 2001

Burg, Tobias, *Die Signatur. Formen und Funktionen vom Mittelalter bis zum 17. Jahrhundert*, Berlin 2007

Burkert, Walter, *Wilder Ursprung. Opferitual und Mythos bei den Griechen*, Berlin 1991

Burzachechi, Mario, "Oggetti parlanti nelle epigrafi greche", *Epigraphica: Rivista Italiana di epigrafia*, XXIV (1962), pp. 3–54

Busch, Werner, "Alexander Cozens' 'blot'-Methode. Landschaftserfindung als Naturwissen-schaft", in: *"Landschaft" und Landschaften im achtzehnten Jahrhundert*, ed. Heinke Wunderlich, Heidelberg 1995, pp. 209–28

Bynum, Caroline Walker, *The Resurrection of the Body in Western Christianity 200–1336*, New York 1995

Byzantium 330–1453, exh. cat., ed. Robin Cormack and Maria Vassilaki, Royal Academy of Arts, London 2008

Caillois, Roger, *Méduse et Cie*, Paris 1960

Camille, Michael, *The Gothic Idol. Ideology and Image-making in Medieval Art*, Cambridge 1989

Campbell, Lorne, *The Fifteenth-Century Netherlandish Schools (National Gallery Catalogues)*, London 1998

Campe, Rüdiger, "In der Stadt und vor Gericht. Das Auftauchen der Bilder und die Funktion der Grenze in der antiken Rhetorik", in: *Bildwelten des Wissens. Kunsthistorisches Jahrbuch für Bildkritik*, VI / 2 (2008), pp. 42–52

Canavas, Constantin, "Automaten in Byzanz. Der Thron von Magnaura", in: *Automaten in Kunst und Literatur des Mittelalters und der frühen Neuzeit*, ed. Klaus Grubmüller and Markus Stock, Wiesbaden 2003, pp. 49–72

Cancik-Kirschbaum, Eva and Bernd Mahr, "Anordnung und ästhetisches Profil. Die Herausbildung einer universellen Kulturtecnik in der Frühgeschicte der Schrift", in: *Bildwelten des Wissens. Kunsthistorisches Jahrbuch für Bildkritik* III / 1 (2005), pp. 97–114

Cassirer, Ernst, *Individuum und Kosmos in der Philosophie der Renaissance*, Berlin 1927

— *Phänomenologie der Erkenntnis*, Berlin 1929 (= *Philosophie der Symbolischen Formen*, Vol. III)

Castris, Pierluigi Leone de, *Simone Martini*, Milan 2003

Catoni, Maria Luisa, *Schemata. Communicazione non verbale nella Grecia antica*, Pisa 2005

— *La communicazione non verbale nella Grecia antica. Gli schemata nella danza, nell'arte, nella vita*, Turin 2008

Catoni, Maria Luisa, *Bere vino puro. Immagini del simposio*, Milan 2010

Cecchi, Alessandro, "Sandro Botticelli, l'uomo e l'artista", in: *Atti e memorie della Accademia Petrarca di Lettere, Arti e Scienze*, LXVI (2004), pp. 97–116

Cellini, Benvenuto, *La Vita*, ed. Lorenzo Bellotto, Parma 1996

Chadarevian, Soraya de, "Modelle und die Entstehung der Molekularbiologie", in: *Struktur, Figur, Kontur. Abstraktion in Kunst und Lebenswissenschaft*, ed. Claudia Blümle and Armin Schäfer, Zürich and Berlin 2007, pp. 173–97

Chang, Sheng-Ching, *Natur und Landschaft. Der Einfluss von Athanasius Kirchers "China illustrata" auf die europäische Kunst*, Berlin 2003

Chapeaurouge, Donat de, *Das Auge ist ein Herr, das Ohr ein Knecht*, Wiesbaden 1983

Chapuis, Alfred and Edmond Droz, *Les Automates des Jaquet-Droz*, Neuenburg, n. d.

— *Les Automates: Figures artificielles d'Hommes et d'Animaux. Histoire et technique*, Neuchâtel 1959

Chargaff, Erwin, "Segen des Unerklärlichen", in: *Scheidewege. Jahrbuch fur skeptisches Denken*, XXIII / 1 (1993/94), pp. 3–15

Checa, Fernando, "Tizian und die Mythologie", in: *Der späte Tizian und die Sinnlichkeit der Malerei*, exh. cat., ed. Sylvia Ferino-Pagden, Vienna 2007, pp. 217–23

Les chemins de l'Art Aurignacien en Europe. Die Aurignacien und die Anfänge der Kunst in Europa. Actes du colloque 2005 d'Aurignac. Tagungsband der gleichnamigen Internationalen Fachtagung 2005, ed. Harald Floss and Nathalie Rouquerol, Aurignac 2007

Chézy, Helmina von, *Unvergessenes. Denkwürdigkeiten aus dem Leben von Helmina von Chézy. Von ihr selbst erzählt. Erster Theil*, Leipzig 1858

Christin, Oliver, *Une révolution symbolique. L'iconoclasme huguenot et la reconstruction catholique*, Paris 1991

Christo, *Der Reichstag und urbane Projekte*, exh. cat., ed. Jacob Baal-Teshuva, Munich 1993

Christo und Jeanne-Claude: Early works 1958–1969, ed. Simone Philippi Cologne, London et al. 2001

Claussen, Peter Cornelius. "Früher Künstlerstolz. Mittelalterliche Signaturen als Quelle der Kunstsoziologie", in: *Bauwerk und Bildwerk im Hochmittelalter. Anschauliche Beiträge zur Kultur und Sozialgeschichte*, ed. Karl Clausberg, Dieter Kimpel, Hans-Joachim Kunst, Robert Suckdale, Giessen 1981, pp. 7–53

— "Die Statue Friedrichs II. vom Brückentor in Capua (1234–1239). Der Befund, die Quellen und eine Zeichnung aus dem Nachbild von Séroux d'Agincourt", in: *Festschrift für Hartmut Biermann*, ed. Christoph Andreas et al., Weinheim 1990, pp. 19–39, 291–304

— "Nachrichten von den Antipoden oder den mittelalterliche Künstler über sich selbst", in: *Der Künstler über sich in seinem Werk. Internationales Symposium der Bibliotheca Hertziana*, Rome 1989, ed. Matthias Winner, Weinheim 1992, pp. 19–54

— "Kathedralgotik und Anonymität 1130–1250", in: *Wiener Jahrbuch für Kunstgeschichte*, XLVI / XLVII (1993–94), pp. 141–60.

Clement of Alexandria, *The Exhortation to the Greeks [...]*, Greek text and Eng. trans. by G. W. Butterworth, Cambridge, Mass. (Loeb Classical Library), 2nd edn., 1953

Cloeren, Hermann J., *Language and Thought. German Approaches to Analytic Philosophy in the 18th and 19th Centuries*, West Berlin and New York 1988

Cole, Michael, "Cellini's Blood", *The Art Bulletin*, LXXXI / 2 (1999), pp. 215–55

Colonna, Francesco, *Hypnerotomachia Poliphili*, ed. Giovanni Pozzi and Lucia A. Ciapponi, 2 vols., Padua 1980

Conard, Nicholas J., "... und noch mehr Tiere! Die neuen Kleinkunstwerke vom Hohle Fels und vom Vogelherd", in: *Eiszeit. Kunst und Kultur*, exh. cat., Ostfildern (Ruit) 2009, pp. 259–66

— "Die erste Venus", in: *Eiszeit. Kunst und Kultur*, exh. cat., Ostfildern (Ruit) 2009, pp. 268–71

— and Petra Kieselbach, "Eindeutig männlich! Ein Phallus aus dem Hohle Fels", in: *Eiszeit. Kunst und Kultur*, exh. cat., Ostfildern (Ruit) 2009, pp. 282–86

Condillac, Étienne Bonnot de, *Traité des sensations*, 2 vols., Paris and London 1754

— *Traité des Animaux*, Amsterdam 1755

Das Corpus Hermeticum Deutsch, ed. and trans. Jens Holzhausen, Stuttgart-Bad Canstatt 1997

Corrigan, Kathleen, *Visual Polemics in the Ninth-Century Byzantine Psalters*, Cambridge and New York 1992

Cremonini, Andreas, "Was ins Auge sticht. Zur Homologie von Glanz und Blick", in: *Movens Bild. Zwischen Evidenz und Affekt*, ed. Gottfried Boehm, Munich 2008, pp. 93–117

Cronin, Helena, *The Ant and the Peacock. Altruism and Sexual Selection from Darwin to Today*, Cambridge, Mass., 1991

Cropper, Elisabeth, "The Petrifying Art. Marino's poetry and Caravaggio", in: *Metropolitan Museum Journal*, XXVI (1991), pp. 193–212

Cudworth, Ralph, *Collected Works*, ed. Bernhard Fabian, Vol. I, Hildesheim 1977 (reprint of edn. of London 1678)

The Currency of Fame. Portrait Medals of the Renaissance, ed. Stephen K. Scher, New York 1994

Dagan, Tal, Yael Artzy-Randrup and William Martin, "Modular networks and cumulative impact of lateral transfer in prokaryote genome evolution", in: *Proceedings of the National Academy of Sciences of the United States of America*, CV / 29 (2008), pp. 10 039–10 044

Dante Alighieri, *La Divina Commedia*, Testo critic della Società Dantesca, 10th rev. edn., ed. Giuseppe Vandelli, Milan 1938

Darriulat, Jacques, *Sébastien, le Renaissant. Sur le martyre de Saint Sébastien dans la deuxième moitié du Quattrocento*, Paris 1998

Darwin, Charles, *On the Origin of Species*, London 1859

— *On the Origin of Species*, 5th edn., London 1869

— *The Expression of the Emotions in Man and Animals*, London 1872

— *Beagle Diary*, ed. Richard Darwin Keynes, Cambridge 1988

— *On the Origin of Species. A facsimile of the first edition (1859)*, intr. Ernst Mayr, Cambridge, Mass. and London 2001

— *The Descent of Man and Selection in Relation to Sex* (reprint of 2nd edn., 1871), intr. Richard Dawkins, London 2003

Daston, Lorraine and Peter Galison, "Das Bild der Objektivität", in: *Ordnungen der Sichtbarkeit. Fotografie in Wissenschaft, Kunst und Technologie*, ed. Peter Geimer, Frankfurt am Main 2002, pp. 29–99

Deceptions and Illusions. Five Centuries of Trompe l'Oeil Painting, exh. cat., ed. Sybille Ebert-Schifferer, Washington, D.C. 2002

Le dernier portrait, exh. cat. ed. Emmanuelle Héran, Paris 2002

Derrida, Jacques, *La verité en peinture*, Paris 1973

— "Signature Event Context", trans. Samuel Weber and Jeffrey Mehlman (from the 1971 first French publication), in: Jacques Derrida, *Limited Inc*, ed. Gerard Graff, Evanston, Ill., 1988, pp. 8–23

Descartes, René, *Discours de la methode pour bien conduire sa raison et chercher la verité dans les sciences [...]* [Leiden 1637], French text and Engl. trans. George Heffermann, Notre Dame and London 1994

Dhanens, Elisabeth, *Hubert und Jan van Eyck*, Königstein 1980

Didi-Huberman, Georges, *Ce que nous voyons, ce qui nous regarde*, Paris 1992

— "Fra Beato Angelico, Kreuzigung", in: *Glaube Hoffnung Liebe Tod*, exh. cat., ed. Christoph Geissmar-Brandi and Eleonore Louis, Vienna 1995, pp. 253–55

— "Das nachlebende Bild. Aby Warburg und Tylors Anthropologie", in: *Homo pictor*, ed. Gottfried Boehm, Munich and Leipzig 2001, pp. 205–24

— *L'image survivante. Histoire de l'art et temps des fantômes selon Aby Warburg*, Paris 2002

— *Images malgré tout*, Paris 2003

— and Laurent Mannoni, *Mouvements de l'air. Étienne Jules Marey, photographe des fluides*, Paris 2004

— *La resemblance par contact: archéologie, anachronisme et modernité de l'empreinte*, Paris 2008

Dieckmann, Friedrich, *Die Geschichte Don Giovannis. Werdegang eines erotischen Anarchisten*, Frankfurt am Main 1991

Diers, Michael, *Schlagbilder. Zur politischen Ikonologie der Gegenwart*, Frankfurt am Main 1997

— "Die Gegenwart der Bilder. Zur Erinnerung der Antike bei Aby Warburg", in: Michael Diers, ed., *Fotografie Film Video. Beiträge zu einer kritischen Theorie des Bildes*, Hamburg 2006, pp. 299–332

Dietl, Albert, "In arte peritus. Zur Topik mittelalterlicher Künstlerinschriften in Italien bis zur Zeit Govanni Pisanos", in: *Römische Historische Mitteilungen*, XXIX (1987), pp. 75–125

— "Künstlerschriften als Quelle für Status und Selbstverständnis von Bildhauern", in: *Studien zur Geschichte der europäischen Skulptur im 12. / 13. Jahrhundert*, ed. Herbert Beck and Kerstin Hengevoss-Dürkop, Vol. I, Frankfurt am Main 1994, pp. 175–91

— *Die Sprache der Signatur. Die mittelalterlichen Künstlerinschriften Italiens*, Parts I–IV, Berlin and Munich 2009

Dijksterhuis, E. J., *De Mechanisierung van het Wereldbeeld*, Amsterdam 1950; Eng. trans by C. D. Dikshoun, *The Mechanisation of the World Picture*, Oxford 1969

Dinkla, Söke, *Pioniere interaktiver Kunst von 1970 bis heute*, Karlsruhe 1997

Di Paolo, Ezequiel, "Extended Life", *Topoi*, XXVIII (2009), pp. 9–21

Dobschütz, Ernst von, *Christusbilder. Untersuchungen zur christlichen Legende*, Leipzig 1899

Doolittle, W. Ford and Eric Bapteste, "Pattern Pluralism and the Tree of Life Hypothesis", in: *Proceedings of the National Academy of the Unitred States of America*, Vol. CIV (2007), pp. 2043–49

Döpler, Jacob, *Theatrum poenarum*, Leipzig 1697

The Drawings of Eric Mendelsohn, exh. cat., ed. Susan King, University of Califormia at Berkeley 1969

Dubois, Philippe, *L'Acte photographique et autres essais*, Paris 1990

Ebert-Schifferer, Sybille, "Trompe l'Oeil: The Underestimated Trick", in: *Deceptions and illusions. Five Centuries of Trompe l'Oeil Painting*, exh. cat., ed. Sybille Ebert-Schifferer, Washington, D.C. 2002, pp. 16–37

— "Zwischen Tabula Rasa und Normerwartung – Kreativität in der Kunst am historischen Beispiel der Malerei", in: *Kreativität ohne Fesseln. Über das Neue in Wissenschaft, Wirtschaft und Kultur*, ed. Gerhard von Graevenitz and Jürgen Mittelstrass, Constance 2008, pp. 105–49

— *Caravaggio. Sehen – Staunen – Glauben. Der Maler und sein Werk*, Munich 2009

Edgerton, Samuel, Y., *Pictures and Punishment. Art and Criminal Prosecution during the Florentine Renaissance*, London 1985

Ehrenreich, Paul, "Ein Ausflug nach Tusayan (Arizona) im Sommer 1898 (1899)", in: *Schlagenritual. Der Transfer der Wissensformen vom Tsu'ti'kive der Hopi bis zu Aby Warburgs Kreuzlinger Vortrag*, ed. Cora Bender et al., Berlin 2007, pp. 23–58

Eichler, Hans, "Ein Kapitell mit Künstlerinschrift und andere Beiträge zur Plastik des 12. Jahrhunderts in Trier", *Trierer Zeitschrift*, X (1935), pp. 79–88

Eisenman, Stephen F., *The Abu Ghraib Effect*, London 2007

Eiszeit. Kunst und Kultur, exh. cat., ed. Archäologisches Landesmuseum Konstanz, Ostfildern (Ruit) 2009

Elkins, James, *The Object Stares Back: On the Nature of Seeing*, New York 1997

— *Pictures and Tears. A History of People who Have Cried in Front of Paintings*, New York and London 2001

Elsner, Norbert, "Die Macht des Weiblichen und die Folgen", in: *"sind eben alles Menschen". Verhalten zwischen Zwang, Freiheit und Verantwortung*, ed. Norbert Elsner and Gerd Lüer, Göttingen 2005, pp. 105–09

Emboden, William, *Leonardo on Plants and Gardens*, Portland, Ore. 1987

Engel, Franz, Moritz Queisner and Tullio Viola, *Das bildnerische Denken: Charles S. Peirce*, Berlin 2012

Engelbach, Barbara, *Zwischen Body Art und Videokunst: Körper und Video in der Aktionskunst um 1970*, Munich 2001

Entdeckung der Abstraktion. Turner – Hugo – Moreau, exh. cat., ed. Raphael Rosenberg and Max Hollein, Munich 2007

Die Entdeckung der Pflanzenwelt. Botanische Drucke vom 15. Bis 19. Jahrhundert aus der Universitätsbibliothek Johann Christian Seckenberg, exh. cat., Frankfurt am Main 2009

Die Epoche der Moderne, ed. Christos M. Joachimides, Ostfildern (Ruit), 1997

Erben, Dietrich, *Der steinerne Gast. Die Begegnung mit Statuen als Vorgeschichte der Betrachtung*, Weimar 2005

Eriksen, Jens-Martin and Frederik Stjernfelt, *Adskillelsens Politik. Multikulturalisme – ideologi og virkelighed*, Copenhagen 2008

Errico, Francesco d' et al., "Archaeological Evidence for the Emergence of Language, Symbolism, and Music – An Alternative Multidisciplinary Perspective", *Journal of World Prehistory*, XVII / 1 (2003), pp. 1–70

— "Nassarius krassianus shell beads from Blombos Cave: evidence for symbolic behaviour in the Middle Stone Age", *Journal of Humanm Sciences*, XLVIII (2005), pp. 3–24

Ettingshausen, Constantim von, "Über die Nervation der Blätter bei den Celastrinneen", in: *Denkschriften der Kaiserlichen Akademie der Wissenschaften. Mathematisch-Naturwissenschaftliche Classe*, Vol. XIII, Vienna 1857, pp. 43–83

Ettlinger, Leopold D., *The Sistine Chapel before Michelangelo*, Oxford 1965

Evolutionary Aesthetics, ed. Eckart Voland and Karl Grammer, Berlin and Hamburg 2003

Ex marmore. Pasquini, pasquinisti, pasquinate nell'Europa moderna. Atti del colloquio internazionale Lecce-Otranto, 17.–19. novembre 2005, ed. Chrysa Damianaki, Paolo Procaccioli and Angelo Romano, Rome 2006

Facchini, Fiorenzo, *Die Ursprünge der Menschheit*, Stuttgart 2006

Farago, Claire J. , *Leonardo da Vinci's Paragone. A Critical Interpretation with a New Edition of the Text in the Codex Urbinas*. Leiden et al., 1992

Fehrenbach, Frank, *Die Goldene Madonna im Essener Münster*, Ostfildern (Ruit), 1996

— *Licht und Wasser. Zur Dynamik naturphilosophischer Leitbilder in Werk Leonardo da Vincis*, Tübingen 1997

— "Blick der Engel und lebendige Kraft. Bildzeit, Sprachzeit und Naturzeit bei Leonardo", in: *Leonardo da Vinci. Natur im Übergang. Beiträge zu Wissenschaft, Kunst und Technik*, ed. Frank Fehrenbach, Munich 2002, pp. 169–206

— "Calor nativus – Color vitale. Prolegomena zu einer Ästhetik der "Lebendigen Bildes" in der frühen Neuzeit", in: *Visuelle Topoi. Erfindung und tradiertes Wissen in den Künsten der italienischen Renaissance*, ed. Ulrich Pfisterer and Max Seidel, Berlin and Munich 2003, pp. 151–70

— "Compositio corporum. Renaissance der Bio Art", in: *Vorträge aus dem Warburg Haus*, Vol. IX, Berlin 2005, pp. 131–76

— "Kohäsion und Transgression. Zur Dialektik lebendiger Bilder", in: *Animationen / Trangressionen. Das Kunstwerk als Lebewesen*, ed. Ulrich Pfisterer and Anja Zimmermann, Berlin 2005, pp. 1–40

— "Leonardo's Point", in: *Vision and Its Instruments. Art, Science, and Technology in Early Modern Europe*, ed. Alina Payne, University Park, Pa. 2015

Felfe, Robert, "Gold, Gips und Linienzug", in: *Der Code der Leidenschaften*, ed. Hartmut Böhme and Johannes Endres, Munich 2010, pp. 197–229

— "Zeitformen der Fotografie, oder: Kann man in Bildern handeln?", in: *Bild und Zeit: Temporalität in Kunst und Kunsttheorie seit 1800*, ed. Thomas Kisser, Munich 2011, pp. 385–402

Ferrari, Michele C., "Gold und Asche. Reliquie und Reiquiare als Medien in Thiofrid von Echternachs *Flores epytaphii sanctorum*", in: *Reliquiare im Mittelalter*, ed. Bruno Reudenbach and Gia Toussaint (= *Forschungen zur Kunstgeschichte*, V), Berlin 2005, pp. 61–74

Ferraris, Maurizio, *Documentalità. Perché e necessario lasciar tracce*, Rome and Bari 2009

Fingerhut, Jörg, "Das Bild. Dein Freund. Der fühlende und der sehende Körper in der enaktiven Bildwahrnehmung", in: *Et in imagine ego, Facetten von Bilakt und Verkörperung. Festgabe für Horst Bredekamp*, ed. Ulrike Feist and Markus Rath, Berlin 2012, pp. 177–98

— "Extended Imagery, Extended Access, or Something Else?", in: *Bildakt at the Warburg Institute*, ed. Sabine Marienberg and Jürgen Trabant, Berlin and Boston 2014, pp. 33–50

Fischer-Lichte, Erika, *Ästhetik des Perfomativen*, Frankfurt am Main 2004

Fisher, Ronald A., *The Genetical Theory of Natural Selection: A Complete Variorum Edition*, ed. J. Henry Bennett, New York 1999 [1930]

Flood, Finbarr Barry, "Between Cult and Culture: Bamiyan, Islamic Iconoclasm, and the Museum", *The Art Bulletin*, LXXXIV / 4 (December 2002), pp. 641–59

— "Image against Nature: Spolia as Apotropaia in Byzantium and the dār al-Islām", *Medieval History Journal*, IX (2006), pp. 143–66

Flores, Carol A. Hrvol, *Owen Jones. Design, Ornament, Architecture, and Theory in an Age of Transition*, New York 2006

Floss, Harald, "Kunst schafft Identität. Das Aurignacien und die Zeit der ersten Kunst", in: *Eiszeit. Kunst und Kultur*, exh. cat., Ostfildern (Ruit) 2009, pp. 248–57

Flür, Wolfgang, *Ich war ein ROBOTER. Electric Drummer bei Kraftwerk*, Cologne 2004

Folie, Sabine and Michael Glasmeier, "Atmende Bilder. Tableau vivant und Attitüde zwischen 'Wirklichkeit und Imagination'", in: *Tableaux Vivants. Lebende Bilder und Attitüden in Fotograpfie, Film und Video*, exh. cat., ed. Sabine Folie and Michael Glasmeier, Vienna 2002, pp. 9–52

Foster, Hal, *Compulsive Beauty*, Cambridge, Mass. and London 1993

Fox Keller, Evelyn, *The Century of the Gene*, Cambrdge., Mass. 2000

— *Self-Organization, Self-Assembly, and the Inherent Activity of Matter*, Uppsala 2010

Frank Gehry, Architect, exh. cat., ed. J. Fiona Ragheb., New York 2001

Frank Gehry at Gemini, Los Angeles 2001

Frank O. Gehry. Pariser Platz 3, ed. Luminita Sabau, Lamspringe 2001

Franke, Birgit, "Automaten im höfischen Lustgärten der frühen Neuzeit", in: *Automaten in Kunst und Literatur des Mittelalters und der frühen Neuzeit*, ed. Klaus Grubmüller and Markus Stock, Wiesbaden 2003, pp. 247–67

Franz, Michael, *Von Gorgias bis Lukrez. Antike Ästhehtik und Poetik als vergleichende Zeichentheorie*, Berlin 1999

Freedberg, David, *The Power of Images. Studies in the History and Theory of Response*, Chicago and London 1989

— and Vittorio Gallese, "Motion, Emotion and Empathyin Esthetic Experience", *TRENDS in Cognitive Sciences*, XI / 5 (2007), pp. 197–203

Freud, Sigmund, *Studienausgabe*, Vol. X: *Bildende Kunst und Literatur*, ed. Alexander Mitscherlich, Angela Richards and James Strachey, Frankfurt am Main 1969

Frey, Dagobert, "Der Realitätscharakter des Kunstwerkes", in: *Festschrift Heinrich Wölfflin zum siebzigsten Geburtstag*, Dresden 1935, pp. 30–67

— "Dämonie des Blickes", in: *Akademie der Wissenschaften und der Literatur in Mainz, Abhandlungen der Geistes- und Sozialwissenschaftlichen Klasse, Jg. 1953, no. 6*, Wiesbaden 1953, pp. 243–98

Freyberg, Sascha and Katharina Blühm, "Bildakt Demystified. Remarks on Philiosophical Iconology and Empirical Aesthetics ", *Bildakt at the Warburg Institute*, ed. Sabine Marienberg and Jürgen Trabant, Berlin and Boston 2014, pp. 51–67

Fricke, Beate, *Ecce Fides. Die Statue von Conques, Götzendienst und Bildkultur im Westen*, Munich 2007

Fried, Michael, "Introduction", in: *Three American Painters: Kenneth Noland, Julius Olitski, Frank Stella*, exh. cat., Cambridge, Mass. 1965

— "Art and Objecthood", *Artforum*, V (1967), pp. 12–23

— *Absorption and Theatricality. Painting and Beholder in the Age of Diderot*, Chicago 1980

— "Barthes' Punctum", *Critical Inquiry*, XXIII / 3 (2005), pp. 539–74

Friess, Peter, "Restaurierung einer Automatenfigur", *Alte Uhren und moderne Zeitmessung*, IV (1988), pp. 40–50

— and Reinhard Steiner, "Frömmigkeits-Maschinen in der Frühen Neuzeit", in: *Automaten und Kunst und Literatur des Mittelaters und der frühen Neuzeit*, ed. Klaus Grubmüller und Markus Stock, Wiesbaden 2003, pp. 223–45

Fritz Langs Metropolis, ed. Deutsche Kinemathek-Museum für Film und Fernsehen, Munich 2010

Frommel, Christoph Luitpold, "Caravaggio und seine Modelle", *Castrum Peregrini*, XCVI (1971), pp. 21–56

— and Gerhard Wolf, "Introduzione", in: *L'Immagine di Christo dall'Archeropita alla Mano d'Artista. Dai tardo medioevo alll'età barocca*, ed. Christoph Luitpold Frommel and Gerhard Wolf, Rome (Vatican City) 2006, pp. 7–15

Frosini, Fabio, "Leonardo da Vinci e il "Nulla": Stratificazioni semantiche e complessità concettuale", in: *Il volgare come lingua di cultura dal Trecento al Cinquecento. Atti del convengo internazionale, Mantova, 18.–20. ottobre 2001*, ed. Arturo Calzone et al., Florence 2003, pp. 209–32

Fuhrmann, Manfred, *Geschichte der römischen Literatur*, Stuttgart 1999

Fürst, Michael, "Emersive Bilder: Zum Zuschauer-Bild-Verhältnis in David Cronenbergs *Videodrome*", in: *Masslose Bilder. Visuelle Ästhetik der Transgression*, ed. Ingeborg Reichle and Steffen Siegel, Munich 2009, pp. 127–42

Futurismo e Futurismi, exh. cat., ed. Pontus Hultén, Milan 1986

Gabriel, Markus, "Auftakt eines Neuen Realismus", in: Paul A. Boghossian, *Angst vor der Wahrheit. Ein Plädoyer gegen Relativismus und Konstruktivismus*, trans. Jens Rometsch, Berlin 2013, pp. 144–56 [see also: Boghosian, Paul A.]

Gadamer, Hans-Georg, *Wahrheit und Methode. Grundzüge einer philosophischen Hermeneutik*, Tübingen 1960
— "Zur Einführung", in: Martin Heidegger, *Der Ursprung des Kunstwerkes*, Stuttgart 1960, pp. 102–25
Gallagher, Shaun, *How the Body Shapes the Mind*, Oxford 2005
Gamboni, Dario, *The Destruction of Art: Iconoclasm and Vandalism since the French Revolution*, London 1997
— "Composing the Body Politic. Composite Images and Political Representation, 1651–2004", in: *Making Things Public. Atmospheres of Democracy*, exh. cat., ed. Bruno Latour and Peter Weibel, Karlsruhe and Cambridge 2005, pp. 162–95
Gedrim, Ronald J., "Edward Steichen's 1936 Exhibition of Delphinium Blooms", *History of Photography*, XVII / 4 (1993), pp. 352–63
Geimer, Peter, "'Nicht von Menschenhand'. Zur fotografischen Entbergung des Grabtuchs von Turin", in: *Homo pictor*, ed. Gottfried Boehm, Munich and Leipzig 2001, pp. 156–72
— "Photographie und was sie nicht gewesen ist. Photogenic Drawings 1834–1844", in: *Wahrnehmung der Natur. Natur der Wahrnehmung. Studien zur Geschichte visueller Kultur um 1800*, ed. Gabriele Dürbeck et al., Dresden 2001, pp. 135–49
— "'Wir müssen die Bilder zeigen'. Ikonographie des Äussersten", in: *Folter. Politik und Technik des Schmerzes*, ed. Thomas Macho, Burkard Wolf, and Katrin Harrasser, Munich 2007, pp. 119–32
— *Theorie der Fotografie*, Hamburg 2009
— *Bilder aus Versehen. Eine Geschichte der fotografischen Erscheinungen*, Hamburg 2010
Geissmar, Christoph, *"Das Symbol 'Auge Gottes'"*, unpublished manuscript, 1990
Gell, Alfred, *Art and Agency. An Anthropological Theory*, Oxford 1998
Gerhardt, Volker, *Individualität. Das Element der Welt*, Munich 2000
Gerke, Friedrich, *Der Tischaltar des Bernard Gilduin in Saint Sernin in Toulouse. Über das Verhältnis der südfranzösischen Frühromanik zur altchristlichen Plastik*, Wiesbaden 1958
Gerlach, Joseph, *Die Photographie als Hülfsmittel mikroskopischer Forschung*, Leipzig 1863
Gernsheim, Helmut, "The 150th Anniversary of Photography", *History of Photography*, I /1 (1977), pp. 2–8
Die Geschichte der antiken Bildhauerkunst, ed. Peter C. Bol, Vol. I: *Frühgriechische Plastik*, Text and Plates, Mainz 2002; Vol. II: *Klassische Plastik*, Text and Plates, Mainz 2004; Vol III: *Hellenistische Plastik*, Mainz 2007
Die Geschöpfe des Prometheus – Der künstliche Mensch von der Antike bis zur Gegenwart, exh. cat., ed. Rudolf Drux, Bielefeld 1994
Gethmann, Daniel, "Das Prinzip Polaroid", in: *Polaroid als Geste – über die Gebrauchsweissen einer fotografischen Praxis*, ed. Meike Kröncke, Barbara Lauterbach, Rolf F. Nohr, Ostfildern (Ruit) 2005, pp. 44–65
Geus, Armin, "Natur im Druck – Geschichte und Technik des Naturselbstdrucks", in: *Natur im Druck. Eine Ausstellung zur Geschichte und Technik des Naturselbstdrucks*, exh. cat., Marburg 1995, pp. 9–27
Gibson, Daniel G. et al., "Creation of a Bacterial Cell Controlled by a Chemically Synthesized Genome", in: *Science*, 2 (2010), www.science-mag.org (accessed 20.05.2010), pp. 1–10
Gibson, James, *The Ecological Approach to Visual Perception*, Boston 1979

Gilbert, Creighton, "A preface to signatures (with some cases in Venice)", in: *Fashioning Identities in Renaissance Art* , ed. Mary Rogers, Cambridge 2000, p. 79–89

Ginzburg, Carlo, "Spie. Radici di un paradigma indizario", in: *Corsi della ragione. Nuovi modelli nel rapporto tra sapere e attività umana*, ed. Aldo Gargani, Turin 1979, pp. 57–108

— *Occhiacci di legno: Note riflessioni sulla distanza*, Milan 1998

— "Welt der Leviathane. Furcht, Verheerung, Schrecken – Thomas Hobbes' Politische Theologie", *Lettre International*, LXXXV (Winter 2008), pp. 23–27

Giovio, Paolo, *Delle Istorie*, 2 vols., Venice 1564

Girardin, Daniel and Christian Pirker, *Controverses. Une histoire Juridique et Éthique de la Photographie*, Lausanne 2008

Giuliani, Luca, *Bild und Mythos. Geschichte der Bilderzählung in der griechischen Kunst*, Munich 2003

Glaube Hoffnung Liebe Tod, exh. cat., ed. Christoph Geissmar-Brandi and Eleonora Louis, Vienna 1995

Gludovatz, Karin, "Von Ehemann vollendet: Die Bildwerdung der Margareta van Eyck", in: *(En) gendered. Frühneuzeitlicher Kunstdiskurs und weiblicher Portaitkultur nördlich der Alpen*, ed. Simone Roggendorf and Sigrid Ruby, Marburg 2004, pp. 18–37

— "Der Name am Rahmen, der Maler im Bild, Künstlerselbstverständnis und Produktionskommentar in den Signaturen Jan van Eycks", in: *Wiener Jahrbuch für Kunstgeschichte*, LIV (2005), pp. 115–75

Gödde, Susanne, "Schêmata – Körperbilder in der griechischen Tragödie", in: *Konstruktionen von Wirklichkeit*, ed. Ralf von den Hoff and Stefan Schmidt, Stuttgart 2001, pp. 241–59

Goethe, Johann Wolfgang von, *Die Italienische Reise*, Sämtliche Werke nach Epochen seines Schaffens. Münchner Ausgabe, Vol. XV, ed. Andreas Beyer and Norbert Miller, Munich and Vienna 1992

Gombrich, E. H., *The Story of Art*, London 1950

— *Art and Illusion*, London 1960

— *Norm and Form: Studies in the Art of the Renaissance*, London 1966

— *Aby Warburg. An Intellectual Biography*, London 1970

Gordon, Donald James, "Giannotti, Michelangelo and the Cult of Brutus", in: Donald James Gordon, *The Renaissance Imagination*, ed. Stephen Orgel, Berkeley, Los Angeles, London, 1975, pp. 233–45

Göttel, Dennis and Katja Müller-Helle, "Barthes' Gespenster", *Fotogeschichte*, XXIX / 114 (Autumn 2009), pp. 53–58

Gould, James L. and Carol Grant Gould, *Sexual Selection in Animals*, New York 1989

Grabar, André, *L'Iconoclasme byzantin*, Paris 1957

Gramaccini, Norberto, *Mirabilia. Das Nachleben antiker Statuen vor der Renaissance*, Mainz 1996

Grau, Oliver, *Virtuelle Kunst in Geschichte und Gegnwart*, Berlin 2001

Gravel, Pierre Bettez, *The Malevolent Eye. An Essay on the Evil Eye, Fertility and the Concept of Mana*, New York et al. 1995

Greenblatt, Stephen, *The Swerve. How the World became Modern*, New York et al. 2011

Griffith, Simon C. and Sarah H. Pryke, "Benefits to Females of Assessing Color Displays", in: *Bird Coloration*, ed. Geoffrey E. Hill and Kevin J. MacGraw, Vol. II, Cambridge, Mass. and London 2006, pp. 233–79

Grimm, Herman, *Über Künstler und Kunstwerke*, Vol. I, Berlin 1865

Grimme, Ernst Günther, *Bronzebildwerke des Mittelalters*, Darmstadt 1985

Groebner, Valentin, *Ungestalten. Die visuelle Kultur der Gewalt im Mittelalter*, Munich 2003

— *Der Schein der Person. Ausweiss und Kontrolle im Mittelalter*, Munich 2004

Gropius, Walter, "Idee und Aufbau des Staatlichen Bauhauses", in: *Staatliches Bauhaus Weimar 1919–1923*, Weimar and Munich 1923, pp. 7–18

Gross, Kenneth, *The Dream of the Moving Statue*, Ithaca et al. 1992

Guillemin, Anna, "The 'Style of Linguistics': Aby Warburg, Karl Vossler, und Hermann Osthoff", *Journal of the History of Ideas*, LXIX / 4 (2008), pp, 605–26

Gumbrecht, Hans Ulrich, *Diesseits der Hermeneutik. Die Produktion von Präsenz*, Fankfurt am Main 2004

— "Partial Answers", *Journal of Literature and the History of Ideas*, VII / 1 (2009), pp. 87–96

Habel, Thilo, "Körpertäuschungen – über Versuche, Volumina durch Abdrücke zu visualisieren", in: *Bildwelten des Wissens. Kunsthistorisches Jahrbuch für Bildkritik*, VIII / 1 (2010), *Kontaktbilder*, ed. Vera Dünkel, pp. 18–25

Habermas, Jürgen, *Strukturwandel der Öffentlichkeit*, 4th edn., Neuwied and West Berlin 1969 [1962]

— "Die befreiende Kraft der symbolischen Formgebung. Ernst Cassirers humanistisches Erbe und die Bibliothek Warburg", in: *Vorträge aus dem Warburg-Haus*, Vol. I, Berlin 1997, pp. 1–29 (see also in: Jürgen Habermas, *Vom sinnlichen Eindruck zum symbolischen Ausdruck*, Frankfurt am Main 1997, pp. 9–40)

Hagner, Michael, "Vom Augenleuchten, Druckbildern und anderen Dingen des Sehens", in: *Philosophischer Taschenkalender*, II (1992/93), pp. 172–85

Hahn, Cynthia, "'Visio Dei': Changes in Medieval Visuality", in: *Visuality before and beyond the Renaissance. Seeing as Others Saw*, ed. Robert S. Nelson, Cambridge 2000, pp. 169–96

Hall, James, *The Sinister Side. How left-right Symbolism shaped Western* Art. New York 2008

Hammerstein, Reinhold, *Macht und Klang. Tönende Automaten als Realität und Fiktion in der alten und mittelalterlichen Welt*, Bern 1986

Handbuch zur politischen Ikonographie, ed. Uwe Fleckner et al., 2 vols., Munich 2011

Hans Bellmer. Anatomie du désir, exh. cat., ed. Agnès de la Beaumelle, Paris 2006

Hans Bellmer. Louise Bourgeois, exh. cat., ed. Udo Kittelmann and Kyllikki Zacharias, Berlin 2010

Hansen, Petrus Allanus [Peter Allen], *Carmina Epigraphica Graeca*, Berlin and New York 1989

Hantelmann, Dorothee von, *How to Do Things with Art*, Zürich and Berlin 2007

Harlan, Volker, *Was ist Kunst? Werkstattgespräche zu Beuys*, Stuttgart 1988

Der Hase wird 500: 1502–2002. Beiträge zu Albrecht Dürer und seinem Hasen, ed. Liane Zettl, Nuremberg 2002

Haskell, Francis and Nicholas Penny, *Taste and the Antique. The Lure of Classical Sculpture 1500–1600*, New Haven and London 1982

Hauschild, Thomas, *Der böse Blick*, West Berlin 1982

Hauser, Andreas, "Andrea Mantegnas 'Wolkenreiter'. Manifestationen von kunstloser Natur oder Ursprung von vexierbildhafter Kunst?", in: *Die Unvermeidlichkeit der Bilder*, ed. Stefan Rieder and Felix Thürlemann, Tübingen 2001, pp. 147–72

Häusle, Helmut, "ΖΩΟΠΟΙΕΙΝ – ΥΦΙΣΤΑΝΑΙ. Eine Studie der frühgriechischen inschriftlichen Ich-Rede der Gegenstände", in: *Serta Philologica Aenipotana*, Vol. III, ed. Robert Muth and Gerhard Pfohl, Innsbruck 1979, pp. 23–139

Haustein, Lydia, *Global Icons. Globale Bildinszenierung und kulturelle Identität*, Göttingen 2008

Hearn, Millard F., *Romanesque Sculpture. The Revival of Monumental Stone Sculpture in the Eleventh and Twelfth Centuries*, Oxford 1981

Heckmann, Herbert, *Die andere Schöpfung. Geschichte der frühen Automaten in Wirklichkeit und Dichtung*, Frankfurt am Main 1982

Heckwolf, Peter, "Naturbücher", in: *Natur im Kasten. Lichtbild. Schattenriss, Umzeichnung und Naturselbstdruck um 1800*, exh. cat., ed. Olaf Breidbach et al., Jena 2010, pp. 98–119

Hedinger, Bärbel, "Trompe l'oeil. Eine moderne Gattung seit der Antike", in: *Täuschend echt. Illusion und Wirklichkeit in der Kunst*, exh.cat., ed. Bärbel Hedinger, Munich 2010, pp. 10–15

Hegarthy, Melinda, "Laurentian Patronage in the Palazzo Vecchio: The Frescoes of the Sala dei Gigli", *The Art Bulletin*, LXXVIII / 2 (1996), pp. 264–85

Hegel, Georg Wlhelm Friedrich, *Vorlesungen über die Aesthetilk*, ed. H. G. Hotho, Vol. II, Berlin 1837

— *Aesthetics. Lectures on Fine Art by G.W.F. Hegel*, trans. T. M. Knox, 2 vols. Oxford 1975

Heidegger, Martin, "Der Ursprung des Kunstwerkes", in: Martin Heidegger, *Holzwege*, Frankfurt am Main 1950, pp. 7–68

— *Übungen für Anfänger. Schillers Briefe über die ästhetische Erziehung des Menschen. Wintersemester 1936/37. Seminar-Mitschrift von Wilhelm Hallwachs*, ed. Ulrich von Bülow, Marbach am Neckar 2005

Heikamp, Detlef "La grotta grande del Giardino di Boboli", *Antichità Viva*, IV / 4 (1965), pp. 27–43

Heilmann, Peter, *Die Natur als Drucker. Naturselbstdrucke der k.u.k. Hof- und Staatsdruckerei*, Vienna and Dortmund 1982

Heindl, Robert, *System und Praxis der Daktyloskopie und der sonstigen technischen Methoden der Kriminalpolizei*, Berlin and Leipzig 1922

Helas, Philine, "Fortuna-Occasio. Eine Bildprägung des Quattrocento zwischen ephemerer und ewiger Kunst", in: *Städel-Jahrbuch*, XVII (1999), pp. 112–51

— *Lebende Bilder in der italienischen Festkultur des 15. Jahrhunderts*, Berlin 1999

Henkelmann, Vera, "Der Siebenarmige Leuchter des Essener Münsters und die Memoria der Äbtissin Mathilde. 'Äbtissin Mathilde befahl mich anzufertigen und weihte mich Christus'", in: *... wie das Gold den Augen leuchtet. Schätze aus dem Essener Frauenstift (Essener Forschungen zum Frauenstift)*, Vol. V, ed. Brigitta Falk, Thomas Schilp and Michael Schlagheck, Essen 2007, pp. 151–67

Hensel, Thomas, "Aby Warburgs Bilderatlas 'Mnemosyne'. Ein Bildervehikel zwischen Holztafel und Zelluloidstreifen", in: *Der Bilderatlas im Wechsel der Künste und Medien*, ed. Sabine Flach et al., Munich 2005, pp. 221–49

— "*Lusus naturae et picturae. Von der Geburt der Kunst aus Kaffeesatz, Gespieenem und Tintensäuen*", *Barockberichte*, XL / XLI (2005), pp. 669–74

— "Kupferschlangen, unendliche Wellen und telegraphische Bilder. Aby Warburg und das technische Bild", in: *Schlangenritual. Der Transfer der Wissensformen vom Tsu'ti'kive der Hopi bis zu Aby Warburgs Kreuzlinger Vortrag*, ed. Cora Bender, Thomas Hensel and Erhard Schüttpelz, Berlin 2007, pp. 297–360

Herding, Klaus, "Robespierre und die Magie der Zeichen. Zum Augensymbol unter der Revolution", in: *Bildfälle. Adolf Max Vogt zum 70. Geburtstag*, ed. Beat Wyss, Zürich and Munich 1990

Hermann Finsterlin. Eine Annäherung, exh. cat., ed. Reinhard Döhl, Stuttgart 1988

Hermès Trismégiste. Corpus Hermeticum, ed. Arthur Darby Nock, French trans. André-Jean Festugière, 4 vols., Paris 1980 [1946–54]

Hesberg, Henner von, "Mechanische Kunstwerke und ihre Bedeutung für die höfische Kunst des frühen Hellenismus", in: *Marburger Winckelmann-Programm*, Marburg 1987, pp. 47–72

— "Temporäre Bilder oder die Grenzen der Kunst", in: *Jahrbuch des Deutschen Archäologischen Instituts*, Vol. CIV (1989), pp. 61–82

Hickey, Dave, *VB 08–36. Vanessa Beecrofts Performances. Vanessa Beecroft Painted Ladies*, Ostfildern (Ruit) 2003

Hill, Geoffrey E., "Female Mate Choice for Ornamental Coloration", in: *Bird Coloration*, ed. Geoffrey E. Hill and Kevin J. MacGraw, Vol. II, Cambridge, Mass. and London 2006, p. 137–200

Hinz, Berthold, *Aphrodite: Geschichte einer abendländischen Passion*, Munich and Vienna 1998

Historisches Wörterbuch der Philosophie, ed. Joachim Ritter and Karlfried Gründer, Vol. VI, Darmstadt 1984

Hobbes, Thomas, *The English Works of Thomas Hobbes of Malmesbury*, ed. William Molesworth, 11 vols., London 1839–45

— *Leviathan*, ed. Richard Tuck, Cambridge 1991 [1651]

— *The Correspondence*, ed. Noel Malcolm, 2 vols., Oxford 1994

Hoffmann, Detlef, Eduard and Charlotte, "Studium und Punctum", *Fotogeschichte*, XXIX / 114 (2009), pp. 5–11

Hoffmann-Curtius, Kathrin, "Trophäen in Brieftaschen – Fotos von Wehrmachts-, SS- und Polizeiverbrechen", in: *kunsttexte.de*, 2002, no. 3

Hofmann, Werner, Georg Syamken und Martin Warnke, *Die Menschenrechte des Auges. Über Aby Warburg*, Frankfurt am Main 1980

Hogarth and his Times, exh. cat., ed. David Bindman, London 1997

Hogrebe, Wolfram, "Mantik und Hermeneutik. Eine Skizze", in: *Zeichen und Interpretation*, ed. Josef Simon, Frankfurt am Main 1994, pp. 142–57

— *Echo des Nichtwissens*, Berlin 2006

— *Die Wirklichkeit des Denkens. Vorträge der Gadamer-Professur*, ed. Jens Halfwassen and Markus Gabriel, Heidelberg 2007

— *Riskante Lebensnähe. Die szenische Existenz des Menschen*, Berlin 2009

— *Beuysianismus. Expressive Strukturen der Moderne*, Basel 2010

Holmes, Oliver Wendell, "The Stereoscope and the Stereograph", *The Atlantic Monthly*, III / 3 (1859), pp. 738–48

Holmström, Kirsten Gram, *Monodrama Attitudes Tableaux Vivants. Studies on some trends of theatrical fashion 1770–1815*, Stockholm 1967

Holzer, Anton, "Die Kamera und die Henker. Tod, Blick und Fotografie", *Fotogeschichte*, XX / 78 (2000), pp. 43–62

Honneth, Axel, *Pathologien der Vernunft. Geschichte mit Gegenwart der kritischen Theorie*, Frankfurt am Main 2007

Hoppe, David Heinrich, *Botanisches Taschenbuch für die Anfänger dieser Wissenschaft und der Apothekerkunst auf des Jahr 1790*, Regensburg 1790

Horstmann, Friederike, "La Ricotta von Pier Paolo Pasolini. Untersuchungen zum Wechselverhältnis von Film und Malerei", MA dissertation, Humboldt-Universität Berlin 2007

Hotho, Gustav, *Geschichte der deutschen und niederländischen Malerei. Eine öffentliche Vorlesung an der Friedrich-Wilhelms-Universität zu Berlin*, Vol, II, Berlin 1843

Huber, Gabriele, "Warburgs 'Ninfa', Freuds 'Gradiva' und ihre Metamorphose bei Masson", in: *Denkräume zwischen Kunst und Wissenschaft, 5. Kunsthistorikerinnentagung in Hamburg*, ed. Silvia Baumgart et al., Berlin 1993, pp. 443–60

Hubert, Hans W., "'Fantasticare col disegno'", in: *Sankt Peter in Rom 1506–2006. Beiträge der internationalen Tagung vom 23.–25. Februar 2006 in Bonn*, ed. Georg Satzinger and Sebastian Schütze, Munich 2008, pp. 111–25

Humboldt, Alexander von, *Personal Narrative of Travels to the Equinoctial Regions of the New Continent during the Years 1799–1804*, Vol. IV, London 1819.

— *Reise in die Äquinoktial-Gegenden des Neuen Kontinents*, ed. Ottmar Ette, 2 vols., Frankfurt am Main and Leipzig 1991

Huyssen, Andreas, "The Vamp and the Machine, Fritz Lang's 'Metropolis'", in: *Fritz Lang's Metropolis. Cinematic Visions of Technology and Fear*, ed. Michael Minden and Holger Bachmann, Rochester, NY 2000, pp. 196–225

Iconoclash. Beyond the Image Wars in Scence, Religion and Art, exh. cat., ed. Bruno Latour amd Peter Weibel, Karlsruhe 2002

Imboden, Gudrun and Thomas Kallein, *Ad Reinhardt*, Stuttgart 1985

Imhof, Michael and Léon Krempel, *Berlin. Neue Architektur. Führer zu den Bauten von 1989 bis 2002*, Petersberg 2002

Immerwahr, Henry R., *Altic Script. A Survey*, Oxford 1990

Ingold, Felix P., *Literatur und Aviatik. Europäische Flugdichtung 1909–1927*, Frankfurt am Main 1980

Inscriptiones Latinae Liberae Rei Publicae, ed. Atilius Degrassi, Florence 1965

Jackson, Michael, *Moonwalk*, London 1988

— *Dancing the Dream. Poems and Reflections*, New York 1992

Jacob, James and Timothy Raylor, "Opera and Obedience: Thomas Hobbes and 'A Proposition for Advancement of Moralitie' by Sir William Davenant", in: *The Seventeenth Century*, Vol. VI, 1991, pp. 205–50

Jacobs, Frederike H., *The Living Image in Renaissance Art*, Cambridge 2005

Jäger, Ludwig, "Sprache als Medium. Über die Sprache als audio-visuelles Diapositiv des Medialen", in: *Audiovisualität vor und nach Gutenberg. Zur Kulturgeschichte der medialen Umbrüche*, ed. Horst Wenzel et al., Vienna 2001, pp. 19–42

Jahn, Wolf, *Die Kunst von Gilbert & George oder eine Ästhetik der Existenz*, Munich 1989

Das Jahrhundert der Bilder, ed. Gerhard Paul: Vol. I: *1900 bis 1949*; Vol. II: *1949 bis heute*, Göttingen 2009

Jan van Eyck und seine Zeit. Flämischen Meister und der Süden 1430–1530, exh. cat., ed. Till-Holger Borchert, Stuttgart 2002

Janich, Peter, *Euklids Erbe. Ist der Raum dreidimensional?*, Munich 1989

Janson, Horst Woldemar, "The 'Image Made by Chance' in Renaissance Thought", in: *De Artibus Opuscula XL, Essays in Honor of Erwin Panofsky*, ed. Millard Meiss, Vol. I, New York, 1961, pp. 254–66

— "Chance Images", in: *Dictionary of the History of Ideas*, Vol. I, ed. Philip P. Wiener, New York 1973, pp. 340–53

Janzing, Godehard, "Bildstrategien asymmetrischer Gewaltkonflikte", *kritische berichte*, XXXIII / 1 (2005), pp. 21–35

Jarzombek, Mark, *On Leon Baptista Alberti. His Literary and Aesthetic Theories*, Cambridge, Mass. 1989

— "The Victim and the Hangman: The Tragedy of the Humanist Eye", *Architecture California*, XIV / 1 (1992), pp. 43–49

Jay, Martin, *Downcast Eyes. The Denigration of Vision in Twentieth-Century French Thought*, Berkeley, Los Angeles and London 1993

Jelenski, Constantin, *Die Zeichnungen von Hans Bellmer*, ed. Alex Grall, West Berlin 1966

Jelonnek, Dennis, "Sofortbild und Vera Icon", MA dissertation, Humboldt-Universität Berlin 2010

Jenkins, Ian and Kim Sloan, *Vases and Volcanoes: Sir William Hamilton and his Collection*, London 1996

Johnson, Mark, *The Meaning of the Body. Aesthetics of Human Understanding*, Chicago and London 2007

Jones, Owen, *The Grammar of Ornament*, London 1856

Jooss, Birgit, *Lebende Bilder. Körperliche Nachahmung von Kunstwerken in der Goethezeit*, Berlin 1999

Jung, Matthias, *Der bewusste Ausdruck. Anthropologie der Artikulation*, Berlin and New York 2011

Junker, Thomas and Sabine Paul, *Der Darwin Code. Die Evolution erklärt unser Leben*, Munich 2009

Jurkowlaniec, Grazyna, "The Slacker Crucifix in St. Mary's Church in Cracow. in: *Wokół Wita Stwosza. Materiały z międzynarodowej konferencji naukowej w Muzeum Narodowym w Krakowie, 19.–20. maja 2005*, ed. Dobosława Horzela and Adam Organisty, Kraków 2006

Kablitz, Andreas, "Representation and Participation. Some Remarks on Medieval French Drama", in: *Rethinking the Medieval Senses. Heritage, Fascinations, Frames*, ed. Stephen G. Nichols et al., Baltimore 2008, pp. 194–205

Kaiser Friedrich II. (1194–1250). Welt und Kultur des Mittelmeerraums, ed. Mamoun Fansa and Karen Ermete, Mainz 2008

Kamel, Pepe, "Der Ringkampf. Pollock und Picasso", in: *Action Painting. Jackson* Pollock, exh. cat, Fondation Beyeler, Basel, 2008, pp. 22–36

Kant, Immanuel, *Kritik der Urteilskraft und Schriften zur Naturphilosophie*, ed. Wilhelm Weischedel, Wiesbaden 1957 (*Werke*, Insel-Verlag, Vol. V)

— *Werke in 12 Bänden*, ed. Wilhelm Weischedel, Frankfurt am Main 1968

Kantorowicz, Ernst, *Kaiser Friedrich der Zweite*, Stuttgart 1987

— *Die Zwei Körper des Königs. Eine Studie zur politischen Theologie des Mittelalters*, Munich 1990 [1957]

Kanz, Roland, *Die religionsgeschichtliche Forschung an der kulturwissenschaftlichen Bibliothek Warburg*, Bamberg 1989

— *Die Kunst des Capriccio. Kreativer Eigensinn in Renaissance und Barock*, Munich and Berlin 2002

Kapustka, Mateusz, "Die verlorene *carnosità* oder Skulptur und Fossilien im Zeitalter des Paragone. Versuch einer vegleichenden Bildanalyse", in: *Material of Sculpture Between Technique and Semantics*, ed. Aleksandra Lipińska, Warsaw 2009, pp. 275–92

Karafyllis, Nicole C., "Das Wesen der Biofakte", in: *Biofakte. Versuch über den Menschen zwischen Artefakt und Lebewesen*, ed. Nicole C. Karafyllis, Paderborn 2003, pp. 11–26

— "Bewegtes Leben in der Frühen Neuzeit. Automaten und ihre Antriebe als Medien des Lebens zwischen den Technikauffassungen von Aristoteles und Descartes", in: *Technik in der Frühen Neuzeit – Schrittmacher der europäischen Modene*, ed. Gisela Engel and Nicole C. Karafyllis, Frankfurt am Main 2004, pp. 295–335

Karanastassis, Pavlina, "Hocharchaische Plastik", in: *Die Geschichte der antiken Bildhauerkunst*, ed. Peter C. Bol, Vl. I / 1: *Frühgriechische Plastik*, Text volume, Mainz 2002, pp. 171–211

Kaulbach, Friedrich, *Der philosophische Begriff der Bewegung. Studien zu Aristoteles, Leibniz und Kant*, Cologne and Graz 1965

Kemp, Wolfgang, "Walter Benjamin und die Kunstwissenschaft, I: Benjamins Beziehungen zur Wiener Schule", *kritische berichte*, I / 3 (1975), pp. 30–50

— *Theorie der Fotografie, I: 1839–1912*, Munich 1980

— *Rembrandt. Die Heilige Familie oder die Kunst, einen Vorhang zu lüften*, Frankfurt am Main 1986

Kendall, Calvin B., "The Gate of Heaven and the Fountain of Life. Speech-Act Theory and Portal Inscriptions", in: *Essays in Medieval Studies*, X (1993), pp. 111–28

Kern, Andrea, "Der Ursprung des Kunstwerkes: Kunst und Wahrheit zwischen Stiftung und Streit", in: *Heidegger-Handbuch. Leben – Werk – Wirkung*, ed. Dieter Thomä, Stuttgart and Weimar 2003, pp. 162–74

Kessler, Herbert L., "Configuring the Invisible by Copying the Holy Face" in: *The Holy Face and the Paradox of Representation*, ed. Herbert L. Kessler and Gerhard Wolf, Bologna 1998, pp. 129–51

Kessler, Herbert L., "Evil Eye(ing). Romanesque Art as a Shield of Faith", in: *Romanesque Art and Thought in the Twelfth Century. Essays in Honor of Walter Cahn*, ed. Colum Hourihane, Princeton, N. J., 2008, pp. 107–35

Keyssner, Hugo, *Das Recht am eigenen Bilde*, Berlin 1896

Kindermann, Heinz, *Theatergeschichte Europas*, Vol. II: *Das Theater der Renaissance*, Salzburg 1959

Kiosk. Eine Geschichte der Fotoreportage 1839–1973, ed. Bodo von Dewitz and Robert Lebeck, Göttingen 2001

Kittler, Friedrich, *Musik und Mathematik*, Vol. I: *Heller*; Part II: *Eros*, Munich 2009

Kjørup, Søren, "Georg Inness and the Battle at Hastings, or Doing Things with Pictures", *The Monist*, LVIII (1974), pp. 216–33

Kjørup, Søren, "Pictorial Speech Acts", in: *Erkenntnis*, XII (1978), pp. 55–71

Klee, Paul, *Pädagogisches Skizzenbuch (Bauhausbücher, Vol. II)*, Munich 1925

Klein, Yves, *Le depassement de la problematique de l'art et autres écrits*, ed. Marie-Anne Sichère and Didier Semin, Paris 2003

Klett, Alexander P., "Bildnisschutz heute aus anwaltlicher Sicht", in: *Bildregime des Rechts*, ed. Jean-Baptiste Joly et al., Stuttgart 2007, pp. 211–21

Klinger, Kerrin, "*Ectypa Plantarum* und Diletttantismus um 1800. Zur Naturtreue botanischer Pflanzenselbstdruck", in: *Natur im Kasten. Lichtbild, Schattenriss Umzeichnung und Naturselbstdruck um 1800*, ed. Olaf Breidbach, Kerrin Klinger and André Karliczek, Jena 2010, pp. 80–96

Klonk, Charlotte, *Spaces of Experience: Art Gallery Interiors from 1800 to 2000*, New Haven and London 2009

Klotz, Heinrich, *Die Entdeckung von Çatal Höyük. Der archäologische Jahrhundertfund*, Munich 1997

Kniphof, Johann Hieronymus, *Botanica in Originali [...]*, Erfurt 1733

Koch, Gertrud, "Latenz und Bewegung im Feld der Kultur. Rahmungen einer performativen Theorie des Films", in: *Performativität und Medialität*, ed. Sybille Krämer, Munich 2004, pp. 163–87

Koch, Robert, "Zur Untersuchung von pathogenen Organismen", in *Mitteilungen des kaiserlichen Gesundheitsamts*, Vol. I (1881), pp. 1–48

Kohl, Jeanette, "Gesichter machen. Büste und Maske in Florentiner Quattrocento", in: *Marburger Jahrbuch für Kunstwissenschaft*, XXXIV (2007), pp. 7–99

Kohl, Karl-Heinz, *Die Macht der Dinge. Geschichte und Theorie sakraler Objekte*, Munich 2003

Köhler, Jens, *Pompei. Untersuchungen zur hellenistischen Festkultur*, Frankfurt am Main et al. 1996

Köhnen, Ralph, *Das optische Wissen. Mediologische Studien zu einer Geschichte des Sehens*, Munich 2009

Kolnai, Aurel, *Ekel Hochmut Hass. Zur Phänomenologie feindlicher Gefühle*, Frankfurt am Main 2007 [1929]

König, Helmut, *Politik und Gedächtnis*, Göttingen 2008

König Lustik!? Jérôme Bonaparte und der Modellstaat Königreich Westphalen, exh. cat., ed. Michael Eissenhauer, Munich 2008

Konstantin der Grosse: Imperator Caesar Flavius Constantinus, exh. cat., ed. Alexander Demandt and Josef Engemann, Darmstadt 2007

Körner, Hans, *Botticelli*, Cologne 2006

Kornmeier, Uta, "Almost Alive. The Spectacle of Verisimilitude and Madame Tussaud's Waxworks", in: *Ephemeral Bodies. Wax Sculpture and the Human Figure*, ed. Roberta Panzanelli, Los Angeles 2008, pp. 67–81

Körte, Werner, "Albrecht Dürers *Der Hase* 1502", in: *Martin Heidegger, Übungen für Anfänger. Schillers Briefe über die ästhetische Erziehung des Menschen. Wintersemester 1936/37. Seminarmitschrift von Wilhelm Hallwachs*, ed. Ulrich von Bülow, Marbach am Neckar 2005, pp. 149–68

Koss, Juliet, "Bauhaus Theatre of Human Dolls", *The Art Bulletin*, LXXXV / 4 (2003), pp. 724–45

— "On the Limits of Empathy", *The Art* Bulletin, LXXXVIII / 1 (2006), pp. 139–57

— *Modernism after Wagner*, Minneapolis and London 2010

Kracauer, Siegfried, *Theory of Film: The Redemption of Physical Reality*, New York 1960

Krämer, Sybille, "Operationsraum Schrift. Über einem Perspektivwechsel in der Betrachtung der Schrift", in: *Schrift. Kulturtechnik zwischen Auge, Hand und Maschine*, ed. Gernot Grube, Werner Kogge and Sybille Krämer, Munich 2005, pp. 23–57

Krause, Katharina, *Hans Holbein der Ältere*, Munich and Berlin 2002

Krauss, Rosalind E., "Notes on the Index. Part I [1976]", in: Rosalind E. Krauss, *The Originality of the Avant-Garde and Other Modernist Myths*, Cambridge, Mass. and London 1985, pp. 196–209

Kress, Susanne. "'Laurentius Medices – Salus Publica'. Zum historischen Kontext eines Voto Lorenzo de' Medicis aus der Verrocchiowerkstatt", in: *Die Christus-Thomas-Gruppe von Andrea del Verrocchio. Akten des Symposiums des Liebieghauses*, ed. Herbert Beck et al., Frankfurt am Main 1996, pp. 175–95

Krieg der Bilder. Druckgraphik als Medium politischer Auseinandersetzung im Europa des Absolutismus, exh. cat., ed. Wolfgang Cillessen, Berlin 1997

Kris, Ernst and Otto Kurz, *Die Legende vom Künstler. Ein geschichtlicher Versuch*, Vienna 1934

Krois, John Michael, "Problematik, Eigenart und Aktualität der Cassirerschen Philosophie der symbolischen Formen", in: *Über Ernst Cassiers Philosophie der symbolischen Formen*, ed. Hans-Jürg Braun et al., Frankfurt am Main 1988, pp. 15–44

— "Kunst und Wissenschaft in Edgar Winds Philosophie der Verkörperung", in: *Edgar Wind. Kunsthistoriker und Philosoph*, ed. Horst Bredekamp et al., Berlin 1998, pp. 181–205

— "Universalität der Pathosformel. Der Leib als Symbolmedium", in: *Quel Corps? Eine Frage der Repräsentation*, ed. Hans Belting et al., Munich 2002, pp. 295–307

— "Ernst Cassirer's Philosophy of Biology", *Sign Systems Studies*, XXXII / 1 & 2 (2004), pp. 278–95

— "Für Bilder braucht man keine Augen. Zur Verkörperungstheorie des Ikonischen", in: *Kulturelle Existenz und symbolische Form. Philosophische Essays zu Kultur und Medien*, ed. John Michael Krois and Norbert Meuter, Berlin 2006, pp. 167–90

— "Philosophical Anthropology and the Embodied Cognition Paradigm. On the Convergence of Two Research Programs", in: *Embodiment in Cognition and Culture*, ed. John Michael Krois et al., Amsterdam and Philadelphia 2007, pp. 273–89

— "Beginnings of Depiction. Iconic Form and the Body Schema", in: *Individualität und Selbstbestimmung*, ed. Jan-Christoph Heiliger et al., Berlin 2009, pp. 361–77

— "Einleitung", in: *Edgar Wind, Heilige Furcht und andere Schriften zum Verhältnis von Kunst und Philosophie*, ed. John Michael Krois and Robert Ohrt, Hamburg and Leipzig 2009, pp. 9–40

— "Image Science and Embodiment or: Peirce as Image Scientist", in: *Kompetenzen der Bilder*, ed. Ulrich Ratsch et al., Tübingen 2009, pp. 201–15

— "Tastbilder. Zu Verkörperungstheorie ikonsicher Formen", in: *Intermedien: Zur kulturellen und artistischen Übertragung*, ed. Alexandra Kleihues, et al., Zürich 2010, pp. 219–35

— *Bildkörper und Körperschema*, ed. Horst Bredekamp and Marion Lauschke, Berlin 2011

— "Eine Tatsache und zehn Thesen zu Peirce' Bildern", in: *Das bildnerische Denken: Charles S. Peirce*, ed. Franz Engel et al., Berlin 2012, pp. 53–64

Kronauer, Brigitte, *Die Sprache von Kunst- und Sockenspitze*, Warmbronn 2008

Krüger, Klaus, "Jean-Luc Godards PASSION (Frankreich 1982): Kunst als Wirklichkeit postmoderner Imagination" in: *Kunst und Künstler im Film.*, ed. Helmut Korten and Johannes Zahlten, Harmeln 1990, pp. 81–92

— *Das Bild als Schleier des Unsichtbaren. Ästhetische Illusion in der Kunst der frühen Neuzeit in Italien*, Munich 2001

— "Das Sprechen und Schweigen der Bilder, Visualität und rhetorischer Diskurs", in: *Der stumme Diskurs der Bilder. Reflexionsformen des Ästhetischen in der Kunst der Frühen Neuzeit*, ed. Valeska von Rosen et al., Munich and Berlin 2003, pp. 17–52

Kruse, Christiane, "Vera Icon – oder die Leerstellen des Bildes", in: *Quel Corps? Eine Frage der Repräsentation*, ed. Hans Belting et al., Munich 2002, pp. 105–29

— *Wozu Menschen malen. Historische Begründung eines Bildmediums*, Munich 2003

— "Nach den Bildern. Das Phantom des transikonischen Bildes", in: *Bilderfragen. Die Bildwissenschaften im Aufbruch*, ed. Hand Belting, Munich 2007, pp. 165–80

Kubitza, Anette, *Fluxus, Flirt, Feminismus? Carolee Schneemanns Körperkunst and die Avantgarde*, Berlin 2002

Kuni, Verena, "Pygmalion, entkleidet von Galathea, selbst? Jungesellengeburten, mechanische Bräute und das Märchen vom Schöpfertum des Künstlers im Surrealismus", in: *Puppen Körper Automaten. Phantasmen der Moderne*, exh. cat., ed. Pia Müller-Tamm and Katherina Sykora, Düsseldorf 1999, pp. 176–99

Kunst. Die Geschichte ihrer Funktionen, ed. Werner Busch and Peter Schmook, Weinheim and West Berlin 1987

Künstliche Menschen: manische Maschinen, kontrollierte Körper, exh. cat., ed. Rolf Aurich, Wolfgang Jacobsen and Gabriele Jatho, Berlin 2000

Kuryluk, Ewa, *Veronica and Her Cloth: History, Symbolism and Structure of a "True" Image*, Cambridge, Mass. et al. 1991

Lacan, Jacques, *Le séminaire*, ed. Jacques-Alain Miller, Vol. XI: *Les quatres concepts fondamentaux de la psychanalyse 1964*, Paris 1973

Lachman, Charles, "'The Image made by Chance' in China and the West. Ink Wang Meets Jackson Pollock's Mother", *The Art Bulletin*, LXXIV / 3 (1992), pp. 499–510

Lack, H. Walter, *Ein Garten Eden. Meisterwerke der botanischen Illustration*, Cologne 2001

— "Photographie und Botanik. Die Anfänge", in: *Bildwelten des Wissens. Kunsthistorisches Jahrbuch für Bildkritik*, Vol. I / 2 (2003), pp. 86–94

— "Bilder aus Asphalt. Zur Rolle von Kontaktverfahren bei der Erfindung der Photographie", in: *Bildwelten des Wissens. Kunsthistorisches Jahrbuch für Bildkritik*, VIII / 1 (2010): *Kontaktbilder*, ed. Vera Dünkel, pp. 64–71

Lakoff, George and Mark Johnson, *Philosophy in the Flesh. The Embodied Mind and its Challenge to Western Thought*, New York 1999

Landucci, Luca, *Diario Fiorentino dal 1450 al 1516, continuato da un anonimo fino al 1542*, ed. Iodico del Badia, Florence 1883

Lange, Günter, "Der byzantinische Bilderstreit und das Bilderkonzil von Nikaia (787)", in: *Handbuch der Bildtheologie*, ed. Reinhard Hoeps, Vol. I, Paderborn 2007, pp. 171–90

Langner, Johannes, "Ledoux' Redaktion der eigenen Werke für die Veröffentlichung", *Zeitschrift für Kunstgeschichte*, XXIII (1960), pp. 136–66

Laqueur, Walter, *Terrorismus*, Kronberg im Taunus 1977

Latenz. 40 Annäherungen an einem Begriff, ed. Stefanie Diekmann and Thomas Khurana, Berlin 2007

Latour, Bruno, *Politiques de la nature: Comment faire entrer les sciences en démocratie*, Paris 1999

Laubichler, Manfred D., "Die Virtuosität der Natur im Spiegel der Naturwissenschaft", in: *Virtuosität. Liechtensteiner Exkurse VI*, ed. Norbert Hass et al., Eggingen 2007, pp. 153–75

Lauschke, Marion, *Ästhetik im Zeichen des Menschen. Die ästhetische Vorgeschichte der Symbolphilosophie Ernst Cassirers und die symbolische Form der Kunst*, Hamburg 2007

— "Bodily Resonance. Formative Processes in Aesthetic Experience and Developmental Psychology", in: *The Body in Relationship. Self, Other, Society*, ed. Courtney Young, Stow 2014, pp. 175–96

Lavin, Irving, "Bernini's Bust of the Medusa. An Awful Pun", in: *Docere, delectare, movere. Affetti, devozione e retorica nel linguaggio artistico del primo barocco romano*, ed. Sible de Blaauw et al., Rome 1999, pp. 155–74

— "Decantarse por el Barocco. Frank Gehry y los paños plegados postmodernos", *El Croquis*, CXVII (2003), pp. 40–47

— "Going for Baroque. Observations on the postmodern fold", in: *Estetica Barocca*, ed. Sebastian Schütze, Rome 2004, pp. 423–52

Ledoux, Claude-Nicolas, *L'architecture considerée sous le rapport de l'art, des moeurs et de la législation*, Paris 1997 [1804]

Leduc, Stéphane, *The Mechanisms of Life*, New York 1911

Lefebvre, Henri, *Critique de la vie quotidienne. II: Fondements d'une sociologie de la quotidienneté*, Paris 1961

Lehmann, Hannes, "Wolfgang Helbig (1839–1915). An seinem 150. Geburtstag", in: *Mitteilungen des Deutschen Archäologischen Instituts, Römische Abteilung*, Vol. XCVI (1989), pp. 7–86

Leibniz, Gottfried Wilhelm, *Essai de Théodicée sur la Bonté de Dieu, la Liberté de l'Homme et l'Origine du Mal*, 2nd edn, Amsterdam 1712

— *L'Analyse des Êtres Simples & Réels. Ou la Monadologie de feu Msr. Le Baron de Leibniz [...]*, ed. S.F. Weismüller, Nuremberg 1736

— *Nouveaux Essais sur l'Entendement Humain*, in: *Oeuvres philosophiques latines et françoises de feu Mr. Leibnitz*, ed. R. E. Raspe, Amsterdam and Leipzig 1765

— *Sämtliche Schriften und Briefe*, ed. Preussische / Deutsche Akademie der Wissenschaften zu Berlin, Berlin et al. 1923 et seq.

— *Meditationes de Cogitatione, Veritate et Ideis / Betrachtungen über die Erkenntnis, die Wahrheit und die Ideen*, in: *Gottfried Wilhelm Leibniz, Opuscules Mataphysices / Kleiner Schriften zur Metaphysik (Philosophische Schriften*, Vol. I, ed. Hans Holz, Darmstadt 1985, pp. 32–47

Leitner, Werner, "Bilder zu Beweiszwecken im Strafprozess", in: *Bildregime des Rechts*, ed. Jean-Baptiste Joly et al., Stuttgart 2007, pp. 171–79

Lenné, Aurelia, "Die naturgetreue Struktur der Pflanzen unmittelbar vor Augen führen", in: *Die Sache selbst*, exh. cat., ed. Silke Opitz and Gerhard Wiesenfeldt, Weimar 2002, pp. 110–20

Lentes, Thomas, "Nur der geöffnete Körper schafft Heil. Das Bild als Verdoppelung des Körpers", in: *Glaube Liebe Hoffnung Tod*, exh. cat., ed. Christoph Geissmar-Brandi and Eleonora Louis, Vienna 1995, pp. 152–55

— "Verum Corpus und Vera Imago. Kakulierte Bildbeziehungen in der Greorsmesse", in: *Das Bild der Erscheinung. Die Gregorsmesse im Mittelalter*, ed. Thomas Lentes and Andreas Gormans, Berlin 2007, pp. 13–35

Lentz, Matthias, *Konflikt, Ehre, Ordnung. Untersuchungen zu den Schmähbriefen und Schand-bildern des späten Mittelalters und der frühen Neuzeit (ca. 1350 bis 1600)*, Hanover 2004

Leonardo da Vinci, *I manoscritti e i disegni*, ed. Reale Commissione Vinciana, serie minore, Vols. I–V, Rome 1930–36

— *Traité de la peinture*, ed. André Chastel, Paris 1960

— *I manoscritti dell'Institut de France. Edizione nazionale dei manoscritti e dei disegni di Leonardo da Vinci*, ed. Augusto Marinoni, 12 vols., 1987–92, *Il manoscritto F*, ed. Augusto Marinoni, Florence 1988

— *I Codici Forster del Victoria and Albert Museum di Londra. Il Codice Forster* III (facsimile edn.), ed. Augusto Marinoni, Florence 1992

— *Libro di pittura*, ed. Carlo Pedretti, Florence 1995

— *Trattato della pittura*, ed. Ettore Camesasca, Milan 1995

Lepik, Andres, *Das Architekturmodell in Italien 1335–1550*, Worms 1994

Le Tensorer, Jean-Marie, "Ein Bild vor dem Bild? Die ältesten menschlichen Artefakte und die Frage des Bildes", in: *Homo pictor*, ed. Gottfried Boehm, Munich et al. 2001, pp. 57–75

Lethen, Helmut, "Die Sehnsucht nach dem indexikalischen Zeichen beschleunigt den Zerfall des Kunstwerks", in: *Totalität und Zerfall im Kunstwerk der Moderne*, ed. Reto Sorg and Stefan Bodo Würfel, Munich 2006, pp. 195–206

Lévi-Strauss, Claude, *Regarder écouter lire*, Paris 1993

Levine, George, "'And If It Be a Pretty Woman All the Better' – Darwin and Sexual Selection", in: *Literature, Sciences, Psychoanalysis, 1830–1970. Essays in Honour of Gillian* Beer, ed. Helen Small and Trudi Tate, Oxford 2003, pp. 37–51

Liess, Bernhard, *Zum Logos der Kunst Rogier van der Weydens. Die "Beweinigen Christi" in den Königlichen Museen in Brüssel und in der Nationalgalerie in London*, 2 vols., Münster, Hamburg and London 2000

Limon, John, "The Shame of Abu Ghraib", *Critical Inquiry*, XXXIII / 3 (2007), pp. 543–72

Lindberg, David C., *Theories of Vision from Al-Kindi to Kepler*, Chicago and London 1976

Lindsey, Bruce, *Digital Gehry. Material Resistance / Digital Construction*, Basel et al. 2001

Linfert, Carl, "Die Grundlagen der Architekturzeichnung. Mit einem Versuch über französische Architekturzeichnungen des 18. Jahrhunderts", in: *Kunstwissenschaftliche Forschungen*, Vol. I (1931), pp. 133–246

Lissel, Edgar, "The Return of Images: Photographic Inquiries into the Interaction of Light", *Leonardo*, XLI / 5 (2008), pp. 438–45

— *Vom Werden und Vergehen der Bilder*, Vienna and Berlin 2008

Lomazzo, Giampaolo, *Tratatto dell'arte delle pittura, scultura ed architettura*, Rome 1844

Lorblanchet, Michel, *La naissance de l'art. Genèse de l'art préhistorique*, Paris 1999

Lorch, Helga, "Ein Hamburger Herbarium des 16. Jahrhunderts und seine Stellung in der Geschichte des Naturselbstdruckes", MA dissertation, Universität Hamburg 1980

Louis XIV, *Mémoires de Louis XIV pour l'instruction du Dauphin [...]*, ed. Charles Dreyss, 2 vols., Paris 1860

Der Löwenmensch. Geschichte – Magie – Mythos, exh. cat., ed. Ulmer Museum, Ulm 2005

Loxley, James, *Perfomativity*, London and New York 2007

Lucian. In Eight Volumes, Vol. VIII (including the *Erotes*), Greek text and Eng. trans. by M. D. Macleod, London and Cambridge, Mass. (Loeb Classical Library) 1967

Lucio Fontana, exh. cat., ed. Bernard Blistène, Paris 1987

Lucretius, *De rerum natura*, Latin text and Eng. trans. by W.H.D. Rouse, London and New York 1924 (Loeb Classical Library)

Luhmann, Niklas, *Die Kunst der Gesellschaft*, Frankfurt am Main 1995

Lullies, Reinhard, *Griechische Plastik*, Munich 1956

Luther und die Folgen für die Kunst, exh. cat., ed. Werner Hofmann, Munich 1983

Lyre, Holger, "Erweiterte Kognition und neutraler Enaktivismus", *Zeitschrift für philosophische Forschung*, LXIV / 2 (2012), pp. 190–215

Maak, Niklas, "Der Krieg der Bilder", in: *Frankfurter Allgemeine Zeitung*, 6 January 2007, p. Z4

The Machine as seen at the end of the mechanical age, exh. cat., ed. K. G. Pontus Hultén, New York 1968

Macho, Thomas, "Blutende Bilder. Eine Glosse", *Horizonte der Emanzipation. Texte zu Theater und Theatralität. Berliner Theaterwissenschaft*, Vol. VII, Berlin 1999, pp. 327–33

— "Steinerne Gäste. Vom Totenkult zum Theater", in: *Quel Corps? Eine Frage der Repräsentation*, ed. Hans Belting et al., Munich 2002, pp. 53–66

Mack, Rainer, "Facing down Medusa (An aetiology of the gaze)", *Art History*, XXV / 5 (2002), pp. 571–604

Magna Graecia. Archeologia di un sapere, exh. cat., ed. Salvatore Settis and Cecilia Parra, Milan 2005

Mahr, Bernd, "Die Informatik und die Logik der Modelle", *Informatik Spektrum*, XXIII / 3 (2009), pp. 228–48

— "Modelle und ihre Befragbarkeit. Grundlagen einer allgemeinen Modelltheorie", *Erwägen – Wissen – Ethik*, XXVI (2015), pp. 1–14

Mai, Ekkehard, "Das Auto in Kunst und Kunstgeschichte", in: *Die nützlichen Künste*, ed. Tilmann Biddensieg and Henning Rogge, Berlin 1981, pp. 332–46

Mainberger, Sabine, *Experiment Linie. Künste und ihre Wissenschaften um 1900*, Berlin 2010

Majetschak, Stefan, "Iconic Turn", *Philosophische Rundschau*, XLIX / 1, (2002), pp. 44–64

Malcolm, Noel, *Aspects of Hobbes*, Oxford 2002

Malerei der Welt, ed. Ingo Walther, Cologne 1995

Malet, Antoni, "The Power of Images: Mathematics and Metaphysics in Hobbes's Optics", *Studies in History and Philosophy of Science*, XXXII / 2 (2001), pp. 303–33

Mandel, Ursula, "Räumlichkeit und Bewegungserleben – Körperschicksale im Hochhellenismus (240–190 v. Chr.)", in: *Die Geschichte der antiken Bildhauerkunst* , ed. Peter C. Bol, Vol. III: *Hellenistische Plastik*, Maniz 2007, pp. 105–87

Mandylion: Intorno al Sacro Volto da Bisanzio a Genova, ed. Gerhard Wolf, Colette Dufour Bozzo et al., Geneva and Milan 2004

I Manifesti del Futurismo. Prima Serie, ed. "Lacerba", Florence 1914

Manow, Phillip, "Sexualität und Souveranität – Neue Nachrichten vom Vor- und Nachleben des Leviathan-Frontispizes", *Leviathan*, XXXV / 4 (2007), pp. 470–94

Mansuelli, Guido Achille, *Galleria degli Uffizi. Le sculture*, Vol. I, Rome 1958

Marek, Kristin, *Die Körper des Königs. Effigies, Bildpolitik und Heiligkeit*, Munich 2009

Mariacher, Giovanni, *La scultura del Cinquecento*, Turin 1987

Marie Raymond – Yves Klein, exh. cat., ed. Beate Reifenscheid, Bielefeld 2006

Marinetti, F.T., *Teoria e invenzione Futurista*, ed. Luciano Di Maria, Milan 1968

— *Selected Writings*, ed. and Eng. trans. R.W. Flint, London 1972

Marino, Giambattista, *La Galeria del Cav. Marino. Distinta in Pitture e Sculture*, Venice 1675 [1620]

Marks, Edward B., *A World of Art. The United Nations Collection*, Rome 1995

Markschies, Christoph, "Antike Weltbilder in der Kritik", in: *Movens Bild. Zwischen Evidenz und Affekt*, ed. Gottfried Boehm, Birgit Mersmann and Christian Spies, Munich 2008, pp. 345–61

Marr, Alexander, "Understanding Automata in the Late Renaissance", *Journal de la Renaissance*, II (2004), pp. 205–22

Martin Schongauer, exh. cat., ed. Musée du Petit Palais, Paris 1991

Marucci, Valerio, *Pasquinate de Cinque e Seicento, Rome 1988*

Marx, Karl, *Das Kapital: Kritik der politischen Oekonomie*, Vols. I–III, 4th edn., ed. Friedrich Engels, Hamburg 1890–94

— *Das Kapital. Kritik der politischen Ökonomie*, Vols. I–III (*Marx-Engels Werke*, Vols. XXIII–XXV), East Berlin 1970

Die Masken der Schönheit. Hendrick Goltzius und das Kunstideal um 1600, exh. cat., ed. Jürgen Müller et al., Hamburg 2002

Mattenklott, Gert, *Der übersinnliche Leib. Beiträge zur Metaphysik des Körpers*, Reinbek bei Hamburg 1982

Matthias, Andreas, *Automaten als Träger von Rechten. Plädoyer für eine Gesetzesänderung*, Berlin 2008

Matyssek, Angela, *Überleben und Restaurierung. Barnett Newmans Who's afraid of Red, Yellow, and Blue III und Cathedra*, Berlin 2010

Mayer-Deutsch, Angela, *Das Museum Kircherianum. Kontemplative Momente, historische Rekonstruktionen, Bildrhetorik*, Zürich 2010

Mayr, Otto, *Uhrwerk und Waage. Autorität, Freiheit und technische Systeme in der frühen Neuzeit*, Munich 1987

Mead, Herbert, *Selected* Writings, ed. Andrew J. Reck, Chicago 1964

Medea. Choreographie von Sasha Walz. Oper Medeamaterial von Pascal Dusapin. Text Heiner Müller, ed. Sasha Walz and Guests GmbH, Berlin 2007

"Meine … alten und dreckigen Götter". Aus Sigmund Freuds Sammlung, exh. cat., ed. Lydia Marinelli, Frankfurt am Main 1998

Meister, Carolin and Wilhelm Roskamm, "Abstrakte Linien. Jackson Pollock und Gilles Deleuze", in: *Struktur, Figur, Kultur. Abstraktion in Kunst und Lebenswissenschaften*, ed. Claudia Blümle and Armin Schäfer, Zürich and Berlin 2007, pp. 223–50

Mellink, Machteld and Jan Filip, *Frühe Stufen der Kunst*, Berlin 1985 (= *Propyläen Kunstgeschichte*, Vol. XIV)

Mende, Ursula, *Die Türzieher des Mittelalters*, West Berlin 1981

— *Die Bronzetüren des Mittelalters 800–1200*, Munich 1994

Menninghaus, Winfried, *Das Versprechen der Schönheit*, Frankfurt am Main 2003

— "Biologie nach der Mode. Charles Darwins Ornament-Ästhetik", in: *Was ist schön?*, exh. cat., ed. Sigrid Walter et al., Dresden 2010, pp. 138–47

Merleau-Ponty, Maurice, "L'Entrelacs – le Chiasme", in: Maurice Merleau-Ponty, *Le visible et l'invisible*, ed. Claude Lefort, Paris 1964, pp. 172–204

Metken, Günter, *Gustave Courbet, Der Ursprung der Welt*, Munich 1997

Mettler, Michel, *Der Blick aus dem Bild. Texte und Bilder. Von Gemaltem und Ungemaltem*, Frankfurt am Main 2009

Metze-Mangold, Verena, *Auf Leben und Tod. Die Macht der Gewalt in den Medien*, Berlin 1997

Meulen, Nicolaj van der, "Ikonische Hypertrophien. Zum Bild- und Affekthaushalt im spätbarocken Sakralraum", in: *Movens Bild. Zwischen Evidenz und Affekt*, ed. Gottfired Boehm et al., Munich 2008, pp. 274–99

Meuter, Norbert, *Anthropologie des Ausdrucks. Die Expressivität des Menschen zwischen Natur und Kultur*, Munich 2006

Meyer, Axel, "The evolution of sexually selected traits in male swordtail fishes (*Xiphophorus poecilidae*)", *Heredity*, LXXIX (1997), pp. 329–37

— Walter Salzburger und Manfred Schartl, "Hybrid origin of a swordtail species (Teleostei: *Xiphophorus clemenciae*) driven by sexual selection", *Molecular Ecology*, XV / 3 (2006), pp. 721–30

Meyer, Hugo, "Copying and Social Cohesion in Rome and Early Byzantium: The Case of the First Famous Image of Christ at Edessa", in: *Interactions. Artistic Interchange between the Eastern and Western Worlds in the Medieval Period*, ed. Colum Hourihane, Princeton 2007, pp. 209–19

Meyer, Ingo, "Pikturale Kosmologie. Horst Bredekamps 'Theorie des Bildakts'", *Merkur. Deutsche Zeitschrift für europäisches Denken*, LXV / 4 (April 2011), pp. 349–54

Meyer-Kalkus, Reinhart, *Stimme und Sprechkünste im 20. Jahrhundert*, Berlin 2001

— Reinhart, "Blick und Stimme bei Jacques Lacan", in: *Bilderfragen. Die Bildwissenschaften im Aufbruch*, ed. Hans Belting, Munich 2007, pp. 217–36

Michalski, Sergiusz, "Das Phänomen Bildersturm. Versuch einer Übersicht", in: *Bilder und Bildersturm im Spätmittelalter und in der frühen Neuzeit. Arbeitsgespräch der Herzog August Bibliothek Wolfenbüttel, 14.–17. September 1986*, ed. Bob Scribner and Martin Warnke, Wiesbaden 1990, pp. 69–124

Michalsky, Tanja, "'*De ponte Capuano, de turribus eius, et de ymagine Frederici...*'. Überlegungen zu Repräsentation und Inszenierung von Herrschaft", in: *Kunst im Reich Friedrichs II. Von Hohenstaufen*, ed. Kai Kappel et al., Munich and Berlin 1996, pp. 137–51 (*Akten des internationalen Kolloquiums. Rheinisches Landesmusuem, Bonn, 2.–4. Dezember 1994*), Munich and Berlin 1996, pp. 137–51

Michaud, Philippe-Alain, *Aby Warburg et l'image en mouvement*, Paris 1998

Miller, Norbert, *Von Nachtstücken und anderen erzählten Bildern*, ed. Markus Bernauer and Gesa Horstmann, Munich and Vienna 2002, pp. 201–20

La misura del tempo. L'antico splendore dell'orologeria italiana dal XV al XVIII secolo, exh. cat., ed., Giuseppe Brusa and Joyce Hansford, Trento 2005

Mitchell, W. J. T., *What Do Pictures Want? The Lives and Loves of Images*, Chicago 2005

— "Der Schleier um Abu Ghraib: Errol Morris und die 'bad apples'", in: *Masslose Bilder. Visuelle Ästhetik der Transgression*, ed. Ingeborg Reichle and Steffen Siegel, Munich 2009, pp. 51–65

Molderings, Herbert, *Umbo: Otto Umbehr. 1902–1980*, Düsseldorf 1995

— *Duchamp and the Aesthetics of Chance. Art as Experiment*, New York 2010

Molteni, Ferdinando, "Storia e devozione della Sindone", in: *Il volto di Christo*, exh. cat., ed. Giovanni Morello and Gerhard Wolf, Venice 2000, pp. 278–301

Monahan, Laurie J., "Finessing the Found: 20th Century Encounters with the 'Natural Object'", *Oriental Art*, XLIV / 1 (1998), pp. 39–45

Mondzain, Marie-José, *L'image peut-elle tuer?*, Paris 2002

Monfasani, John, "A Description of the Sistine Chapel under Pope Sixtus IV", *Artibus et Historiae*, IV / 7 (1983), pp. 9–18

Moorstedt, Michael, "Nachrichten aus dem Netz", *Süddeutsche Zeitung*, 26 July 2010, p. 11

Morales, Ambrosio de, *Las Antiguedades de las ciudades de España*, Alcala de Henares 1575

Morand, Kathleen, *Claus Sluter. Artist at the Court of Burgundy*, Austin, Tex. 1991

Möseneder, Karl, *Paracelsus und die Bilder. Über Glauben, Magie und Astrologue im Reformations-zeitalter*, Tübingen 2009

Most, Glenn W., *Platons exoterische Mythen. Platon als Mythologe. Neun Interpretationen zu den Mythen in Platons Dialogen*, Darmstadt 2002, pp. 7–19

Movens Bild. Zwischen Evidenz und Affekt, ed. Gottfried Boehm et al., Munich 2008

Mowry, Robert D., "Chinese Scholar's Rocks: An Overview", *Oriental Art*, XLIV / 1 (1998), pp. 2–10

Mozart, Wolfgang Amadeus and Lorenzo Da Ponte, *Il dissoluto punito ossia il Don Giovanni* (facsimile of original score [Bib. Nat. de France] and of libretto of inaugural presentation, Prague 29 October 1787), Los Altos, Ca. 2009

Mülder-Bach, Inka, *Im Zeichen Pygmalions. Das Modell der Statue und die Entdeckung der "Darstellung" im 18. Jahrhundert*, Munich 1998

Müller, Heinrich, *Deutsche Bronzegeschützrohre 1400–1750*, East Berlin 1968

— and Hartmut Kölling, *Europäische Hieb- und Stichwaffen aus der Sammlung des Museums für Deutsche Geschichte*, 3rd edn. East Berlin 1984

Müller, Johannes von, "The Song of the Line. Stephan von Huenes Zeichnungen – die Kontur auf dem Weg zur Spur", in: *Stephan von Huene. The Song of the Line. Die Zeichnungen / The Drawings 1950–99*, exh. cat., ed. Hubertus Gassner and Petra Kipphoff, Ostfildern (Ruit) 2010, pp. 59–77

Müller-Wiener, Martina, "Vom irdischen Paradies zum höfischen Theater. Islamische Automaten und mechanische Konstruktionen des 9. bis 15. Jahrhunderts", *Eothen*, IV (2007), pp. 143–62

— "Puns and Puzzles. The Interplay of the Visual and the Verbal in Thirteenth-Century Mesopotamian Metalwork, Book Painting and Astrolabes", in: *Siculo-Arabic Ivories and Islamic Painting 1100–1300*, ed. David Knipp, Munich 2011, pp. 273–88

Müller-Wille, Staffan and Hans-Jörg Rheinberger, *Das Gen im Zeitalter der Postgenomik. Eine wissenschaftliche Bestandsaufnahme*, Frankfurt am Main 2009

Mungen, Anno, *"BilderMusik": Panorama, Tableaux vivants und Lichtbilder als multimediale Darstellungsformen in Theater- und Musikaufführungen von 9. bis zum frühen 20 Jahrhundert*, 2 vols., Remscheid 2006

Münkler, Herfried, "Symmetrische und asymmetrische Kriege. Der klassische Staatenkrieg und die neuen transnationalen Kriege", *Merkur. Deutsche Zeitschrift für europäisches Denken*, LIX / 8 (August 2004), pp. 649–59

Munro, Jane, "'More like a Work of Art than Nature': Darwin's Beauty and Sexual Selection", in: *Endless Forms. Charles Darwin, Natural Science and the Visual Arts*, exh. cat., ed. Diana Domald and Jane Munro, New Haven and London 2009, pp. 253–92

Mythen der Nationen 1945 – Arena der Erinnerungen, ed. Monika Flacke, Deutsches Historisches Museum, 2 vols. Mainz 2004

Nagel, Ivan, *Gemälde und Drama*, Frankfurt am Main 2009

Nagel, Thomas, *Das letzte Wort*, Stuttgart 1999

Natur im Druck. Eine Ausstellung zur Geschichte und Technik des Naturselbstdrucks, exh. cat., ed. Peter Heilmann, Marburg 1995

Natur im Kasten. Lichtbild, Schattenriss, Umzeichnung und Naturselbstdruck um 1800, exh. cat., ed. Olaf Breidbach et al., Jena 2010

Nelson, Victoria, *The Secret Life of Puppets*, Cambridge, Mass. and London 2001

Neu, Erich, *Das Hurritische: Eine altorientalische Sprache im neuen Licht*, Stuttgart 1988 (Akademie der Wissenschaften und der Literatuir. Abhandlungen der Geistes- und Sozialwissenschaftlichen Klasse, Jg. 1988, no. 3)

Neuweiler, Gerhard, *Und wir sin des doch – die Krone der Evolution*, Berlin 2008

Newark, Tim, *Camouflage*, New York 2007

Newman, Eric P., *The Early Paper Money of America*, Iola, Wis. 1990

Nicholas of Cusa, *Complete Philosophical and Theological Treatises of Nicholas of Cusa*, Eng. trans. by Jasper Hopkins, 2 vols., 2nd edn., Minneapolis 1988; Vol. I, pp. 530–601: *Idiota de mente / The Layman on Mind*; Vol. II, pp. 600–743: *De visione Dei / The Vision of God* [see also: Nikolaus von Kues 1989]

Niki de Saint Phalle, exh. cat., ed. Pontus Hultén, Bonn 1992

Niki de Saint Phalle, Catalogue raisonné 1949–2000, Vol. I: *Peintures, Tirs, Assemblages, Reliefs, 1949–2000*, Lausanne 2001

Nikolaus von Kues, *Philosophisch-theologische Schriften*, Latin text and German trans. by Dietlind and Wilhelm Dupré, ed. Leo Gabriel, 3 vols. 2nd edn., Vienna 1989. Vol. III, pp. 93–219: *De visione Dei*; Vol. III, pp. 479–609: *Idiota de mente* [see also: Nicholas of Cusa]

Nikolaus von Kues, *Opera omnia*, Vol. VI, ed. Adelheid Dorothee Riemann, Hamburg 2000

Nissen, Claus, *Die botanische Buchillustration. Ihre Geschichte und Bibliographie*, Stuttgart 1966

Noë, Alva, *Action in Perception*, Cambridge, Mass. 2004

— *Strange Tools: Air and Human Nature*, New York 2015

Novalis Schriften. Die Werke Friedrich von Hardenbergs, ed. Paul Kluckholm, Richard Samuel et al., Stuttgart 1960–2006

Novitz, David, *Pictures and their Use in Communication. A Philosophical Essay*, The Hague 1977

Oakley, K. P., "Emergence of higher thoughts 3.0–0.2 Ma BP", in: *Philosophical Transactions of the Royal Society of London. Series B: Biological Sciences*, Vol. 292 / 1057 (1981), pp. 205–11

Oberthaler, Elke, "Tizians Spätstil anhand von Nymphe und Schäfer", in: *Der späte Tizian und die Sinnlichkeit der Malerei*, exh. cat., ed. Sylvia Ferino-Pagden, Vienna 2007, pp. 111–21

Objects in Transition. An Exhibition at the Max Planck Institute for the History of Science, Berlin, Berlin 2007

Oettermann, Stephan, "Johann Carl Enslen (1759–1848), ... und zuletzt auch noch Photographie-Pionier", in: *Silber und Salz: Zur Frühzeit der Photographie im deutschen Sprachraum, 1839–1860*, Cologne 1989, pp. 116–36

— "Lichtbilder mit dem 'Zeichenstift der Natur'", in: *Natur im Druck. Eine Ausstellung zur Geschichte und Technik des Naturselbstdrucks*, exh. cat., ed. Peter Heilmannn, Marburg 1995, pp. 32–41

Orchard, Karin, *Annäherungen der Geschlechter. Androgynie in der Kunst des Cinquecento*, Münster 1992

Ornamenta Ecclesiae. Kunst und Kunstler der Romanik, exh. cat., ed. Anton Legner, 3 vols. Cologne 1985

Ortalli, Gherardo, "... pingatur in palatio ...". *La pittura infamante nei secoli xiii–xvi*, Rome 1979

Ortel, Jo, *Re-Creation, Self-Creation: A Feminist Analysis of the Early Art and Life of Niki de Saint Phalle*, 2 vols., Ann Arbor 1992

Osterman Borowitz, Helen, *The Impact of Art in French Literature. From de Scudéry to Proust*, Newark, N. J., London and Toronto 1985

Ovid (Publius Ovidius Naso), *The Fasti*. Latin text and Eng. trans, by James George Frazer, 5 vols., London 1929

— in Six Volumes, Vol. III: *Metamorphoses I–VIII*, Latin text and Eng. trans. by Frank Justus Miller, 3rd rev. edn., Cambridge, Mass. and London (Loeb Classical Library) 1977

— in Six Volumes, Vol. IV: *Metamorphoses IX–XV*. Latin text and Eng. trans. by Frank Justus Miller. 2nd edn., Cambridge, Mass. and London (Loeb Classical Library) 1984

Pächt, Otto, *Van Eyck. Die Begründer der altniederländischen Malerei*, Munich 1993

Pack, Christina, *Alltagesgegenstände in der Fotografie der Gegenwartskunst*, Berlin 2008

Palacký, Franz, *Urkundliche Beiträge zur Geschichte des Hussitenkrieges in dem Jahren 1419–1438*, 2 vols., Prague 1873

Panofsky, Erwin, *Die ideologischen Vorläufer des Rolls-Royce-Kühlers & Stil und Medium im Film. Mit Beiträgen vom Irving Lavin und William S.* Heckscher, Frankfurt am Main 1993; Eng. orig.: "The ideological antecedents of the Rolls-Royce radiator", in: *Proceedings of the American Philosophical Society*, 4 (1963), pp. 273–88

Panzanelli, Roberta, "Compelling Presence. Wax Effigies in Renaissance Florence", in: *Ephemeral Bodies. Wax Sculpture and the Human Figure*, ed. Roberta Panzanelli, Los Angeles 2008, pp. 13–39

Pape, Helmut, *Die Unsichtbarkeit der Welt. Eine visuelle Kritik neuzeitlicher Ontologie*, Frankfurt am Main 1997

— "Die Logik der Bilder und die Objektivität des Geistes. Ist Peirce' graphische Logik eine Theorie geistiger Prozesse?", in: *Pragmata. Festschrift für Klaus Oehler zum 80. Geburtstag*, ed. Kail-Michael and Maria Liatsi, Tübingen 2008, pp. 141–53

— *Hautnah. Die Abformung des Lebens im 19. Jahrhundert*, exh. cat., ed. Edouard Papet, Hamburg 2002

Paragone als Mitstreit, ed. Joris van Gastel et al., Berlin 2014

Parisi-Presicce, Claudio, "Konstantin als Iuppiter", in: *Konstantin der Grosse, Imperator, Caesar Flavius-Constantinus*, exh. cat., ed. Alexander Demand, Mainz 2007, pp. 117–31

Paul, Gerhard, *Bilder des Krieges. Krieg der Bilder. Die Visualisierung des modernen Krieges*, Paderborn 2004

— "Visual History", in: *Visual* History, version 1.0, in: Docupedia-Zeitgeschichte, 11. 2. 2010, http://docupedia.de/docupedia/index.php?title=Visual_History&oldid=68958 (accessed 20.08.2010)

Pavese, Carlo O., "La iscrizione sulla kotyle di Nestor da Pithekoussai", *Zeitschrift für Papyrologie und Epigraphik*, CXIV (1996), pp. 1–24

Pehnt, Wolfgang, *Die Architektur des Expressionismus*, Stuttgart 1998

Peirce, Charles Sanders, *Collected Papers*, ed. C. Hartshorne and P. Weiss, Vols. I–VIII, Cambridge 1931–58

— *Reasoning and the Logic of Things. The Cambridge Conferences Lectures of 1898*, ed. Kenneth Laine Ketner, Cambridge, Mass. and London 1992

Pentcheva, Bissera V., "The Performative Icon", *The Art Bulletin*, LXXXVIII / 4 (2006), pp. 631–55

Peter Paul Rubens: Barocke Leidenschaften, exh. cat., ed. Nils Büttner and Ulrich Heinen, Munich 2004

Pfisterer, Ulrich "'Soweit die Flügel meines Auges tragen'. Leon Battista Albertis Imprese und Selbstbilnis", in: *Mitteilungen des Kunsthistorischen Institutes in Florenz*, XLII / 1 (1998), pp. 205–51

— "'Die Bilderwissenschaft ist mühelos'. Topos, Typhus und Pathosformel als methodische Herausforderung der Kunstgeschichte", in: *Visuelle Topoi. Erfindung und tradiertes Wissen in den Künsten der italienischen Renaissance*, ed. Ulrich Pfisterer and Max Seidel, Berlin and Munich 2003, pp. 21–32

Philosophie der Verkörperung. Grundlagentexte einer aktuellen Debatte, ed. Jörg Fingehut et al., Berlin 2013

Photographs at the Frontier. Aby Warburg in America 1995–96, ed. Benedetta Cestelli Guidi and
 Nicholas Mann, Cambridge 1998

Pichler, Wolfram, "Die Evidenz und ihr Doppel. Über Spielräume des Sehens bei Caravaggio",
 in: *Das Bild ist der König. Repräsentation nach Louis Marin*, ed. Vera Beyer et al., Munich
 2006, pp. 125–56

Pier Paolo Pasolini. Organizzar il Trasumanar, exh. cat., Venice 1996

Pippilotti Rist – Remake of the Weekend, exh. cat. ed. Cornelia Providoli et al., Cologne 1998

Plato, *Cratylus [...]*, Greek text and Eng. trans. by H. N. Fowler, London and New York 1926 (Loeb
 Classical Library)

— *Laws*, Vol. I (Books I–VI), Vol. II (Books VII–XII), Greek text and Eng. trans. by R. G.Bury,
 London and New York 1926 (Loeb Classical Library)

— *The Republic*, Vol. I (Books 1–V), Vol. II (Books VI–X), Greek text and Eng. trans. by Paul
 Shorey, London and New York 1930; 1935 (Loeb Classical Library)

— *The Sophist [...]*, Greek text and Eng. trans. by H.N. Fowler, London and New York 1921
 (Loeb Classical Library)

— *Timaeus [...]*, Greek text and Eng. trans. by R.G.Bury, London and New York 1929 (Loeb
 Classical Library)

Plett, Heinrich, *Rhetorik der Affekte. Englische Wirkungsästhetik im Zeitalter der Renaissance*,
 Tübingen 1975

Pliny the Elder, *Natural History*, Vol. IX (Books XXXIII–XXXVI), Latin text and Eng. trans.
 by H. Rackham, Cambridge, Mass. and London (Loeb Clasical Library) 1961

Ploss, Emil, "Der Inschriftentypus 'N.N. me fecit' und seine geschichtliche Entwicklung bis ins
 Mittelalter", *Zeitschrift für deutsche Philologie*, LXXVII (1958), pp. 25–46

Plutarch's Lives, in Eleven Volumes, Vol. VII: *Demosthenes and Cicero, Alexander and Caesar*,
 Latin text and Eng. trans. by Bernadotte Perrin, London and New York 1919 (Loeb Classical
 Library)

Poeschke, Joachim, "Mann oder Frau? Zum Beitrag 'Stauferdiadem von hinten betrachtet'",
 Kunstchronik, LXII / 5 (2009), pp. 244–47

Politische Kunst. Gebärden und Gebaren, ed. Martin Warnke, Berlin 2004

Politische Räume. Stadt und Land in der Frühneuzeit, ed. Cornelia Jöchner, Berlin 2003

Pope-Hennessy, John, *Cellini*, London 1985

Port, Ulrich, "'Katharsis des Leidens'. Aby Warburgs 'Pathosformeln' und ihre konzeptionellen
 Hintergründe in Rhetorik, Poetik und Tragödientheorie", *Deutsche Vierteljahrsschrift für
 Literaturwissenschaft und Geistesgeschichte*, LXXIII (1999), pp. 5–42

— "'Pathosformeln' 1906–1933: Zur Theatralität starker Affekte nach Aby Warburg", in:
 Theatralität und die Krisen der Repräsentation, ed. Erika Fischer-Lichte, Stuttgart and
 Weimar 2001, pp. 226–51

Portmann, Adolf, *Animal Forms and Patterns: A Study of the Appearance of Animals*, New York 1967

Preisendörfer, Bruno, *Staatsbildung als Königskunst. Ästhetik und Herrschaft in preussischen
 Absolutismus*, Berlin 2000

Prignitz, Christoph, *Erotische Uhren*, Ulm 2004

Prinz, Felix, "Die 'Graue Passion' Hans Holbeins des Älteren. Form und Medienreflexion", in:
 Jahrbuch der Staatlichen Kunstsammlungen in Baden-Württemberg, XLIV (2007), pp. 7–27

Pross, Caroline, "*Coup d'oeil*. Nachbemerkungen zu einem Bild von Claude-Nicolas Ledoux", in: *Szenographien. Theatralität als Kategorie der Literaturwissenschaft*, ed. Gerhard Neumann et al., Freiburg 2000, pp. 453–65

Puppen Körper Automaten. Phantasmen der Moderne, exh. cat., ed. Pia Müller-Tamm and Katharina Sykora, Düsseldorf 1999

Pygmalions Werstatt. Die Erschaffung des Menschen im Atelier von der Renaissance bis zum Surrealismus, exh. cat., ed. Barbara Eschenburg et al., Munich et al. 2001

Rath, Markus, "Die Berliner Gliederpuppe", MA dissertation, Humboldt-Universität Berlin 2008
— "Albertis Tastauge. Neue Betrachtungen eines Emblems visueller Theorie", *kunsttexte.de*, 2009, no. 1 (9 pages), www.kunsttexte.de (accessed 16.03.2010).

Raubitschek, Anton E., "Das Denkmal-Epigramm", *L'Épigramme grecque. Entretiens sur l'antiquité classique*, XIV (1968), pp. 3–36

Réau, Louis, *Histoire de Vandalisme. Les monuments détruits de l'art français*, 2 vols., Paris 1959

Reck, Hans Ulrich, *Eigensinn der Bilder. Bildtheorie oder Kunstphilosophie?*, Munich 2007

Rehberg, Friedrtich, and Tommaso Piroli, *Drawings Faithfully copied from Nature at Naples and with permission dedicated to the Right Honourable Sir William Hamilton*, [Rome] 1794

Reiche, Reimut, "Vom Handeln der Bilder. Horst Bredekamps Frankfurter Adorno-Vorlesungen 2007", *WestEnd. Neue Zeitschrift für Sozialforschung*, V / 2 (2008), pp. 174–81

Reichle, Ingeborg, *Kunst aus dem Labor. Zum Verhältnis von Kunst und Wissenschaft im Zeitalter der Technoscience*, Vienna et al. 2005
— "Lebendige Kunst oder Biologische Plastik? Reiner Maria Matysiks Prototypenmodelle postevolutionär Organismen", in: *Visuelle Modelle*, ed. Ingeborg Reichle et al., Munich 2008, pp. 155–73

Reissberger, Maria, "Die 'Sprache' der lebenden Bilder", in: *Tableaux Vivamts. Lebende Bilder und Attitüden in Fotografie, Film und Video*, exh. cat., ed. Sabine Folie and Michael Glasmeier, Vienna 2002, pp. 189–210

Reitlinger, Gerald, "Unglazed Relief Pottery from Northern Mesopotamia", *Ars Islamica*, XV (1951), pp. 11–22

Rembrandts Landschaften, ed. Christian Vogelaar and Gregeor J. M. Weber, Munich 2006

Renaissance Faces. Van Eyck to Titian, exh. cat., ed. Lorne Campbell et al., London 2008

Reudenbach, Bruno, *G. B. Piranesi. Architektur als Bild. Der Wandel in der Architekturauffassung des achtzehnten Jahrhunderts*, Munich 1979
— *Die Kunst des Mittelalters*, Vol. I: *800 bis 1200*, Munich 2008

Revolutionsarchitektur. Boulée Ledoux Lequen, exh. cat., ed. Günter Meutken, Baden-Baden 1970

Richard, Birgit, "Pictorial Clashes am medialen Gewaltkörper: Abu Ghraib, Nick Berg und Johannes Paul II", in: *Ich-Armeen. Täuschen – Tarnen – Drill*, ed. Birgit Richard and Klaus Neumann-Braun, Munich 2006, pp. 235–55

Richy, Sophie, untitled text, *Black and White*, VI (undated), pp. 12–13

Riegl, Alois, *Die Entstehung der Barockkunst in Rom*, ed. Arthur Burda and Max Dvořák, Vienna 1908

Rilke, Rainer Maria, *Der Neuen Gedichte. Anderer Teil*, Leipzig 1908

Rizzolatti, Giacomo and Corrado Sinigaglia, *Empathie und Spiegelneureone. Die biologische Basis des Mitgefühls*, Frankfurt am Main 2008

Rolf, Eckhard, *Der andere Austin. Zur Rekonstruktion / Deklonstruktion performativer Äusserungen – von Searle über Derrida zu Cavell und darüber hinaus*, Bielefeld 2009

Rosen, Valeska von, "Die Enargeia des Gemäldes. Zu einem vergessenen Inhalt des Ut-pictura-poesis und seiner Relevanz für das cinquecenteske Bildkonzept", in: *Marburger Jahrbuch für Kunstwissenschaft*, XXVII (2000), pp. 171–208

— *Caravaggio und die Grenzen des Darstellbaren*, Berlin 2009

Roudinesco, Elisabeth, *Jacques Lacan. Esquisse d'une vie, histoire d'une système de pensé*, Paris 1993

Rousseau, Jean-Jacques, *Pygmalion [...] Scène lyrique*, Geneva 1771

Sachs-Hombach, Klaus, *Das Bild als kommunikatives Medium. Elemente einer allgemeinen Bildwissenschaft*, Cologne 2003

— "Illokutionäre Kraft und kommunikative Verbindlichkeit. Anmerkungen zur Differenz sprachlicher und visueller Kommunikation", in: *Bildpolitik – Sprachpolitik. Untersuchungen zur politischen Kommunikation in der entwickelten Demokratie*, Berlin 2006, pp. 181–96

The Sacred Made Real. Spanish Painting and Sculpture 1600–1700, exh. cat., ed. Xavier Bray, London 2009

Safran, Linda, "What Constantine Saw. Reflections on the Capitoline Colossus, Visuality, and Early Christian Studies", *Millennium*, Vol. III (2006), pp. 43–73

Saint Phalle, Niki de, *Mon secret*, Paris 1994

— *Traces. An autobiography. Remembering 1930–1949*, Lausanne 1999

Sánchez, Alfonso E. Pérez and Júlian Gallégo, *Goya. Das druckgraphische* Werk, Munich and New York 1995

Sander, Jochen, *Hugo van der Goes. Stilentwicklung und Chronologie*, Mainz 1992

Sandro Botticelli. Pittore della Divina Commedia, ed. Sebastiano Gentile, Rome 2000

Sanvito, Paolo, "Il concetto di Immagine e Immaginazione nella dottrina della percezione e nell'estetica di Nicola da Cusa", in: *Potere delle immagini?*, ed. Tonino Griffero and Michele Di Monte (= *Sensibilia*, Vol. I), 2007, pp. 187–210

Sartre, Jean-Paul, *L'Être et le Néant*, Paris 1943

Sasha Waltz, Gespräche mit Michaela Schlagenwerth, Berlin 2008

Sauerländer, Willibald, *Die Skulptur des Mittelalters*, Frankfurt am Main 1963

Savoy, Bénédicte, "'Une simple mission de superbes choses'. Les missions en Allemagne et en Autriche 1806–1809", in: *Dominique-Vivant Denon. L'oeil de Napoléon*, exh. cat., ed. Pierre Rosenberg, Paris 1999, pp. 170–81

— "Erzwungener Kulturtransfer – Die französische Beschlagnahmung von Kunstwerken in Deutschland 1794–1815", in: *Beutekunst unter Napoleon. Die "französische Schenkung" an Mainz 1803*, exh. cat., ed. Sigrun Paas and Sabine Mertens, Mainz 2003, pp. 137–44

— *Patrimoine annexé. Les biens culturels saisis par la France en Allemagne autour de 1800*, 2 vols. Paris 2003

Schaaf, Larry, *The Photographic Work of William Henry Fox Talbot*, Princeton 2000

Schadow, Johann Gottfried, *Kunstwerke und Kunstansichten. Ein Quellenwerk zur Berliner Kunst- und Kulturgeschichte zwischen 1780 und 1845. Kommentierte Neuausgabe der Veröffentlichung von 1849*, ed. Götz Eckhardt, 3 vols., West Berlin 1987

Schäffner, Wolfgang, "Stevin, der Punkt und die Zahlen", in: *"Der liebe Gott steckt im Detail". Mikrostrukturen des Wissens*, ed. Wolfgang Schäffner et al., Munich 2003, pp. 201–17

— "Interdisziplinäre Gestaltung. Einleitung in das neue Feld einer Geistes- und Material-
 wissenschaft", in: *Haare hören. Strukturen wissen und Räume agieren. Berichte aus dem
 Interdisziplinären Labor Bild Wissen Gestaltung*, ed. Wolfgang Schäffner and Horst
 Bredekamp, Bielefeld 2015

Schalldach, Ilsabe, "Johannes Hieronymus Kniphofs 'Botanica in originali' – ein frühes
 Zeugnis der Gartenbauwissenschaft in Deutschland", *Archiv für Gartenbau*, XXXVI / 6
 (1988), pp. 387–93

Schapiro, Meyer, "The Still Life as a Personal Object. A Note on Heidegger and van Gogh",
 in: *The Reach of Mind*, ed. Marianne L. Simmel, New York 1968, pp. 203–09

Schaub, Mirjam, "Grausamkeit und Metaphysik. Zur Logik der Überschreitung in der abendlän-
 dischen Philosophie und Kultur", in: *Grausamkeit und Metaphysik. Figuren der Überschrei-
 tung in der abendländischen Kultur*, ed. id., Bielefeld 2009, pp. 11–31

Schirrmacher, Christine, "Schlaglichter zum Karikaturenstreit und Bilderverbot in islamischen
 Gesellschaften der Moderne", in: *Das Bild Gottes in Judentum, Christentum und Islam. Vom
 Alten Testament bis zum Karikaturenstreit*, ed. Ekhard Leuschner and Mark R. Hesslinger,
 Petersberg 2009, pp. 273–86

*Schlangenritual. Der Transfer der Wissensformen vom Tsu'ti'kive der Hopi bis zu Aby Warburgs
 Kreuzlinger Vortrag.*, ed. Cora Bender et al., Berlin 2007

Schleiermacher, Friedrich Daniel, *Hermeneutik*, ed. Heinz Kimmerle, Heidelberg 1959

Schlie, Heike, "Abdruck und Einschnitt – Die medialen Träger der Spur als appendicia exteriora
 des Christuskörpers", in: *Bildwelten des Wissens. Kunsthistorisches Jahrbuch für Bildkritik*,
 VIII / 1 (2010): *Kontaktbilder*, ed. Vera Dunkel, pp. 83–94

Schmidt, Ernst A., *Clinamen. Eine Studie zum dynamischen Atomismus der Antike*, Heidel-
 berg 2007

Schmitt, Arbogast, "Der Philosoph als Maler – der Maler als Philosoph. Zur Relevanz der
 Platonischen Kunsttheorie", in: *Homo Pictor*, ed. Gottfried Boehm, *Colloqium Rauricum*, VII,
 Munich and Leipzig 2001, pp. 32–54

Schmitz, Ulrich, "Bildakte? How to do things with pictures", *Zeitschrift für germanische
 Linguistik*, XXXV (2007), pp. 419–33

Schmölders, Claudia, "Bilderglauben. Horst Bredekamp nimmt Abschied von der Dekonstruk-
 tion [review of *Theorie des Bildakts*]", *Zeitschrift für Ideengeschichte*, V (2011), pp. 115–20

Schneemann, Carolee, *More Than Meat Joy: Complete Performance Works and Selected* Writings,
 New Paltz, NY, 1997

Schneider, Birgit, "Gefleckte Gestalten. Die Camouflage von Schiffen im Ersten Weltkrieg", in:
 Struktur, Figur, Kontur. Abstraktion in Kunst und Lebenswissenschaften, ed. Claudia Blümle
 and Armin Schäfer, Zürich and Berlin 2007, pp. 141–58

Schneider, Pablo, "Fritz Saxl – Gebärde, Form und Ausdruck", in: *Gebärde, Form, Ausdruck,
 Fritz Saxl: Zwei Untersuchungen*, ed. Pablo Schneider, Zürich 2002, pp. 109–34

— "Begriffliches Denken – verkörpertes Sehen. Edgar Wind (1900–1917)",
 in: *Ideengeschichte der Bildwissenschaft. Siebzehn Portraits*, ed. Jörg Probst and Jost Philipp
 Klemm, Frankfurt am Main 2009, pp. 53–74

Schnitzler, Norbert, *Ikonoklasmus – Bildersturm. Theologischer Bilderstreit und ikonoklastisches
 Handeln während des 15. und 16. Jahrhunderts*, Munich 1996

Schoell-Glass, Charlotte, *Aby Warburg und der Antisemitismus. Kulturwissenschaft als Geistes-
 politik*, Frankfurt am Main 1998

— "Aby Warburg's Late Comments on Symbol and Ritual", *Science and* Context, XII / 4 (1999), pp. 621–42

Scholz, Oliver, *Bild, Darstellung, Zeichen. Philosophische Theorien bildhafter Darstellung*, Feiburg and Munich 1991

— *Bild, Darstellung, Zeichen. Philosophische. Theorien bildhafter Darstellung*, new edn. Frankfurt am Main 2009

Die Schöninger Speere. Mensch und Jagd vor 400 000 Jahren, exh. cat., ed. Hartmut Thieme, Hanover 2007

Schrift. Kulturtechnik zwischen. Auge, Hand und Maschine, ed. Gernot Grubeet al., Munich 2005

Schulz, Martin, *Ordnungen der Bilder. Eine Einführung in die Bildwissenschaft*, Munich 2005

Schümer, Dirk, "Ich zeige Euch, wie ein Italiener stirbt. Das Video des im Irak ermordeten Fabrizio Quattrocchi erschüttert seine Landsleute", *Frankfurter Allgemeine Zeitung*, 12 January 2006, p. 40

Schürmann, Eva, *Sehen als Praxis. Ethisch-ästhetische Studien zum Verhältnis von Sicht und Einsicht*, Frankfurt am Main 2008

Schuster, Michael, *Malerei im Film: Peter Greenaway*, Hildesheimet al., 1998

Schwartz, Frederic J., *Blind Spots. Critical Theory and the History of Art in Twentieth-Century Germany*, New Haven and London 2005

Schweitzer, Stefan and Hanna Vorholt, "Bildlichkeit und politische Legitimation im Vorfeld des Irakkrieges 2003", in: *Bildwelten des Wissens. Kunsthistorisches Jahrbuch fur Bildkritik*, II / 1(2004), pp. 29–40

Schwemmer, Oswald, *Die kulturelle Existenz des Menschen*, Berlin 1997

— *Kulturphilosophie. Eine medientheoretische Grundlage*, Munich 2005

Searle, John R., *Speech Acts: An Essay in the Philosophy of Language*, Cambridge 1969

— "Reiterating the Differences: A Reply to Derrida", *Glyph*, I (1977), pp. 198–208

Sedlmayr, Hans, "Die 'Macchia' Bruegels", in: *Jahrbuch der Wiener Kunsthistorischen Sammlungen*, new series VIII (1934), pp. 137–60

Seel, Martin, *Die Macht des Erscheinens. Texte zur Ästhetik*, Frankfurt am Main 2007

Segelkern, Barbara, *Bilder des Staates. Kammer, Kasten und Tafel als Visualisierungen staatlicher Zusammenhänge*, Berlin 2010

Seibold, Jürgen, *Michael Jackson*, Rastatt 1992

Seidel, Linda, *Legends in Limestone. Lazarus, Gislebertus and the Cathedral of Autun*, Chicago 1999

Seidel, Max, "Burma, September 2007. Contemporaray Art and Political Iconography", in: *Mitteilungen des Kunsthistorischen Instituts in Florenz*, LI / 3 & 4 (2007), pp. 503–38

Seja, Silvia, *Handlungstheorien des Bildes*, Cologne 2009

Serres, Michel, *La Naissance de la Physique dans le Texte de Lucrèce. Fleuves et Turbulences*, Paris 1977

Settis, Salvatore, "Pathos und Ethos, Morphologie und Funktion", in: *Vorträge aus dem Warburg-Haus*, I (1997), pp. 31–73

— "Schemata e Pathosformeln far gli antichi e i moderni", in: *La communicazione non verbale nella Grecia antica. Gli schemata nella danza, nell'arte, nella vita*, ed. Maria Luisa Catoni, Turin 2008, pp. VII–XI

Severi, Carlo, "La parole prêtée. Comment parlent les images", in: *Paroles en Actes*, ed. Carlo Severi and Julien Bonhomme, Paris 2009, pp. 11–42

Seymour, Charles, Jr., "Homo Magnus et Albus. The Quattrocento Background for Michelangelo's David of 1501–04", in: *Stil und Überlieferung in der Kunst des Abendlandes. Akten des 21. Internationalen Kongresses für Kunstgeschichte in Bonn 1964*, Vol. II, West Berlin 1967, pp. 96–105

Shearman, John, *Only connect … Art and the Spectator in the Italian Renaissance*, Princeton 1992

Shin, Seung-Chol, *Vom Simulacrum zum Bildwesen. Ikonoklasmus der virtuellen Kunst*, Vienna 2012

Le Siècle de Titien. L'âge d'or de la peinture à Venise, exh. cat., ed. Gilles Fage, Paris 1993

Siegel, Steffen, *Tabula. Figuren der Ordnung um 1600*, Berlin 2009

Siegert, Bernhard, *Passage des Digitalen*, Berlin 2003

Sierek, Karl, *Foto, Kino und Computer, Aby Warburg als Medientheoretiker*, Hamburg 2007

Silverman, Kaja, *World Spectators*, Stanford 2000

Sladeczek, Franz-Josef, *Der Berner Skulpturenfund: die Ergebnisse der kunsthoistorischen Auswertung*, ed. Ellen J. Beer, Gesellschaft für Schweizerische Kunstgeschichte und Bernisches Historisches Museum, Bern 1999

Smith, Graham, "Talbot and Botany. The Bertolini Album", *History of Photography*, XVII / 1 (1993), pp. 33–48

Smith, Jonathan, *Charles Darwin and Victorian Visual Culture*, Cambridge 2006

Sontag, Susan, *Regarding the Pain of Others, New York 2003*

Spaemann, Robert, "'Kunst ist immer Simulation'. Ein Gespräch mit Ulrich von Bülow und Mark Schweda", in: *Joachim Ritter. Vorlesungen zur Philosophischen Ästhetik*, ed. Ulrich von Bülow and Mark Schweda, Göttingen 2010, pp. 179–95

Der späte Tizian und die Sinnlichkeit der Malerei, exh. cat., ed. Sylvia Ferino-Pagden, Vienna 2007

Spencer, Herbert, *The Principles of Biology*, 2 vols., London 1898 [1864]

Speroni, Sperone, "Dialogo d'amore", in: *Tratattisti del Cinquecento*, ed. Mario Pozzi, Milan 1978, pp. 471–850

Springborg, Patricia, "Leviathan, Mythic History and National Historiography", in: *The Historical Imagination in Early Modern Britain. History, Rhetoric, and Fiction, 1500–1800*, ed. David Harris Sacks and Donald Kelley, Cambridge 1997, pp. 267–97

Staats, Reinhardt, "Stauferdiademe von hinten betrachtet", *Kunstchronik*, LXII / 1 (2009), pp. 9–16

Stähli, Adrian, "Bild und Bildakte in der griechischen Antike", in: *Quel Corps? Eine Frage der Repräsentation*, ed. Hans Belting, Dietmar Kamper and Martin Schulz, Munich 2002, pp. 67–84

Statnik, Björn, "'Lebe, du Jupiterspross, du Erbe des römischen Namens!' – Bemerkungen zur Antikenrezeption im Königreich Sizilien Friedrichs II", in: *Ansichtssache. Das Bodemuseum Berlin im Liebieghaus Frankfurt. Europäische Bildhauerkunst von 800 bis 1800*, ed. Herbert Beck and Hartmut Krohm, Frankfurt am Main 2002, pp. 11–17

Steffen, Barbara, "Schleier und Schleieren als Isolationsmotive", in: *Francis Bacon und die Bildtradition*, exh. cat., ed. Wilfried Sepiel, Barbara Steffen and Christoph Vitali, Vienna 2003, pp. 133–45

Steimel, Michael, *"Truly Wonderful Facts". Groteskes in Darwins Evolutionstheorie*, Marburg 2010

Steinhart, Matthias and Eckhard Wirbelaur, *"Par Peisistratou. Epigraphische Zeugnisse zur Geschichte des Schenkens"*, *Chiron*, XXX (2000), pp. 255–89

Steinhauer, Fabian, "Das Recht am eigenen Bild in den Kollisionen der Sichtbarkeit ", in: *Bildregime des Rechts*, ed. Jean-Baptiste Joly et al., Stuttgart 2007, pp. 222–46

— *Bildregeln. Studien zum juristischen Bilderstreit*, Munich 2009

Steinhauser, Monika, "Das Theater bei Ledoux und Boullée, Bemerkungen zur sozialen Funktion einer Bauaufgabe", in: *Bolletino del Centro Internazionale di Studi di Architettura Andrea Palladio*, XVII (1975), pp. 337–59

Stephan von Huene, The Song of the Line. Die Zeichnungen / The Drawings 1950–1999, exh. cat., ed. Hubertus Gassner and Petra Kipphoff, Ostfildern (Ruit) 2010

Stetter, Christian, *Schrift und Sprache*, Frankfurt am Main 1999

— "Bild, Diagramm, Schrift", in: *Schrift. Kulturtechnik zwischen Auge, Hand und Maschine*, ed. Gernot Grube et al., Munich 2005, pp. 115–35

Steudel-Günther, Andrea, "Schema", in: *Historisches Wörterbuch der Rhetorik*, ed. Gert Ueding, Vol. VIII, Darmstadt 2007, col., 469–73

Stewering, Roswitha, *Architektur und Natur in der "Hypnerotomachia Poliphili" (Manutius 1499) und die Zuschreibung des Werkes an Niccolo Lelio Cosmico*, Hamburg 1996

Stiegler, Bernd, *Theoriegeschichte der Photographie*, Munich 2006

Stjernfelt, Frederik, *Diagrammatology. An Investigation on the Borderlines of Phenomenology, Ontology and Semiotics*, Dordrecht 2007

— *Natural Propositions. The Actuality of Peirce's Doctrine of Dicisigns*, Boston, 2014

Stock, Alex, "Die Rolle der 'icona dei' in der Spekulation 'De visione Dei'" in: *Das Sehen Gottes nach Nikolaus von Kues*, ed. Rudolf Haubst, Trier 1989, pp. 50–62

Stöcklein, Ansgar, *Leitbilder der Technik. Biblische Tradition und technischer Fortschritt*, Munich 1969

Stoellger, Philipp, "Das Bild als unbewegter Beweger? Zur effektiven und affektiven Dimension des Bildes als Performanz seiner ikonischen Emergie", in: *Movens Bild. Zwischen Evidenz und Affekt*, ed. Gottfried Boehm et al., Munich 2008, pp. 182–222

Stoichita, Victor I., *L'instauration du tableau: métapeinture à l'aube des temps modernes*, Paris 1993; rev. edn. Geneva 1999

— *L'effet Pygmalion: pour une anthropologie historique des simulacres*, Geneva 2008

Strobl, Andreas, *Otto Dix. Eine Malerkarriere der zwanziger Jahre*, Berlin 1996

Strube, W., "Sprechakt", in: *Historisches Wörterbuch der Philosophie*, Vol. IX, ed. Joachim Ritter and Karlfried Gründer, Darmstadt 1995, col. 1536–42

Stutzinger, Dagmar, "Einleitung. Die Einschätzung der bildenden Kunst", in: *Späntantke und frühes Christentum*, exh. cat., ed. Herbert Beck and Peter C. Bol, Frankfurt am Main 1985, pp. 223–40

Suckale, Robert, "Arma Christi", in: *Städel-Jahrbuch*, new series VI (1977), pp. 177–208

Suthor, Nicola, *Bravura. Virtuosität und Mutwilligkeit in der Malerei der Frühen Neuzeit*, Munich 2010

Sutter, Heribert, *Form und Ikonologie spanischer Zentralbauten. Torres del Rio, Segovia, Eunate* and Weimar 1997

Svenbro, Jesper, *Phrasikleia: anthologie de la lecture en Grèce ancienne*, Paris 1988; Eng. trans. by Janet E. Lloyd, *Phrasikleia: An Anthology of Reading in Ancient Greece*, Ithaca, NY 1993

Sykora, Katharina, *Unheimliche Paarungen. Androidenfaszination und Geschlecht in der Foto-grafie*, Cologne 1999

— *Die Tode der Fotografie*, Vol. I: *Totenfotografie und ihr sozialer Gebrauch*, Munich 2009

Tableaux Vivants, Lebende Bilder und Attitüden in Fotografie, Film und Video, exh. cat., ed. Sabine Folie and Michael Glasmeier, Vienna 2002

Tacke, Alexandra, "Aus dem Rahmen (ge-)fallen. Tableaux vivants in Goethes *Wahlverwandschaften* und bei Vanessa Beecroft", in: *Äpfel und Birnen. Illegitimes Vergleichen in den Kulturwissenschaften*, ed. Hela Lutz et al., Bielefeld 2006, pp. 73–93

Talbot, H[enry] Fox, *Some Account of Photogenic Drawings [...] (Read Before the Royal Society, January 31 1839)*, London 1939

Talbot, William Henry Fox, *The Pencil of Nature*, London 1844–45 (six separately issued installments)

— *The Pencil of Nature* (combined facsimile edition of six installments of 1844–45), ed. Beaumont Newhall, New York 1969

Tammen, Silke, "Blick und Wunde – Blick und Form: Zur Deutungsproblematik der Seitenwunde Christi in der spätmittelalterlichen Buchmalerei", in: *Bild und Körper im Mittelalter*, ed. Krisitn Marek et al., Munich 2006, pp. 85–114

Taraborelli, J. Randy, *Michael Jackson. The Magic and the Madness*, London 2003

Taube, Volkmar, "Bildliche Sprechakte", in: *Intention – Bedeutung – Kommunikation. Kognitive und handlungstheoretische Grundlagen der Sprachtheorie*, ed. Gerhard Preger et al., Frankfurt am Main 2001, pp. 247–56

Taylor, Charles, *Das Unbehagen an der Moderne*, Frankfurt am Main 1995

The Technical Image. A History of Styles in Scientific Imagery, ed. Horst Bredekamp et al., Chicago and London 2015

Das Technische Bild. Kompendium zu einer Stilgeschichte wissenschaftlicher Bilder, ed. Horst Bredekamp et al., Berlin 2008

Thayer, Gerald H., *Concealing Coloration in the Animal Kingdom. An Exposition of the Laws of Disguise through Color and Pattern. Being a Summary of Abbott H. Thayer's Discoveries*, New York 1909

Theweleit, Klaus, *Männerphantasien*, Vol. I: *Frauen, Fluten, Körper, Geschiche*, Frankfurt am Main 1977

Thoenes, Christof, "Über die Grösse der Peterskirche", in: *Sankt Peter in Rom 1506–2006. Beiträge der internationalen Tagung vom 22.–25. Februar 2006 in Rom*, ed. Georg Satzinger and Sebastian Schütze, Munich 2008, pp. 9–28

Thomä, Dieter, *Die Zeit des Selbst und die Zeit danach. Zur Kritik der Textgeschichte Martin Heideggers 1910–1976*, Frankfurt am Main 1990

Thompson, Evan, *Mind in Life. Biology, Phenomenology and the Science of Mind*, Cambridge, Mass 2007

Thümmel, Hans Georg, *Die Konzilien zur Bilderfrage im 8. und 9. Jahrhundert. Das 7. ökumenische Konzil Nikaia 787*, Paderborn et al., 2005

Tomasello, Michael, *Origins of Human Communication*, Cambridge, Mass. and London 2008

Trabant, Jürgen, *Mithridates im Paradies. Kleine Geschichte des Sprachdenkens*, Munich 2003

— "Nacquero esse gemelle. Über die Zwillingsgeburt von Bild und Sprache", in: *Et in imagine ego. Facetten von Bildakt und Verkörperung. Festgabe für Horst Bredekamp*, ed. Ulrike Feist and Markus Rath, Berlin 2012, pp. 77–92

Traumwelt der Puppen, exh. cat., ed. Barbara Krafft, Munich 1991

Trautsch, Asmus, "Der freie Blick", *Kalliope. Zeitschrift für Literatur und Kunst*, I (2008), pp. 48–50

Treasures of Mount Athos, exh. cat., ed. Athanasios A. Karakatsanis, Thessaloniki 1997

Trempler, Jörg, "Der Stil des Augenblicks. Das Bild zum Bericht", in: *Jean Bapteste Henri Savigny und Alexandre Corréard. Der Schiffbruch der Fregate Medusa*, Berlin 2005, pp. 191–240

— "Vom Terror zum Bild – Von der Autentizität zum Stil. Gedanken zur historischen Begründung authentischer Bilder", in: *Sprachpolitik – Bildpolitik. Beiträge zur sprachlichen und visuellen Kommunikation in der entwickelten Demokratie*, ed. Wiilhelm Hofmann, Münster 2006, pp. 117–35

— *Katastrophen. Ihre Entstehung aus dem Bild*, Berlin 2013

Trinks, Stefan, *Skulpturen in Serie: Antike als Produktivkraft im Wandel vom Mittelalter in die Frühe Neuzeit*, ed. Corinna Laude and Gilbert Hess, Berlin 2008, pp. 181–205

Tripps, Johannes, *Das handelnde Bildwerk in der Gotik*, Berlin 1998

Trivers, Robert L., "Parental Investment and Sexual Selection", in: *Sexual Selection and the Descent of Man*, ed. Bernard Campbell, London 1972, pp. 136–79

Turing, Alan M., "Computing Machinery and Intelligence", *Mind*, LIX / 236 (1950), pp. 433–60

Uccelli, Giovanni Battista, *Il Palazzo del Podestà*, Florence 1865

Ünal, Ahmet, "Hurro-hethitische Bilinguen", in: *Weisheitstexte, Mythen und Epen*, ed. Karl Hecker et al. (= *Texte aus der Umwelt des Alten Testaments*, Vol. III: *Mythen und Epen* II), Gütersloh 1994, pp. 860–63

Uppenkamp, Bettina, "Der Fingerabdruck als Indiz. Macht, Ohnmacht und künstlerische Markierung", in: *Bildwelten des Wissens. Kunsthistorisches Jahrbuch für Bildkritik*, Vol. VIII / 1: *Kontaktbilder*, ed. Vera Dünkel, Berlin 2010, pp. 7–17

Van Wezel, Elsa, "Das akademische Museum. Hirts gescheiterte Museumsplannungen 1797/98, 1820 und 1825", in: *Aloys Hirt, Archäologe, Historiker, Kunstkenner*, ed. Claudia Sedlarz and Rolf H. Johannssen, Hanover-Laatzen 2004, pp. 105–28

Varchi, Benedetto, "Storia Fiorentina", in: id., *Opere*, Vol. I, Trieste 1858

Varela, Francisco J. et al., *The Embodied Mind: Cognitive Science and Human Experience*, Cambridge, Mass., 1991

Vasari, Giorgio, *Le Vite de' più eccellenti Pittori, Scultori ed Architettori*, ed. Gaetano Milanesi, 9 vols., Florence 1906

Verspohl, Franz-Joachim, *Joseph Beuys. Das Kapital Raum 1970–1977. Stategien zur Reaktivierung der Sinne*, Frankfurt am Main 1986

— *Michelangelo Buonarrotti und Papst Julius II. Moses – Heerführer, Gesetzgeber, Musenlenker*, Göttingen and Bern 2004

Verstegan, Richard, *Théâtre des cruautés des hérétiques de notre temps*, Paris 1995 [1587]

Verzar, Christine and Charles T. Little, "Gothic Italy: Reflections of Antiquity", in: *Set in Stone. The Face in Medieval Sculpture*, exh. cat., ed. Charles T. Little, New York 2006, pp. 146–50

Verzeichnis von Gemälden und Kunstwerken, welche durch die Tapferkeit der vaterländischen Truppen wieder erobert wurden, Berlin 1815

Villhauer, Bernd, *Aby Warburgs Theorie der Kultur. Detail und Sinnhorizont*, Berlin 2002

Vogtherr, Christoph Martin, "Das königliche Museum zu Berlin. Planungen und Konzeption des ersten Berliner Kunstmuseums", in: *Jahrbuch der Berliner Museen*, XXXIX (1997), Beiheft

Vos, Dirk de, *Hans Memling. Das Gesamtkunstwerk*, Stuttgart and Zürich 1994

Voss, Julia, "Augenflecken und Argusaugen: Zur Bildlichkeit der Evolutionstheorie", in: *Bildwesen des Wissens. Kunsthistorisches Jahrbuch für Bildkritik*, I / 1 (2003), pp. 75–85

Wagner, Monika, "Selbstbegegnungen. Lebende Denkmäler in den Maifeiern der Sozialdemokratie um 1900", in: *Mo(nu)mente. Formen und Funktionen ephemerer Denkmäler*, ed. Michael Diers, Berlin 1993, pp. 93–112

— "Der kreative Akt als öffentliches Ereignis", in: *Topos Atelier. Werkstatt und Wissensform*, ed. Michael Diers and Monika Wagner, Berlin 2010, pp. 45–58

Waldenfels, Bernhard, *Antwortregister*, Frankfurt am Main 2007

— "Von der Wirkmacht und Wirkkraft der Bilder", in: *Movens Bild. Zwischen Evidenz und Affekt*, ed. Gottfried Boehm et al., Munich 2008, pp. 47–63

Waldmann, Susann, *Die lebensgrosse Wachsfigur*, Munich 1990

Walter-Karydi, Elena, "Die Entstehung des beschrifteten Bildwerkes", *Gymnasium. Zeitschrift für Kultur der Antike und Humanistische Bildung*, CVI / 4 (1999), pp. 289–309

Warburg, Aby M., *Ausgewählte Schriften und Würdigungen*, ed. Dieter Wuttke, Baden-Baden 1979

— *Schlangenritual. Ein Reisebericht*, ed. Ulrich Raulff, Berlin 1988

— *Die Erneuerung der heidnischen Antike. Kulturwissenschaftliche Beiträge zur Geschichte der europäischen Renaissance (Gesammelte Schriften. Studienausgabe*, Part I, Vol. I / 1&2, ed. Horst Bredekamp and Michael Diers), Berlin 1998

— *Der Bilderatlas MNEMOSYNE (Gesammelte Schriften. Studienausgabe*, Part II, Vol. I / 1, ed. Martin Warnke and Claudia Brink), Berlin 2000

— *Tagebuch der Kulturwissenschaftlichen Bibliothek Warburg mit Einträgen von Gertrud Bing and Fritz Saxl (Gesammelte Schriften. Studienausgabe*, Part VII, Vol. VII, ed. Karen Michels and Charlotte Schoell-Glass), Berlin 2001

— *Gli Hopi. La sopravivenza dell'umanità primitiva nella cultura degli Indiani dell' America del Nord*, ed. Maurizio Ghelardi, Turin 2006

— *Werke in einem Band*, ed. Martin Treml et al., Berlin 2010

Warning, Rainer, "Rousseaus Pygmalion als Szenario des Imaginären", in: *Pygmalion. Geschichte des Mythos in der abendländlichen Kultur*, ed. Mathias Mayer and Gerhard Neumann, Freiburg 1997, pp. 225–70

Warnke, Martin, "Weltanschauliche Motive in der kunstgeschichtlichen Populärliteratur", in: *Das Kunstwerk zwischen Wissenschaft und Weltanschauung*, ed. Martin Warnke, Gütersloh 1970, pp. 88–105

— "Durchbrochene Geschichte? Die Bilderstürme der Wiedertäufer in Münster 1534/1535", in: *Bildersturm. Die Zerstörung des Kunstwerks*, ed. Martin Warnke, Munich 1973, pp. 65–98

— "Vier Stichworte: Ikonologie – Pathosformel – Polarität und Ausgleich– Schlagbilder und Bilderfahrzeuge", in: *Die Menschenrechte des Auges. Über Aby Warburg*, ed. Werner Hofmann et al., Frankfurt am Main 1980, pp. 61–68

— "Warburg und Wölfflin", in: *Akten des internationalen Symposions Hamburg 1990*, ed. Horst Bredekamp et al., Weinheim 1991, pp. 79–86

— *Politische Landschaft. Zur Kunstgeschichte der Natur*, Vienna 1992

— "Politische Ikonographie", in: *Bildindex zur politischen Ikonographie*, ed. Forschungsstelle politischer Ikonographie, Hamburg 1993, pp. 5–12

— "Politische Ikonographie. Hinweise auf eine sichtbare Politik", in: *Wozu Politikwissenschaft? Über das Neue in der* Politik, ed. Claus Leggewie, Darmstadt 1994, pp. 170–78

— *Nah und Fern zum Bilde. Beiträge zu Kunst und Kunsttheorie*, ed. Michael Diers, Cologne 1997

"Was noch begraben lag". Zu Walter Benjamins Exil. Briefe und Dokumente, ed. Geret Luhr, Berlin 2000

Watson, James D. and Francis H. Crick, "Molecular Structure of Nucleic Acids. A Structure for Deoxyribose Nucleid Acid", *Nature*, 25 April 1953, pp. 737–38

Wehrberger, Kurt, "Der Löwenmensch von Hohlenstein-Stadel", in: *Les chemins de l'Art Aurignacien en Europe / Das Aurignacien und die Anfänge der Kunst in Europa. Actes du colloque 2005 d'Aurignac / Tagungsband der gleichnamigen Internationalen Fachtagung 2005*, ed. Harald Floss and Nathalie Rouquerol, Aurignac 2007, pp. 331–44

Weigel, Sigrid, "Nichts weiter als ...". Das Detail in den Kulturtheorien der Moderne: Warburg, Freud, Benjamin", in: *"Der liebe Gott steckt im Detail". Mikrostrukturen des Wissens*, ed. Wolfgang Schäffner et al., Munich 2003, pp. 91–111

Wellmann, Marc, *Die Entdeckung der Unschärfe in Optik und Malerei. Zum Verhältnis von Kunst und Wissenschaft zwischen dem 15. und dem 19. Jahrhundert*, Frankfurt am Main et al. 2005

Wenderholm, Iris, *Bild und Berührung. Skulptur und Malerei auf dem Altar der italienischen Frührenaissance*, Munich and Berlin 2006

Wendler, Reinhard, *Das Modell zwischen Kunst und Wissenschaft*, Munich 2013

Wensberg, Peter C., *Polaroid. A company and a man who invented* it, Boston1987

Wenzel, Horst, *Hören und Sehen. Schrift und Bild, Kultur und Gedächtnis im Mittelalter*, Munich 1995

Werckmeister, Otto Karl, *Der Medusa-Effekt. Politische Bildstrategien seit dem 11. September 2001*, Berlin 2005

— "Das Collateral Murder Video", *Frankfurter Allgemeine Zeitung*, 5 May 2010, p. 3

Wescher, Paul, *Kunstraub unter Napoleon*, West Berlin 1976

Wessely, Anna, "Die philosophische Funktion von Bildrhetorik", in: *Idea. Jahrbuch der Hamburger Kunsthalle*, VIII (1989), pp. 7–13

Whitehead, Alfred North, *Symbolism. Its Meaning and Effect*, Cambridge 1928

Wieacker, Franz, *Die Manios-Inschrift von Präneste. Zu einer exemplarischen Kontroverse*, Göttingen 1984

Wiesing, Lambert, "Pragmatismus und Performativität des Bildes", in: *Perfomativität und Medialität*, ed. Sybille Krämer, Munich 2004, pp. 115–28

— "Zur Kritik um Interpretationismus oder Die Trennung von Wahrheit und Methode", in: *Internationales Jahrbuch für Hermeneutik*, III (2004), pp. 137–51

Wimmer, Dorothee, "'Die Vergewaltigung ist der Tod' – Niki de Saint Phalles autobiographische Bilder, Filme und Bücher", in: *Bühnen des Selbst. Zur Autobiographie in den Künsten des 20. und 21. Jahrhunderts*, ed. Theresa Georgen and Carola Muysers, Kiel 2006, pp. 249–64

— *Das Verschwinden des Ichs. Das Menschenbild in der französischen Kunst, Literatur und Philosophie um 1960*, Berlin 2006

Wind, Edgar, "Warburgs Begriff der Kulturwissenschaft und seine Bedeutung für die Ästhetik", in: *Vierter Kongress für Ästhetik und allgemeine Kunstwissenschaft, Hamburg 7.–9. Oktober 1930, Zeitschrift für Ästhetik und allgemeine Kunstwissenschaft*, XXV (1931), Beilagenheft, pp. 163–79

— *Kunst und Anarchie*, Frankfurt am Main 1979

Winner, Matthias, "Das 'O' von Lorenzo Lotto und Parmigianinos Selbstbildnis im Konvexspiegel", in: *Römisches Jahrbuch der Bibliotheca Hertziana*, XXXVI (2005), pp. 93–116

Wittmann, Mirjam, "Die Logik des Wetterhahns. Kurzer Kommentar zur Debatte um fotografiische Indexikalität", *kunsttexte.de*, 2010, no. 1, pp. 1–4

Wolf, Gerhard, "Kreuzweg, Katzenweg, Affenweg oder: Glaube, Hoffnung, Liebe", in: *Glaube Hoffnung Liebe Tod*, exh. cat., ed. Christoph Geissmar-Brandi and Eleonora Louis, Vienna 1995, pp. 438–43

— "Mandylion to Veronica", in: *The Holy Face and the Paradox of Representation*, ed. Herbert L. Kessler and Gerhard Wolf, Bologna 1998, pp. 153–79

— "Cusanus 'liest' Leon Battista Alberti: Alter Deus und Narziss (1453)", in: *Portrait*, ed. Rudolf Preimesberger et al., Berlin 1999, pp. 201–09

— "Das verwunderte Herz – Das verwunderte Bild", in: *Rhetorik der Leidenschaft. Zur Bildsprache der Kunst im Abendland*, ed. Ilsebill Barta-Fliedl et al., Hamburg 1999, pp. 20–21

— *Schleier und Spiegel. Traditionen des Christusbildes und die Bildkonzepte der Renaissance*, Munich 2002

— "Urbilder Christi. Zur Geschichte der Suche nach dem wahren Bild", in: *Ansichten Christi. Christusbilder von der Antike bis zum 20. Jahrhundert*, exh. cat., ed. Roland Krischel et al., Cologne 2005, pp. 97–139

— "Vom Scheitern eines Porträtisten. Überlegungen zur künstlerischen Inszenierung des Mandylions von Genua und zum Begriff der 'historia' zwischen Ost und West", in: *Grammatik der Kunstgeschichte. Sprachproblem und Regelwerk im "Bild-Diskurs", Oskar Bätschmann zum 65. Geburtstag*, ed. Hubert Locher and Peter J. Schneemann, Zürich et al. 2008, pp. 225–38

Wolf, Hertha, "Das, was ich sehe, ist gewesen. Zu Roland Barthes' *Die helle Kammer*'", in: *Paradigma Fotografie. Fotokritik am Ende des fotografischen Zeitalters*, ed. Herta Wolf, Vol. I, Frankfurt am Main 2002, pp. 89–107

Worringer, Wilhelm, *Abstraktion und Einfühlung*, 7th to 9th edn., Bonn 1919

"Worte des Danziger Bildes, das jüngste Gericht vorstellend, an seine Freunde", *Berlinische Nachrichten von Staats- und gelehrten Sachen*, 31 October 1815, n. p.

Wortmann, Volker, *Authentisches Bild und authentische Form*, Cologne 2003

Wunder und Wissenschaft, Salomon de Caus und die Automatenkunst in Gärten um 1600, exh. cat., ed. Stiftung Schloss und Park Benrath, Düsseldorf 2008

Wynn, Thomas, "Archaeology and Cognitive Evolution", *Behavioral and Brain Science*, XXV / 3 (2002), pp. 389–402

Wyss, Beat, *Vom Bild zum Kunstsystem*, 2 vols., Cologne 2006

— *Renaissance als Kulturtechnik*, Hamburg 2013

Yves Klein, exh. cat., ed. Sidra Stich, Ostfildern (Ruit) 1994

Zahavi, Amotz, *The Handicap Principle: A Missing Piece of Darwin's Puzzle*, New York and Oxford 1997

Zampieri, Girolamo, *Il Museo Archeologico di Padova*, Milan 1994

Zapperi, Giovanna, "Vénus mécanique. L'automate féminin à l'époque de sa reproductibilité technique", in: *Les cahiers de MNAM*, no. 107 (2009), pp. 18–37

Die Zeit der Stauffer. Geschichte – Kunst – Kultur, exh. cat., ed. Württembergisches Landes-museum, 3 vols., Stuttgart 1977

Zeki, Semir, "Art and the Brain", *Journal of Consciousness Studies*, VI / 6 & 7 (1999), pp. 76–96

— *Inner Vision: An Exploration of Art and the Brain*, Oxford 1999

Ziemba, Antoni, "Rembrandts Landschaft als Sinnbild. Versuch einer ikonlogischen Deutung", *Artibus et Historiae*, VIII / 15 (1987), pp. 109–34

Zimmermann, Anja, *Skandalöse Bilder – Skandalöse Körper. Abject Art vom Surrealismus bis zu den Culture Wars*, Berlin 2001

— "Vererbung als kreativer Akt. Mythen von Geschlecht, Autorität und Lebendigkeit in der 'Bio-Art'", in: *Animationen / Transgressionen*, ed. Ulrich Pfisterer and Anja Zimmermann, Berlin 2005, pp. 283–304

Zittel, Claus, *Theatrum philosophicum. Descartes und die Rolle ästhetischer Formen in der Wissenschaft*, Berlin 2009

Zumbusch, Cornelia, *Wissenschaft in Bildern. Symbol und dialektisches Bild in Aby Warburgs Mnemosyne-Atlas und Walter Benjamins Passagen-Werk*, Berlin 2004

Zuschlag, Christoph, "Transformationen der Antike in der zeitgenössischen Kunst", in: *Das Originale der Kopie. Kopien als Produkte und Medien der Transformation von Antike*, ed. Tatjana Bartsch et al., Berlin and New York 2010, pp. 313–28

Index

The presence of accents is not taken into account in this alphabetical listing. Footnotes are listed only when the page on which they occur contains no reference to the item concerned in its main text (which will itself refer to relevant footnotes).

Picture Credits

1: From: Steffen 2003, p. 136. ___ **2**: By courtesy of the Metropolitan Museum, New York. ___ **3**: From: *Eiszeit* 2009, fig. 109. ___ **4**: By courtesy of the Metropolitan Museum of Art, New York. ___ **5**: From: Bahnsen 2005, p. 547. ___ **6**: From: *Eiszeit* 2009, fig. 85. ___ **7**: From: *Eiszeit* 2009, fig. 322. ___ **8**: From: *Eiszeit* 2009, fig. 310. ___ **9**: From: *Eiszeit* 2009, fig. 294. ___ **10**: From: Monahan 1998, p. 44. ___ **11**: From: *Die Masken* 2002, p. 167. ___ **12**: From: *Der Hase* 2002. ___ **13**: From: Wieacker 1984, fig. I. ___ **14**: From: Walter-Karydi 1999, fig. 2. ___ **15**: By courtesy of the British Museum, London. ___ **16**: By courtesy of the Museum of Fine Arts, Boston. ___ **17**: From: *Die Geschichte der antiken Bildhauerkunst* 2002, vol. I, I, fig. 27. ___ **18**: By courtesy of the British Museum, London. ___ **19**: From: Pastoureau, Michel, *Storie di pietra*, Turin 2014, p. 89. ___ **20**: From: Ullmann, Cécile (ed.), *Révélation. Le grand portail d'Autun*, Lyon 2011, p. 9. ___ **21**: From: Trinks, Stefan, *Antike und Avantgarde. Skulptur am Jakobsweg im 11. Jahrhundert. Jaca – León – Santiago*, Berlin 2012, fig. 91. ___ **22**: Photograph by Stefan Trinks. ___ **23**: Photograph by Barbara Herrenkind. ___ **24**: Photograph by Barbara Herrenkind. ___ **25**: Photograph by Barbara Herrenkind. ___ **26**: From Mende 1981, fig. 28. ___ **27**: From Bredekamp 2000 *Mittelalter*, fig. 15. ___ **28**: From: Sauerländer 1963, fig. 38. ___ **29**: From: *Die Zeit der Staufer* 1977, fig. 452. ___ **30**: From: Campbell 1998, p. 213. ___ **31**: From: Dhanens 1980, p. 303. ___ **32**: From: Dhanens 1980, p. 292. ___ **33**: From: Dhanens 1980, pp. 54–55. ___ **34**: Photograph by Barbara Herrenkind. ___ **35**: Photograph by Barbara Herrenkind. ___ **36**: Photograph by Barbara Herrenkind. ___ **37**: Photograph by Barbara Herrenkind. ___ **38**: By courtesy of the Rüstkammer, Staatliche Kunstsammlungen Dresden. ___ **39**: From: Haskell and Penny 1982, p. 292. ___ **40**: From: Erben 2005, fig. 2. ___ **41**: From: Vos 1994, pp. 82–83. ___ **42**: © VG Bild-Kunst, Bonn 2017. ___ **43**: © VG Bild-Kunst, Bonn 2017. ___ **44**: © VG Bild-Kunst, Bonn 2017. ___ **45**: © VG Bild-Kunst, Bonn 2017. ___ **46**: From: Helas 1999, fig. 1. ___ **47**: From: Sander 1992, plate 14. ___ **48**: From: Pächt 1993, fold-out plate. ___ **49**: From: Jenkins and Sloan 1996, fig. 159. ___ **50**: © Man Ray Trust, Paris/VG Bild-Kunst, Bonn 2017. ___ **51**: From: *Tableaux Vivants* 2002, p. 120. ___ **52**: © VG Bild-Kunst, Bonn 2017. ___ **53**: Archivio Storico del Cinema / AFE. ___ **54**: From: *Bill Viola* 1997, pp. 62–63. ___ **55**: Filmstill from: Peter Greenaway, *The Draughtsman's Contract*, 1982. ___ **56**: By courtesy of Sasha Waltz. ___ **57**: From: Andres et al. 1994, fig. 639. ___ **58**: With kind permission of the artists. ___ **59**: From: *Beecroft* 2003, pp. 314–15. ___ **60**: By courtesy of the Bibliothèque nationale, Paris. ___ **61**: From: *Künstliche Menschen* 2000, p. 193. ___ **62**: Collection of the author. ___ **63**: Collection of the author. ___ **64**: Collection of the author. ___ **65**: Collection of the author. ___ **66**: Postcard, collection of the author. ___ **67**: Postcard, collection of the author. ___ **68**: From: Stöcklein 1969, fig. 15. ___ **69**: Collection of the author. ___ **70**: © Bertina Schulze-Mittendorff and Deutsche Kinemathek. ___ **71**: © Friedrich-Wilhelm-Murnau-Stiftung. ___ **72**: © Friedrich-Wilhelm-Murnau-Stiftung. ___ **73**: © ZKM, Karlsruhe. ___ **74**: © ZDF. ___ **75**: From: *Das alte Griechenland* 1995, p. 275. ___ **76**: By courtesy of the Staatsbibliothek, Berlin. ___ **77**: By courtesy of the Staatsbibliothek, Berlin. ___ **78**: From: Jean-Jacques Rousseau, *Collection com-*

pletes des œuvres, 1774–1783. ___ **79**: From: Erben 2005, fig. 1. ___ **80**: From: *"Meine ... alten und dreckigen Götter"* 1998, p. 15. ___ **81**: © VG Bild-Kunst, Bonn 2017. ___ **82**: Collection of Eric Le Roy. ___ **83**: © VG Bild-Kunst, Bonn 2017. ___ **84**: From: Müller-Tamm, Pia and Sykora, Katharina, *Phantasmen der Moderne*, Köln 1999, p. 376. ___ **85**: © VG Bild-Kunst, Bonn 2017. ___ **86**: © VG Bild-Kunst, Bonn 2017. ___ **87**: Photograph by Barbara Herrenkind. ___ **88**: Photograph by Barbara Herrenkind. ___ **89**: By courtesy of Liane Lang. ___ **90**: In: *Sandro Botticelli* 2000, p. 127. ___ **91**: In: *Futurismo e Futurismi* 1986, p. 513. ___ **92**: In: Lullies 1956, plate 262. ___ **93**: In: *Futurismo e Futurismi* 1986, p. 423. ___ **94**: By courtesy of Howard Phillips. ___ **95**: Private archive of the author. ___ **96**: © VG Bild-Kunst, Bonn 2017. ___ **97**: By courtesy of Edgar Lissel. ___ **98**: By courtesy of Eduardo Kac. ___ **99**: By courtesy of Ionat Zurr, SymbioticA Researcher & Academic Coordinator, University of Western Australia. ___ **100**: From: *Mandylion* 2004, p. 49. ___ **101**: From: *Martin Schongauer* 1991, p. 181. ___ **102**: From: Belting and Kruse 1994, fig. 2. ___ **103**: From: Emboden, 1987, fig. 90. ___ **104**: From: Lack 2001, p. 147. ___ **105**: From: Ettingshausen 1857, plate IV. ___ **106**: From: *Objects in Transition* 2007, fig. 2.8. ___ **107**: From: Becker 2005, fig. 16. ___ **108**: From: Gethmann 2005, p. 63. ___ **109**: From: Gernsheim 1977, p. 4. ___ **110**: From: *The Photographic Art* 2000, fig. 6. ___ **111**: From: *Objects in Transition* 2007, fig. 2.1. ___ **112**: From: Pentcheva 2006, fig. 11. ___ **113**: From: Thomas Hobbes, *Leviathan*, 1951. ___ **114**: ETH-Bibliothek Zürich, Rar 9315, n.p., By courtesy of the ETH-Bibliothek Zürich. ___ **115**: From: Lentz 2004, fig. 23. ___ **116**: From: Lentz 2004, fig. 85. ___ **117**: By courtesy of the Otto-von-Bismarck-Foundation. ___ **118**: © Nastasja Weitsz, Getty Images. ___ **119**: State Historical Museum of Russia, Moscow, Cod. add. gr. 129, Fol. 67r. In: *The Glory of Byzantium. Art and Culture of the Middle Byzantine Era. A.D. 843–1261*, exh. cat., ed. Helen C. Ewans and William D. Wixom, New York 1997, p. 97. ___ **120**: From: *Bildersturm* 2000, p. 60. ___ **121**: From: Gramaccini 1996, fig. 10. ___ **122**: Photograph by the author. ___ **123**: From: Sladeczek 1999, fig. 341. ___ **124**: From: *Bildersturm* 1973, fig. 9. ___ **125**: From: *Bildersturm* 2000, no. 166. ___ **126**: © Barnett Newman Foundation/VG Bild-Kunst, Bonn 2017. ___ **127**: From: *Kaiser Friedrich II.* 2008, p. 365. ___ **128**: From: Claussen 1990, fig. 4. ___ **129**: Photograph by Barbara Herrenkind. ___ **130**: From: Cecchi 2005, p. 163. ___ **131**: From: Körner 2006, fig. 80. ___ **132**: From: Pope-Hennessy 1985, plate 18. ___ **133**: Photograph by Reinhard Saczewski. ___ **134**: © Randal Rauser. ___ **135**: © CNN. ___ **136**: © Spencer Platt, Getty Images. ___ **137**: © AP. ___ **138**: From: *Peter Paul Rubens* 2004, p. 223. ___ **139**: From: *Konstantin der Grosse* 2007, p. 97. ___ **140**: From: Fehrenbach 1996, p. 15. ___ **141**: From: Claude-Nicolas Ledoux, *L'architecture considerée sous le rapport de l'art des moeurs et de la législation*, vol. I, Paris 1804, p. 225. ___ **142**: © AERIA, Antikensammlung Erlangen Internet Archive, Photograph by Giraudon (1926). ___ **143**: By courtesy of the Royal Collection Trust /© HM Queen Elizabeth II 2017. ___ **144**: Photograph by Jörg P. Anders. ___ **145**: From: *Glaube Hoffnung Liebe Tod* 1995, p. 255. ___ **146**: From: Krause 2002, fig. 83. ___ **147**: From: *Hans Holbein d. Ä. Die Graue Passion in ihrer Zeit*, exh. cat., ed. Elsbeth Wiemann, Ostfildern 2010, p. 250, fig. 49. ___ **148**: From: *Hans Holbein d. Ä. Die Graue Passion in ihrer Zeit*, exh. cat., ed. Elsbeth Wiemann, Ostfildern 2010, p. 246, fig. 45. ___ **149**: © VG Bild-Kunst, Bonn 2017. ___ **150**: © VG Bild-Kunst, Bonn 2017. ___ **151**: By courtesy of Petra Kipphoff. ___ **152**: By courtesy of the Bibliothèque Royale, Brussels. ___ **153**: From: *Glaube Hoffnung Liebe Tod* 1995, p. 153. ___ **154**: © Lucio Fontana by SIAE/VG Bild-Kunst, Bonn 2017. ___ **155**: © Anselm Kiefer and Collection Van Abbemuseum, Eindhoven, The Netherlands, Photograph by Peter Cox. ___ **156**: From: Orchard 1992, p. 50. ___ **157**: From: *Le Siècle* 1993, cat. no. 265. ___ **158**: From: *Der späte Tizian* 2007, p. 120, fig. 17. ___ **159**: From: *Rembrandts Landschaften* 2006, fig. 28. ___ **160**: From: *Entdeckung der Abstraktion* 2008, fig. 30. ___ **161**: Photograph by Hans Namuth. ___ **162**: From: Bredekamp 2008 *Rom*, fig. 11. ___ **163**: From: Hubert 2008, fig. 5. ___ **164**: From: Thoenes 2008, fig. 1. ___ **165**: From: *The Age of the Marvelous* 1991, plate 14. ___ **166**: From: *Deceptions and Illusions* 2002, fig. 76. ___ **167**: © VG Bild-Kunst, Bonn 2017. ___ **168**: By courtesy of Houghton Library. ___ **169**: Private Collection. ___ **170**: From: Morand 1991, plate 131. ___ **171**: From: Lindsey 2001, p. 61. ___ **172**: From: *Frank Gehry* 2001, p. 156. ___ **173**: From: *Frank Gehry at Gemini* 2001, p. 22. ___ **174**: With kind permission of Frank O. Gehry. ___ **175**: With kind permission of Frank O. Gehry. ___ **176**: With

kind permission of Frank O. Gehry. ___ **177**: By courtesy of the Metropolitan Museum of Art, New York. ___ **178**: Charles Darwin, Model of "natural selection". ___ **179**: From: *Nature*, 25 April 1953. ___ **180**: From: William Hogarth, *The Analysis of Beauty*, 1753. ___ **181**: By courtesy of the Cambridge University Library. ___ **182**: From: Warburg 1979, p. 323, fig. 1. ___ **183**: From: Warburg 2006, plate 109. ___ **184**: From: Ehrenreich 2007, fig. 8. ___ **185**: From: *Der Frühe Dürer*, exh. cat., ed. Daniel Hess and Thomas Eser, Nuremberg 2012, p. 254, fig. 7. ___ **186**: From: Mansuelli 1958, p. 121, no. 82. ___ **187**: By courtesy of the National Gallery of Art, Widener Collection, Washington, D.C. ___ **188**: From: Warburg 1998, vol. I, 1, plate IV, fig. 6. ___ **189**: From: Warburg 1998, vol. I, 1, Plate IV, fig. 7. ___ **190**: From: Colonna 1980, Bd. I, S. 186. ___ **191**: From: *Pipilotti Rist 1998*. ___ **192**: From: Warburg 2000, plate 79. ___ **193**: From: Darwin 2003 [1871], p. 137. ___ **194**: By courtesy of Cornelius E. Klots. ___ **195**: From: Papet 2002, fig. 47. ___ **196**: From: Darriulat 1998, p. 19. ___ **197**: By courtesy of the National Gallery of Art, Washington, D.C. ___ **198**: From: *Architekturmodelle* 1995, p. 167. ___ **199**: By courtesy of Markus Rath